W9-AML-732

"This is a crackerjack of a book—with enough rogues, thieves, and amoral civilians (not all of them on the radar of relentless cops) to people a dozen crime novels. First-rate."

—**GILES BLUNT**, best-selling author of the John Cardinal series, including *Crime Machine* and *Forty Words for Sorrow*

"Now this is investigative reporting. Dogged, fearless, and thrillingly thorough, Joshua Knelman becomes our Virgil through the secret underworld of stolen art. Like legendary muckrakers Bob Woodward, Seymour Hersh, and Barlett and Steele, Knelman relentlessly trails both the bad guys and the slightly less bad guys, looking for truth amidst all the deceit. It's an astonishing debut—and serious readers must take note—long-form reporting has a new title in the canon."

—**RICHARD POPLAK**, author of *Ja No Man: Growing up White in Apartheid Era South Africa*, *The Sheik's Batmobile: Pop Culture in the Middle East*, and *Kenk: A Graphic Novel*

"Knelman's book is the Godfather of investigative journalism. He takes us to places we always wanted to be but didn't dare to enter, he makes us fall for people we are not supposed to love—on both sides of the law. Congratulations, this is haute art!"

—**ANDRAS HAMORI**, Executive Producer, *The Sweet Hereafter* and *Fugitive Pieces*

"Art theft is one of the largest underground markets in the world, yet very few people know how it works, or how to stop it. Joshua Knelman delves into this uncharted world with an open curiosity, befriending the detectives dedicated to retrieving stolen art, the lawyers struggling to protect cultural property, and the thieves who have their own reasons for doing what they do. These pages are full of shady characters and experts determined to outwit each other; an intriguing look at human lusts and foibles. *Hot Art* is fascinating, smart, and a page-turner."

—**CATHERINE OSBORNE**, Deputy Editor, *Azure Magazine*

# HOT ART

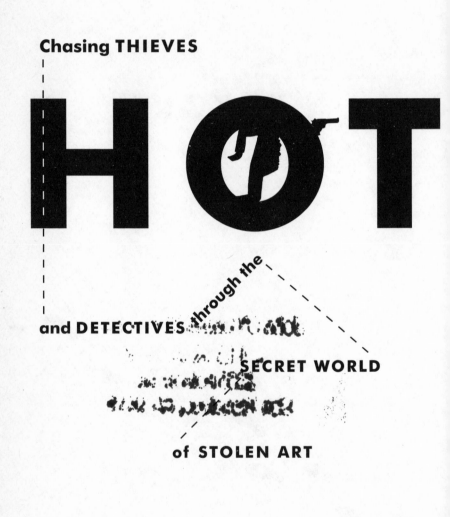

Chasing THIEVES

# H⦿T

and DETECTIVES through the

SECRET WORLD

of STOLEN ART

# JOSHUA KNELMAN

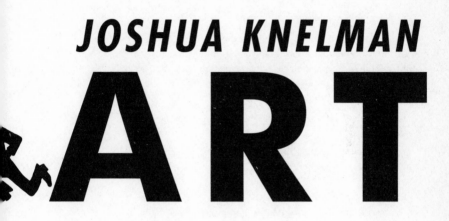

# ART

John O'Connell High School
LIBRARY
2355 Folsom St.
San Francisco, CA 94110

Tin House Books
Portland, Oregon & New York, New York

Copyright © by Joshua Knelman 2011

First published in Canada by Douglas & McIntyre, 2011

First U.S. edition published by Tin House Books 2012

All rights reserved. No part of this book may be used or repro-
duced in any manner whatsoever without written permission from
the publisher except in the case of brief quotations embodied in
critical articles or reviews. For information, contact Tin House
Books, 2601 NW Thurman St., Portland, OR 97210.

Published by Tin House Books, Portland, Oregon, and New York,
New York

Distributed to the trade by Publishers Group West, 1700 Fourth
St., Berkeley, CA 94710, www.pgw.com

Library of Congress Cataloging-in-Publication Data

Knelman, Joshua.

Hot art : chasing thieves and detectives through the secret world
of stolen art / Joshua Knelman.

pages cm

ISBN 978-1-935639-38-1 (pbk.) -- ISBN 978-1-935639-
39-8 (ebook)

1. Art thefts. I. Title.

N8795.K59 2012

364.16'287--dc23

2011049500

www.tinhouse.com

Printed in the USA
Interior Design by Jessica Sullivan

*For Bernadette Sulgit
and Martin Knelman*

"The best way of keeping a secret is to pretend there isn't one."

**MARGARET ATWOOD**

"The greatest crimes in the world are not committed by people breaking the rules but by people following the rules."

**BANKSY**

# CONTENTS

# HOT ART

# 1. _ _ _ _ _

## HOLLYWOOD

*"This happened fast, and in the dark."*
**DONALD HRYCYK**

LAPD detective Donald Hrycyk knew his way around a homicide investigation. He knew about the Bloods and the Crips, how the color of your shoelaces could indicate which gang you belonged to, and whom you had to kill to get ahead in life. He knew about semiautomatics and shotguns and butcher knives, and about streets that felt a universe away from the pristine white walls of the art scene, or the jet set who ruled it. By the time I met him, though, the detective had visited almost every gallery and auction house in the Greater Los Angeles area and had contacts all over the world. He didn't gloat about it. Mostly, he just got up early every day and worked his cases.

One afternoon in L.A., in 2008, Detective Hrycyk and his partner, Detective Stephanie Lazarus, were cruising through the city in their unmarked silver Chevrolet

Impala. Hrycyk was at the wheel, and drove down Sunset Boulevard toward a crime scene. It was a hot, bright day, and the sunlight burned a little. On Sunset the car passed the Chateau Marmont and the Comedy Store—the marquee read "George Carlin, RIP."

At a red light, the Impala idled between two gleaming white SUVs. A driver looking down into the lowly Chevy would have seen that the detectives wore similar uniforms: checkered shirts, slacks, and black running shoes. On their wrists, both sported big digital watches. Their style was so uncool it was almost cool. Beneath their loose shirts, hardly noticeable, they kept a few of their work tools: LAPD badge, cell phone, handcuffs, tape recorder, extra ammo, and gun. They looked like gym coaches on their way to practice.

Just before crossing into Beverly Hills, Hrycyk hung a left on La Cienega Boulevard. He was heading to a strip of antique and design stores. A few minutes earlier, when the detectives picked me up, they had both turned from the front seat and inspected my shoes (black Adidas with white stripes). Lazarus exchanged a glance with Hrycyk—the original wireless connection.

Lazarus said, "No. The soles don't look right."

Hrycyk's eyes smiled quietly in the rearview mirror. "The antique store that was burglarized has a few clues," he said. "Apparently there are some shoeprints on an antique dining-room table. From the description, they don't match yours."

So I was a suspect?

"You never know," Lazarus said. "A journalist is here from Toronto writing about art theft, and an antique store happens to be hit. It's good news for you, right? Because you get to ride along for the investigation. We just wanted to rule you out." Later Hrycyk and Lazarus told me about a journalist in the

Midwest who had murdered people and then written about the murders for the local paper. Their point: don't rule out anyone too early—it's all about motivation. Everyone's a suspect. I felt guilty just sitting there in the back seat.

Hrycyk parked on La Cienega near the crime scene. The antique store was at street level, one of two in the same unit, with a large bay window facing the sidewalk and traffic. The window, which was intact, featured a few choice pieces of Italian Renaissance furniture.

The attached store was under construction; a large piece of plywood covered the empty hole where its front window should have been. A shade tree stood near the sidewalk in front of the store. A small group of construction workers huddled in the pool of its shadow, their workday frozen by the burglary next door. The construction site was now part of the crime scene. There was almost no breeze that afternoon, and the heat was stifling. The group of men, roughly in their twenties, looked slightly nervous at the sight of the detectives, but it was one of them who had discovered the break-in and called 911. For now the workers waited for their foreman and watched the police from the shadows.

Hrycyk and Lazarus stood on the sidewalk in the open sunlight as a black and white cruiser with the gold insignia "TO PROTECT AND TO SERVE" pulled into the asphalt driveway leading to the antique store's back parking lot. A tall white-painted iron gate, there to protect the back lot from intruders, stood ajar.

In the patrol car were two officers from Hollywood Division. Officer Ramirez occupied the driver's seat. He was a sleek-looking man in his early thirties, in perfect athletic shape, with shorn black hair. His aviator shades reflected back the intense afternoon light. Ramirez was relaxed and smiled often. His movie-star white teeth matched

the aesthetic of the neighborhood—upscale fashion and design, expensive. On the road, a cherry-red BMW with tinted windows slowed down, the driver staring at the small crowd and the police cruiser.

Hrycyk and Lazarus strolled over to the window of the patrol car. On the way, Hrycyk explained to me that Ramirez and his partner had already done a preliminary inspection of the crime scene. The detectives now taking over relied on the officers' notes and first impressions. "We completely depend on them," said Hrycyk.

According to Ramirez, this is what the officers had uncovered: The lock on the gate to the back parking lot had been opened. A large white pickup truck had been seen driving into the lot. The thieves had entered the building through the plywood on the store next door, then unlocked that store's back door for the crew in the truck. Once inside the empty store, the thieves had knocked a hole straight through the shared wall into the antique store. The thieves had then entered the store and carried a number of antiques through the hole, through the empty store, out the back door, and into the truck in the parking lot.

Ramirez got out of the patrol car and strolled with Hrycyk and Lazarus down the driveway and into the parking lot. The lot was enclosed at the back by a high fence, behind which the balconies of a large, low-slung apartment complex had a perfect view of the lot. Ramirez and his partner had already canvased the apartment building. They got lucky. A witness had seen the events unfold from a balcony—and had noticed a tattoo on one of the men's legs.

"Yeah," said Ramirez. "It was a cobra or a snake."

"Maybe a marine tattoo? Something like that?" asked Hrycyk.

"No, I know marines, and it's nothing like that."

"So more like a creature?" asked Hrycyk.

The problem was that the witness spoke only Russian.

"We'll have to find a translator," Hrycyk nodded. "We have a number for someone, right?"

"Lost in translation for now," answered Ramirez.

"Lost in translation," echoed Hrycyk.

Hrycyk walked into the darkness of the back door of the building under construction. The room was long and narrow. In the process of being gutted, it was empty save for some bundles of plywood. Along the wall shared by the two stores two holes had been smashed through the drywall. One was very small, the other large.

Hrycyk peered through the smaller hole. "Come have a look," he said. Through the small hole was the antique store, where a crime-scene photographer roamed around the furniture, snapping pictures. "This is what's called a peephole," Hrycyk explained. The thieves had created the smaller hole to look into the store and figure out the best place to smash a larger hole.

Hrycyk walked up to the larger hole. It was big, brutal, the kind the Incredible Hulk would make. It didn't just provide a perfect view of the antique store—it was a door: the antique store was right there. Lower down, a thick electrical wire stretched across the jagged opening.

"Nothing here was finessed," said Hrycyk.

He noticed some broken pieces of porcelain on the construction-zone floor. "Can we bag these?" Hrycyk said to the room.

According to Ramirez, the thieves had also stolen the tools stored by the construction workers, who were still waiting outside in the shade. They watched as the owner of the antique store arrived in a silver Porsche and disappeared up the driveway into the back lot.

When Hrycyk entered the antique store through its own back door a few minutes later, Lazarus was already questioning the owner, who stood just inside the back door to his shop, beside a desk and computer that looked out onto the showroom floor.

The owner was dressed in a pale blue polo top, designer jeans, and brown loafers. He was in his late thirties and had just returned from one of his Italian expeditions with a tan and Calvin Klein–worthy facial stubble. He was sporty Euro ultra-cool. He agreed to let me stay and watch the investigation as long as I did not mention his name or the name of the store.

The owner explained that he dealt mostly in Italian Renaissance and French antiques and served a wealthy clientele all over the city. The room was still full of supply— a French nineteenth-century gilded mirror for $9,000; a neoclassical nineteenth-century Italian mirror for $13,500; a Tuscan walnut refectory table for $27,000. There was a nail on a wall where a painting had once hung. He told Lazarus that he visited Italy often, to hand-pick the pieces for his shop. A few of those pieces he carried with him on the plane home, and the rest arrived via shipping container.

While Hrycyk focused on the scene, Lazarus focused on the owner. Her voice as she questioned him was flat, and her questions were brief and pointed.

"Sir, where were you last night?"

"Sir, have you noticed anyone unusual around the store lately?"

"Oh, and sir, do you happen to have the only key to that lock on the fence?"

Lazarus kept steady eye contact with the owner. She was pleasant without being nice. I got the feeling from the speed of her questions that she was looking for inconsistencies in

his answers. She was so direct and at ease while she worked that it was obvious she had done this a thousand times.

There didn't seem to be any inconsistencies. The owner remained calm, serious, and slightly detached from the whole scenario. He may have been in shock.

The large, dark, antique wooden table in front of them dominated the space. Its surface held precious pieces of evidence left behind by the thieves—those shoeprints. According to the owner, four large chandeliers used to hang above the table, each worth around $20,000. The intruders had climbed right up onto the table, using it as a stepladder, and removed the chandeliers from hooks on the ceiling. Hrycyk and Lazarus both noted that it would have required at least two people. Hrycyk also noted that this all would have happened with little light except from the streetlamps and the traffic passing by the front window, now bright with sunlight.

"This happened fast, and in the dark," said Hrycyk.

"Yeah, no light," said Lazarus.

The shoeprints were very faint, their shape formed by the dust from the construction site next door. It was hot in the store, and suddenly everyone looked a little sweaty. Lazarus wiped her brow and smiled just slightly with her eyes. "It's hot out, isn't it?" she said, to no one in particular.

The owner offered to turn on the air conditioning.

Lazarus thought about it, exchanging a glance with Hrycyk.

"No," she said, "'cause we don't want the air to blow in here. Not until we get those shoeprints off the table. Would be nice, though."

Lazarus continued to question the owner on his whereabouts, his business practices, and whether anyone might want to hurt his business.

Someone in the room commented that no one in the apartment building or any of the neighbors had called police. The break-in wasn't reported until the construction workers showed up for work that morning, noticed their tools were gone, and saw the new holes in the wall.

"It's unbelievable that no one called 911," echoed the owner.

"People just don't want to get involved," said Lazarus. "It's unfortunate."

Hrycyk had produced a tape measure and was walking the length and width of the shop, jotting down notes after each trip. He drew a little diagram of the layout. The photographer snapped pictures then sat down in one of the plush, multi-thousand-dollar chairs.

In the middle of the interview, a UPS delivery man knocked on the front door. He held a package and waded through the crime scene to deliver it. Normal life intruded. The Scientific Investigation Division (SID) officer entered through the back door. Hrycyk and Lazarus had both been excited that they got to have a SID technician show up. Or rather, they seemed excited for me to see him work. "It's like magic," Lazarus said. "Just like on *CSI*."

The SID was dressed in black slacks, a black T-shirt, and black cross-trainers with black laces. He had short, cropped black hair. His biceps bulged out of his T-shirt, just like on television. He surveyed the table and began to unpack his equipment. Hrycyk had already placed folded pieces of paper at four different points on the table: A, B, C, D. Hrycyk explained that the SID was using an electrostatic current to pick up a picture of the shoeprints and fingerprints.

The SID worked carefully. He chose his first spot on the table, examined it from a few different angles. Then he produced a square piece of foil, very thin, slowly placed the

foil on top of a shoeprint, and used a roller to mash the foil into the surface. The foil was so thin it formed around the shoeprint, which was now visible in the metallic skin. He looked up at us and said, "You only get one chance, because once you apply and roll, the dust is gone."

Then he took two wires, attached them to a small black box, and turned it on. There was a crackle of electricity. "Done," he said, and moved on to point B. It was indeed magic: electromagnetic resonance.

An hour later Hrycyk and Lazarus walked out into the heat and looked up and down the sidewalk. At this time of the afternoon there was barely a soul. It was too hot. The detectives looked up at the rooftops and above the alcove doorways of stores.

"We're hoping one of these stores has a security camera," Hrycyk explained.

"Can't see any," said Lazarus.

"Let's go ask around," said Hrycyk.

The two detectives spent the next two hours getting to know the neighborhood. At the first store Hrycyk asked the owner directly if he had a camera. The owner was suspicious. He said no. Hrycyk thanked him. The owner said, "Next time show me a badge."

A furniture store next door had no camera either. It sold slick stuff—expensive retro bookshelves, tables, and lighting. The woman working the cash said there was a gallery space upstairs. Hrycyk looked at Lazarus: "Want to go have a look?"

"Yes I do," she replied.

The detectives went upstairs. The exhibit was photography from Iraq: Eye of the Storm: War through the Lens of American Combat Photographers. There was a photograph of a boxing match, the ring surrounded by American

soldiers in tank tops and camouflage pants. "That is a great picture," commented Hrycyk. Then he noted, "It's good for us to look at what's being shown around town. You never know, one day we might be hunting for this work."

At another shop there was a piece of meteorite for sale, a dark hunk of rock. It was 4.6 billion years old. It sat on a table almost right beside the front door, with an $18,500 price tag. The owner said he had a fake camera mounted out back. The man seemed happy to chat with the detectives. He said the store was moving: they'd been priced out of the neighborhood. "Twenty-eight grand a month," he smiled. "The fashion people are moving in. Marc Jacobs is down the street. They pay something like $32,000 a month."

The detectives continued to search for cameras. The last place they tried was a giant old house surrounded by a perimeter of lush trees and bushes and guarded by a high iron fence. It looked like something out of a fairy tale. Lazarus rang the bell, but there was no answer. She shouted, "Hello! Police!" No answer. She raised her voice slightly and shouted again. "Hello! Police!"

The detectives walked around to the rear of the house. They found a door in the fence and slipped into the back garden, which was full of statues and plants packed tightly together. A narrow path led to a back door. They knocked. A Hispanic caregiver answered and invited them inside. The back hallway opened into a yawning room, two floors high. The room was packed full of antiques and paintings. It was chaotic; it looked like the piled-up remains of what once was a thriving antiques business.

An old woman sat in a chair near a row of television screens filled with images from cameras. Bingo. It turned out that she had just come out of a coma and her health was delicate. A voice somewhere screamed, "Hello. Hello. Hello." It

sounded very much like Detective Lazarus. "It's a bird," said Hrycyk. And so it was, in a cage near the front door.

The detectives took an hour figuring out if the cameras had picked up anything useful, scrolling through tape. Nothing so far. They'd have to come back. Before they left, both Hrycyk and Lazarus had noticed what looked like a Picasso perched carelessly on a cluttered sofa. They inquired about it, and the woman told them it was a genuine Picasso worth a huge sum of money. Hrycyk surreptitiously took a photo of the painting with his cell.

By the time the detectives climbed back into their Chevrolet Impala, they had spent a total of four hours at the crime scene and canvasing La Cienega. During that four-hour period they had both been standing or walking, but even though they had started their day at dawn, neither seemed tired. The car slipped into a traffic jam on Sunset, which ate up more time. The light cut harshly across the rush-hour traffic. They would drive back to the office to transfer their written notes into a computer file, check messages and updates on other cases, and make a few calls.

That was late June. Three months passed. In September, Hrycyk received a call from the Los Angeles district attorney's office. They'd been following the activities of a gang of Armenians, through an informant working for the DA. The informant had identified the gang for the antique-store job on La Cienega. This was organized crime, not a simple break-and-enter: the Armenian gang was under surveillance because it was involved in a host of criminal activities. The DA passed along to Hrycyk the address of a house they believed the Armenians were using to store, among other material possessions like drugs and money, the antiques stolen from the shop on La Cienega.

After a search warrant was secured, the house was raided. The DA was right. The search turned up a cache of the stolen loot. It wasn't everything, though. "We've seized that stuff and we're still looking for the rest," Hrycyk told me.

"This particular gang was known for stealing from tobacco stores, so the upscale antique store was new for them. The gang was using the Italian antiques as furniture. That's the problem with stealing art or antiques. If you don't know the art market—in this case the Italian antique market—then it's going to be difficult to move it," Hrycyk said. "The Armenians weren't connoisseurs of antique Italian furniture. What they were interested in was money. They're into anything that is a commodity and that can be sold." The gang got sloppy and kept stealing from the same locations before they moved on to antiques. "If you keep hitting the same place, police put it together," the detective said.

For Hrycyk, the case was a prime example of the strides made possible by cooperation and an efficient flow of information. It was also another indication that organized crime was interested in art. The trial took place in May 2009, and a number of the men were convicted. For the detective, it was a small victory.

Hrycyk had seen all the movies about art theft, but his experience was different from the films being churned out by the city he patrolled. According to Hollywood, art thieves are dashing, educated, incredibly rich, obsessive, and cunning, and the world is their playground. Art theft, in fact, is a subgenre of heist films—films like *Once a Thief*, *Entrapment*, *The Score*, *The Good Thief*, *Ocean's Twelve*, and, of course, *Hudson Hawk*, starring Bruce Willis and a gang of whistling fools out to steal an invention by Leonardo da Vinci. Mostly, these movies star the thief as sympathetic protagonist—and we want the thief to get away with the crime.

There is no film that has done more to push the myth of the dashing art thief—or the rogue collector—than the remake of *The Thomas Crown Affair*, starring Pierce Brosnan. As Mr. Crown, Brosnan embodies the ultimate art thief: a Wall Street mogul, lover of champagne, women, and fine art. Crown has money and toys but he is bored, so for fun he rips off a hundred-million-dollar Claude Monet from a New York museum (think the Metropolitan Museum of Art). Later, at his mansion, he knocks back some red wine and laughs in self-satisfied glee while gazing at the Impressionist master's blood-orange sunset—now his alone to enjoy. Rene Russo plays the sexy insurance agent hot on his tail, but Crown seduces her as he seduces the audience, who, like him, are captured by Russo's fiery beauty. The Monet, it turns out, isn't the artistic centerpiece of the film; Russo is. Hollywood knew that fine art wasn't enough to keep the public, or Crown, aesthetically engaged.

At the end of the film, Crown slips the Monet back into the museum, undetected. He has a conscience: the restless billionaire wreaked havoc on the museum, got away with his crime, and then made good—a happy ending. John McTiernan directed *The Thomas Crown Affair*, based on the 1968 Norman Jewison cult classic starring Steve McQueen and Faye Dunaway. McTiernan changed one important detail: Jewison's Thomas Crown was a bank robber. McTiernan, though, felt that audiences wouldn't be sympathetic to a hardened criminal knocking over your local teller, so he changed Crown's crime of choice to something more palatable—stealing art from a museum. The new version got at least one fact right: police, mostly, do not rank stolen art cases as a high priority. In one of the last scenes of the movie, a New York City detective admits, "I

don't really give a shit. The week before I met you I nailed two crooked real-estate agents and a guy who was beating his kids to death. So if some Houdini wants to snatch a couple swirls of paint that are really only important to some very silly rich people, I don't really give a damn."

Homicides, drugs, violence, sexual abuse, organized crime—those are urgent affairs. Art theft is the opposite. That is why Hrycyk was such a rare find: a detective who had spent years specializing in art theft investigations and who worked his cases with the patience of a scientist—playing the long game.

On that late afternoon in 2008, driving back through the pink haze of L.A. gridlock, Hrycyk's eyes flicked to the rearview. He'd been watching me take notes on the investigation all afternoon while he took notes at the crime scene. The detective asked, "So how did you get into all this?" He and Lazarus stared out the front window, listening to the former suspect in the back seat.

# 2. _ _ _ _ _

## LAW AND DISORDER

"Art is one of the most corrupt, dirtiest industries on the planet."
**BONNIE CZEGLEDI**

I t was just after midnight when the phone rang.

A stranger's voice said, "It's ————. You've been looking for me."

The name he'd given me clicked. Yes, I'd been looking for him.

"I thought you were in jail," I said.

"I was," he replied. "Now I'm out."

Then the art thief listed off a few details about my education and my professional life. He told me he knew where I lived, and proved it by reciting my address.

"I've done my research," he said.

He agreed to a meeting.

I was twenty-six in 2003 and working as a researcher for the *Walrus*, a Canadian magazine, earning enough to save some money while living with my parents. I was comfortable doing research, not being researched. I was also

working on an article about a burglary at a small art gallery. It was supposed to be fun. Now the story was taking a turn I hadn't expected. After the conversation I was apprehensive, but I still wanted to meet the midnight caller.

A few weeks later, on a crisp afternoon, we sat down at a small table on an outdoor patio in Toronto. The patio was unoccupied save for us. The man across from me was in his late forties, of medium height and medium build, and wore a yellow windbreaker. He was good-looking, but not movie-star handsome. In fact, he looked like a middle-aged father, except there was an almost invisible edge to him, some heightened sense of awareness in his eyes that vibrated with tension. I didn't want to feel nervous, but I did.

"Hello," he said. And we shook hands.

He opened our conversation by threatening me. He told me that if I wrote anything about his involvement in the art gallery theft I would be physically hurt. Specifically, one of his business associates would be sure to cross paths with me. At best his associate would break my legs. No names, he said. Then he reached down beside his chair. I hadn't noticed the long white papers rolled up in a red elastic band. He handed them to me across the table. The roll practically glowed in the afternoon sun. Not thinking, I reached out and accepted it. When my hand closed around the roll I knew I had made a mistake—fingerprints, possession of stolen property. His eyes flickered playfully.

"What's this?" I asked.

"They're for you. I can't use them. They're from the gallery," he said.

I knew what I was holding, and I knew I shouldn't be holding it.

On the morning of September 11, 2001, Chad Wolfond had woken up, skipped breakfast, and left on his usual ten-minute walk to his Lonsdale Gallery, a two-storey semidetached house on a picturesque street in Toronto's upscale Forest Hill Village. At his desk on the second floor Wolfond tapped the keyboard of his computer, expecting it to power up. When the screen didn't glow, he glanced down to see that his computer tower was gone. Then he noticed a paper trail across the gallery floor leading to the filing cabinets where he stored his vintage pinhole photography collection. As Wolfond looked through the drawers his heart sank. The best works he owned, including those by leading French photographer Ilan Wolff, were missing.

Wolfond was shaken. He phoned the police. Then he phoned his wife. She sounded panicked.

"Do you have any idea what just happened in New York?" she asked. It was after 9:00 AM, and the World Trade Center had been struck by hijacked passenger planes.

By noon officers were at the gallery, glued to their radios for the latest updates from New York and Washington. They dusted for fingerprints and inspected the hole that had been smashed through the drywall from an attached store that was under construction. Before leaving, one of the officers told Wolfond that a detective would be in touch, and then added, "Chances are slim that you will ever see those photographs again."

The detective never materialized. Wolfond remained on edge, and rightly so. One month later the thief returned and stole more art. All told, Wolfond had been stripped of photographs valued at over $250,000. This time a detective visited and took notes. He said he couldn't do much.

Wolfond became paranoid. He had trouble sleeping and left his gallery every day with a sense of dread. He phoned

a few other gallery owners for advice. Most told him not to alert the media or talk to anybody about what had happened. Some hinted that they too had been stung by theft but had mourned the loss in private. News of the break-ins, they argued, would only damage his reputation as an art-gallery owner.

One of them, however, suggested Wolfond call a lawyer named Bonnie Czegledi, who specialized in cultural property law. She gave Wolfond the opposite advice.

"Go to the media," Czegledi told him. "Do everything you can to promote those stolen pictures. Publicizing your stolen art will make the works impossible to sell. Contact Interpol. Get listed on the Art Loss Register."

Interpol? The Art Loss Register? Wolfond had never heard of them.

About a year and a half later, when I showed up at the Lonsdale Gallery to write a piece about the burglaries, Wolfond hadn't taken Czegledi's advice: he was still nervous about moving his story into the public arena. He had settled the insurance already and was fearful of the thief's reprisal if he spoke openly about the burglaries. Still, I got the sense from him that he wanted to talk. He was warming up to the idea of a story but obviously needed more time. He told me to come back, and I did.

At our second meeting Wolfond disappeared into a back room and brought out the file he'd kept on the burglary—twelve inches of paperwork. He flipped through the file and showed me some photocopies of a few of the photographs that were still missing. He also told me that, by fluke, a man had been arrested who was in possession of some of Wolfond's stolen art.

"I remember being simultaneously pissed off and mildly flattered after the first theft," Wolfond told me. "The thief

had left photos that I also thought were inferior. I doubt I'll see the rest of them again. I really don't know much about this world of art theft." Before I left he scribbled down the phone number of the detective who was working on the case and of the art lawyer who had advised him—Bonnie Czegledi. "You should talk to her," was Wolfond's advice.

I phoned the detective a couple of times, and we finally connected. I told him I would be interested in talking to the thief's lawyer and gave him my number. The detective said he would pass the message on. I figured I'd never hear anything; at best, if the thief's lawyer got in touch, I could get a quote, maybe a little more information about the case. Instead I got the late-night phone call, and now I was apparently holding some of Wolfond's stolen artwork and looking across the table at the thief.

"I can't accept these," I said, dumbstruck.

"They're yours now," he said. "Hang them up. Or hide them. If you don't take them, I might have to destroy them." That didn't sound like the best choice. I imagined telling Wolfond that I'd seen some of his missing art and that it was now probably a pile of ashes.

"Isn't there another option?" I asked. "You can return them to the gallery through a third party, anonymously. That way everybody is happy. Otherwise I might have to call the police."

"A third-party arrangement might work," he said, after a moment. "Let me think about it."

I handed back the roll, and he placed it beside his chair on the concrete patio. I wondered why the art thief would even consider destroying the prints. After all, he'd gone through the trouble of breaking into the gallery, sorting through the flat files in the dark, and stealing works he'd carefully chosen. He had what he wanted, didn't he?

The thief told me that keeping the art was too much of a risk. He didn't want to go back to prison, and he didn't have a buyer lined up. Add to those problems the journalist sitting across from him asking questions. Clearly, he had agreed to meet with me only to neutralize one of many things that were going wrong.

He seemed to be educated in art history and to have a collector's eye, because he'd stolen specific works and bypassed other, less valuable ones in the mess he'd left behind. He was also, I discovered, manipulative. At one point I went inside to the washroom. When I returned, the thief had vanished but the roll of stolen art was still on the concrete beside his chair, unattended. What should I do with it? I pictured myself showing up at the gallery and handing the artwork back to Wolfond, trying to explain how I'd got hold of it. Or ending up in a police station for a day while a detective questioned me. I wouldn't want to mention the thief: my legs. I stood there staring at the roll of paper on the ground for a few seconds, and my face probably looked nearly as white as the paper.

Then there was a knock from inside the window, beside the patio. The thief hadn't disappeared, only moved inside, but he'd left the stolen art for me. I picked up the roll and carried it inside to his new table. I placed it next to his chair, on the floor. He smiled. He was in control, said his smile.

He decided to change the subject. He wanted to tell me more about how art theft worked as an industry. He seemed to be trying to figure out ways to trade information with me, to get me away from the specifics of his story. There is a larger story, he explained. He discussed how poor the security systems were at most of the major cultural institutions and, of course, at midsized and smaller galleries. That made his job easier. So there was that angle—art galleries and

museums weren't adequately protecting themselves against pros like him.

Then he veered in another direction.

"Okay, this is how it works," he said. "It's like a big shell game. All the antique and art dealers, they just pass it around from one to another." He moved his fingers around the table in circles and then looked up. "Do you understand?" He looked very intense, as if he had just handed me a top-secret piece of information, but I had no idea what he meant. What did art dealers have to do with stealing art? But our meeting was over.

We got up from the table. He picked up his roll of stolen art. We paused at the door and shook hands. There were people inside the café, but even so, the thief repeated his earlier threat in a casual whisper and then looked at me coldly, in silence. I watched him walk up the street, just another shopper on a busy afternoon, and I never saw him again.

I'd now sat across from a criminal whose income was, at least partly, earned from the black market in stolen art. True, I didn't know how that black market worked or who the players were or where stolen art went. I had learned that there seemed to be more to the booming illegal trade than just the Hollywood myth, but how did it all connect? Some fine art had been stolen from a gallery and the person who'd stolen it had tried to give it back to me. He had also said he might destroy it. It was confusing and didn't add up to a coherent narrative. I walked away feeling as if I knew more about art theft but quickly came to feel as if I knew even less.

When in doubt, read. I started looking at articles from the BBC, the *New York Times*, the *Guardian*, and other papers from around the globe, articles usually written

in response to the theft of a work of art from a museum. I encountered what seemed to be the opposite of Wolfond's case—high-profile stories that chronicled the sometimes-violent raids on cultural institutions for famous artworks. These stories provided the basic facts: what had been stolen, in some cases how it was stolen, and always how much it was estimated to be worth. Millions of dollars stolen off a wall at gunpoint made for exciting copy. Usually there was a quote from a detective saying the authorities were "following all leads." Sometimes a corrupt billionaire collector was mentioned—"Dr. No," he was usually called, in homage to the James Bond villain. This was the fallback position for art theft stories—a very rich, unscrupulous person had hired a thief to steal a work of genius. There was usually no follow-up reporting. The story vanished, just like the painting. And no billionaires were arrested.

Considering the number of articles that had been written about stolen art, it was amazing how few definitive facts were available about the illicit art trade, as opposed to, for example, the drug trade. I was at a loss.

I checked in with Wolfond, hoping he would tell me he'd received a surprise delivery, but he had no news to report. I kept quiet and waited. Then one afternoon several months later I ran into the gallery owner at the Toronto International Art Fair. He was excited. A small miracle had occurred: the police had recovered a few more of his missing prints, undamaged.

In 2005 the article I'd started about Wolfond was published in the *Walrus*, but it turned out to be not about the thief (although I did mention Wolfond's burglaries) but a feature article about international art theft. A week later I received another phone call from the art thief. This time he left a message for me at work.

"It's me. I just wanted to tell you how much I enjoyed your piece," he said.

I never heard from him again. I should have realized, after my initial meetings with Wolfond, the midnight phone call, and my encounter with the thief, that this wasn't a straightforward story. But what did I know? Wasn't this what every young journalist dreams of—to be called in the middle of the night by a criminal and then threatened? In some ways, it was encouraging. I followed up with the lawyer, the one whose phone number Wolfond had given me, who turned out to be an avid follower of the global black market.

Bonnie Czegledi has many theories about why you might want to steal a work of art: because you fell in love with it; because it is fragile and needs your protection; because if you steal just one more, your collection will be complete; because you loathe the snooty cultural establishment; because strolling out of a museum onto a crowded street with a stolen painting under your arm is an adrenaline rush like no other; because hanging a stolen work on your wall will impress your friends; because you can reap a ridiculous profit; because no one will catch you.

In April 2003, I met Czegledi at a coffee shop tucked into the base of one of the tallest towers in Toronto's financial district, where she worked. Czegledi is striking—pale skin, angular cheekbones, straight black hair. Her eyes are large and dark with a slightly haunted quality. She wears elegant clothing punctuated by artful jewelry, colorful designer heels, and bright red lipstick. When she enters a room, people stare. She has the look of a Hungarian queen in exile and a confident, musical voice to match. "Hi, I'm Bonnie. So what do you want to know?"

I told Czegledi I was writing about a small art theft at an upscale local gallery. She nodded and smiled. Yes, of course, she knew about that one. "Sorry to be the bearer of bad news," she laughed, "but I get calls all the time from galleries that have had art stolen. The art world, as you probably know, is very secretive, and that only makes it easier for criminals. It's the Wild West out there."

Czegledi wasn't talking just about the violent museum thefts that seemed to be occurring with irritating frequency across the globe, and it wasn't just Rembrandts and Picassos that were attracting thieves. "It's everything," she said. The world's cultural heritage had become one big department store, and thieves of all kinds, at all levels, were shoplifting with impunity, as if the one security guard on duty was out on a smoke break. When artistic genius, money, and ego collided, morality quickly fell by the wayside. And sometimes criminals wore suits and ties and acted as if they were respectable members of the establishment.

"Good, you have an empty notebook," she noticed. Then she jogged through a list of travesties besieging the world's cultural heritage: thousands of Holocaust-looted artworks still missing; the pillaging of antiquities from Egypt, China, Afghanistan, Poland, the Czech Republic, Hungary, Turkey; the spectacular thefts of multi-million-dollar artworks from museums; thousands more unreported thefts from galleries and residences; the looting of underwater cultural heritage—shipwrecks and the like; the looting and destruction of Native artifacts; the use of donations to galleries and museums to launder stolen artwork into prominent institutions; the inability of dealers, galleries, and museums to adhere to a sensible system of provenance checks on the artwork they acquire; the total disregard of the legitimate art market for the big mess.

"Have you looked at auction houses!" she boomed. Major auction houses played a role in laundering stolen art, she said, as did smaller ones and art dealers. They all served the demand of the market—the hunger of collectors.

Czegledi was respectful of most art collectors but insisted that a number of them acted like psychopathic stalkers: they would do anything to get their hands on a specific work of art. Collecting art, she explained, had started as a hobby of the aristocracy in the eighteenth century and had grown into a multi-billion-dollar business driven by obsessive behavior. "Some of these collectors and dealers operate like a cult. If you possess something that is special, *you* become special," she said. "It's about power. And there are no checks and balances in the art world. Police aren't trained to investigate art thefts, and lawyers aren't trained to prosecute them. Meanwhile, the criminal network is international, sophisticated, and organized."

The "Problem," as Czegledi called it, had been building for decades and had infected the entire global system. "If the legitimate business of art were to suddenly be made transparent, the entire industry would simply collapse," she said. What Czegledi meant was that over the course of the last century, so much stolen art had been absorbed by the legitimate market, and so much was continuing to be absorbed, that if the stolen goods were identified, the industry would be forced to reevaluate the entire way it operated. I thought back to the art thief, his fingers circling the tabletop.

Czegledi's passion had personal roots. Her family came from a famously bloody region of Eastern Europe, near Dracula's birthplace—Hungary's Carpathian Mountains. The mountains were once populated by hundreds of small tribes, and Czegledi is descended from one of those. The

Székely were almost wiped out in what Czegledi calls a slow, torturous genocide by Romania. Her tribe's language, art, music, and traditions were destroyed.

"There's almost nothing left of my people except a few songs collected by Béla Bartók," she said. "The best way to destroy a civilization is to erase their cultural heritage. The Nazis, for example, understood that very well."

The Czegledis moved to Canada before the genocide, and Bonnie was born in Toronto, where she began painting when she was ten. Her mother, though, wanted her to pursue a more practical profession. Czegledi hid her drawings under her bed but continued to paint even while she studied law at Toronto's prestigious Osgoode Hall. In 1987 she graduated and joined a corporate firm. When a fellow artist needed a contract examined or paperwork for an exhibition looked over, she did so—often for free. Word of her interest in the area of art and law spread quickly through the community, and soon she began to receive phone calls about cultural heritage law.

One afternoon Czegledi answered a call from a lawyer representing a client selling a valuable antique tapestry, worth in the neighborhood of $20,000. The lawyer wanted Czegledi's opinion: the tapestry had been stolen during World War II and was on a war-loot list. He wanted her to tell him how to sell it on the legitimate market without being caught. Czegledi was shocked, and laughed into the phone. She told him that it was a criminal act to sell the tapestry and that his client should restitute it to the rightful owners or country of origin. The lawyer berated Czegledi for being self-righteous and hung up on her.

"You shouldn't be selling a piece of art if it's been stolen!" she told me. "And you don't need to be a lawyer to understand that." But soon she figured out that his attitude

was the norm—it was her own that was deviant. The phone call came near the beginning of Czegledi's steep learning curve. "Over a period of a few years, I discovered that the business of art is one of the most corrupt, dirtiest industries on the planet. There are no regulations and theft is rampant. It's not pretty. The patina of loveliness that most people associate with art didn't exist in the reality that I found. It was filled with criminals—and a lot of different kinds."

Instead of being scared off, though, Czegledi became intrigued. She decided she wanted to know everything about stolen art and the law around it. There were no courses she could take, so she would have to educate herself. She soon learned there was at least a fuzzy regulatory framework in place.

In Lyon, France, there was Interpol, the international police organization established in 1923, which issued posters and CDs listing stolen artwork from across the globe. It had a database of stolen art. She flew to Lyon and met with Interpol staff.

In Paris, there was the International Council of Museums (ICOM), founded in 1946, which provided guidelines for the buying practices of museums in most countries, but it was loosely organized. She met them too.

In New York, there was the International Foundation for Art Research (IFAR), a private foundation established in 1969 that mainly represented the interests of archaeologists in studying the impact of the massive looting of cultural heritage across the earth. IFAR lobbied governments, hosted conferences, and had started to make its own list of missing pieces of art. Czegledi attended its conferences.

In London, there was the Art Loss Register, a private company started in the 1990s that had created the world's largest international database of stolen artworks; collectors,

auction houses, museums, and galleries paid a fee to search it. So far, the database contained over 100,000 stolen pieces of art, including hundreds of Picassos. Czegledi met the owner, Julian Radcliffe, and brought one of ALR's staff to Toronto to speak to the art crowd.

The most important international treaty was the UNESCO 1970 Convention on the Means of Prohibiting and Preventing the Illicit Import, Export and Transfer of Ownership of Cultural Property (Czegledi can say that really fast). Canada accepted the convention in 1978, the United States in 1983. "Basically, it says, if you're a member of this treaty, you cannot knowingly bring stolen artwork from another country into your country. Doesn't that sound fair?" Czegledi said.

By the time she received a call from Wolfond, she'd traveled to dozens of conferences around the globe and met the leading lawyers in the field, including Lawrence Kaye and Howard Spiegler, at Herrick, Feinstein, in New York, who were making strides in efforts to restitute Holocaust-looted artwork; John Huerta, General Counsel for the Smithsonian Institution, in Washington, D.C.; and Norman Palmer, the London-based figurehead of the cultural property law community. There weren't many cultural property lawyers Czegledi could seek out: "We could all fit in one very small room," she said. By then she knew enough to tell Wolfond about the Art Loss Register and Interpol. She had also started receiving calls from Toronto police officers, who wanted to learn more as well: they didn't understand this world, they told her.

"The issues I was encountering were local and current, or historical, like the Holocaust or the Russian Revolution, or international, dealing with imports and exports. There were all these layers and levels," Czegledi said. By 2003,

she was teaching a course in international art law at the University of Lyon's Faculty of Law. This was around when we met in Toronto's financial district and she barraged me with information. She'd been storing it up.

After our meeting, as promised, my notebook was full, and that evening, when I turned on my television, art theft was the news. Images from the looting of the National Museum of Iraq flashed across all the major networks: the museum was in ruins; display cases had been smashed, humanity's earliest tools and art looted. The world watched, including museum curators, who had warned of the incident in advance, and hundreds of archaeologists, who were ashamed at and tormented by the sight. It wasn't a shock to Czegledi.

"Give me a break," she said. "The whole world knows this museum is going to be looted, and then, surprise—it's looted! Talk about pathetic." As far as anyone could tell, this was the largest museum theft in history. She told me those stolen pieces would be moving fast through Jordan and Kuwait to the art markets in Geneva, London, New York, and Toronto—wherever the money was. There was an efficient shadow transportation system in place, Czegledi assured me.

I called the Royal Ontario Museum a few months later, and a curator there confirmed that he had been offered the chance to buy some Iraqi antiquities. The institution declined. "We will never see some of those pieces again," Czegledi said. "Iraq's two greatest nonrenewable resources: oil and antiquities." About a year after we met, Czegledi moved out of her corporate law practice and dedicated herself full-time to cultural heritage law. She rented an office on the first floor of a brick house on a tree-lined street and bought a domain name, czeglediartlaw.ca. On her website

she posted a list of provenance requirements and tips for staying clean in the art market. Her new digs quickly became a hub for local artists and gallery staff who'd been struck by theft. One afternoon, Tarah Aylward, director of Toronto's Ingram Gallery, met with Czegledi to discuss the thefts that had beset the gallery.

"You feel very alone," said Aylward. "Where do I turn, who do I go to? I get emails from galleries across the country saying they have been robbed." Aylward, like Wolfond, was experiencing paranoia. "I keep thinking I'm going to walk into a gallery or someone's condo and see these artworks. I want the gallery to be secure. But are people going to come in if there are bars on the windows, if it's all gated up? At openings, I'm suspicious now. The thieves who do this work are not street criminals. They are sophisticated, polished, and certainly they are successful."

As if to prove Czegledi's point about ineptitude, a Toronto lawyer was busted with a condominium full of stolen art. Czegledi attended some of the court proceedings. The Crown had flipped one of the lawyer's associates, who in turn agreed to testify against the accused lawyer. During the trial, it was revealed that the man who had been flipped was a convicted art thief. His credibility as a witness was destroyed by the defense. In exchange for his testimony, though, the art thief had secured immunity. The judge acquitted the lawyer, and because of the deal with police, the art thief was free to go. "So there's a condo full of stolen art, but everyone gets off the hook," Czegledi said.

"There are only a handful of detectives in the entire world who have the experience and the training to investigate art thefts properly," she told me, and most of them were in her Rolodex. In the United States there was a unit of two in Los Angeles; in Canada, a unit of two in

Montreal; in England, Scotland Yard's Art and Antiques Squad; in Italy, a unit with the Carabinieri charged with preventing the theft of Italian antiquities, which was rampant. Paris had a unit, and some officers in the Netherlands kept a list of stolen work. The FBI had a famous undercover agent named Robert Wittman, with whom Czegledi consulted once in a while. The "Problem," though, ignored borders and jurisdictions. Countries across the globe were being drained of cultural loot for the markets in New York and London, which in turn served collectors in wealthy enclaves across the planet.

"China, Afghanistan, all of Eastern Europe, now Iraq," said Czegledi. "The statistic for looting actually went down in the Czech Republic recently. You know why? Because everything has been stolen. It's like a bad joke."

In 2006, she flew to Brussels to speak on a conference panel about what Europe was doing to stem the tide of illegal imports, and discovered the answer: "Not much." After the conference she met with a Brussels police investigator, who took Czegledi to a chic part of the city, where they toured antique stores. At one shop specializing in Chinese antiquities, they chatted up the owner. He explained how he got his merchandise. Sometimes he traveled to China, to a warehouse where all the looted antiquities were stored, and picked out whatever he wanted. He used a special cargo company to transport the illegal items to the borders of Belgium. It cost one euro per kilo. At the border he met the cargo himself, put the loot in his trunk, and drove it back to his shop. Sometimes, though, he went to China for longer, to participate personally in excavating an archaeological site. He could buy items as they were lifted out of the ground. The dealer did not realize that he was speaking to an international art lawyer and a criminal investigator. The

Belgian investigator was shocked at how comfortable the dealer was telling them how he ripped off China's cultural heritage. Nothing surprised Czegledi anymore.

Everything about the Problem was opaque: the relationships between the players, the cash transactions, the collision between high and low culture, between street thugs and elite collectors, between detectives' quest to learn and their access to information, between the urge to protect a work of art and the urge to possess it—all little pieces of the mysterious puzzle scattered across the globe. According to Czegledi, the war on art theft was being lost, and nobody even knew how big the war was or where the lines of battle were. She told me she came to see the Problem in terms of information—more specifically, as a lack of credible information. "How do we know how large the illegal economy in art is? There's simply not enough data," Czegledi said. "Hello. This is the twenty-first century. How can that be?"

Interpol and UNESCO listed art theft as the fourth-largest black market in the world (after drugs, money-laundering, and weapons). But what did that mean? After I'd been following Czegledi's career for several years, one point was clear: don't look at the Hollywood versions of an art thief—the Myth. This is a bigger game, with more players, and the legitimate business of art is directly implicated. A lot of the crimes are hidden in the open. Stealing art is just the beginning. Then the art is laundered up into the legitimate market, into private collections, into the world's most renowned museums. In 2007, this was happening all over the world, and there was only this little group of lawyers who gathered in conference rooms, darkly bemused by the size and scope of the mess. Part of the Problem was that it had been allowed to become so big that it was everyone's problem and, therefore, no one's.

That year I went with Czegledi to see first hand what those rooms of lawyers were like. We traveled to an International Council of Museums conference in Cairo. There was a bonus: Egypt was one of the oldest civilizations in the world, had had its cultural heritage pillaged for thousands of years—every colonial power of note had stolen from Egypt—and was where the first recorded trial of an art thief took place. Egypt was the ultimate source country.

# 3.

## EGYPT

"They shouted, 'Look over here!
The loot is inside us! Rob me!'"
**RICK ST. HILAIRE**

On the hot sand an Egyptian teenager in a dirty T-shirt runs after me with a tray of sunglasses. "Shades! You buy shades!" The Sphinx sits behind him. Dozens of air-conditioned buses are parked in the open sun, and around them hundreds of figures holler for camel rides and photo ops. It all feels insignificant compared to the giant stone triangles that rise, alienlike, out of the desert: the only survivor of the Seven Wonders of the Ancient World.

Most tourists to Egypt come home with pictures of themselves standing in front of Khufu's pyramid—the Great Pyramid. When it was completed, in 2560 BCE, it was the tallest structure on earth. It remained the tallest until the Eiffel Tower was built over four thousand years later. Astronauts can see it from orbit. The pyramid was supposed to allow Khufu to live longer than everyone else,

in the afterlife. He spent two decades creating his get-out-of-jail-free card, with the help of thousands of laborers who lived in worker camps on site. When Khufu died, he was sealed inside his pyramid with his earthly possessions for what was supposed to be eternity. Now it is a tourist site, and Bonnie Czegledi and I are part of a large crowd standing in front of it.

This afternoon two guards in dusty blue uniforms stand outside the entrance of Khufu's pyramid. Up close, I can see the entrance is not so much a door as a dark crack in the tilting wall of ancient limestone that vanishes into the sunlight. The guards are stone-faced as well. Bad news, they tell the latest busload of tourists: cameras are not allowed. The guards collect dozens of them before allowing people to step into the darkness and crawl up a very narrow, hot passageway that leads into the center of the ancient skyscraper. "This looks uncomfortable," Czegledi says.

The tunnel is so small that sometimes we're forced onto our hands and knees. One line of tourists crawls up, another line clambers down. When the space isn't wide enough for both lines, there's a bottleneck of sweat, khaki shorts, and sandy running shoes—extreme claustrophobia. And just when I think I can't take it anymore, the tunnel opens into an almost perfectly square room with smooth black stone walls and a dim light hanging in the corner.

No sunlight penetrates here. It is eerily quiet. At the far end of the room rests a tomb, open and empty, where the body of a king of Egypt once lay. Bright flashes of light pulse. For every camera confiscated, a cell phone is retrieved from a pocket, a small camera from another. Trying to stop tourists from raiding the tomb with light is futile. There is no guard here—a person would go mad standing

inside this room. And the only reason we're here at all is because thieves found the way in first.

My visit to the pyramids coincided with the gathering of some of the world's experts on international cultural crimes at the Marriott Hotel in Cairo. I was part of a Canadian group that included Czegledi, as well as two detectives from the Montreal art theft unit. The conference was supposed to be a chance for lawyers, law enforcers, and cultural specialists from around the world to trade information. And it was. We spent two afternoons in a dark, cavernous conference room in the Marriott. Each speaker presented a lecture and a PowerPoint presentation.

The first speaker, from a museum in Greece dedicated to knives and guns, filled us in on how bad conditions were for the preservation of knives. By midafternoon, the man sitting beside me, who'd flown in from Britain to present on copyright law, was experiencing intense jet lag and, perhaps, was bored. He lay down on the floor, curled up under his chair, and fell asleep.

One of the conference organizers was a handsome Egyptian man in his midthirties. My first contact with him was shortly after I arrived at the Marriott. I'd made reservations for $100 a night through a travel agent. When I checked in, the manager on duty that morning said that, as part of the conference, I should be paying $140 a night. We haggled for half an hour until he agreed to let me pay the $100 for the room. Then, on the first afternoon of the conference, I was approached by the Organizer. He was wearing a suit and was flanked by a couple of serious but subservient-looking men. The Organizer informed me that I had to pay the conference rate for the hotel, but instead of making up the difference by Visa, I could simply give him the difference in U.S. cash. I told him I'd already

settled the issue with the manager. The Organizer waved his hand imperiously. He said that he would be speaking to the manager about the matter. His tone was threatening. You should pay, he said.

Later that evening, I ran into Detective Alain Lacoursière from Canada. He had had a similar interaction. The detective had been thinking it over when he returned to his room and found a note on his pillow asking again for the money and wishing him a nice stay in Cairo. "I decided to pay," the detective told me. "To be honest, it scared me. I'm out of my world here, and I don't want to risk getting into trouble with anyone. So I paid."

Unlike Lacoursière, I hadn't been sent to the conference by a company or a police force; I'd had to pay for my own plane ticket and room. It was already a stretch for me, and I couldn't afford the overhead.

Over the next few days, the Organizer hovered: at the conference, on the party boat on the Nile, on the Marriott's epic back patio. He was figuring out how to handle me, I could tell, but he wasn't ready to make a move. I wondered when he would. In the meantime, I'd met and was spending a lot of time with Rick St. Hilaire, at the time a county prosecutor in New Hampshire, who lectured on the impact of art theft in the United States and knew a lot about the impact of art theft on Egypt.

"Egypt," he said, "is a great place to start with the history of art theft." St. Hilaire has a boyish face and says he gets teased all the time about how young he looks. He got hooked on art theft in university, when he took an elective about Egyptian art and architecture. Several years later, when he was a prosecutor, he reconnected with his professor, Dr. John Russell, who told him to look into the black market. He did, and, like Czegledi, he was astounded at

what he found—a giant mess, with billions of dollars of stolen work traversing the world, summarily ignored by most of the world's police forces.

St. Hilaire's eyes are green, friendly, and energetic, and he loves talking about Egyptian history. He also possesses the rare gift of being able to summarize huge swaths of history in easy-to-digest narratives. Just like Czegledi, he is a natural teacher, and on a day off from the conference, St. Hilaire took me for a tour of the Egyptian Museum in Cairo for a crash course on the history of art thieves. We strolled through Tahrir Square. It's hard for me, even now, to believe that just a few years later the square would be filled with thousands of citizen-revolutionaries facing off against President Hosni Mubarak's thugs. On that day, it was relatively peaceful and sunny. Crowds of men smoked and hung out in the garden in front of the museum.

The museum is grand and dusty, and its 177 halls are crammed with more than 120,000 artifacts, remnants of great dynasties taken from the pyramids and temples of the ancient royalty of Egypt. Also here are the preserved bodies of twenty-seven of those kings and queens, some of them more than 5,000 years old. They lie in climate-controlled chambers under soft light, protected by thick coffins of Windex-clear glass: Ramses III, Seti I. Some of the mummified corpses still have the hair they died with, brittle as straw. Their bodies were wrapped in cloth and locked in the black center of pyramids. Now lines of tourists look down at their dead faces, gawking.

"This wasn't the plan," explained St. Hilaire. "Ancient Egyptians had no word for art. These were tools, and they served a purpose. The pyramids and their treasures were all part of an elaborate machine that the ruling families of Egypt devised to move safely from their lives on earth to

a world beyond death." The afterlife was as real to them as water, sand, or stone. "The machine gets them to the other world and lets them live well there. But only if the machine stays intact," St. Hilaire said. "The pyramids, unfortunately, were also these great big beacons to thieves, to the poor of Egypt. They shouted, 'Look over here! The loot is inside us! Rob me!'"

He pointed to a stone statue in a glass case. It was tiny, about two inches tall. "Khufu was an ancient king, and one of the most powerful kings in the history of the world, but that little statue is the only image we have left of him."

Khufu had one of the largest tombs, and it was probably heavily looted. "The entrance to Khufu's pyramid wasn't created by the king; it's a looter's entrance," St. Hilaire told me. "Most of the early looting in Egypt happened by locals." The history of Egypt, he explained, was a history of plunder—first by Egyptians, and then by the world.

Locals started raiding the pyramids around 2200 BCE, while Egypt was still reeling from the reign of Pepi II, considered to be one of the longest-reigning kings in history (somewhere between sixty and eighty-four years). After Pepi's rule, Egypt fell into what is now banally titled the First Intermediate Period, which means that Egypt was in chaos; with no one in charge, society collapsed.

"Think Iraq, after the fall of Baghdad," St. Hilaire said. "There was no social structure in Egypt to make sure looting didn't happen. The common person who lived in Egyptian society knew that the king was buried in the pyramid, with lots of great stuff in there. He also knew that the king had a special gate, to travel into the afterlife. And now there was no one stopping them."

St. Hilaire paused in front of a large statue—of the pharaoh Djoser—with empty eye sockets. "This statue used to

have beautiful crystal-rock eyes. You rarely find the glass eyes intact. Stolen," he said. "Well, take the eyes out, and how does the king see? That's why the punishment for looting was severe." A few minutes later he pointed to a small scrap of something like paper, in a glass case. "That's papyrus. It was the predecessor to paper."

One of the earliest recorded trials of a thief in human history occurred during the New Kingdom Period in Egypt, and its details were captured on papyrus, after the man was caught stealing from a tomb. His punishment was death on the stake. "It's not a great way to go," mused St. Hilaire with a smile, "but gruesome punishments didn't stop the looting."

When tombs continued to be raided, Egypt's ruling class regrouped. "Some priests-kings got together and said, 'We now rule this kingdom.'" These new pharaohs decided that the buried kings and their treasures were vulnerable, so they moved all of them into one tomb—in the Valley of the Kings. Local thieves, though, quickly became a minor irritation compared to the invasions by a parade of foreign powers: Libyans, Nubians, Assyrians, Persians, and Macedonians. Alexander the Great fell in love with Egypt and wanted to be a pharaoh. Then the Romans arrived and carted off thousands of treasures to Europe. "Where are the most Egyptian obelisks found today? Not in Egypt. In Italy. So if you want to see an Egyptian obelisk, you go to Rome."

When Napoleon invaded Egypt, he brought scientists from France to help him categorize and organize the artifacts he pillaged. Napoleon would never have considered it pillaging, though. "Both the Louvre and the British Museum started to collect around roughly the same time, so we know there was a healthy international trade in

Egyptian artifacts." The Louvre built up a lot of its early collection from Napoleon's Egyptian campaign, and after Napoleon was defeated by Lord Nelson, much of the loot was redirected to the British Museum.

"Archaeology and museums grew up together," St. Hilaire explained. "It is important to understand that modern scientific archaeology is a relatively new idea. That practice started fairly late in human history, when the folks from Britain ended up in modern-day Iraq and Egypt. For many years, the difference between archaeology and treasure hunting is indistinguishable. Looting was the norm."

In the nineteenth century, Egyptomania hit Britain and other parts of the world full force. The aristocracy in London held mummy-unwrapping parties. Ancient Egyptians could not have predicted the value the world would place, thousands of years later, on the objects they created. Stealing cultural heritage became mainstream, and a group of collectors sprang up, first in the West and then in wealthy pockets around the globe. "What's important to remember is that there was nothing illegal about taking these artifacts. It was all a free market at that point." This was *Indiana Jones* for real. Men came to the desert from far-off lands and carried pieces of it home with them.

In Egypt, that changed in the mid-twentieth century, when the country began to wrestle back control of its cultural heritage from foreign-interest groups. The Department of Antiquities was created to take stock of ancient treasures and move forward with archaeological work. Of the sixty-three tombs excavated from the Valley of the Kings when it was rediscovered in 1992, not one dig had been led by an Egyptian. But by 2002, Zahi Hawass, an Egyptian archaeologist and showman, had taken charge of Egyptian antiquities and seemed to rule the billion-dollar industry with the

power of a pharaoh. Hawass, head of what's now called the Supreme Council of Antiquities, told a writer at the *New Yorker*, "To control all this, you have to make them fear you and make them love you at the same time." He controlled the pyramids at Giza and all the archaeological digs in the country. He also began exporting Egypt's cultural heritage to the world—for big money. If you saw King Tut's treasures on tour in the last few years, that was a Zahi Hawass production. Perhaps for the first time in the ancient kingdom's history, Egypt was profiting from its cultural heritage.

By this time, though, the world seemed addicted to "free" loot courtesy of Egypt, and stolen antiquities remained a major draw for thieves and corrupt dealers. Case in point: in 2005, a Manhattan-based art dealer was convicted of smuggling a bust of Amenhotep III—likely King Tut's grandfather—into the United States. Frederick Schultz, who was sentenced to three years in prison, was linked to a vast network of middlemen spread out over a number of different countries. "There are constants in the history of human desire," St. Hilaire told me. "There is a desire to loot that is constant. There's also a desire to preserve. In Egyptian history, both of those are plainly evident."

On the last night of the conference, Bonnie Czegledi, Rick St. Hilaire, and I had dinner in a beautiful old restaurant in Cairo. We were all flying out the next morning. I said goodbye to St. Hilaire, who was staying at a smaller, less expensive hotel. When Czegledi and I returned to the Marriott, we decided to check out and then have a drink on the patio. We queued up at the front desk. When it was my turn, the desk clerk calmly informed me that I owed an extra $40 per night on my room. I felt a chill. "That can't be right," I said.

The clerk assured me it was. There was a note attached to my account, he said. I asked to speak to the manager. The

clerk looked nervous. I explained to him that I'd already had this conversation when I checked in, and the issue had been resolved. At first I was successful. He began preparing me a second bill, without the extra charge. Then he informed me that he had called the Organizer, who was coming downstairs to the lobby. "What does *he* have to do with this? Does he run the Marriott Hotel?" I asked. The clerk said, "Please wait here. He is coming soon." Czegledi stood in the lobby while all of this unfolded. I watched as the new bill was printed up. I gave the clerk my Visa card and hoped the payment would go through before the Organizer arrived. Everything was happening very slowly. Finally, the card number was entered into a machine and the receipt began to print just as I saw the Organizer walk into the lobby.

"Did you pay?" he asked in a loud voice as he approached.

"Yes," I answered, "I paid."

He turned to the clerk and they had a quick, terse exchange in Arabic. It ended with him berating the desk clerk. Then he stepped very close to me, until our faces were just inches apart.

"You must pay the rate I told you to pay."

"I've already paid the bill with my Visa card. The bill is settled."

"I don't care about that bill. You will pay the rate I gave you."

"Do you understand that I'm a journalist from North America, writing about the corruption in the art world?"

"I don't care what you are writing about," he said. "You will pay."

"I've paid. It's over." I wasn't sure what to do. I stood still, didn't step back. But the Organizer stepped closer. The clerk, other staff in the lobby, and a few guests circulating near the desk looked frightened. Czegledi watched

intently from a few feet away. I thought the Organizer was going to punch me. Instead he poked me with his finger.

"You haven't paid *me!*" he shouted.

I did not respond. His eyes were wide with rage, and he was shaking. We stood like that for what seemed like a long time, but it was probably less than a minute.

Then he collected himself and lowered his voice to a whisper.

"I am leaving now. I will leave instructions for you on your phone, in your room. They will include my room number. You will follow those instructions. You will follow those instructions and leave the money at the room that I tell you. There will be a message on your phone in your room."

And then he left. I turned back to the clerk. He looked like a kid watching his father leave the dinner table after a fight. I didn't understand. How could the Organizer have power over the entire Marriott staff? Who was he? Czegledi and I went and had our drink on the patio. I was shaking from adrenaline. Later, on the way to our rooms, we had to pass through the lobby. The clerk approached.

"Sir," he said politely. "Mr.——— has instructed me to tell you he has left a message on your phone and you are to follow the instructions and deliver the envelope to his room. He wanted to make sure I told you this."

I was worried now. I was staying in a hotel that seemed to be completely under the Organizer's control. What would happen if I didn't pay? He obviously knew what room I was in. He probably had a key card to it. It was past midnight. Czegledi looked concerned as well. "What are you going to do?" she asked. "Do you think you should go to your room? He might be waiting for you."

"I'm going to go to my room right now, grab my stuff, and sleep on your floor," I said.

Czegledi agreed. Before I left my room with my bag, I looked at my phone. The message blinker was flashing hypnotically. Czegledi let me into her room. I was so tired I don't even remember hitting the pillow. The next morning we woke at 5:30 and went straight to the airport, then flew to London, where I stayed on for a week.

Before we'd said goodbye, I'd asked St. Hilaire about the size of the global black market. "I know in terms of dollar value that it's the fourth-largest crime, globally," he said, "but it has remained a mostly invisible problem on the world stage. There isn't a lot of data out there, so it's very difficult to get models. What would be especially valuable is an anatomy of an art thief. Not the movie version of the billionaire who steals a Picasso. Just a thief who uses the giant black market to make a living." As it turns out, there was someone just like that in the United Kingdom, and he wanted to talk.

_ _ _ _ _ **4.**

# THE ART THIEF

"It's a marvelous time to be an art thief.
Art theft has become one big game."
**PAUL**

P aul broke into a house for the first time when he was
sixteen years old, in Plymouth, a city about four hours
away from where he was born.

A different teenage boy had already visited the house,
posing as a door-to-door merchant who was trading in
junk. The scam was called "knocking" because it began
with knocking on a stranger's door. It was a more sinister
version of the encyclopedia-salesman routine—a cold call
with malice.

The whole point was to get inside the house and look
around. If possible the knocker would buy something
cheap from the family—maybe a few pieces of grimy silver-
ware or an old watch. Once the family had allowed the boy
in, he could figure out what he really wanted but could not
buy, items too valuable—or too prized by the family—to
sell. Jewelry, cash, antiques.

Now it was late at night and the first boy was sitting in the car outside the house, waiting for Paul to finish the job. Paul stepped around the back to a window he knew was unlocked. The first boy had provided the intelligence: no alarm system, no dogs. The residents were old and had retired to bed early. It should have been easy. The problem was that Paul was not agile or quiet. In fact, he was surprisingly clumsy. Nothing went according to plan.

Instead of lowering himself gracefully through the window, he decided to jump. "I was so stupid," he remembered. The minute Paul landed inside he had a sick feeling in his stomach—fear and adrenaline. Everything happened in fast forward.

The residents of the house awoke. The lights flicked on. In the hallway, Paul was confronted up close by the husband. They stared at each other, not knowing what to do. Violence was not an option. Paul didn't know the first thing about violence. He was unarmed. "Guns weren't part of the art theft game when I started," he said. Instead he did what came naturally. He was charming and upbeat. He smiled apologetically and relied on his practised innocence, the shock of his young face.

"I'm so sorry to disturb you," Paul said. "Obviously I am terrible at this. You have my word that I will never break into another house again in my life." Then he ran. He fled out the front door and into the waiting car. It was a failed mission, but Paul had learned a valuable lesson, and his bold promise to a frightened man in the middle of the night turned out to be true.

Over the next decade and a half, as Paul climbed the criminal ranks from small-town hoodlum to major handler of millions of dollars in stolen paintings and antiques, he never did break into another house. After all, why should

he? Breaking into houses was what professional thieves were for, and there was always one willing to be hired for a straightforward, if dishonest, night's work.

I emailed Paul on February 28, 2008, although I didn't know his name at the time. I'd found him online, where he had been interviewed under a pseudonym for the magazine *Foreign Policy*. The interview identified him as a former art thief advocating for stronger laws and more severe sentences for anyone caught stealing art from a major museum or gallery. It struck me as funny, and counterintuitive, that an art thief would be pushing for harsher sentences for art thieves. Paul, it turned out, loved to shock, and counterintuitive was his middle name. (He had a few names.)

In my email I explained that I was a North American journalist writing an investigative book, hoping to shed light on the world's mysterious and increasingly violent black market for stolen art. It was an earnest note that requested a phone appointment at his convenience. The thief's email address was a Hotmail account registered in the United Kingdom.

The same day I sent that email, Sotheby's auction house in London broke records again, this time for its famous fall contemporary art sale. Every year the two dominant auction houses (the other being Christie's) commanded higher and higher prices for paintings. On the podium at Sotheby's that night, Francis Bacon's *Study of Nude with Figure in a Mirror* sold for $39.7 million, and three self-portraits by Andy Warhol sold for over $20 million. The evening's total sales exceeded $145 million. As usual, most of the buyers were anonymous. Bidders at auction are often not named, and multi-million-dollar sums are promised via assistants on cell phones.

Earlier that month the world had been stunned by two blockbuster art thefts. They had occurred within five days of each other in the heart of a country that happened to be the world's most safely guarded bank vault—Switzerland. The first theft took place on February 6, when two works by Pablo Picasso had been lifted from a small gallery in a tiny town. Those two paintings by the reigning brand name in art were estimated to be worth $10 million—not bad for an evening's work.

Then, on February 11, three armed men wearing masks visited one of the world's most important Impressionist museums, the Foundation E. G. Bührle Collection in downtown Zurich. The gunmen stormed the galleries during operating hours. Staff and security guards hit the floor, held at gunpoint by one man. With precision and speed, the other two removed the museum's four most important paintings: works by Claude Monet, Edgar Degas, Vincent van Gogh, and Paul Cézanne. Even Swiss police admitted that the armed robbery was "spectacular." However, the theft was also eerie, because the scenario was familiar.

In August 2004, in Norway, two armed and masked men had entered Oslo's Edvard Munch Museum, also during operating hours. Tourists and staff scrambled onto the floor. The men were absurdly barbaric. They ripped two paintings from the museum wall, smashed the frames repeatedly to dislodge their delicate canvases, then fled in an Audi. They'd stolen the most valuable works in the museum: *Madonna* and one of the most famous paintings in the world, *The Scream*. It was the second time in ten years that a painting of *The Scream* had been stolen (Munch created a series of images with that title, two of which are paintings). In 1994, thieves had gone for a night tour of Norway's National Gallery and walked away with the other painted version.

When a museum theft of great magnitude occurred, the ensuing media attention was usually intense and often referenced the art world's most popular ghost story, the 1990 theft from the Isabella Stewart Gardner Museum in Boston. Two thieves wearing police uniforms entered the Gardner and tied up the security guard, and a dozen paintings simply vanished. The most famous was Johannes Vermeer's *The Concert*. Instead of replacing the Vermeer with another painting, the museum installed an empty frame. The Gardner theft became a symbol of all art thefts, and the works stolen that night remain among the most sought-after missing children of the cultural world.

The pattern kept repeating: A dazzling art theft would unfold in an otherwise serene museum. The eyes of the world would stare in amazement and shock. The media would mourn the loss of another precious painting pulled into the criminal vacuum. Museum directors would grumble about their limited security budgets. A few months later, another museum would be hit. The extreme nature of the crimes seemed to match in ferociousness the appetite of the art market itself. The higher auction prices climbed, the crazier art thefts became. But how did it connect, and what were the thieves doing with those paintings?

A reply from Paul was sitting in my inbox the next morning:

> I am happy to give you any assistance I can for your book. I am a bit busy this week but next week is good and we can firm up a time to speak on the phone. All I ask for is a credit and perhaps a description as a leading authority on global art related crime . . . Let me know a contact number for you and when you are free next week. Kind Regards.

He sent me a phone number and we scheduled a call for the next week.

When I phoned, Paul answered with a tentative "Hahloh?" He had a working-class British accent, and there was a flat tone to his voice. As I later learned, a lot of different people call Paul, for a lot of different reasons, so on that day I could have been anyone in a range of categories—a petty criminal, a master thief, a detective from Scotland Yard or the local Sussex police force, an insurance adjuster, or one of the other shadowy souls I'll never know about. Paul added me to his weird list of contacts.

Our first conversation lasted about an hour. I asked Paul about his background and he didn't hold back. Yes, he had been an art thief and, in his opinion, quite a gifted one. "I've never held a real job," he told me. "I'm a capitalist, through and through. Profit from pain. And I made a killing."

Then he discussed some of the major heists of the past couple of decades, including the still-unsolved Gardner case. He seemed obsessed by the missing Gardner paintings, and told me he had spent years trying to figure out where they were. "They are the Holy Grail of art theft."

When I asked him if he had ever stolen any famous paintings from a museum, he burst into laughter. "Do you think I'm a fucking moron?" Those kind of high-value, high-risk jobs weren't his style. They were unprofessional and only led to trouble for everyone.

"Headache Art," he called them, "because they only give everyone involved a fucking headache! The criminals who get greedy and pull off high-profile art thefts are mostly idiots, they have no idea what they're doing most of the time. They just see that something is worth money and they take it. Greed is their undoing," he said. "Stealing art is the easy part—moving it is the hard part. A good thief

stays out of the spotlight, and under the radar. That's the golden rule."

Paul said the goal of an educated thief was to avoid attracting attention. "Everyone wants to make money," he said, "just like in any professional organization or company." And there was more than enough money to be made stealing lesser-known artworks without drawing the attention of law enforcement or the spotlight of the media. He pointed out that the media were seduced by the larger thefts—finding out where the multi-million-dollar canvases were. But these were isolated spectacles that made for great cocktail conversation and Hollywood blockbusters. For the most part, very famous paintings were a trap for criminals. It was the Myth versus the reality of the Problem again, but from a criminal's point of view.

With the right training, a sophisticated eye for value, and the appropriate network of art dealers, an art thief had no need to steal from larger institutions, ever. "Thieves who steal from museums should be prosecuted. End of story," Paul said.

He told me that he was retired, but when I asked how his day was progressing, he answered, "You know, I'm up to my usual Machiavellian ways."

Toward the end of our first conversation, Paul said to me about art theft, "Once you start thinking about this subject, you will never be able to stop thinking about it. Every time a painting is stolen somewhere in the world and you read about it in the news, you will feel compelled to think about it, and to know where that painting went. It grabs you and never lets you go."

We struck up what turned out to be a three-year conversation. In addition to being an art thief, Paul was an accomplished con man—and therefore a great storyteller. "I always use a paragraph when a word will do."

Paul once told me a well-known joke that encapsulated his view of how people think. Two men are walking in the desert. Across the plain, they see a group of lions. More important, the lions see them. The lions look hungry. One of the men bends down and begins to tie his running shoes. His friend, watching him, points out diplomatically, "You'll never outrun those lions." The man tying his shoes replies, "I don't need to outrun the lions. I just need to outrun you."

Paul's career as a thief, he told me, was a study in the follies and hypocrisies of human behavior, and it had resulted in a very specific view of how the world worked. "If you look at human beings, we are selfish and greedy. You drive one car, but you buy a second or a third car. Why does anyone have to own fifteen Rolls-Royces? One of the great philosophers of our time is George Lucas, and we are all a little like Jabba the Hut. We always want more than enough. In fact, we're the only species on the planet that gratuitously wants more than enough." Another trait Paul focused on was dishonesty. "It's more natural for a human being to be dishonest than to be honest," he told me. "Each person is as despicable as the next. Everyone is out to fuck you. It's just that some people use lubricant."

And no business exemplified lying, cheating, dishonesty, and greed more than the art world, according to Paul. "Deliciously dishonest" was his description of the industry. "That's the art world I came to know and love, and exploit." In a lot of ways, his description of the trade matched Bonnie Czegledi's, but he was more brutal about it.

The real criminals weren't just the thugs running into museums with guns. They could be found at all levels of the industry and were willing to turn a blind eye to the looting of global cultural heritage because of a need to make money or climb the social ladder. The corruption and

moral degradation didn't surprise him, though. It was the illusion of respectability that people associated with the art world that confounded Paul.

He was especially intense in his cynicism when it came to art dealers. "I'd go as far as to say that the term 'honest antique dealer' is an oxymoron," he laughed. "No one cares about selling stolen art as long as you're smart about it. It's not even considered criminal. It's more as if it's naughty behavior. You know . . . wink, wink. It's the norm."

Paul was charming and eccentric, and he liked to joke around, but there was always an undercurrent of hyper-awareness about him. He could lead you down a dozen different roads in a conversation, but he was always probing and listening intently for a reaction. He wanted to know what my situation was in life. "Are you married? Kids? Did you get a seven-figure advance for your book? I am probably going to be the most exciting character in your book, let's face it."

Early on he mentioned a verbal altercation he'd had with someone, which ended with Paul saying, "If you fuck with me, I will spend the rest of my life destroying yours. I will fucking destroy you." I got his message. Sometimes talking to him felt like an interview with a vampire, because Paul had indeed been a vampire. He told me in detail how he spent years of his life stealing hard-earned material wealth from hundreds, perhaps thousands, of homes around him and selling those stolen items to art dealers and auction houses. But the more I talked to Paul, the more I came to think of him as the Cheshire Cat, always appearing out of the ether, posing absurd questions, offering paradoxes and philosophical arguments about the relationship between people and their possessions.

And just like the Cheshire Cat, Paul was intelligent and mischievous, although there was always a darkness to his

personality that would suddenly cut through his playful charm. Still, when the Cheshire Cat disappeared, the last thing you remembered was his grin. Our phone calls would usually end with Paul telling a joke or a riddle, and then he was gone.

Paul wasn't just a thief, he was steeped in the lore of thieves, and he drew a line through British history from Jonathan Wild to John McVicar. Paul was a huge fan of Wild, a criminal genius in early-eighteenth-century London, a man who played both sides of society. He passed himself off as a savior to the public by taking back from thieves items that had been stolen, but he was indeed the king of London thieves. He orchestrated everything, and was eventually unmasked, convicted, and executed.

"Being a thief is a terrific life. The trouble is, they put you in jail for it," Paul laughed. He was quoting McVicar, one of the most famous armed robbers in 1960s London, who was convicted and sent to prison for twenty-six years. After he was released he wrote a book about his life that was eventually turned into a film starring Roger Daltrey. "As a kid, I always rooted for the villains in the movies," Paul said.

We started to talk once, twice, sometimes three times a week. I would make an appointment and call, and he would always answer with that flat "Hah-loh." (I sometimes heard the words as "Hell, Low.") Over several months, Paul outlined his own creation myth of international art theft. He was Adam, in the garden, studying the apple on the Tree of Life.

Paul had perfectly balanced himself high up on a branch that overlooked the game, with a view both of law enforcement and of the criminals and thieves who were doing such an expert job of evading the law. He seemed to enjoy being on the shadow line of those two worlds, but it was always a mystery how deep his relationships were on either side. Like

Jonathan Wild, he moved in both networks. But beneath the veneer, Paul possessed a coherent view of the multi-billion-dollar industry that was sweeping across the planet.

"It's a marvelous time to be an art thief," he said. "Art theft has become one big game. It's just one big circular game. Art and antiques are objects that don't change. They remain exactly as they were made. What changes is who owns them. People pay small fortunes to own them for a period of time. So the objects get passed around the country, and now the world. Their value increases. Ultimately, they outlive us all." Paul found the game of international art theft both amusing and absurd. Police were always ten steps behind thieves, and for every art theft that was publicized in the media, there were hundreds that never made the news. These thefts were practically invisible—as if they had never happened. "For every Picasso that is stolen, there are hundreds of lesser-known works of art that are never reported," said Paul.

If I hadn't already spent time learning about art theft from Bonnie Czegledi and Rick St. Hilaire, I would have been disappointed that Paul hadn't stolen from any major museums. But it was precisely because the two lawyers had both pointed toward the larger black market and the interplay among thieves, middlemen, and the network of international dealers that I became so interested in Paul, in the way he had operated as an art thief. He was a missing piece of the puzzle, and he confirmed much of what the lawyers and detectives feared was happening. He was exactly the kind of thief St. Hilaire had suggested I find—one who had perfected how to sneak through the system and make a profit without attracting attention.

It was easy to make a living from stealing art, according to Paul, if a thief made intelligent choices, if he stayed

below a certain value mark—about $100,000. Less was better. Don't steal a van Gogh. To someone who knew how to work the system, the legitimate business of fine art became a giant laundry machine for stolen art. You could steal a piece and sell it back into the system without anyone being the wiser.

"It's called 'pass the hot potato,'" Paul told me. "A dealer sells it on to the next dealer, and the next, until nobody knows where it came from. It's a fantastic system! And that system is the same wherever you are. It doesn't matter if you're talking about London, New York, or New Delhi," he explained. "Art is something you have to think about as a commodity that goes round in circles. The only time it appears in the open is when someone tries to filter it into the legitimate art market—auctions, art fairs, gallery sales, dealers. Otherwise it's hidden away inside someone's home."

Paul loved to chat and seemed thrilled that someone who was following the international art theft dramas wanted to discuss them with him. I had hoped that Paul would be a good background source, someone to check details and theories with. But he turned out to be far more valuable.

From a young age, Paul told me, he had received the training necessary to climb the criminal ladder. His career matured around the same time that art theft transformed from an eccentric criminal pastime into a multi-billion-dollar global industry, during the boom in fine art sales in the 1980s. "It was always about supply and demand," he said. "And during those years, demand had never been higher for fine art and antiques."

On that night in Plymouth, in 1980, after the failed burglary, the two boys drove through the dark to Brighton, where Paul had grown up. Paul told me that to understand the foundations of the global black market in art, it was

necessary to take a closer look at Brighton as it was before all the art and antiques started to disappear. As he likes to say, "All roads lead back to Brighton."

Wasn't Brighton a nice little resort town with a view of the sea?

"Brighton and hot art fit hand in glove," he said. He was a pro and knew exactly how to reel me in. "How did I learn to become an art thief? We have to go back to my teenage years. Most people live a mundane life, and the prospect of some kind of danger excites them. The general population doesn't come into contact with criminals unless they put in a DVD." On that note, he said that if his story were a movie, it might begin the same way that *Goodfellas* does, with the camera panning in from above to a close-up on his face as a kid on the streets of Brighton, his adult voice narrating the scene: "Ever since I was boy, I always knew I wanted to be an antiques dealer." Just like any boy hungry to make his mark on the world, what Paul needed was an education.

At about the same time that I began talking to Paul, I also began my phone conversations with Detective Donald Hrycyk. Paul was the flip side of the coin to Hrycyk.

# 5. _ _ _ _ _

## TRAINING DAYS

"Suddenly I'm walking into museums and galleries asking questions. I was dealing with the rich and the powerful, the most influential people of the city."

**DONALD HRYCYK**

The Los Angeles Police Academy is tucked into the hills of Elysian Park, around the corner from Dodger Stadium.

From the window of the Impala, Detective Donald Hrycyk pointed out the sunny hills filled with eucalyptus trees. He knew them well: he'd had to run up and down the slopes as a rookie. He spent four months training here after being accepted into the academy in 1974.

"Police built this place," he said, as he pulled into the grand driveway that cut through the trees and opened up into a spacious parking lot. At first glance the academy looks like a hotel. The grounds are protected from the city by the hills and shaded by soaring palm trees. There's even a swimming pool, and at the gift shop the soundtrack to *Top Gun* was playing: "Danger Zone," by Kenny Loggins.

Hrycyk was born in New York but grew up in the L.A. suburbs. His parents came from an area on the border of

Poland and Ukraine, which they fled during World War II. They were pushed around a few different refugee camps, found a sponsor, and arrived in New York, where they stayed for a time. "My parents divorced," Hrycyk told me. "I never knew my father, and, in fact, I think he ended up in Canada. My mother worked a number of menial jobs, everything from cleaning to dental assistant. She's the one who moved us to Long Beach." Hrycyk bought a muscle car—a meridian turquoise blue Pontiac GTO. He drove it to California State University, Long Beach, where he studied criminology, and then he applied to the academy.

"When I went through here, there were a lot of Vietnam vets. The department wanted ex-military experience, and in fact it had a militaristic organizational structure. One of my instructors wore his LAPD uniform by day; by night he wore his Marine Corps uniform."

Down the hall from the gift shop, a half-empty diner was populated by beefy-looking young men in LAPD T-shirts, a few officers in uniform, and some older detectives in slacks and sports jackets. We sat at a table under a photograph of the first fleet of radio-equipped police cars, circa 1931. They looked like new toys, black and shining. There was no graffiti in the washroom.

After he graduated, Hrycyk found himself in the middle of the gang wars raging across the southeast of the city, where he drove a black-and-white cruiser. He bounced around divisions for a few years working tough neighborhoods, mostly in the south of the city. By the time he became a detective, it was the early 1980s—an era when the city had over a thousand murders a year: drug murders, gang murders, senseless murders, horribly violent murders—and he was in South Central Los Angeles. "Murders seven days a week, twenty-four hours a day," he said. "I

was part of an on-call team. My memory of those days is chaotic. You had to be on your toes all the time, and you couldn't work those kinds of jobs alone."

Once I asked Hrycyk what he'd been doing in 1985. He emailed me a picture. It was of a younger detective, in brown suit slacks and a white shirt strapped with a gun holster; he was standing over a bloody body laid out in a morgue. We talked about some of the cases he remembered. One involved an ice-cream pushcart vendor. One day, a gang of kids decided to rob the ice-cream man. They organized themselves, got a gun, and decided that if he put up any resistance, they would shoot him in the arm. When the kids approached, the man resisted—so one of the kids shot him in the arm. Unfortunately, the bullet also tore straight through his arm and entered his chest. He died beside his ice-cream cart, and the kids took off.

When Detective Hrycyk showed up, he saw an empty pair of running shoes near the ice-cream cart, in front of an alley. "One of the kids had run so fast he'd run straight out of his shoes, into the alley." A few days later, driving around the neighborhood, Hrycyk spotted a kid wearing a brand-new pair of shoes almost exactly the same as the ones that were in front of the alley. It was the ice-cream killer, of course.

"We had another case that started when the storm drains overflowed after a heavy rain. The city sent out street maintenance crews, who lifted a manhole cover and couldn't see to the bottom. They went to a neighboring manhole cover, and tried to unclog the pipe. They pulled something through this one-foot pipe—it was a body. So somebody killed somebody else and hid the body in a manhole."

He had other stories: crack houses being targeted by rival drug gangs, who sent hit teams in to spray the place

with bullets, leaving bodies behind; a man waiting at a bus stop, shot dead, apparently just for wearing the wrong color of shoelaces.

Hrycyk was often working three separate murder cases at once. "We were constantly running out of time. No computers, no databases, everything was handwritten," he said. "The advantage of that work, as opposed to art investigations, was that there was a strong tradition—a body of knowledge and history to fall back on. There are schools for homicide investigation, and plenty of other detectives available to get advice from. I developed sources of information, talked to witnesses. There were a lot of people skills involved—cajoling people to get information out of them, people who are scared to talk."

By 1986 Hrycyk was feeling worn out. "I got tired of dealing with dead bodies," he said. An opening came up in Burglary-Auto Theft Division, and he applied. He got the job, but instead of heading to Auto Theft, he was transferred to a new Burglary Special unit under the command of Detective Bill Martin. That unit's mission, it turned out, was to explore stolen art.

Inside Burglary Special, in the downtown headquarters of the LAPD, rows of pigeonhole boxes lined a wall, and those boxes were stuffed with accumulating crime reports generated from across the city. One of the boxes was dedicated to cases involving stolen art, an area no detective in the department knew much about, or wanted to. The box was so full that paperwork was falling out of it.

Detective Martin was curious. Once in a while he'd take a few minutes to peek at some of the cases. What he found was that, unlike the other property-crime boxes, these cases sometimes involved enormous sums of money—half a million dollars in some instances—but, also unlike the

other property-crime boxes, no detective was paying attention to them. It was as if major bank robberies were tearing up the city and no one could be bothered to investigate.

There were a few good reasons for detectives to be hands-off when it came to art. Many of the case files listed no suspects. In the politics of a police department, that meant little incentive to spend time hunting around. No closed case, no glory. LAPD detectives with a desire to climb the ranks want a high clearance rate for the crimes they investigate. Stolen art cases remained the X-files in Burglary Special—too strange to touch.

Martin got hooked, though, and began staying late to read through the case files. The more he read, the more he started to see the cases in a new way. Property crimes meant stolen goods: televisions, jewels, cars, watches, and so on. A lot of the material goods that went missing in the city were duplicates—there were other material objects that looked just like them. Sure, they had serial numbers, but those could be changed or destroyed.

What Martin was seeing in these files were paintings, drawings, and sculptures: unique pieces of property. His theory was that these artworks should be easier to identify than a stereo made in Japan by the millions and sold all over the world, identifiable only by a serial number. These artworks had histories to them, and instead of serial numbers, they had personal signatures. The detective decided to follow his hunch and work a few of the cases. From them, Martin developed a set of principles to guide his investigations, principles that often ran counter to standard property-crimes protocol.

For example, up to that point most cases in Burglary Special got hot once they had a witness and a suspect. A suspect could be hunted down, and even if the stolen items

were no longer in his possession, he could divulge their whereabouts. Because art theft cases usually had no witness and no suspect, Martin reversed the process. He started with the community and followed the trail to the person who might have had a motivation to sell the artwork. It was more Sherlock Holmes than *Lethal Weapon*. "Traditional methods for finding property do not lend themselves to finding stolen art," Hrycyk told me. "There are no schools for learning this stuff, so you learn from cases."

In Los Angeles in the mid-1980s, art theft was a hidden crime, blending many different worlds. It cut across socio-economic lines and could move in a heartbeat from blue-collar to white-collar criminals. A thug who knew nothing about art except that it was valuable could steal a painting; that same afternoon, the painting could wind up in the possession of an auction house; within the week or the month, it could be sold to one of the Los Angeles art elite.

In 1986, when Donald Hrycyk started to work cases with Bill Martin, the two detectives picked up a phone book and extracted long lists of art galleries, auction houses, museums, and private art dealers. Their goal: to visit all of them. That's a tall order in a city where every time detectives take out a car they have to deal with long distances and traffic. It was also a risk, because it could be a huge time-waster.

Each time the detectives visited a new gallery, they asked for suggestions, for other contacts in the art world they should talk to. This also advertised the LAPD Art Theft Detail's existence. It was the oldest form of marketing a new product—going door to door and knocking.

Hrycyk also hunted for any reading material that might help. The only thing close to a manual was a book by Laurie Adams called *Art Cop*. "That book was about a

New York detective called Robert Volpe," Hrycyk said. "It wasn't designed as a playbook for other detectives to use. It was written as a fast read, as entertainment." Hrycyk bought a copy and ripped through it.

I knew *Art Cop*. It had been one of the readings assigned to me by Bonnie Czegledi, and here's what I learned from it. In the early 1970s, calls were coming in to the NYPD from museums, galleries, and art dealers. Paintings were going missing. The city was battling a more urgent crisis, though—the surge of violent crimes related to drugs. Homicide rates were way up.

One detective was picked for a quick assignment: venture into the art world and figure out what was going on. Everyone on the force knew about Robert Volpe, the eccentric cop who loved art, who painted portraits of nudes in his spare time and was teased for it by his peers. They called him "Rembrandt."

Volpe never fit the standard profile of an NYPD detective. He wore blue jeans and a black leather jacket, had shaggy hair and a thick handlebar moustache. Anyone who bothered to get to know him understood that his passion was painting—and the passion went deep. Born in Brooklyn in 1942, Volpe wanted to become a visual artist. As a teenager he had a few exhibits of his work at smaller NYC galleries: scenes of tugboats—the view from his childhood home. He graduated from Manhattan's High School of Art and Design and went to the Parsons School for Design. Then his life took a sharp curve: he joined the army. When he was released, he applied to the NYPD.

Volpe worked undercover in narcotics in late-1960s New York, when heroin was the drug to hunt. One of his cases became famous. Known as the French Connection,

it centered on a ring of heroin dealers importing the drug from France (the case became the film *The French Connection*, starring Gene Hackman). But Volpe never abandoned his childhood dream of becoming an artist, although he'd graduated from tugboats to women. His favorite model was a woman called simply "Tiger."

His new assignment was mostly a stab at PR with the Madison Avenue set. It was a smart, easy play for the department and cost them no resources except one detective's hours for a couple of weeks. It was supposed to be reconnaissance: survey the art scene, gather information, and find out if there was an easy fix. Basically, file a report. When Volpe ventured out he was probably the first detective in North America ever to investigate art theft fulltime, even if it was supposed to be a short-term assignment. To his fellow officers, the art investigation was the equivalent of working for the Bureau of Paranormal Activity. But Volpe jumped at the chance. After all, he was still allowed to wear blue jeans and a leather jacket. Even better, he was getting a paycheck to look at paintings. Instead of writing a report, though, Volpe started to open cases.

He arranged to meet with a curator at the Museum of Modern Art (MoMA), which had reported missing prints to the NYPD, including works by Henri de Toulouse-Lautrec, Pierre Bonnard, and Edward Hopper. MoMA's print department welcomed a steady flow of public visitors—anyone who wanted to spend an afternoon looking at original prints could simply sign out boxes of them to examine in a room at the museum and then bring back the box when finished. But since they had to book an appointment, there was a list of names.

Volpe examined the list of people who had signed out boxes of prints and came up with a shortlist of names that

coincided with the dates the prints had gone missing. Then he went through the motions that the thief would have gone through: he signed out boxes of prints and spent an afternoon leafing through them. The prints were brought to him in large cardboard boxes full of dozens of works, and he was left alone with them. He returned them when he was finished.

At the Metropolitan Museum of Art he did the same thing, and asked the Met whether they'd had any prints go missing. They didn't think so but said they'd check. A few hours later the Met called. Yes, prints were missing.

Volpe toured other museums around the city and examined their checkout systems. He visited the New York Public Library and chatted up the librarian. She remembered one man in particular, Ted Donson. Donson's name was on the MoMA list.

Next, Volpe did the rounds on Madison Avenue, skipping from one gallery to another. He asked about Donson—a man who turned out to be quite popular and who was, apparently, buying and selling prints. Actually, Donson was buying prints at one gallery and then selling them to another gallery for less. Why? Volpe's theory was that this was Donson's way of ingratiating himself to gallery owners and gaining access to their collections.

Related cases started opening up. At the Dain/Schiff Gallery on Madison Avenue, Volpe was told that a Pablo Picasso painting had been stolen. A man had walked into the gallery while Robert Dain was out and dropped the owner's name. While the assistant dealt with other clients, the man left, probably with the Picasso. Volpe remembered that one of the boxes Donson had signed out at MoMA was of Picasso's Vollard Suite. It turned out that Dain had done business with Donson. "Has he gone to Zurich yet?" Dain asked Volpe.

Zurich?

That was when Volpe first made contact with Interpol, the international police agency. It is likely Volpe was the first North American police officer to specifically request the international police organization's help on an art theft case. Interpol didn't have much information for the NYC detective.

Volpe searched through newspaper archives. Donson had worked at a law firm on Wall Street and had been caught trying to sell a series of stolen letters, correspondence between Roswell Gilpatric and Jacqueline Kennedy, to an autograph dealer. He was fined $100; his lawyer called it a "mistake of youth."

Volpe had a suspect. He called MoMA, the Metropolitan Museum, and the New York Public Library and told them to look out for Donson. Eventually, Donson called the Metropolitan to make an appointment. The museum called Volpe.

The detective arranged for a female undercover detective to be in the print room. She was leafing through a set of Paul Gauguin prints when Donson sat down with a briefcase. The detective watched as Donson opened the box and flipped through a few prints. Then she saw him take out his pen. He used his pen to quietly peel off the labels, then slipped a few prints from the box into his briefcase. Donson was arrested on the steps of the Metropolitan but later released without bail.

Less than two weeks after Donson's arrest, an anonymous caller contacted the NYPD and told the police department that they would find something they wanted in a locker at Grand Central Station. Volpe went to Grand Central, opened the locker, and found thirty-four original prints worth hundreds of thousands of dollars, as well as

four rare books from the New York Public Library. The prints included work by Paul Gauguin, Henri de Toulouse-Lautrec, and Albrecht Dürer, a woodcut by Pierre Bonnard, and a reclining nude by Henri Matisse.

Then the case became even weirder: prints started showing up at museums all over the city, sent through the mail. At Cooper-Hewitt, a Rembrandt appeared in an envelope and the assistant who received it figured it must be a joke—the print was surely a duplicate. When the museum checked its records and inventory, it found that the Rembrandt was, in fact, from their collection. It had been stolen without the museum's knowledge.

A few days later a Degas appeared in the mail at the Brooklyn Museum. Two more Rembrandts arrived that same day at the Association of American Artists. A year later Ted Donson pleaded guilty to possession of stolen property in the case of the prints from the Metropolitan Museum, and was sentenced to five years' probation. No one was ever arrested for the prints that were returned by mail.

The case, though, was instructive: with an education and a little charm, a person could walk into the most prestigious museums in New York and steal prints by the most famous artists in the world.

Volpe received an extension to continue his work as an art detective and set off to further explore New York's world of artists, dealers, auction houses, and museums—wandering through the galleries in the East Fifties and up and down Madison Avenue, through the antique shops on First, Second, and Third Avenues, and through the newer galleries in Soho. He introduced himself as the police department's Art Identification Team.

Around the same time in New York, another investigator was hunting for information about the black market in

cultural property. Bonnie Burnham was born in Florida, graduated from the Université Paris–Sorbonne, and worked at the International Council of Museums in Paris, where she published *The Protection of Cultural Property: Handbook of National Legislations*. She followed up with a 1975 book called *The Art Crisis*, which was meant to be a wake-up call for the art industry. Burnham had tried to cover the industry from a number of angles—black-market antiques, blockbuster heists in Europe, and the expanding worldwide network of art dealers and auction houses being used by criminals. She pointed out that art prices were rising at rates never before seen and that the higher prices climbed, the more thieves became interested in fine art.

"When I was working on *The Art Crisis*, it was a time when there had been an explosion of these violent heists from museums and private collections," she told me in the spring of 2011. "It was a direct outgrowth of the significant expansion of the art market." After *The Art Crisis* was published, Burnham went to work for the International Foundation for Art Research and, based on her research, decided to conduct a study of art theft in the United States. "There was not very much information at that time," she said. "We found out from museums that they did not usually report thefts, because they thought it would be embarrassing and not conducive to their relationships with collectors and donors. They also didn't have the kind of real face-to-face relationship with law enforcement, so calling the police just didn't sound like something pleasant. Everybody in the art world prefers to keep their business to themselves."

Under Burnham's direction, IFAR released the report *Art Theft: Its Scope, Its Impact, and Its Control*. She also

started IFAR's Art Theft Archives, a list of stolen works based on items from those initial surveys sent to museums and dealers. "Most institutions had things missing from their inventory. It was mostly smaller, unobtrusive pieces—collections of objects that were similar to each other," she said. "Then auction houses began to support us. I had connections with Interpol. We went to the New York Police Department and the FBI. It was never anything official, though—in terms of information. There was no way to get to that level. Up until then, trading in the art market was always based on trust. But this issue changed things—whether you liked it or not—and a lot of people in the field didn't like it at all. The issue divided the art community and created a very unpleasant environment in what used to be a collegial world."

Bonnie Burnham and Robert Volpe crossed paths. "Volpe had a flamboyant career, " she said. "I knew Volpe for a number of years. We would exchange war stories." Both Burnham and Volpe noted that the art market was just beginning to wake up to how large and insidious a problem art theft was, and by the time Burnham left IFAR for a position at the World Monuments Fund, in 1985, IFAR's list of stolen art was climbing toward twenty thousand registered items. "At the time the art market was just trying to hide from it and pretend it didn't exist," Burnham told me. She added, "The art market was complicit."

Volpe's early scouting missions allowed him a chance to size up the nature of the particular scene he was dealing with. The cast of characters was entirely new to the former narcotics detective, and he started to divide them into categories and profiles. There were the dealers, whom Volpe considered to be the priests of the art world, because almost every art dealer in New York had a front room for the

public and a back room for more trusted clients. In these back rooms the dealers kept their magical wares—works of art or antiques that seemed to possess a power that drew the rich to them and that collectors would pay vast sums of money to own. The dealers decided when to reveal the art, and to whom.

The collector was the character with the will to possess, some more obsessively than others. Collectors needed dealers to provide them with their fix. It was the wallets and the desires of the collectors that pushed the art market along. The collectors provided the demand, while the dealers gathered and guarded the supply.

Then there were the museums, which Volpe considered to be the cathedrals of the art world. His take on them was that they managed to remain aloof from the bustle of the art trade. They served a higher force: the public good.

Volpe noted that his new cast of characters was vulnerable to another, more sinister character—the art thief, "a despoiler of our national and international sacred trust." Volpe believed that the only way to combat this breed of criminal was to maintain an art theft unit within the NYPD. To do this, Volpe needed to train a few more detectives who were able to "enter and exit the world of art with perfect ease." That never happened.

Volpe's investigations included burglaries, robberies, and consignment frauds—when an artist or patron would lend a piece of work to a gallery and the gallery would vanish or refuse to return the art. He believed that art theft in New York in the 1970s had reached the same stage as narcotics a decade earlier. "The criminals who dealt in art were on the rise. This was true on a local level, nationally, and internationally. More and more the criminals were familiarizing themselves with the ins and outs of the art market

as they had once done with the drug market." Volpe theorized, "More money is reported stolen in New York in art than dollars stolen from banks."

He found the new field of crime to be epic: the entire art world seemed to be open to corruption—it was full of fakes, and it was self-policed. "If all the old French furniture was real," Volpe told the *Christian Science Monitor*, "there would never have been a French Revolution. Everybody in the country would have been too busy making furniture."

Volpe's department gave him the okay to take a course with Parke-Bernet, a New York auction house that has since been absorbed by Sotheby's. But the turnover among his superiors meant that his position as an art detective was under constant threat. He garnered even less sympathy from his fellow detectives—he once found a nude centerfold stuck to his locker with the handwritten note, "But is it art?"

The recovery rate for stolen art was at best, Volpe guessed, 10 percent. He lamented to *Time* magazine that judges rarely gave harsh sentences to art thieves, and he attributed this fact to Hollywood. "An art thief is entertaining, romantic," Volpe said, referring to the ever-present challenge of the Myth. "I've seen cases where the thief has pleaded guilty and gotten no sentence at all."

The public attention to some of his early cases shielded Volpe from the ire of his commanding officers, and the detective took advantage of the protection by learning more about trafficking stolen art. There was only one other police organization in the English-speaking world investigating art thefts with any authority, and that was Scotland Yard, in London. Volpe sent a detective to London to spend time with the Yard, to learn what they were learning. As it turned out, London was suffering from similar cases. By

1972 the British force was recovering on average £75,000 worth of fine art a year. Its advice to the NYPD was to publicize stolen art and train more officers.

After Volpe retired in 1983, he continued to lecture about his insights into art crime at universities across the nation. He also spoke at the FBI's training headquarters in Quantico, Virginia. But his position within the NYPD was never filled. New York City still does not have a full-time art detective on the force, even though it is considered the art capital of the world. Over his career, Volpe came to view New York as a depot for stolen art. The collectors who populated the penthouses of Manhattan acted as a magnet, drawing the looted antiquities and stolen paintings to the island from around the globe. Volpe saw the holes in the system clearly and understood that criminals were already exploiting them.

He also identified the much larger challenge that he was powerless to tackle: art theft was both a local and an international crime. The fingers of illegal activity that he found on Madison Avenue seemed to stretch far beyond his reach, outside of the city, across state lines, and in many cases across oceans to other art-market capitals in Europe and Asia. Volpe died at his house on Staten Island in 2006, at the age of sixty-three, of a heart attack.

Laurie Adams, the author of *Art Cop*, learned about his death from the obituary in the *New York Times*:

> As epicenter of the art world, New York brims with priceless art in museums and private residences, and according to Mr. Volpe, is the world's clearinghouse for stolen art.
>
> Before Mr. Volpe was unleashed in 1971 as the city's first and only art detective, art crimes were handled by the burglary division and other units. After his retirement in 1983, regular details took them up again.

For most of his career, Volpe was stranded in local bureaucracy with a small piece of a much larger picture and no support from within the department to uncover it.

Adams told me, "We only saw each other once or twice after the book was written. I think it's too bad that New York doesn't have an art squad. You need somebody infiltrating these areas—that's what Volpe demonstrated. Back then, the seventies, no one could have predicted that art prices would go up the way they did. It's always about the money."

If not for *Art Cop*, there would be little record of Volpe's work. Because of Adams, though, L.A. Detective Donald Hrycyk figured out that he was sharing an experience, was now part of a much larger pattern—one that seemed to repeat itself. "I found parallels to the work we were doing. It was interesting," Hrycyk told me. When Hrycyk sent me emails, it wasn't his name that showed up in the address bar. Instead, the sender name was displayed in capital letters: LAPD ARTCOP.

One afternoon in 1987, Bill Martin and Don Hrycyk were called to investigate a theft at the residence of Howard Keck, a Los Angeles oil tycoon. Hrycyk noted the high walls surrounding the property, the advanced security system, and the twenty-four-hour armed guards. In the living room the detective also noticed the Thomas Gainsborough portrait above the fireplace mantel, easily worth over one million.

Keck's wife, Elizabeth, played cards in an anteroom within view of a painting by Swedish Impressionist Anders Zorn. The painting had been bothering her lately. Why? One day she walked up to it and touched her finger to the canvas. Her fingertip sailed easily across the woman's body,

a comfortably smooth surface with zero texture. It was supposed to be oil on canvas, but what she was feeling was a photograph, perfectly sized inside the original frame. "It was incredible quality," Hrycyk said.

Three months earlier the Kecks' butler had quit.

Rune Donell was a Swedish-born sixty-one-year-old who had worked at the Keck home for eleven years. When he left, he cited medical reasons. Elizabeth remembered Donell admiring the Zorn, and that he had once pointed out to her that the painting would probably sell easily at auction in Sweden, which he visited often. Hrycyk called Interpol, which contacted police in Sweden; they agreed to help. This was now an international effort. In Sweden, detectives found out that one year earlier, long before Elizabeth Keck had discovered the fake in her card room, her butler had showed up at a Swedish auction and sold a painting called *Fête Galante* by French artist Jacques Sébastien Le Clerc.

Donell was living two lives. In Los Angeles, he was a lowly butler; in Sweden, he was a high roller. Hrycyk phoned the Kecks. Did they own a painting by Le Clerc? Yes. They searched their estate. No photograph replacement this time—it had simply vanished.

Swedish police also learned that Donell had visited the auctioneers again, this time with a photograph of the Zorn painting. Based on the date when Donell set foot back in Sweden with the painting, the detectives calculated that the photograph Elizabeth Keck had touched that afternoon with her finger had been hanging in her card room for five months. The real one had already been auctioned off in Sweden, for $527,000.

The butler went back to Los Angeles, where Hrycyk arrested him and held him on $500,000 bail. Hrycyk searched

Donell's West L.A. apartment and found evidence of money transfers from the sales, cameras, and film negatives of the paintings—as well as a receipt from a Redondo Beach storage yard. Hrycyk called the yard's manager: Donell was keeping a twenty-five-foot motor home there. In the motor home Hrycyk found two more enlarged photos of the Zorn painting, just like the one in the frame. He also found another photograph, exactly matching a different work at the Kecks', *Ducks on the Banks of a River* by German painter Alexander Koester. Hrycyk asked Elizabeth Keck to check that the original painting was still on her wall. It was. The Koester had been Donell's next target.

Meanwhile, Hrycyk had managed to track down the shop where the prints had been made, Rossi Photography Custom Lab in Hollywood. Owner Tom Rossi remembered Donell. Rossi had spent months making dozens of high-quality large prints until Donell was satisfied. It was an expensive, time-consuming process, and it worked.

Donell was prosecuted on two counts of grand theft. He admitted that he'd sold the two paintings but claimed he did so as Elizabeth Keck's agent—that she had been keeping her asset sales secret from her husband. Donell said he'd given the money to Elizabeth Keck, except for a $90,000 commission. She was outraged and said Donell's accusation was "ludicrous." But enough doubt was cast that Donell was acquitted. Elizabeth Keck sued Donell for $31 million. Meanwhile, the Swedish government held on to the paintings; under Swedish law, they said, auction buyers purchasing in good faith did not have to return the goods. Hrycyk sat back. He'd done his job, and everyone now knew where the paintings were.

When Hrycyk first started working cases with Bill Martin, the learning curve was steep and resources were scarce.

"Our recovery rate was lower" as a result, he told me. They also didn't have a framework of like-minded organizations to help them. The FBI wasn't dedicating any serious resources to the problem, the Internet was in its infancy, and the Art Loss Register didn't yet exist. Interpol was the only resource they could use, and they didn't know how to use it properly. "It was slow." Hrycyk was also getting to know a whole new world within the city.

"Even in those early days, without any experience at this kind of work, I knew immediately this work was different," said Hrycyk. "I'd been working gangs and ghetto crimes. Suddenly I'm walking into museums and galleries asking questions. I was dealing with the rich and the powerful, the most influential people of the city."

Some of the wealthiest collectors in L.A. were incredibly irresponsible when it came to buying, selling, and storing their art. In many of the early cases, Hrycyk discovered, no records of transactions had been held on to. For a detective, a paper trail is vital; it's a path to follow. In this new scene, often nothing remained to signify that any transaction had even occurred. "Just one person saying they had paid for a work, or another saying they had sold a painting," he said. "It didn't make any sense."

Another big difference from traditional property-crimes work was that even when there were suspects they often had no prior criminal convictions. "I found that a very high percentage of the cases I investigated involved people who had never been in trouble with the law before," he said.

The detectives theorized that stolen art was also unlike other property-crime cases when it came to time frames. If a stolen TV wasn't found immediately, it might as well not exist. Paintings were different. A few years could go by, even a decade or two, and a painting could suddenly

reappear at an auction house or a gallery. Information, then, became critical to solving these cases. Martin and Hrycyk wrote their reports by hand and filed them in blue binders. They started organizing those blue binders by year, and soon they had a few shelves' worth. The blue binders were their database and their archive—whoever worked those cases in the future would need to rely on the information in those binders. Without those records, it would be as if the cases had never happened.

"The art world as a whole is very secretive," Hrycyk said. "Deals are done on a handshake, on a sense of trust, and on the basis of a relationship. I've run into many situations where people will enter into million-dollar financial deals based upon their personal relationship and evaluation of another person, just by eyeballing them."

Confidence, Hrycyk figured out, was a big part of the problem. In the art world, confidence often replaced good business practices and safeguards. The sums of money trading hands without records were large, and so were the egos.

"Pride and reputation ruled the scene," he said. "A lot of people in this city take pride in their judgment of character. Over the years I have seen that kind of pride in judgment be the undoing of many people." He explained, "A stranger with a business card can walk into a gallery and say, 'I think I have a client who would be interested in buying this painting.' The gallery owner might take a chance on this stranger only because he possesses a business card. That stranger may be a con man." The con man may ask to borrow a small piece of art, to see how it fits with the collector's taste. He may do this several times, always returning the art to the gallery or dealer. By going through these motions, the con man creates a relationship, becomes a friend.

"Then he might borrow a much more valuable painting, and simply disappear," continued Hrycyk, who has investigated dozens of cases where a borrowed painting simply vanished. In those cases, when a detective asks for records or proof of purchase, the gallery owner often winces and shrugs. This leaves the detective powerless: "If a crime has been committed I can make an arrest, but the prosecutor must have evidence. If there is no paper trail, a prosecution might be impossible."

The art world, it turned out, was totally unregulated. It relied on a code of ethics that no longer applied to other business practices. "Art galleries and art dealers often don't ask for everything they need. Instead, they decide they should appear to value their customer, and to treat them as royalty. Oddly, not asking for information seems to be a part of that world's business practice." Hrycyk had seen this kind of behavior before—in South Central, watching drug dealers.

"That model—no paper trail, business on a handshake—is the textbook example of how criminals buy and sell products: drugs, stolen items, et cetera," he said. "There's not a big difference between a criminal receiver and a person who is confidential."

The detective describes a classic drug deal: "The buyer of the drugs doesn't know who the supplier is. The buyer only meets with the middleman. Cash is paid. There are no records. The transaction is invisible. It never happened," he said. Hrycyk then described the process of someone selling a work of art: "The person selling that painting is probably not the actual owner of that painting to begin with. Instead, he is a middleman, acting as a broker for the owner." Just as often, the person acting as the buyer isn't the actual buyer. "It is considered rude to ask questions about

the provenance of an artwork—who owned it, where it came from. Embarrassment is often one of the leading factors for secrecy," he said. Sometimes this comes down to practical social etiquette—the people selling their beloved artwork could be going through a divorce or have simply fallen on hard financial times. They don't want the community to know the details of their personal or financial lives. The painting gets bought and moves from one collector to another. The middlemen take their cut. But "the action is invisible."

Hrycyk noted that the idea of the rich and famous falling into financial trouble hadn't occurred to him before he began investigating art thefts. One afternoon he was visiting a Beverly Hills pawnbroker who bought and sold art to the Hollywood jet set. Hrycyk recognized a movie star loitering in the store, looking depressed.

"I suddenly realized that a lot of very famous people run into cash-flow problems, so they pawn their jewels and their art. It is done quietly, to avoid attention and embarrassment." The more Hrycyk learned, the better he was able to build profiles of different art thieves. His work expanded: he wasn't just dealing with burglaries anymore. He was dealing with con men, fraud, fakes being bought for large amounts of money. His conclusion: thieves of all kinds were taking full advantage of the art market. "Once they understood that the system was unregulated, they could manipulate it to serve their needs," the detective said.

"One thing I found was that when I first started going to these art galleries, I'd glance around and see colors and shapes. As the years went on, my eyes would go to an artwork and I would know: that's a Salvador Dalí."

In 1989, after working with Martin for three years, Hrycyk transferred jobs again, and went to work in the

office of a deputy police chief in charge of detectives. At that time, the LAPD Art Theft Detail was the only unit in North America dedicated to investigating art thefts. There was a problem in Los Angeles, and from *Art Cop*, Hrycyk knew that the same pattern was playing out in New York. But where had it come from? Who else was seeing cases like these? The only example from law enforcement that Hrycyk and Martin could point to in the English-language world was across the Atlantic, in England. Scotland Yard's unit, they believed, was the first one in the world to hunt stolen art. But that honor actually went to a much smaller force—the Sussex Police, who had jurisdiction over a swath of the south coast of England, including Brighton.

# 6. _ _ _ _ _

## BRIGHTON KNOCKERS

*"I became very good at a bad thing."*
**PAUL**

Paul Hendry, aka Paul Walsh, aka Turbo Paul, aka the Turbocharger, was born in Brighton in 1964, one year before the first Art and Antiques police squad in the English-language world was established there.

I visited Brighton on a couple of occasions: wandered from the train station down through the Lanes to the pebble shore, where the grand white Palace Pier stretches out over the sparkling water. On a sunny day it feels like a perfectly formed and packaged childhood memory from an old movie. The pier is white, like a big cruise-ship deck, and weighed down with stalls hawking doughnuts and hot chocolate, piles of candy, carnival rides, and games. Across the water, in the distance, lie the remains of a second pier. That pier was destroyed by fire; many residents suspect arson. Its charred husk lies deteriorating, a half-sunken pirate ship abandoned in the shallows—and a perfect physical

symbol of the split personality that is Brighton. In one sense, Brighton is an easy getaway from the sprawling gloom of London—cheerful, relaxed, and semiquaint. But there's a darker edge to its cheerfulness, and it was on that edge that Paul grew up.

Paul told me he was given away by his birth mother and adopted into a family on the outskirts of the resort town. He was raised as part of the lower class that serviced the hotels, shops, and restaurants where the rich paraded in the summer months. His family lived in a three-bedroom apartment on the council estate of Moulsecoomb, built in 1918 for English soldiers returning from the First World War. He remembers seeing posters advertising the units as "Homes Fit for Heroes." That wasn't how Paul perceived his circumstances.

"People who are born poor stay poor," he said. "The place where I grew up was built for cannon fodder. And that's what I was supposed to be—fodder for a consumer society." As a kid Paul played around on the piers, did cartwheels on the beach, and ate doughnuts in the sun. And because he lived on the seedier side of town, he recognized early that Brighton was a transient place.

"A lot of people would come to Brighton and do things they would never do in London. It's the kind of place you'd take your mistress for a dirty weekend. Brighton is certainly not the kind of place that inspires work. There's always someone wandering around on holiday," he said. Paul would see the "English gents" strolling along the piers, but he also saw the hookers at three o'clock in the morning "with bright red lipstick and short cut skirts, rubbing their crotches." On its surface Brighton was its own postcard, as advertised, but on the fringe of that picture was a carnival of souls.

Paul dropped out of school and had no prospects. He had little formal education, few skills, no contacts, and he didn't have a vision. He was, though, attracted to the wealth that he could see all around him, in the pockets of the tourists flooding his home turf.

"I wanted money. And in my neighborhood, there was the right way to make money, and there was the fast way. I found the fast way much more attractive," he said. "You have to understand the history of the place to know that the criminal element was right there, all around me, waiting for me."

Brighton is about eighty-five kilometers south of London, and its beach is famous for all-day, all-night rock festivals. Fatboy Slim played here in 2002, in what turned into a legendary party—more than 200,000 people showed up to dance. The beach got trashed.

The shore was first settled around 1000 CE, but it was the rock stars of the eighteenth century who made it famous— royalty. In 1783, England's Prince Regent visited Brighton, and he fell in love with it. Later, after he was crowned King George IV, he constructed an extravagant Royal Pavilion in the center of Brighton that functioned as a sanctuary during his reign. George was famous for womanizing, and he probably did a lot of that in Brighton. The king often retreated to Brighton's shores during his rule of the expanding empire, while his ships brought back amazing riches from the far reaches of the planet—bronze, silver, gold, and other treasures from conquered civilizations.

His presence acted as a magnet for the British aristocracy, who flocked to Brighton and constructed summer mansions. In 1841, a new railway made the trip from London to Brighton more comfortable and faster. Weekend trips from the capital were now possible. A steady flow of urban

visitors arrived, as did row upon row of manors and houses, their facades painted in bright colors—whites, creams, yellows, pale pinks, and blues—like lines of seashells leaning toward the sea. The rich moved in, and so did their service industries: dressmakers, courtiers, and antique dealers.

The dealers set up shops in a labyrinth of narrow streets just a stone's throw from the king's pavilion. That area became known as the Lanes, and as the population and reputation of Brighton grew, so did the steady stream of customers in the Lanes. The merchants there did a fast business with the aristocracy and the upper middle class, who needed to decorate their new homes.

"A long time ago these lords and ladies built these big houses on the seafront, and they furnished them with antiques and paintings," said Paul. "That's where it all started. Antiques were always big business in Brighton, and there's always going to be someone who figures out a way to exploit that."

By 1864 the Grand Hotel faced the sea, and other hotels followed. Construction began on two great piers that stretched out into the water, first the West Pier in 1866, then the Palace Pier in 1899. These elegant white structures that floated above the waves became the symbols of Brighton's cheerful disposition, as were the candy shops that sold the now famous Brighton Rock—long sugary-white sticks infused with swirls of red, blue, and green (they are delicious on a sunny day).

Between 1800 and 1900, Brighton's population swelled from 7,000 to 160,000, and after the First World War the population grew again, this time with returning soldiers and their families searching for the same qualities that a king had once craved: a quiet, clean, bright place to live near the sea. The British government supported this less affluent class of newcomers with affordable housing. The estates

of Whitehawk and Moulsecoomb—where Paul grew up—soon dotted the outskirts of the city.

A group of those returning soldiers formed the core of a new criminal element that operated in the shadow of the resort culture, providing the kind of perks some vacationers were looking for—drugs, girls, gambling: all the obvious vices to entertain a tourist for a weekend. This was Graham Greene's territory, the underworld he chronicled in *Brighton Rock*. "All of this criminal history came before me, and it was part of the foundation that formed me. That became my world," Paul said. It was the other Brighton, of housing projects and petty criminals who circled tourists and subsisted on pickpocketing and scamming.

"That was the beginning," Paul told me. "But it kept growing. During World War II gangs of scavengers and mercenaries used Brighton," making it their jumping-off point for quick trips into London during the Blitz, to raid and pillage empty houses while the population took refuge in bomb shelters. They stole furniture, antiques, food-ration coupons, and anything else that was valuable. "They'd steal the shoes off your feet if they could," said Paul. "But they always came back to Brighton, a safe haven where they were out of reach of London police and the British military."

Many of the criminals who took refuge in Brighton during the war found it comfortable, as so many other people had before them. Brighton's air and water became legendary as a healing ground for tired urban souls. Tourism remained its lifeblood, but by 2000, the population of Brighton had almost tripled from the turn of the previous century, to over 450,000.

"So there were these two worlds," said Paul. On its surface Brighton was idyllic. It was a sunny slice of real estate

in a famously rainswept country where the upper middle classes of London could retreat during the summer months for fresh air and fun in the sun, to stroll down the beautiful white piers sucking on a piece of Brighton Rock. In the other Brighton lived the merchants and families who worked the service stalls, as did the burgeoning criminal class.

"By the 1960s, Brighton attracted hundreds of thousands of tourists a year, some of them from as far away as America, who were drawn specifically to the Lanes, to tour the antiques," Paul told me. For almost two centuries these two worlds—the upper crust and the working class—existed quietly beside each other, conveniently detached. In 1964, the year Paul was born, those two spheres collided in a new way.

"This is how it happened," Paul said. In the middle of Brighton, just a few minutes from the train station, is a big shopping mall called Churchill Square. Outside the mall are about a dozen food vendors, including one that sells delicious Cornish pasties. The mall itself is pure suburbia. Before the mall, there had been a large open-air market, filled with hundreds of stalls, where locals could stroll to buy fresh produce. "That market was home to all these fruit and vegetable sellers, before my time," Paul said. "They had a singsong patois: 'I got strawberries-strawberries-strawberries-for-sale.'"

The market was loud and dirty and served a community need. It also provided vital employment for its vendors and their families. But as Brighton grew and commercialized, the city council had ambitious plans. In 1964 it voted to close the market and make way for the massive American-style shopping center—progress.

"The vendors suddenly found themselves unemployed and, according to city planners, obsolete. Those vendors

weren't about to go quietly. They'd been hawking produce to Brighton for decades," Paul told me. "Something unexpected happened. Something unforeseen. The vendors adapted. They were forced into becoming entrepreneurs overnight."

In the following weeks and months, a sound echoed all over Brighton: fists knocking on doors, up and down the rows of cheerfully painted houses. The merchants were still singing, but they were wandering through the streets, roving door to door, selling their fruit and vegetables direct. The residents of Brighton enjoyed the new service. Why not? It was a welcome convenience—free grocery delivery.

"What happened next happened quickly," said Paul, who had heard the story told many times. "The fruit sellers realized that some of those people were less interested in buying produce and more interested in selling the junk that they'd accumulated for more than a century in their homes—cracked dishes, old fridges, scrap metal, a set of old chairs, peeling silverware, and all sorts of trinkets. Stuff."

The smart merchants adjusted, and some people who had never hawked fruit or vegetables joined in. Produce wasn't needed to make a living. What was required were social skills, powers of negotiation, and an eye for "good junk." The roving merchants created a crude and more intimate predecessor to eBay. Family heirlooms changed hands quickly on doorsteps, for cash on the spot. For many people this was just another added convenience—a way to clean out their closets and cupboards and earn a little money while they did it. It wasn't even necessary to haul anything to the curb for the garbage collection. The merchants, or "knockers," as they became known, carried it away for them. Free grocery delivery, plus 1-555-GOT-JUNK service, combined.

It was a win-win situation for residents and merchants, or so those residents thought. "But you know people," laughed Paul. "If they can exploit a situation, they will. And they did."

Brighton is under the jurisdiction of the Sussex Police, whose jurisdiction stretches over a large section of the coast, including Hove, Eastbourne, and Horsham. Brighton is the largest urban center within its jurisdiction. By the end of 1965, the Sussex Police were receiving a high volume of phone calls from angry Brighton residents. Houses were being burglarized, and at far higher rates than ever recorded in Brighton's history. All the usual things were going missing—cash and jewelry—but thieves were also targeting such items as antiques, lamps, clocks, and sometimes even landscape and still-life paintings. Sussex Police did some investigating: the break-ins were an unintended consequence of the rise of the knockers.

The business model had evolved in a matter of months, from fruit to junk, but the merchants were no longer standing on the front steps of the houses they visited. Instead people were inviting them into their living rooms to inspect the wares on offer. On the surface, knocking was a service, but now the business model had another layer.

Knockers spent their days wandering through houses and buying families' refuse, and they ended their days at the Lanes or the North Lanes, selling the junk to savvy, educated antique dealers. The dealers could discern between lesser and greater varieties of junk, and they were finding some incredibly valuable merchandise. "Ah, but there was something else going on now," Paul continued. "The information was also moving to more insidious circles, from the knocker to the criminal down the block." Knocking turned into a devious game that allowed thieves to peek at

the inventory inside the houses of the upper middle class. It was a plague on the houses of Brighton, but it was a godsend for Paul.

In the 1960s, art theft was still an eccentric crime, relegated to the file of international mystery. The Sussex Police believed they were dealing with a local nuisance, and one that could be contained. Sussex's five-man art theft unit did not possess the foresight or resources to stop what was happening. The problem was not contained. The movement was still going strong when, in 1979, Paul joined the fraternity of knockers working the streets of Brighton. He spent his first few days with a family down the block—a father and two sons who showed him the tricks of the trade. Soon Paul was happy to go knocking on his own.

"You knock on a stranger's door, you get the owner of the house to let you inside, you buy stuff from them. You take that stuff to the antique dealers. You sell it for more than you bought it for. There's your profit. Simple. One man's junk was another man's treasure," Paul said. "It's a small business."

Paul was a natural when it came to knocking. He possessed exactly the skill set required: he was relaxed, fun, and chatty, and he had a wry sense of humor, making people laugh and feel at ease—a bright young kid who enjoyed meeting elderly, lonely strangers. Paul had no qualms about talking them into selling him their valuables for a discount price, and his methods became more sophisticated with practice. "It wasn't exactly illegal, but it wasn't very nice, was it."

The first "real money" Paul earned was with the boy down the block, on his first couple of days working the streets. "We got into a house and bought a few gold chains

for £20. Then we walked to a dealer in the Lanes and he bought those chains from us for £200." Minus the twenty they'd paid, that left £90 profit each. "You have to understand that in those days that was a lot of money," said Paul. "It was a cartoon kind of moment. I had these big fucking green dollar bills in my eyes."

The money was an aphrodisiac. "I was hooked," he said. "I took to it like a duck to water." The new job became addictive, and it opened up the capitalist in Paul. During that first year of knocking he found himself transformed from a hapless teenager into an ambitious young blood scouring the streets of Brighton every day for doors that would open. It was like a game show: behind every door was a prize.

"The hardest part of the job was getting through the front door," he said. "Once I'm in the front door, half my job was done." Paul soon found himself doing anything to gain access, and many of his methods were devious. Here is an example of a conversation between a knocker and victim, as told by Paul:

> **Knocker:** "Hello, dear. I wonder if you received my flyer yesterday about buying antiques?"
> **Mrs. Old Innocent Victim:** "Oh yes, I did get that. Well, I probably don't have anything you'd be interested in buying."
> **Knocker** (peering through the open door): "Well, I was just talking to Mrs. Whoever-the-Old-Lady-Down-the-Block-Is and she said you have some excellent items. For example, look at that beautiful vase behind you. Did you know that's worth two hundred pounds?"
> **Mrs. Victim:** "Oh my, I had no idea."

Knocker walks inside the house to fawn over near-worthless vase but appraises chest of drawers worth £2,000, three landscape paintings in the living room, gold candlesticks, and so on. Knocker begins to create a mental inventory: a list of all the valuable items he can spy. Then knocker pushes his luck and sees if she will bring him upstairs, where the jewels are usually kept.

**Knocker**: "This vase is absolutely gorgeous. And did you know we also pay top dollar for old bead necklaces? Do you happen to have any old bead necklaces?"
**Mrs. Victim**: "Well that's amazing because I do have some old bead necklaces. I had no idea they were valuable. They're upstairs."
**Knocker**: "Really? Just upstairs? We should go have a looky."

The knocker follows upstairs and inspects the beads that are stored in a silver box with her other jewels. He may negotiate for some of the more valuable jewelry, or not. The knocker has now been given a tour of the house. He buys something and leaves. The knocker remembers her face, the address, the street, and the inventory of the house.

"From day one my advantage was my intelligence and my youth," Paul told me. "I'd knock on a door with a fist full of cash, and people would think they were taking advantage of a kid. They thought they were exploiting my youth, and were lulled into a false sense of security by my young face. But they were the ones being shafted. I'd buy half the house, and they wouldn't even know I'd taken them. It was all about bullshitting, but let's face it, life is one big line of bullshit. It just depends on how good your line is."

Every afternoon became an adventure. "The entire allure of the game was the unknown. You never knew what you'd find the next day. It could be anything. You could find Michelangelo's finger tomorrow."

Paul figured out quickly that a day's work knocking gave him two categories of things he could sell: one, the junk he'd bought that day, which he could off-load to the dealers in the Lanes or the North Lanes; two, the information he had gathered about the houses he had been inside. "I was friends with a man, at that point, who would buy me drinks or dinner and ask me lots of questions about what I saw on the knock that day," Paul told me. "It didn't take long for me to understand what he was using my information for." Knockers provided a flow of information to the criminal down the block, who would then have a shopping list of what was inside the houses. "A knocker's primary role turned out to be reconnaissance. It was about gathering information for later use. I realized, why give away that information when I could hire thieves myself," he said. "What I learned on the knock was that he who controls the information controls the world." So family silver was bought during the day. Jewels, high-end antiques, and paintings disappeared by night.

"If you were a knocker and you were smart you moved up quickly. Moving up in the world is always about circumnavigating," Paul said. "Why would I want to wait for other people to do what I could?"

That can-do attitude served him well. In 1980, in Plymouth, when Paul tried his hand at a home burglary and failed, he realized he wasn't good at the manual labor. Where Paul was gifted was in intel—organizing talent, giving orders, making connections, negotiating: he was management. When he made that link, he gave himself his first

promotion, to middleman. Paul was just a teenager, but he took the information that he collected from his days scouring the streets of Brighton and converted it into a more efficient business model.

In his new role, Paul wasn't just a knocker and he wasn't just a thief. He was a criminal organizer and a handler of stolen art. Below him was the hired muscle, and above him were the dealers and the network of the legitimate trade. He was the bridge in a larger system forming around the art market boom that was occurring all over the globe. The Brighton knockers were becoming a means of delivering supply to that system, and Paul was figuring out the best way to deliver his product. "If thieves could help me deliver more supply, so be it."

He wanted to move up the chain and he wanted to make a larger profit, so he did what any CEO of that era would have done: he outsourced to a cheap labor force that could deliver a higher-value product while he searched for more buyers. When he could have been drinking like any other teenager, Paul would go home to study auction-house catalogs and read up on the history of art and antiques. "I was learning about the product that I was now dealing in."

Over a few conversations, I asked Paul to analyze the system for me. He said he'd never quite thought about art theft in terms of a corporate structure, but he had fun breaking it down into categories: "Victim, Knocker, Thief, Organizer, Handler, Dealer, Auction House, and End User," he told me. "It begins with the victim. The victim supplies the raw material. The art and antiques are drained from their homes," Paul said. "Victims are the people that get shafted in this system."

Paul came to understand that the purpose of a burglary was to steal the prize, and every house had prizes. "The

more practice you have at the game, the easier it is to identify those items. The more you learn, the faster you know what the prize is in that particular house." So it was just a matter of identifying which houses had the best prizes.

It was a beautiful business model, because there could never be a shortage of supply. "Art and antiques always serve a practical purpose," he said. "A grandfather clock worth $10,000 might actually tell the time. An antique vase holds flowers. A painting also serves a purpose—it may be something that has been handed down through generations and that is a part of the family history. A painting can become a part of the fabric of the family. Even if it's a beautiful object that has been placed behind a glass cabinet door, that object is still serving a purpose. It raises the quality of life for a person. It makes the world a better place for the person who gazes at it."

Paul's goal was to strip any family he could of whatever material possessions they loved and cherished. He told me that he appreciated the quality of much of the art he stole and handled but maintained that art was not something for him to covet. It was a product. "It was like being a drug dealer. You don't want to become a user. You want to get it out of your hands and onto the street to an art dealer."

Paul felt that mansions were too much of a risk. "Lords and ladies were a waste of time. They were guarded and secretive. They didn't let anyone in. They were smart," he said. He also ruled out the other end of the spectrum—the lower class living in the kind of social housing where he himself had grown up. "The goods weren't high quality or as valuable. It wasn't worth my time."

For Paul, the best targets were families from the upper middle class—the level just below the mansions. He explained, "Three generations ago these families might have

been the lords and ladies, and may have lived in a mansion once. Time had changed their financial position. Now they have a modest house and a modest life. But inside that modest house may be the remnants of that once richer life. That's what I'm going to take."

According to statistics Paul studied, one in eight people in Britain at that time was an elderly person living alone. "Just to be clear, I didn't target the elderly to be vindictive," said Paul. "It's sad, but elderly people are targeted because they are the ones who own art and antiques. If young people owned art and antiques, they would be targeted."

But the older the victim, the easier to burglarize. Elderly people were physically slow; senile, if Paul was lucky. Maybe with a case of advanced arthritis, and usually talkative. Sometimes they were complete blabbers. Many suffered from impaired hearing or weak eyesight. And they went to bed early. They owned fine art but often didn't know very much about it, or what it was worth. If Paul was out knocking and knew more than they did, he'd already won. As Paul pointed out, "It really was like taking candy from a baby."

Paul was also diligent about gathering information from unlikely sources. He visited libraries to scour electoral rolls. "I'd study the names on those lists, and it cut down a lot of legwork. On an electoral roll you could just tell by looking at those names who was old: Roberta, Vernon, Geraldine, Gwendolyn, Florence, Stanley, Winifred." And their addresses were written beside the names.

"Then I'd spend a few days knocking. Okay, door number six. Remember that door." Paul estimates that when he started there were over two thousand knockers and thieves operating from Brighton, but they were constantly moving across the countryside.

While Paul was out infiltrating future targets to burglarize, he also studied the habits of his victims. At one point he noticed that a lot of people he visited were watching snooker on television in the afternoons. So Paul started to watch snooker. "I could get inside a strange woman's house and talk to her for half an hour about snooker," he said.

Paul's outlook was optimistic because there could never be a shortage of targets. If he was smart at his job, each house he arranged to steal from gave him a healthy profit margin. Sometimes he would spend months hitting the same house, first as a knocker and then by paying thieves to steal the rest. "If there was a house that had a lot of stuff, you just kept going back until there was nothing left. I might have gone knocking to the same house six times and then had it robbed. It's nothing personal. I could have taken the most personal thing to them, but to me it could be worth $10,000. It's shameful, but that was my attitude."

One day, a few minutes after we'd said goodbye after we'd spent an hour on the phone talking about his spectacular break-and-enter career, Paul called me back. I picked up and he said, "Look, I just need you to realize, I know I've said a lot of horrible things today, about all these terrible things I've done. You need to keep in mind that I came from a rough life. I didn't have anything to fall back on. This is what I had." He paused. "Do you believe in redemption?" he asked.

Maybe talking to a stranger on the phone for an hour about all the victims he'd stolen from had struck a self-reflective nerve? I wondered if this was another line of bullshit. But he sounded sincere.

Paul didn't have a hard time finding thieves to hire. "They were down at the pub in the neighborhood where I grew

up. You just knew who was game. These were relatively simple men, with simple wants, who treated their jobs with professionalism in order to fuel a lifestyle. Stealing things was what they did to support themselves," he said.

"A professional thief will break into a house to steal an object, which he can then sell for cash value. This is what he does each week to earn his living. If you saw these men at the pub, they would appear normal to you. They might live normally all week, and then at the end of the week they'll do one high-value burglary to pay the rent," Paul explained. "They didn't care what they were stealing. It could be a stereo, jewels, a couch. They really didn't care. Most of the men I dealt with enjoyed a drug habit or wanted to live a certain type of way, and stealing is simply what they did to support that lifestyle. They don't care about art or antiques, they just want to earn a living."

A good thief required a few basic skills, and those skills were quite different from Paul's talents of charm, negotiation, and bullshitting. It was this that Paul learned that night in Plymouth, in 1980. He had the courage to break into a home, but he just wasn't fast enough, graceful enough.

"An average burglary takes twenty minutes," Paul said. "In that twenty minutes a thief is doing a lot of work and managing a series of stresses and anxieties. It's a high-pressure job. You must have courage to do what they do, to enter a house illegally that may or may not be empty. Courage in a man, by the way, can be enhanced by certain drugs, and some of the thieves I dealt with used heroin or cocaine to artificially gain the courage they needed to do their work," he said. "I didn't mind if a thief took heroin, because heroin is an opiate. Cocaine is different, though. I didn't like thieves on coke. They could just freak out."

The time frame for a burglary is so short that a thief must have the ability to remain calm. "You're not in there for very long, so you have to keep your wits about you and stay focused," Paul said. The focus was essential because in the dark, with the adrenaline turned up and the senses buzzing, it was easy to lose track of why you were there.

"Always keep your eye on the prize," said Paul. This was his new corporate mantra. "The prize is the whole point of the job. It doesn't matter how much courage you have or how calm you are. If you don't come out of that house with the prize, it's a waste of everyone's time." The prize could be a number of different material items: porcelain miniatures, Royal Doulton pieces, gold, silver, clocks. Larger pieces of furniture could be worth a lot as well: chests of drawers, grandfather clocks, lamps. There were also, of course, paintings.

One of Paul's new challenges was making sure that the thieves he hired came out with the prize he wanted. It was a quick lesson in communications. "I couldn't tell a thief to go inside and take the nineteenth-century still-life painting, because they wouldn't know what I was talking about," he said. So instead of describing paintings or antiques formally, he found simple ways to order the items on his shopping lists. "For example: Okay, Mr. Thief, there's a clock on the living-room table, and on the wall there are two pictures. There's one picture of a man, and another picture with apples and oranges in it. I want you to take the clock, and I want you to take the picture with the apples and oranges."

Thieves were definitely not what Hollywood portrayed them to be. They were not dashing or rich, nor especially smart or cunning. They weren't political or strategic. "These were lads out to have a good time. They didn't care who painted what, and they didn't give a fuck about the difference

between Impressionism and Abstract Expressionism. Picasso who? They were oblivious to art history. Believe me, the thieves of Brighton had never tread the floors of an auction house. This wasn't *The Thomas Crown Affair*. This was the opposite," Paul said. "This was the bottom of the barrel."

The game, as Paul described it, was fast and dirty. It was about getting into the house, creeping through the dark, locating the material, staying quiet, getting out of the house again with the prize, into the cool dark air with the heart pumping. Getting into the car or the van and disappearing into the night without anyone ever having known you were there in the first place.

After adding hired help to the equation, Paul reaped larger profits. "I'd hire guys to go in at night. I'd sit down the road in a van and wait for them to rob a house and deliver the stuff. Let's say I paid them a thousand pounds for the job. Well, then I could turn around and sell what they'd delivered to me for three thousand pounds."

After a job was finished, Paul didn't spend time with his workforce. He treated them like business associates and kept them at arm's length. "I wasn't down at the pub having a drink with them. A good organizer has no relationship with thieves. You do the job and go your separate ways," he said.

Paul told me about all kinds of talent he recruited. "Some of the men I worked with were incredible. There were specialists who could scale drainpipes, who could basically transform into the human fly. There were thieves so talented and graceful that they could sneak into a bedroom with a sleeping couple and take a watch off the husband's wrist; we called these guys 'creepers.' There were guys with blowtorches who could melt the lead around the windows of the old country houses and then simply remove the glass. It didn't really matter how they did it. As long as no one

got hurt and the prize came out of the house, the business model worked and I made my money."

Paul liked thieves because they were exactly what they said they were. "Thieves might not be the sharpest tools in the shed, but they get the job done and that's all that matters. The burglar doesn't pretend to be anything else. As I learned in the art world, this was refreshing."

Demand was the other side of the organizer's job, and without the antique dealers in Brighton's Lanes and North Lanes, the business model Paul was pursuing would have dried up fast. "That was where you could bring your loot and get rid of it," Paul said. Stealing art and antiques was the easy part of the game; selling them required a network, and Paul had grown up with the network all around him.

While knockers were busy off-loading their junk to dealers for small profits, Paul became more and more interested in higher-quality items. And, it turned out, so were the dealers in Brighton. "Ask a gallery owner or a dealer how much they paid for something. They won't tell you. If you're savvy and you can find out the price they paid, then you ask them the real question, which is how much money do they want to earn on it."

Paul remembered seeing, as a young boy, lines of cars and vans with furniture tied to their rooftops, waiting to sell their wares to the cabal of dealers at the North Lanes. According to him, they were low-level players, middlemen themselves, and crucial when it came to buying stolen art and moving that art back up into the legitimate system. Just as important, these dealers carried it out beyond Brighton's circle of police.

"A lot of the dealers didn't care whether what I was selling them was stolen or not. They would turn a blind eye.

Nobody asks questions in the art world. It's all about what you're bringing to them. Because for these dealers, what we were bringing them was incredible. We're talking about antiques and art that hadn't seen the light of day for decades, sometimes centuries.

"Price always tells you whether something has been stolen. If it came from a heavy-duty robbery, the price is low. Price denotes legitimacy." So, for example, when Paul brought a clock to a dealer, if he was selling it for a fraction of its price, the dealer would immediately understand that it was stolen. "But it doesn't matter. This is a good deal. They always bought it. The dealers I dealt with didn't care if it was pried from the dead hand of a grandmother."

Paul was also expanding his network of dealers, out of necessity. "I'd call recognizable stuff 'sticky-out stuff,' because it sticks out like a sore thumb. Paintings normally fall into this category. I would save a few things for foreign buyers. At the same time I was buying other recognizable stuff from other organizers and thieves, who knew I could handle it. I'd buy it for cheap. Recognizable material is always sold for a fraction of its worth. So, a stolen painting that might be worth $100,000 could be bought for $10,000. Ten percent. Or if I bought it from a thief, it would be even less. I'd pay $3,000 or $4,000, maybe 3 or 4 percent of its value. It's a hooky price.

"Foreign buyers I sold to always knew if something had been stolen. I could tell them. Or, if I bent my finger a certain way, that was the sign. Crooked. A crooked finger. Get it?

"More and more foreign buyers started calling on me. It would work like this. Brighton was famous for its antiques, and so a foreign buyer might visit Brighton and hire a driver for the day. He might meet me on the street near the Lanes. I might have a van full of stuff. At the time, Volvo station wagons were a favorite. And foreign buyers loved us,

because the knocker boys were discovering stuff that really hadn't been on the market before." Foreign buyers helped spread stolen goods around the world. They were a great laundry machine. The groups Paul dealt with were mostly Americans, Dutch, and Germans, sometimes Italians, and the odd Portuguese buyer. "They were a line to the collectors of the world," said Paul.

"Most collectors from the middle to high range don't actually go and collect themselves. They are not in the know. They have dealers that scout for them, and so the dealers who came over and bought goods could take them back to their own country and sell them for a huge profit. Once a work of art crosses an ocean it doesn't matter if it's stolen. It's cleansed. You could have a dealer come to Brighton or London and buy a painting for $10,000. Then he might bring it back and sell it to a specialist in nineteenth-century paintings for $20,000, who then has access to a small group of collectors who value that type of painting and who are willing to pay substantially more for it," Paul said.

"Back then, you didn't have the Internet. Crossing international lines really meant self-laundering stolen work. Foreign dealers have been working this way for 150 years. How do you think a lot of those antiques got to America? The whole point of moving stolen art is to get it to an end user—a rich person who will hang it up on their wall for years, maybe decades, maybe until they die. Then their children inherit the stolen painting. Then the trouble starts."

Paintings were different, though. "Paintings were a niche market. They were something I had to learn more about, because if you're ever going to buy or steal a million-dollar work of art, it's going to be a painting," he said.

"With almost every other piece of art or antique it would be obvious what it was worth," Paul explained. "On

paintings you could make an amazing profit if the seller didn't understand what they were in possession of. If someone had a painting in the family for two hundred years, they might not realize that it was special or valuable," Paul said. "A diamond ring is obvious. A little ten-inch by six-inch landscape could be worth millions and not necessarily look like it at all."

Paul realized there were limitations to working in Brighton, and while he was selling to dealers, he was also studying their system. When he sold a piece to a dealer in Brighton, that piece might not stay with that dealer. Instead, it could be passed along the chain very quickly to other dealers in the vicinity, or it might travel to the other hub, London. "Pass the hot potato, right?" he said. Dealers, he figured out, were just another bridge to a vast network that had its own socioeconomic structure. Paul's success had always relied on circumnavigating, and soon he saw a chance to do that again.

By 1981 Paul had saved up £10,000 from knocking, hiring thieves to steal on his behalf, and using the network of dealers in Brighton to launder his product. "I became very good at a bad thing," Paul said. "Actually, I became ruthless. Margaret Thatcher had swept to power in Britain in 1979, her Conservative Party preaching an aggressive brand of capitalism. These were the eighties. It was a decade of excess, and I was a pure, cutthroat capitalist. We were a vacuous society. And we all regarded ourselves as Thatcher's stormtroopers. If I'd grown up in a poor Cockney family in East London and made my way up the ladder, I would have been one of those aggressive stock traders who would do anything I could to earn a dollar. As it happened, I grew up in Brighton, and I became a handler of stolen art. It's all about geography and politics. That was what Brighton had

to offer me. I wanted to earn my daily bread. And if I had to do it dishonestly, well, I did."

Paul wanted to keep expanding his business, so he set his eyes on London, the economic center of his new trade. "It was that dark road," he told me. "I just followed that road, and it led me to London." But as he knew by then, there were other criminals operating in the art world who weren't willing to network or to use volume to earn a decent profit. Instead, some thieves were looking for big, easy scores. They walked into museums and art galleries and ripped paintings right off the wall. "Headache Art," as Paul had coined it.

He read about cases like these in the newspapers. "These kinds of guys can be real morons," Paul said. "They don't follow that golden rule: Stay under the radar." Paul drove to London looking for a larger network and bigger profits, not quite sure what to expect.

# 7. _ _ _ _ _

## HEADACHE ART

"Those were some of the most
difficult days of my life."
**GILES WATERFIELD**

G iles Waterfield, director of the Dulwich Picture Gallery in London, was supposed to be relaxing. He woke up in Scotland on his first holiday that year, excited about attending the Edinburgh International Festival—music, poetry, literature. He hadn't even left a telephone number where he could be contacted by staff.

Waterfield was out of bed by 9:00 AM and strolled from the art dealer's apartment where he was staying to nearby Waverley train station, where he bought a copy of *The Times*. He scanned the front page of the most venerated newspaper in England. The date was August 15, 1981. "It was right there in bold letters: 'Rembrandt Stolen for Third Time,'" remembered Waterfield.

Waterfield and I met because my younger sister was studying art history at the Courtauld Institute of Art in London. Waterfield was her professor and thesis adviser,

and she mentioned to him that I was in the middle of writing a book about international art theft. "I didn't realize that Giles was the director of Dulwich when it had a Rembrandt stolen," she told me. "And apparently it was the third or fourth time that painting was stolen. If you want to talk to him, he said he'd be willing to tell you about his experience. I think it was a ransom case," she said.

"It is a director's worst nightmare to have a famous painting stolen from their gallery," Waterfield told me when we sat down at a pub around the corner from his apartment on a damp London afternoon. Waterfield is in his midfifties, trim, with a tuft of gray hair and very calm, considered blue eyes.

Reading the article on the front page was slightly humiliating, he recounted: a high-profile theft, and of a painting that had previously been stolen—twice. Dulwich Gallery came off as irresponsible, and now one of the stars of its collection was gone for the third time. Waterfield clicked through the two earlier thefts, although both had taken place before he was the director.

"The first took place on New Year's Eve 1966, I believe. Ten paintings, including the Rembrandt, were stolen." A major bank robbery had also taken place in London around the same time. The stolen works were later recovered at Streatham Common, in a bag under a bush. "Much speculation was given to the idea that the bank robbers had stolen the paintings as an insurance policy and traded them with the police for a favor." That was the rumor, but it was never proven. "Everyone was just happy the art came back."

The second time the Rembrandt was stolen was less sinister but more bizarre. "It was an eccentric theft," noted Waterfield. The portrait disappeared in the middle of the day, during business hours. When staff members saw

the blank space on the wall, they got into a car and drove around the neighborhood, searching for a suspect. A few streets away they saw a man with a large beard riding a bicycle up a hill. There was a package in the bicycle's basket, about the size of the stolen painting. A staff member pulled up the car beside the bicycle and asked, "Excuse me. What do you have in your bicycle basket?"

The man admitted it was, in fact, Rembrandt's portrait of Jacob de Gheyn III. He didn't try to outrun them on his bike. Instead he complained that the gallery was always closed at the most inconvenient times. He planned to copy it and then return it to the gallery. He didn't understand what all the fuss was about. The police didn't press charges.

Now the painting was gone again, and Waterfield's vacation was over. He was on the next train back to London.

Dulwich Picture Gallery sits back from the road on a lawn dotted with trees. Opened in 1817, it is widely considered to have been the first public art gallery in Britain. In 1981 Dulwich had recently reopened after a renovation, and it was Waterfield's mission to garner the gallery more attention. That wasn't a problem anymore. "The media were all over us. And so were the police." He remembered looking at the empty spot on the wall. "There was a sense of real violation," he told me.

Dulwich held a major old-master collection of seventeenth- and eighteenth-century paintings, and one of the main draws was the Rembrandt room, which held several paintings by the revered Dutch artist, including the now missing portrait. Staff knew it as Gallery Eleven. Waterfield had last seen the painting three days earlier. He knew it well: he'd spent hours looking at Jacob's face. Rembrandt Harmenszoon van Rijn had painted the portrait of Jacob de

Gheyn on wood early in his career. Born on July 15, 1606, the artist was the son of a miller and a baker, one of nine children. He had success as a portraitist at a young age, but died poor, outliving his wife and son. After his death, he became one of the most treasured painters in history, and one of the most popular among art criminals—close to two hundred Rembrandts are listed as stolen.

The portrait at Dulwich was a well-known easy target. The frame hung on just two hooks, for a reason: "The hanging system was designed for easy removal so that even an idiot could move it if there was a fire," explained Waterfield. When I strolled into Gallery Eleven, the portrait was the first in sight, facing me. It hung at chest level and was small compared to most of the works in the room. So small, in fact, that it was easy to understand the inclination to grab it off the wall and run. Jacob stares out darkly from the glistening canvas, almost daring you, "Take me."

"There was one piece of good news," Waterfield told me. "Two of the thieves had been caught on camera." But as the days passed Waterfield lost hope. The media decamped. So did the police. Dulwich went from circus to graveyard. For eleven days nothing happened. Every once in a while Waterfield would get a phone call from a friend wanting to commiserate. He got used to these calls. On the morning of Tuesday, August 25, Waterfield was sitting at his desk in the gallery when the phone rang. He assumed it was another pity call.

"Is this the managing director of the gallery?" The voice was male, with a foreign accent.

"Yes, I'm the director," Waterfield answered.

The voice said, "I am a German businessman and I act as a broker. I deal in pictures, sometimes for private

clients in America interested in very high-quality works."
He told Waterfield that a person was offering to sell him a
Rembrandt painting for one million pounds.

"It is a portrait of Jacob de Gheyn," said the voice. "I
have looked it up in a catalog of Rembrandt paintings, and I
see it belongs to you."

Waterfield stayed calm, his voice steady. "It has been
stolen from us," he said.

"Oh. I have not seen any newspaper report of the theft,"
said the voice. "I would like to help you but I need to dis-
cuss it with you further." Then he asked, "Can you fly to
Amsterdam tomorrow to talk about it?"

The question floated in Waterfield's mind for a moment.

"Yes, I think so," he answered. Of course he could.
It was his Rembrandt. He'd do whatever the man on the
phone commanded.

"Is the picture insured?" the voice asked.

"No, because the premiums are too expensive for the
gallery, but there is a reward."

"How much?"

"Five thousand pounds."

"Not much for a Rembrandt," the voice laughed.

"Ours is a poor gallery," said Waterfield.

The voice laughed again.

"May I tell the police?" Waterfield asked.

"I would prefer not at this moment," the voice an-
swered. "There is a need for haste, as there is an interested
American buyer coming to Europe on the weekend."

Waterfield agreed to fly the next day. The voice said
he would call back in one hour with further instructions.
Waterfield hung up the phone and ran all the way to the
bursar's office at Dulwich College, which at that time was
responsible for the gallery. The two men decided to ignore

the warning and call the police, who agreed to send an officer to the gallery.

Meanwhile, the voice called back at 11:15 as promised.

Waterfield had already arranged his flight to Holland. He would arrive at the airport at noon, and the voice instructed him to take the airport bus to the Schiphol Hilton hotel. The bus was free, he added, consolingly.

"Could you tell me your name?" Waterfield politely inquired.

"Müller," said the voice. It was a common German name.

Müller provided further instructions. Waterfield should go to the reception desk at the Hilton and ask for Mr. Müller. Agreed. Waterfield hung up.

The police arrived at the gallery too late for that conversation, but now they attached a tape recorder to his phone. This was 1981, and the tape recorder was big, Waterfield remembered. "It was a low-tech offering. Not much of a secret weapon, but it would do."

Then the police left him alone. An hour passed, and Waterfield suddenly remembered that his passport had expired the week before. "There was a passport strike in progress!" He made a few phone calls. There was something called a Visitor's Passport that he could pick up at the post office. He rushed around London to get some passport photos, then to the post office. Success. When he returned to the gallery, he found a message from a Detective Chief Inspector Evans, who was requesting a meeting. He went to see the detective.

DCI Evans had white hair and a relaxed smile. He coached Waterfield on what to say to Müller. "This whole thing could be a hoax," the detective warned, and in his opinion it probably was. In case it wasn't, though, the DCI and another police officer would make the trip to

Amsterdam as well. Waterfield was relieved. "This James Bond stuff wasn't my thing," he said.

In Holland, the Dutch police would be the active officers; the Brits weren't going to be allowed even to observe the meeting. The night before the trip, DCI Evans gave Waterfield this advice: "Get a good night's sleep." That was not possible.

The next morning Waterfield flew to Amsterdam. In the arrivals lounge he caught sight of another British detective he had met, a Detective Inspector Sibley, but he pretended not to recognize him in case Müller was watching. Waterfield skipped the free bus ride and hailed a taxi. The taxi driver scolded him for not taking the free bus.

The Hilton lobby was anonymous, comfortable, and not large. At reception Waterfield asked for Mr. Müller. The receptionist paged the German, but there was no sign of anyone. Maybe it was all a hoax? Waterfield started to relax. He walked a few paces away. Then a stranger appeared beside him. "Mr. Waterfield?"

He recognized the voice.

Müller was about six feet tall, receding hairline, overweight, rings of sleeplessness under his brown eyes. His style was garish, his jacket and tie brightly colored. "Orange is what I remember most," said Waterfield. The stranger steered the gallery director toward the hotel lounge. It was crowded, but oddly, nobody sat near them.

Müller told Waterfield that he had a wife and children and that his wife was worried. It was a nice touch, a personal detail that put Waterfield at ease. Maybe this man was just trying to be honest and helpful. Maybe he was just trying to get Waterfield's painting back. Müller said exactly that: he was an honest businessman who wanted to help the gallery director, and he was prepared to cooperate with the police, but not at this point.

Müller said he felt he deserved 10 percent of the painting's value as a finder's fee. That is the percentage Paul had told me dealers received as a hooky price for high-profile stolen items. Like Paul, Müller was a middleman, but he had decided to play a much higher-stakes game than Paul ever would. As Paul pointed out, "You don't want to do anything that will attract the attention of law enforcement, or the media." The Rembrandt theft had already done both.

"I'm not used to dealing with stolen property," Müller told Waterfield. Müller said that he had been contacted by an intermediary but that even the intermediary did not have the picture. Someone else did—someone he didn't know.

"I've now seen reports in German and Dutch newspapers suggesting that the value of the painting is one million pounds. One hundred thousand pounds seems like a suitable sum," Müller said.

"Is that your price?" Waterfield snapped a little too quickly. The director was repelled.

"Yes," Müller answered. "We must hurry as the American buyer coming this weekend is prepared to pay one million dollars. This should be sorted out by the weekend. I would prefer you to have the painting because of my concern for the gallery."

Waterfield probed, just as DCI Evans had instructed him: "I need proof that the picture is available before I can persuade my chairman and bursar to pay out. I am willing to believe you, but it is not in my hands. I cannot make out large checks. I need to know what is on the back of the picture, and I also need a photograph."

Müller was irritated. "I do not see the necessity, but I will make a telephone call." Müller mentioned that he was thirsty. Waterfield felt obliged to buy him a drink. Müller

ordered a tonic, Waterfield an orange juice—nonalcoholic choices. Both men wanted to stay sharp.

Waterfield watched the German businessman leave the lounge to make his phone call. He came back ten minutes later and said, "I can tell you what is on the back of the picture this evening. I don't think it's essential for you to have photographs."

Waterfield replied, "I think I will need them to persuade my chairman and bursar."

Müller said, "I will telephone you this evening with a description of what is on the back of the picture."

The two strangers sipped their little drinks across from each other. Waterfield probed again, this time for personal details. Müller said he had graduated from Harvard Business School, had gone on to Cambridge to study English literature, and spoke five languages. He had been an investment analyst. One of his partners had been involved in criminal activities of a vague nature, and Müller had lost a lot of money. It was because he'd lost so much money that Müller wanted the 10 percent.

It became obvious to Waterfield that Müller wanted him to leave the Hilton first. Müller suggested that he catch the next plane to London, but Waterfield had other plans: he was scheduled to meet with police. He told Müller he wanted to see the treasures of the Rijksmuseum. So when he left Müller, that's exactly where he went.

At the museum Waterfield didn't quite know how to act. He suspected he was being followed, so he started to walk quickly up and down flights of stairs, looking over his shoulder. He'd turn corners sharply, retrace his steps. He'd walk into a washroom and then leave immediately. Nothing. At the cafeteria he tried to choke down a sandwich, but his appetite had vanished. Finally he used the

phone number he'd been given for Detective Constable Bosworth Davies, another British detective who had followed him to Holland.

The DC was boiling with impatience. "What happened!"

Waterfield refused to get into details on the phone. DC Bosworth Davies gave him the number for the Dutch police contacts. Waterfield called them from the same phone and arranged to meet them at another hotel, the Prinsengracht. Evans and Sibley would be there as well.

It was a sunny afternoon, which felt odd to Waterfield. He couldn't enjoy the weather. He strolled along a gorgeous canal to the hotel, where a stranger lounging outside shot Waterfield an almost imperceptible smile then disappeared. Evans and Sibley were waiting upstairs in a room. Waterfield told them what he'd discussed with Müller. The detectives said he should go back to London and wait it out. He took a flight back. At eleven o'clock that night the phone rang and he turned on the tape recorder. It was Müller.

"Yes, good evening, Mr. Waterfield."

"Oh hello, is that Mr. Müller?"

"Yes."

"Yes, hello."

"How are you?"

"Fine, thank you."

Müller said, "Well, I have here a few things which were on the back. There were some things they couldn't read because it was very, very small. They needed a special glass for it but they didn't have it with them but they could read, um, it's as follows: XTR . . ."

"Yes."

"TMUM . . ."

"Yes."

"and M . . . U . . . N . . . US . . ."

"Right."

"then M . . . O . . . I . . ."

"Yes."

"I . . .S. And then a separate R. And then the museum, Amsterdam 1952. And that's on the backside."

"Fine," Waterfield said.

"Is that correct or . . . ?"

It was correct.

The director insisted on photographic proof of the painting. Müller wasn't happy but agreed to try. He'd have to phone back. Click.

Waterfield tried to get some sleep. Life had become absurd. The next morning he carried the tape recorder to work under his arm. He tried to conceal it but it was big. He couldn't concentrate. He sat around feeling nervous. His phone would ring. He'd turn on the recorder and answer. A friend: "Giles, how are you?" Turn it off. He'd lie. "Great, great. Never better." Hang up. Wait. Phone would ring. Tape recorder again. An artist. Turn off the recorder. At noon Müller called. Tape recorder running.

Müller said the photographs should be ready by evening. Waterfield should go home after work and wait at his flat for a phone call with further instructions on where to pick up the photos. Müller warned Waterfield not to talk to the police and added that when Waterfield went to get the photographs he should park his car at a distance from the pickup location. He warned, "Be careful."

He called back a few minutes later, wanting to make sure Waterfield wasn't on the phone with the police. The police, in fact, were at Dulwich Gallery. Waterfield walked back to his flat. The sky darkened, and so did his mood. DCI Evans kept phoning to find out if a meeting place had

been arranged. No news. Waterfield waited. His mood sank deeper. Then at 8:00 PM the phone rang. Tape recorder on. It was the dreaded voice.

Müller had decided to tell Waterfield a few details about the theft. He said it was an inside job. One of Waterfield's staff was an accomplice. For Waterfield, who trusted his staff, this was horrible news.

Then the voice told him to go to the Playboy Club. "Take somebody with you," instructed the voice, "for your own health." The London Playboy Club had opened in 1965, after gambling had been legalized. Girls in bunny suits fawned over men as they stared at legs and lost their money. In 1981, the Playboy Club branch Waterfield was told to visit was the most profitable casino in the world.

When he arrived at the club, these were the instructions: He should ask for the doorman. The doorman would possess an envelope from a man called Leo. Waterfield should collect the envelope and leave immediately. The proof Waterfield was looking for, the photographs of the stolen Rembrandt, would be inside. It was a simple plan. Waterfield hung up. Was somebody from the gallery involved? And he'd been warned about his safety.

Waterfield went directly to meet with DCI Evans. Evans was in a bright mood and greeted Waterfield warmly. "Well, Mr. Waterfield? I can't call you that all the time. What's your first name?"

"Giles."

"Well, Giles, enjoying it, are you?"

"No, I am not."

They went to the Playboy Club. DC Bosworth Davies rode along. Bosworth Davies had been a rugby player at Cambridge, and his pure physical strength reassured the gallery director. Waterfield parked illegally near the club.

"For the first time in my life I wasn't worried about getting a parking ticket," he told me.

As Bosworth Davies and Waterfield left the car, a stranger walked past and nodded. "Hi Boz," said the undercover officer.

Waterfield entered the Playboy Club. He felt as if he were on stage but didn't know where the audience was or who they were. He asked for the doorman by the name he'd been given.

"Oh, he's away on holiday," a staff member at the club finally told him. Then the Playboy Club employee pointed to the door. "But try out there." Waterfield left the club. A small group was gathered near the door.

"Envelope from Leo?" Waterfield asked them.

A man looked at him for a moment, then handed Waterfield an envelope. Waterfield took it and walked briskly back to the car. The officers wouldn't let him open the envelope until they arrived safely at Waterfield's apartment, which was now feeling a little crowded: nine policemen were camped in his living room. Eight of them were drinking beer. The inspector liked whiskey. Waterfield was nursing club soda.

Bosworth Davies delicately eased the mouth of the envelope open, reached inside, and pulled out nine Polaroid pictures. Waterfield couldn't believe it. Each Polaroid featured the Rembrandt in a different and unglamorous pose. In one, the canvas was propped up behind a rusted sink. In another it leaned on a graffiti-stained wall at the top of a squalid set of stairs. The pictures were somehow pornographic. It was kind of a fuck-you gesture: instead of photographing the painting on a lovely velvet carpet, they'd put it in a dirty washroom.

There was no doubt, though: Müller's men possessed the masterpiece.

Waterfield's phone rang several times over the next half hour. Each time Waterfield reached for the phone, the inspector warned his men that if they so much as moved while Waterfield was on the line he'd kill them. They all clutched their drinks in silence.

The callers always seemed to be friends of the director, checking in. "I am lucky to have had such great friends. Of course I couldn't tell them anything." He felt awkward talking to his friends while nine strange men listened. "Things are fine," he said. "I'm fine."

Shortly past eleven, Müller phoned. He was angry. Why did Waterfield go to the Playboy Club himself? he wanted to know. He'd been instructed not to "go by himself." That, it turned out, had been a code, meaning "don't go in person."

Waterfield explained that he hadn't understood but that he was satisfied with the photographs. Müller was impatient. The men who had the painting in their possession were getting fed up with the whole thing. They were threatening to set the Rembrandt on fire. They would burn it up. He hung up. Another sleepless night.

Waterfield spent the next day at the gallery, but he was now under the full-time supervision of DC Bosworth Davies. "I'm sure it was partly to keep up my morale," he told me. Nothing happened. Waterfield went home with his clunky tape recorder and waited by the phone. The phone was his life. It was very claustrophobic. He lived a one-minute walk from the gallery.

At eleven o'clock the phone rang. Waterfield stalled for time. He told Müller that the chairman of the Dulwich Picture Gallery was in Finland but would be returning to England shortly; until then nothing could be done about the money. The good news, he told Müller, was that the chairman was onside to pay.

Müller asked if Waterfield could travel to Amsterdam the next day.

Waterfield made excuses, and Müller was sympathetic. They agreed that Monday might be possible. The idea of Müller coming to London was raised. Müller weighed the risks; Waterfield knew they were high. The police wanted to arrest Müller now. The director played it cool. "Don't be too eager," the police had advised.

Waterfield and Müller wished each other a good weekend, both sounding friendly and warm. Then Müller called back. He'd decided to risk the visit to England, and Waterfield should arrange the ticket. He would arrive at Heathrow Airport on September 1 at 9:00 AM.

Waterfield drove to the airport to pick him up. In the car with him was David Banwell, the bursar. They sat in Terminal 1 and waited. Müller didn't show.

Waterfield phoned the gallery: Müller had called and left a number. It turned out to be for the Schiphol Hilton, in Amsterdam. Müller picked up. He was angry again. When he'd arrived at the Amsterdam airport, the ticket hadn't been paid for, and it was only a one-way reservation. Waterfield agreed to pay for the full round-trip ticket. It was late morning.

Müller's flight arrived at Heathrow Airport at 1:00 PM, and the three men—Waterfield, Banwell, and Müller—drove from the airport in Banwell's car straight to Barclays Bank in Dulwich Village. They sat down with the bank manager, who had been briefed in advance by the police. The manager was fascinated by the case and had received permission from his superiors to play along. The bushes outside the bank acted as cover for several police officers keeping an eye on the meeting.

Point one: Müller wanted a guarantee that there was £100,000 in the Dulwich bank account. The manager

confirmed that there was. Actually, the foundation's account held millions.

Point two: Müller wanted to know how the money could be made available to him—banker's draft or cash. If it was a draft, could the draft be rendered void at any point if criminal activity was suspected? They discussed the matter. Müller decided on cash.

Müller threatened that if anything went wrong, he knew where to find Waterfield and Banwell. The meeting wrapped up at 3:45 with no agreement. Müller flew back to Amsterdam.

That night he called Waterfield again. He wanted to fly back to London. Waterfield reserved and paid for another ticket. The flight arrived in London at ten the next morning, and the three men met in the airport lounge.

Müller had a new plan. Waterfield was to meet with a new player, an intermediary posing as an art adviser to an American client who wanted to buy the painting for $1.2 million. The extra $200,000 would go to Müller. "It was getting crazy," said Waterfield.

At the airport, Müller was nervous. He had to find a phone and get in touch with his contact. It had to be a pay phone, but one that wouldn't show up as a London number. Müller didn't want his contact knowing he was in London. There was a specific type of pay phone that didn't show the number, he explained. They could find no such phone in Heathrow. They tried the Posthouse hotel but couldn't find one there either. They hung around the Posthouse for fifteen minutes, and suddenly Waterfield felt like he was surrounded by undercover police officers. He wasn't wrong.

A few days earlier, in Amsterdam, Müller had been observed by the Dutch police at the Schiphol Hilton with a man who turned out to be a German criminal with a conviction

for physical assault. Müller and the German had a conversation and then split up. Police followed the German. He flew to London, and went to an apartment in the Cornwall Gardens neighborhood, where he stayed for the next three days. That building was watched round the clock by police.

This is what they observed: The German and another man emerged from Cornwall Gardens and went to a leather goods shop. A police officer followed them and lingered in the shop. The men wanted to buy a briefcase, but the shop didn't have one the right size. The men visited a second leather shop, found a suitable briefcase, and returned to the apartment. They emerged again with their new briefcase and hailed a taxi.

Their destination was Brown's Hotel, which had two entrances, one on Albemarle Street and one on Dover Street. It was a smart location for a quick getaway. The men had booked a room at Brown's for their meeting with Waterfield and Müller. Waterfield was supposed to hand over £100,000 in cash, as a down payment. Waterfield had indeed asked for £100,000 in notes, but the police had said, "We just don't have £100,000 lying around." Instead they packed a bunch of £5 notes on top of some old newspapers.

On that morning, the taxi from Cornwall Gardens was trailed by five police cars. When it arrived at Berkeley Square, in front of Brown's Hotel, the police surrounded the taxi and asked the men inside, "What do you have in your briefcase?" The briefcase was opened, and there he was: Jacob. That team phoned a second team of police who were trailing Waterfield and Müller, watching the pair as they looked for pay phones at the Posthouse hotel. A dozen police officers surrounded Waterfield and Müller, and placed Müller under arrest. Waterfield sat down in the hotel lobby. What had happened? Was it over?

Waterfield was driven to Dulwich police station. He was led into a room to look at a painting. It wasn't in its frame, but it was the Rembrandt. It appeared to be undamaged. The last time he'd seen it was in a Polaroid, propped up against a rusty sink, in what was now revealed to be the apartment at Cornwall Gardens.

Waterfield sat there with the artwork, in the police station, for three hours.

"I felt thrilled. It was like a parent getting back a long-lost child," he said.

After Waterfield finished telling me his story, I asked him if he could list the resources the police had dedicated to his case—Paul and I had often discussed the gap between resources for little cases and those for "headache art." Paul's point, repeated over and over, was that as a thief you don't want to draw that kind of attention to your criminal activities. Any contact with police was a negative. "Once you attract the attention of law enforcement, an enormous amount of resources can be brought to bear on you. It's exactly what you don't want," Paul said. "It also draws the ire of other criminal organizations, because police start beating down doors, asking questions, disrupting business as usual."

Waterfield thought it over for a moment. "The resources the police dedicated to finding this painting were incredible." Here is a partial list: one tape recorder, the Flying Squad (armed police officers) watching Cornwall Gardens, DCI Evans, DI Sibley, DC Bosworth Davies, the London officers camped out at Waterfield's home while he negotiated with Müller, and the Dutch police following Müller's movements in Amsterdam twenty-four hours a day. "I was told later that during that first meeting at the hotel in Amsterdam, almost every person in the lobby was a police officer—the person at the front desk, the bartender, the people sitting in the

lounge." Waterfield was also told that on the first day, they were followed by two motorbikes and a car.

"Those were some of the most difficult days of my life," Waterfield told me. "It really was a headache."

And it wasn't the last time that painting was stolen. Two years later a man entered the gallery at night, breaking through a skylight, and pried the Rembrandt off the wall with a crowbar. The painting disappeared for three years. In 1986 it was recovered by police at a train-station lost-property office. "That's a story for another time," laughed Waterfield.

Rembrandt's *Jacob de Gheyn* is small, just 29.9 by 24.9 centimeters. "It's easy to run away with and was worth over $20 million that year," Waterfield said. Today the painting's estimated value is $80 million, and rising. "People love to steal it," said Waterfield. It's been stolen four times, making it, by most accounts, the most stolen painting in history. Currently on display at Dulwich Picture Gallery, it is the ultimate piece of headache art.

"Yes. I've seen that painting," Paul told me. "It's called the Takeaway Rembrandt. A lot of art went missing from a lot of galleries in the eighties, and most of it wasn't taken off a wall. It came out of storage facilities and archives, quietly." Paul said there was one detective in London, in particular, who made his reputation dealing with headache art cases.

_ _ _ _ _ **8.**

# SCOTLAND YARD

"Let's say I'm a drug dealer, and you owe
me money. Well, you can steal a painting.
You then give me that painting as a down
payment on the loan."
**RICHARD ELLIS**

Richard Ellis, the man who started Scotland Yard's Art
and Antiques Squad—the second time—agreed to
meet me at a wine bar called Hardy's one afternoon
in 2008. When I arrived, Ellis was sitting at a corner table,
the only person in the bar. He had a shaved head, strong,
wide shoulders, and quiet, alert eyes. Alone, in the back
of the bar, there was a little of the Godfather about him.
His phone number ended in 007, and when he answered his
line, he didn't say hello or good morning; he simply said,
"Double-O-Seven."

As a detective, Ellis had been involved in a number of
high-profile cases, including reclaiming a Vermeer from a
criminal organizer in a chase that lasted seven years and
spanned half a dozen countries. That case was chronicled
thoroughly in *The Irish Game: A True Story of Crime and
Art*, by Matthew Hart. Long before that hunt, though,

Ellis's first experience with the art theft industry had parallels to the shady work that Paul was doing in Brighton, and it had a personal connection. "This story begins at home," he told me.

Ellis joined London's Metropolitan Police in 1970. Instead of sleeping at the police barracks after a night shift, he often sought refuge at his parents' house. "The barracks were loud and chaotic," he said. "My family house was set back from the road and stood alone on a large property. It was quiet at night. A good place to rest."

One morning, about a year and a half after Ellis joined the force, he was asleep after a night shift when his mother woke him up. The house had been burglarized, she said. Ellis knew there had been an attempted break-in a few weeks earlier, but the thief had been scared off by the family dog. This time the thief had returned, peeked through the large dining-room windows, and seen that the door to that room was shut: the dog was neutralized. The thief drilled a hole through the Ellises' window, slipped a specialized tool through the hole to unlock the window latch, and tied the open window to the outside wall of the house so it wouldn't swing shut in the wind. He was experienced, and he brought the right skill set to this job.

Missing from the Ellis house were ceramic works, silverware, and two paintings Ellis describes as "of no great value." It was probably the biggest mistake the thief could have made—stealing antiques and art from Richard Ellis. Ellis called police, reported the theft, and then went to work for the Thursday-night shift. He finished at six o'clock Friday morning. Instead of going to bed, though, he went hunting for his family's treasures. His first stop was Bermondsey Market, where his father used to take him to wander the stalls and survey the junk and thousands of

antiques for sale. The market was only open on Fridays, so there was some logic to the Thursday break-in.

There were only so many ways to convert those antiques into cash. The easiest way was to sell them, very quickly, to an antique dealer at a market. The dealer paid a bargain price, then sold them straight from his stall to anyone who wanted to buy, including the hundreds of antique dealers from more expensive and respectable stores who picked up their stock at the markets.

Ellis's instincts were correct. He was at Bermondsey for less than half an hour before he spotted a merchant laying out his family's wares. "I recognized instantly the silver, having spent so many bloody hours cleaning it as a child. I arrested the store owners immediately."

The officer investigating the burglary of his parents' house sped to Bermondsey to interrogate the antique-stall owners, but Ellis was already doing that. They confessed to receiving the goods from a mysterious supplier and admitted that they were expecting another delivery shortly. Sure enough, the supplier arrived with another haul of silverware, and he too was arrested. His name was Henry Wood, and he was about to turn sixty-five. The new shipment turned out to be silverware from a house just up the street from the Ellises.

Wood took police on a drive across London—a tour of his life's work as a criminal. He pointed out hundreds of homes he'd burglarized over a ten-year career. It was an efficient system: steal from homes, then off-load to dealers at Bermondsey on Friday—a system that would sound familiar to Paul. Wood was sentenced to eight years in prison, and Ellis received a commendation for his fast footwork. He moved up the ranks, working in some of London's toughest neighborhoods, investigating armed robbery,

rape, and homicide. But he had his eye on a different department in the Yard.

In 1974, something was awry in London's tightly knit community of stamp collectors. Stamps were a subset of the antiques trade, and the industry was populated by meticulous minds who loved to pore over the details of these micro-artworks—used and abused by the mail system and saved by a small circle of conservationists and historians. Scotland Yard was muscled into forming a new squad by a tiny population of philatelists who were increasingly finding fakes or being robbed. They may have been detail-oriented nerds, but they were a vocal bunch. A few detectives were pulled from their regular duties to look into the matter and make a few arrests. The formation of the Philatelic Squad was intended to be an act of goodwill with a quick result—smart public relations, like Robert Volpe's exploration of the art theft scene in New York. And as with Volpe, that wasn't what happened.

The unit began investigating stamps but was quickly sucked into the larger criminal vortex of the unregulated antiques industry. The Philatelic Squad found, unsurprisingly, that the industry was ripe for fraud. Its staff branched out, began collecting information on the booming business of antiques and art, and eventually evolved into London's first Art and Antiques Squad. Ellis applied to join that squad but was rejected. "At that time, at Scotland Yard, if you knew something about a subject and expressed interest in it, you were considered at risk for corruption," he told me. "So instead I was transferred to East London, a hard area."

Ellis kept track of the squad's status. The Metropolitan Art and Antiques Squad investigated cases for nine years before it was quietly shut down in 1984. London police were overstretched. Crime rates had soared. It was stolen

paintings versus riots and gangland murders. The unit's files, a few cabinets filled with index cards, each holding the name of a stolen work of art, were left to gather dust.

During those years, Ellis applied his skills to investigating homicides, gangs, armed robberies, and rapes, working at a police substation in Tottenham. He crashed down doors on bank robbers, and the work wore on him. He wanted something more intellectually challenging. The same year the Art and Antiques Squad was dissolved, Ellis was transferred to the upper-middle-class division in Hampstead. His new job involved looking into a number of break-ins at private residences in which paintings had been stolen. One afternoon he received a phone call from someone who had spied one of those stolen paintings—*Two Ladies at a Racecourse*, by Sir Alfred James Munnings, one of England's most exciting horse painters—in the collection of Richard Green, a prominent London art dealer.

Ellis looked into it and found out that Green had bought the stolen painting at auction, at Sotheby's in New York. Ellis, getting tougher every year, decided to seize the painting from the dealer. Green wasn't having it, and the art dealer dialed his lawyer. The investigation turned into a legal scrap between the Metropolitan Police lawyers, the victim of the original theft, and the art dealer, who wanted the painting he'd paid for. Green argued that he had bought the painting in good faith, and threatened to sue the previous owner of the painting for sullying his name. Ellis looked at the facts: the painting had been stolen in England, moved across the ocean to Sotheby's, and sold to Green, who shipped it back to London and placed it in his shop window. Ellis thought it through and decided to make the political move of his career.

When the Art and Antiques Squad had been active, it had circulated a list of stolen paintings to galleries, dealers,

and auction houses in the London area. Any dealer who received the report would have been on the hook for buying a painting he knew was stolen. When the squad was disbanded, so was the list.

Ellis advised the victim of the theft to write a letter to Scotland Yard, stating exactly those facts. That letter bounced around the department and eventually landed on the desk of Ellis's manager. "I hope you know what you're doing," he told Ellis. The letter gathered momentum. It essentially stated that by disbanding the Art and Antiques Squad and not circulating a list of stolen artworks to dealers and collectors in London, Scotland Yard could be on the hook for the price of the painting Green had bought.

The letter finally wound its way to the desk of the deputy solicitor, who, according to Ellis, "considered its meaning with increasing nausea." That single letter forced Scotland Yard to reopen the Art and Antiques Squad. Ellis was invited to head the new unit. He accepted. It was 1989, and his dream had come true.

As team leader, Ellis had a partner and not much else: a few contacts and what was left of the previous squad—the filing cabinets and a cue card system. He also had contacts at Sotheby's and Christie's, and he knew his way around the art market. But he didn't have to use that knowledge to find cases: the art market came to him.

One of his first significant cases involved the art collection at Russborough House, an Irish manor that had been pillaged a few years earlier—again. Russborough held a major collection of art assembled by Sir Alfred Beit, and it had already been burglarized once, by Rose Dugdale, who had hoped to use the stolen art as ransom in exchange for Irish Republican Army (IRA) prisoners. Dugdale's attempt had failed, but the target was now well known to the criminal community.

In 1986, an Irish criminal organizer named Martin Cahill decided to try his luck with Russborough. Cahill was feared, because he was known to be vicious; his nickname was "the General." He had started out as a street thug in Dublin, then moved on to stealing diamonds, jewelry, and gold. Now fine art. His gang looted eleven paintings from Russborough, including works by Vermeer, Rubens, Gainsborough, and Goya. The paintings were easy to steal but, as Cahill learned, hard to sell. First he tried to sell them directly into the legitimate market, but that route was blocked by the Irish Garda, who orchestrated a sting operation. That operation failed to retrieve the paintings, so Cahill adjusted his plan. That's when he attracted the attention of Ellis and Scotland Yard.

One afternoon at his new office Ellis received a phone call from a London art dealer. The voice was tense. A stranger had called the dealer earlier that day—a new client. The caller asked that he authenticate eleven paintings. To do this, the dealer would have to fly to Dublin, and for this service he would be paid £500,000. The stranger added that if the dealer did not authenticate the paintings, he'd be shot in the head. "Well, this wasn't exactly typical," remembered Ellis.

Ellis called in an elite squad to wire the dealer's apartment and start surveillance. The dealer scheduled a meeting with the caller at a flat in Notting Hill. When the man showed up, so did Ellis and Scotland Yard. His name was John Naughton, and he had been recruited by Cahill. The plan had been to have the dealer authenticate the paintings and then ransom them back to the Irish government. But Cahill was in over his head; the paintings weren't insured and the Irish government would never have paid a ransom, according to Ellis. Instead, Naughton was arrested and

sentenced to two years in prison. The paintings remained missing, but now Ellis was watching for them.

Ellis kept track of Cahill, and witnessed the evolution of a criminal mind grappling with how to profit from stealing famous paintings. "At the time of his stealing the paintings he had no idea how to dispose of them, but through a process of trial and error he explored all the possibilities . . . starting from the totally naive point of trying to sell it on the open market for its true value, he moved to selling it on the black market," Ellis told me.

Cahill tried to sell the paintings to other organizations. First, the General attempted to sell them to the IRA, but the IRA considered Cahill a liability, and didn't want to do business with him. In fact, the IRA was killing off Cahill's drug dealers. Cahill next contacted the Ulster Volunteer Force (UVF)—Protestants from Northern Ireland. Cahill didn't care about friends or politics. He wanted money.

By this time, a police informant was leaking information out of his gang to the Garda, confirming that the UVF had bought one painting and was moving it to Turkey. This information was passed on to Turkish police, who raided an Istanbul hotel room and recovered the first of the missing Russborough paintings, a 1660s Gabriel Metsu titled *A Woman Reading a Letter*. It was personally escorted back to Ireland by a curator for the Irish National Gallery.

Two more years passed, but Ellis never stopped following the Beit collection. In 1992, Ellis got a phone call from an Irish detective who had an informant of his own. Cahill was trying to move the paintings again. Ellis checked in with his informant in Cahill's gang. The paintings were indeed about to move—the detective just didn't know when, so they watched and waited.

One day in 1993, Cahill arranged for the artworks to be wrapped in blankets and placed in the trunk of a car. The car traveled by ferry to Wales, and then to England. Ellis received another tip from an informant giving very specific information about where those paintings would be stored while in London, and he executed searches at a variety of locations across the city.

Six officers from the Art and Antiques Squad and at least a dozen other police took part in the raids. The Rubens was found behind a couch in an apartment. Four more paintings were found in a factory, and another at Euston train station. But four slipped out of Ellis's reach—including the Vermeer. Those paintings had stopped briefly at a car dealership in North London, and then continued traveling in the back of a truck on their way to Belgium, where Cahill had connections in the diamond industry. A diamond dealer in Antwerp had agreed to buy a share in the remaining paintings, and gave a cash advance of one million dollars to Cahill on profits that would be made on a later deal involving the paintings. The dealer moved the paintings to a bank vault in Luxembourg. "Cahill was using it as collateral for a cash advance with which to set up a money laundering bank to handle drugs money," Ellis told me.

Ellis and the Garda devised a plan: a Scotland Yard undercover agent, Charley Hill, would pose as an American art dealer and offer to buy the paintings. The cash offer would draw the Vermeer and the other paintings out of the bank vault. For that operation, Hill called himself Chris Roberts, and he started advertising the fact that he was in the market for a few incredible paintings. It worked.

Hill was contacted and instructed to fly to Oslo for a meeting, obviously to check him out. His cover stayed intact on the trip, and he was told to fly to Antwerp. When

Hill arrived, Cahill's men led him to a car parked in the diamond district. There, in the trunk, was the unframed Vermeer. Hill took note—he was dealing with the right people. The car drove away.

Ellis waited. The next meeting was scheduled three weeks later in Antwerp. Hill flew back to Belgium with a briefcase full of cash. The detectives knew the bank account where the money would be wired was in the Caribbean, where Cahill had bought a small bank to hold his new fortune. Three cars met at the airport. The trunk was opened. This time not only were all four paintings there, so were the Belgian police.

After seven years underground, the Russborough paintings had been recovered. Cahill had not been at the meeting in Belgium. He was still AWOL, but that mattered less to Ellis. He'd recovered the artworks and made his reputation.

One year later Cahill was shot dead at a traffic light in Dublin, either by IRA hitmen or by other criminal soldiers. "Stealing those paintings had done nothing but harm him," said Ellis at the wine bar. "And the Cahill case proved that paintings weren't just being ransomed back to museums or collectors for money, or sold back into the system. Paintings, in fact, had a monetary value that went beyond the market. They could be used as criminal currency," he said.

"Let's say I'm a drug dealer, and you owe me money. Well, you can steal a painting. You then give me that painting as a down payment on the loan. As a dealer, I know that it's worth something, especially if it's been written about in the newspaper. Those articles always say, so and so painting, worth so and so hundreds of thousands of dollars." The use of stolen art in the black market had evolved.

"You saw Cahill try and use all the avenues, over a period of years. First he tried to sell them on the legitimate market,

then he tried to ransom the paintings back to the government, but we blocked that route. Cahill's last resort was to trade the paintings for a cash loan on future criminal profits from drug dealing. That was new for us. It was another piece of the puzzle," Ellis told me.

One year after the paintings were returned to Russborough House, Ellis found another piece to the global black market puzzle.

In May 1994 he was part of an international operation that recovered Edvard Munch's *The Scream*, stolen from Norway's National Gallery. That same year, he received a call from the British Museum: twenty-seven papyrus texts had been delivered to the museum for appraisal. Museum staff identified them as stolen; they'd disappeared from an Egyptian government storage facility. Ellis investigated and his suspicions focused on an antiques restorer named Jonathan Tokeley-Parry, based in Devon. Eventually, Ellis had enough evidence to raid Tokeley-Parry's house. Under the bed he found a pair of doors from the tomb of Hetepka, a royal hairdresser. That tomb had been looted in 1991, and Tokeley-Parry had been in Egypt that year.

The detective also found customs documents and photographs of dig sites in Egypt. They revealed a system: raw material was being shipped from the Egyptian desert to Switzerland, then to London. "Tokeley-Parry showed up while the raid was happening, and he was fresh off a plane from Cairo," said Ellis. He was carrying a briefcase, and in the briefcase was another stolen piece he'd picked up from his visit abroad.

Tokeley-Parry, it turned out, was using his craft as a restorer to smuggle antiquities out of Egypt, including by disguising real antiquities as fakes, tourist junk. To get the head of Amenhotep III out of the country, he dipped it in clear

plastic and painted it black and gold. It was worth millions of dollars, but it looked like a piece of crap from a shop at the airport. Tokeley-Parry was convicted in 1997. He served three years of a six-year sentence. Before he went to prison, he tried to commit suicide by ingesting hemlock, just like Socrates.

Ellis, seeing that a larger network was in place, kept following the paper trail, which led all the way across the Atlantic to a well-known New York antiques dealer who had been financing Tokeley-Parry. The dealer's name was Frederick Schultz. Schultz owned a gallery in Manhattan and had an international network of contacts pulling in antiquities from across the world.

It took four years, but the FBI prosecuted Schultz. He received three years in prison. He was by far the highest-profile antiques dealer ever to be convicted of stealing art in the United States.

For Ellis, the Russborough case provided the link between stolen art and organized crime, diamond dealers, and a network that stretched across Europe. The Schultz case, which involved fourteen countries on four continents, proved that the stolen-art network was sophisticated and involved criminals at all levels of the trade, from the men who dig in the dirt to the men in the shops and galleries on Madison Avenue.

Ellis retired from Scotland Yard in 1999. He told me his success as a stolen-art detective was primarily due to his ability to gather information. He relied on a network of informants to keep him abreast of what was happening in the criminal underworld. His squad of detectives paid cash for useful information. "Every Friday the calls would come in. Payday," Ellis explained.

Ellis told me that one of those informants was a former Brighton knocker who had made his name by scouring the

country, draining houses of their treasures, and selling the stolen goods through a variety of available channels, including a few in London. Ellis had never caught him, but he had used his information. "No one knows how much art he stole over his career, but he certainly knows the field," said Ellis. "It seems he was quite successful. We've had dealings on a number of occasions. He helped me out on a few things. I can't really talk about that."

# 9. _ _ _ _

## BUSINESS IN
## LONDON

*"Art theft is like a disease you catch
from your friends."*
**JULIAN RADCLIFFE**

London was not Brighton. London was the center of
the big bad empire: dark, epic, dirty, greedy, fast. For
Paul, the city was a blur: men in bespoke suits, women
in heels, the Tower of London and Big Ben looming over
the little specks traveling at quick clips down twisting brick
streets where even the dirt on the bricks felt historic. And
those streets, always winding, opened up toward huge
bridges that arched magnificently over the Thames. Or the
hectic thoroughfares—Oxford Circus, Piccadilly, Trafalgar
Square—jammed with blasting car horns and the roving
red walls of double-decker buses that flew within inches of
your nose at the traffic light.

Following the city's streets, Paul could wind up any-
where—Soho, Buckingham Palace, Brick Lane, Brixton. "I
smoked some incredible stuff in Brixton, you have no idea,"

he told me. He rode the vibe: fast cars handling tight cor-
ners, the constant steel of clouds above, the slanted chim-
ney skyline, the swelling of millions—a nerve center that
never shut down, sprawling, overcrowded, mazelike. It was
a post-Dickensian urban fairytale: monstrously big, fluo-
rescent, chemical-induced, loud, and, of course, expensive.

"And there was money," Paul remembered. Lots of
money—lots of stupid people with lots of money. And
Londoners didn't really care who you were if you could
help them make more money, so long as you added some
glob of value to the throbbing machine that drove the eco-
nomic boom Paul was now a part of. He knew this was a
city where a person could simply disappear or get locked
into a dreary life, pay the rent and subsist, be ground into
history's brick-grime—no.

Or you could drive in, do your business, escape, rein-
vent your life, live the life, make a fortune, have a fucking
blast—yes. To accomplish that, Paul's talent for bullshitting
had to go up a level. After all, London was a bigger game,
with new players, more players. It had a different crimi-
nal history—Jack the Ripper, Jack the Stripper, the Krays,
and Paul's bank robber, John McVicar. And there were new
threats—the legendary Scotland Yard, which hunted down
criminals and locked them up in Her Majesty's Prison
Service. Whatever happened in London, whatever trouble
he got into here, Paul never wanted to end up in prison. His
mission: make money, stay under the radar, have fun.

Paul arrived in 1981, just in time to exploit the greed, the
excess, the cut-throat capitalism of that decade. For the poor,
London was a psychological and physical prison. For the
young and the rich, it was a party that never stopped. There
was the infamous class system to contend with, of course,
and Paul concocted a way to handle that ever-present social

question mark, his working-class Brighton accent. Rather than try to change it, though, he simply reconstructed the circumstances of his youth to better suit his new environment. So, clinking a glass of champagne at an art show or snorting "Class A drugs" in a back room at a club, he talked his way up and around the higher echelons of London society. "Hell-oh, swee-tie. Wher'm'I from? Well, my father owns a lot of land." Always the con man, he tweaked his persona to fit the desired image, he told me. "When I was spending time in London running in those circles, if people asked me what I did, where I was from, I told them I was the son of a farmer and that my father owned a lot of land. And that I was interested in art and antiques. It was plausible." Paul explained away his position in life—what he was doing in that room, at that party, with those people. And why not mingle with them? When it came to art, he knew as much as or more than they did. "My favorite painting is at the National Gallery, *The Hay Wain*, by John Constable."

London was the capital of Britain, but in 1981, it was also competing with New York as the capital of the global art market. It wasn't just that London held a thriving gallery scene and mighty institutions like the British Museum, the Tate, and the National Gallery, with their millions of dollars of art treasures. Paul still wasn't the least bit interested in stealing from museums. Headache art and ransom cases were not his style. He was interested in further expanding his business model.

Hovering above and around all the museums, dealerships, and galleries were the rulers of the global art market: the auction houses, where the gods of art and money resided. Paul loved the crowds, the drugs, the women, the bullshit chatter, and the parties, but the prize in London was the business he could receive from auction houses—a destination for some of

his special spoils. In the grand myth that was the art market, the big auction houses were the source of life. London was exactly the kind of place where a young man on the make could easily get lost. It had a million possible destinations, a million forks in the road to choose from. But when Paul arrived, he knew where he was going and why he was going there. He went straight to the source.

"I always knew, with paintings, you go to auction houses," he told me. "Without auction houses, you wouldn't have a trade in art." Over the course of our conversations, Paul described the economics of the art world as a series of small rivers, flowing to and from the bodies of the big auction houses. "I want you to imagine the big houses, Christie's and Sotheby's, at the center, and all the tributaries that led away from them. One of those tributaries leads to the art dealers in London. Another one leads to the dealers in Brighton, and another to the collectors and buyers, local and international. If you are someone who wants to buy art, you go to an auction house. If you want to sell art, auction house. If you want to learn about the price of art, like I did, auction house. Everyone in the art world goes to the auction houses to feed off of them. I did."

In Brighton, Paul had spent time studying auction house catalogs—one of the ways he learned about the value of objects—and realized he could circumvent the dealers in the Lanes and reap higher profits by selling direct, wholesale, to the main suppliers.

Auction houses, Paul discovered, had created a system where everyone who needed to make money from the art world was forced to use them. "If you're a dealer or a thief, where else would you go to find those clients?" he asked, sounding ever the small-business owner. "It has been this way since those auction houses started, hundreds of years ago."

Sotheby's (at the time called Baker's) held its first auction—a collection of old books—on March 11, 1744, during the reign of King George II. James Christie opened his auction house twenty-two years later, in 1766. Bonhams followed in 1793. In 1796 Harry Phillips defected from his mentor, James Christie, and opened his own house. These four establishments remain the reigning auction houses of the world, and have expanded. For the first 150 years the houses traded mostly in rare editions of books, prints, and coins; after Napoleon died in exile, his collection of books was auctioned at Sotheby's. It wasn't until the early 1900s that sales of paintings caught on and became the houses' main source of revenue.

That happened because Christie's and Sotheby's developed a strategy to convince the middle class to buy what most had thought they could never afford: something special to decorate the mantel. They brought art to the masses. The houses recognized in the 1950s what Paul would discover a couple of decades later: that art was a product, and that as a product its value could be artificially pushed higher by increasing demand. To do this the consumer had to be convinced to buy the product—art, like many other economies, was a confidence game.

Bonnie Burnham's 1975 book *The Art Crisis* recounts how, in 1959, Stanley Clark accepted a job at Sotheby's. An outsider to the art world, Clark came to it with a fresh perspective. He crunched the numbers and figured out that people were buying objects that cost less than £100. So Clark decided that Sotheby's should focus on this market, and his reasoning was simple: business didn't need to just be about the big-ticket items. There was money to be made from the small stuff. Million-dollar profits in a single evening were tempting, but the auction house could rake in

even more by focusing on the lower end of the market. Paul figured out that every house on the planet had a prize, and Clark figured out that all those home owners could be persuaded that they deserved a prize.

"Most people back then had never heard of Sotheby's," Clark told Burnham. Before Sotheby's, he had worked at the *Daily Telegraph*. He used his knowledge of the media to his advantage, and convinced the daily newspapers that auctions should be featured in the news—that, in fact, what was happening at the auction house was news. In return, Sotheby's began advertising free consultation services, which worked well when stories appeared about found treasures.

For example: "A poverty-stricken old woman living on her small pension came in with a shoebox full of glass beads, begging that Sotheby's give her two pounds for them. In the bottom of the box the Sotheby's expert found an ivory Saxon reliquary, missing 400 years, which a British institution was delighted to buy for 40,000 pounds." Burnham found dozens of examples of these "articles" in her research for *The Art Crisis*. The marketing worked, and Londoners started hauling their junk to Sotheby's, with the hope of a lucky find. It was the original *Antiques Roadshow*, and the campaign had the added benefit of giving antique and art dealers a fast-moving business: everyone was a winner.

So while Paul was growing up in the wrong part of Brighton, Sotheby's was developing the market he would reap. By the 1980s, that market experienced its first boom. Some paintings were selling for thousands of dollars, others for hundreds of thousands. And now, a few sold for millions.

Clark's theory had been dead-on—the business was exploding. Added to that, the value of art and antiques kept

rising. There were few if any checks and balances in the auction system, though, and Paul exploited every opportunity. He said that auction houses turned out to be just as irresponsible and greedy as the dealers in Brighton. "If a junkie showed up at an auction house desk with a dozen hypodermic needles sticking out of his arm but he had a great painting under his arm, it wouldn't matter. They'd take the painting. Back then you could take a painting to any of the larger auction houses and sell it to them on the spot," Paul told me.

From time to time, he also used smaller auction houses. They had even fewer checks and balances and were totally beneath the radar of London police. "If I didn't feel confident going to a larger house I'd use a regional house. I could go there with a $10,000 painting. Name? M. Mouse. Address? Disney World, Florida. If the police got involved, well, the name is M. Mouse. Sometimes they didn't ask for a name."

Paul was now building an efficient network for his stolen paintings. And there wasn't a system in place to stop him. In the early 1980s, the closest thing to a global master list of stolen art was Interpol's database, but it wasn't set up to be used by the international art community; it was for police forces. Without a list of stolen artwork to check against, those big auction houses had no way to protect themselves from absorbing stolen art. In New York, the International Foundation for Art Research had started a list in 1976, courtesy of Bonnie Burnham, but its database was obsolete: paper files, plus a "Stolen Art Alert" newsletter published every once in a while for anyone interested. There were dozens of other lists: looted work in France, in Germany, and in Poland. Italy had one, and so did Egypt. But there was no list to rule them all. "Without

a list, I could do what I wanted. I could sell stolen paintings straight into the auction house system. There were no defenses," said Paul.

In 1986, Julian Radcliffe met with Marcus Linell, the director of Sotheby's in London. Radcliffe wasn't from law enforcement or the art establishment. He came from the world of big insurance. He'd graduated from Oxford in international relations and then spent time in Northern Ireland and Beirut, collecting information for MI5 and MI6, although he was not an official agent. He spent a summer working for Lloyd's of London, one of the largest insurance companies in the world, where he quickly moved into risk management. He began consulting globally on kidnappings and terrorism, and in 1975 he was a founding member of a small company called Control Risks, which advises multinationals with staff and operations in danger zones. One of the patterns he noticed was that crime was becoming more organized, moving into wider geographical circles, larger than any one government's control. Control Risks grew to become a major international company with thirty-four offices on five continents, helping companies succeed in "hostile business environments." When Iraq was invaded in 2003, the British government awarded Control Risks a contract to provide security for its diplomats and employees.

When Radcliffe met Linell as a Control Risks consultant, Sotheby's was in the process of expanding its offices all over the world. Linell needed advice about risk management for staff members in exotic locales. During that meeting, the Sotheby's director mentioned to Radcliffe, as an aside, that it would be useful to have a list of stolen artworks to check, one that was comprehensive. At that time, it was extremely difficult to check if an artwork the

house was buying was stolen, said the director. The auction house had to contact dozens of organizations and police departments around the world, and even then it often couldn't get a conclusive answer. As auction prices climbed, so did the interest of criminals. It was a conundrum. Couldn't Control Risks do for art what it did for people and businesses?

After the meeting with Linell, Radcliffe couldn't stop thinking about the idea: that the best way to curb international art theft was to create an international list of stolen artwork. Whoever assembled that list would be the master of the art world. It would work like this: every time a painting was stolen, any victim or police officer, from any country, could register the work on the list; once the work was on that list, art dealers, galleries, and auction houses could cross-check what they were buying or selling. There was a catch, though: the system would work only if everyone in the art market participated—auction houses, dealers, galleries, everyone. Then thieves would no longer be able to use their current business model to launder stolen items back into the system. It was the logical solution—a global solution—and Radcliffe hoped it would be profitable. But where to start? Was there a list to build on?

Yes, there was. Radcliffe found a small organization in New York that had been compiling exactly the kind of list he was looking for—the International Foundation for Art Research. After penning *The Art Crisis*, Bonnie Burnham had accepted the job of director of IFAR, and her first big project was to figure out how much art was being stolen in America. "I started a program at IFAR called the Art Theft Archives," she told me. "We began collecting information and publishing a list of objects stolen. We conducted our museum survey and asked two hundred museums from

New York, Chicago, Los Angeles, other big cities, to submit records of losses." Many of them did. "There was nothing official as a source of information at that time," she said. "I would say that most institutions did say they had things missing from inventory—mostly smaller and more unobtrusive things."

According to Burnham, "When we did the survey of dealers, same thing. That survey was sent to about two hundred dealers. We negotiated with them to release this information. Then auction houses began to support our effort. We also went to police sources. I had old connections with Interpol. We went to the New York Police Department, the FBI. It was never anything official, because there was no way to get to that level back then." Burnham left IFAR in 1985, but ten years after she'd started to catalog stolen works, the list held twenty thousand items—a mix of missing paintings, sculptures, antiques, and antiquities.

Radcliffe decided he wanted to use IFAR's Art Theft Archives as the foundation for his new company. In New York, he met with the new head of IFAR to talk about his new company. He even had a name for it: the Art Loss Register. IFAR had been successful in recording the details of losses, but recoveries were slim. Radcliffe told IFAR, "There are a few missing pieces to your approach: a commercial understanding of the market, technology, and capital."

After the meeting in New York, Radcliffe flew back to London and, using his connections and his track record, raised $100,000 from insurance companies and the art trade— the big auction houses—and used it to commission a feasibility study. The question Radcliffe wanted answered: How much would it cost to computerize the IFAR list and create a searchable database? The answer came back a year later: about

one million dollars in start-up capital to computerize the database, as well as to add a very important component: digital pictures of the artwork. "In that era, the study was groundbreaking," Radcliffe told me. "Putting photographic images on computers! Remember, this was the late 1980s."

Armed with the study and IFAR's list, Radcliffe went back to the insurance companies and auction houses. If they wanted to close the stolen-art loophole, he told them, they each had to kick in the capital. In exchange, they'd receive shares in the company and a seat on the board. The big boys bit: Sotheby's for 20 percent; Hogg Robinson, an insurance company, for 13; Lloyd's for 10; Rosenthal, a bank, for 10; and Christie's for 8. IFAR also got a piece. Radcliffe set to work. He opened an office in London, bought some hardware, and brought the IFAR list to life. In 1991, the Art Loss Register opened for business. Bonnie Burnham remembers looking at the newly launched ALR database and thinking, "This is a quantum leap forward from what we were doing." The price of a search was one pound, and law enforcement could use the service for free. The auction houses started checking their sales catalogs against the register.

The ALR yielded immediate results.

One out of every three thousand items searched by Sotheby's and Christie's turned out to be stolen. And this was based only on the initial list, limited to what IFAR had managed to piece together. Scotland Yard and the Sussex, Thames Valley, and Gloucestershire police forces all started using it too, as did a number of other detectives from around the world. The list started growing, first by the hundreds and soon by the thousands. In principle, the ALR should have thrived, but it barely survived.

"I thought that no one wanted to sell stolen art," said Radcliffe. "I was wrong. Income from the insurance

industry was right on track, but dealer searches and private searches were way down." Instead of being celebrated, Radcliffe found himself at the center of an ideological skirmish among art-world insiders. On one side was the insurance industry, taking huge hits from stolen art. "Insurance was telling the dealers they had to clean up their act, and that they had to pay to clean up," said Radcliffe. "But dealers were saying, 'We have a clean act. We don't have to clean up.' I was persuaded that logic would prevail, but a lot of dealers said to me, 'I've been in business for fifty years, and I've had two stolen items in fifty years. I only buy from people I know. I don't need you, Julian.'"

By 1995 the ALR was in danger of going out of business. "The system was working but the art trade wasn't paying. There was also a recession in the art trade." Sotheby's and Christie's, both with seats on the board of the ALR, took advantage of their leverage and drove down the price of searches. "It was, in a sense, another form of price fixing," said Radcliffe. "The two powerhouses said they would pay half of what they'd been paying."

A major stream of income was suddenly sliced off, and in the four years since he'd started the company, less stolen art was being found at major auction houses, not more. "Stolen work was often consigned to the auction houses by the criminal or someone near the criminal," said Radcliffe. "We thought that as the database grew, we would find more stolen art. But not in London. We also had to expand our net, to other countries. But that takes time."

Radcliffe needed to refinance the company in order to save it. IFAR couldn't refinance, so its share in the company had to drop. But IFAR wanted veto power on the board. "Once IFAR had veto power, everyone wanted veto power. So, everybody with 10 percent got veto power,"

said Radcliffe, who himself bought 10 percent of the company, just so he could have a veto as well. He was now actively pressing dealers to sign up, but they weren't budging. Instead, he came up with another way to make up for lost revenue: ask for a 10 percent recovery fee on any stolen artwork found through the ALR.

The auction houses were against that idea and, it seemed, against Radcliffe. "Auction houses wouldn't give us the names of the consignors when a red flag came up," he said. "We were making matches on a regular basis but not getting any resolutions. They were still applying that code of secrecy to our work."

Radcliffe, meanwhile, was sensing danger signs all over. An outside consultant was brought in to assess the company. "The consultant who was hired told me that they were going to try to fire me. Sotheby's had initiated it. They did not want the company to be active in recovery," Radcliffe said. "Things became very unpleasant between 1998 and 2000." It seemed certain that Radcliffe would be ejected from the Art Loss Register, but somehow he managed to strong-arm the board into accepting the idea of a recovery charge. Then he caught a big break.

One of the cases the ALR inherited from the IFAR list involved a group of valuable paintings stolen in 1978 from the Massachusetts home of Michael Bakwin, heir to a meatpacking fortune. Bakwin was on a holiday when $30 million worth of art was stolen from his home, including Paul Cézanne's *Still Life with Fruit and a Jug*. The theft was one of the largest in the history of Massachusetts. In 1999, those paintings came up on the radar, courtesy of Sotheby's.

Sotheby's asked the ALR to run a search. Bingo— the system worked. The Cézanne was being sold by a

mysterious entity called the Erie International Trading Company. Erie was registered in Panama, but no one knew who the owners were. Radcliffe jumped on it, and Erie agreed to hand over the stolen Cézanne, but only in exchange for a deal—as a reward for the Cézanne, Erie wanted legal title to the other stolen works from the burglary. Radcliffe was in a moral bind, so he engineered his own loophole.

The ALR would accept the deal on one condition: that the owners of Erie sign a legal document stating that they were not involved with the theft in Massachusetts. Erie agreed, and the document was signed and delivered to the office of a London-based lawyer who was acting as middleman.

The Cézanne was returned to Bakwin, by then in his eighties. Bakwin auctioned the painting off at Sotheby's for close to $30 million, and Radcliffe received a percentage of that, as a finder's fee—around $3 million. It was the payday he'd needed. The finder's fee allowed him to buy the company outright, for $2.5 million, and in 2000, Radcliffe was back in control. The ALR was now more than a stolen-art database; it had evolved into an active detective service, and Radcliffe was persistent—just like Richard Ellis, he stayed on the trail of a stolen work for years, waiting, keeping his eye on the prize. But even as the ALR database grew and he made other recoveries, Radcliffe watched for those other missing Bakwin paintings.

In 2005, Erie International tried to sell four of them at Sotheby's in London. Erie believed that, because of the deal struck with Radcliffe, it was immune from criminal charges. Radcliffe pushed back. He hired a lawyer and halted the auction, arguing that the deal to pass legal title to Erie was void because it was made under duress. A judge agreed.

Erie hired its own legal team and requested that the matter be moved to arbitration in Switzerland. But Radcliffe wanted the envelope opened—the one that stated Erie was not connected to the initial burglary. Again, a judge agreed. Inside that envelope was a document signed at the bottom by a man named Robert Mardirosian.

Robert Mardirosian was a Massachusetts-based lawyer who, in 1978, was representing a man named David Colvin on a criminal matter. One night Colvin turned up at the lawyer's house with Bakwin's millions worth of art in a bag. He told Mardirosian he was planning to send the stolen paintings to a fence in Florida who could sell them for a decent price. Mardirosian told him it was a bad idea—if Colvin got caught with the paintings, it wouldn't look good. Colvin took his lawyer's advice. He left the art upstairs in Mardirosian's attic, where he slept that night. The next morning Colvin left, but the paintings stayed in the attic. Less than a year later Colvin was shot dead.

Mardirosian later said that he'd thought about returning the paintings in his attic. Instead, in 1988, he moved them to Monaco, and then to a Swiss bank, where they sat for years. Meanwhile, he defended drug dealers, violent offenders, and a few white-collars. In 1995 he retired and split his time between France and the town of Falmouth, Massachusetts. It appeared that he incorporated the shell company in Panama—Erie International—specifically to hold the paintings from the Bakwin theft. But when Mardirosian tried to move those paintings to London in 1999, he popped up on the radar, because of the ALR. He weaseled his way out of that situation but popped up again in 2005, the second time he tried to sell the stolen art. When the court date arrived, Mardirosian was a no-show and the judge ordered the paintings returned to Bakwin.

Mardirosian was also ordered to pay $3 million in court fees. By then he was also being investigated by the FBI.

In 2007 Mardirosian was indicted on charges of transporting, possessing, and trying to sell stolen goods that had crossed U.S. borders. He was arrested as he was getting off a plane from France. A few months later he was found guilty.

That single case had a lifespan, from theft to conviction, of almost thirty years, and it demonstrated the power that a global institutional memory could serve in recovering stolen art. Even so, prying back those paintings from Erie required many players: Radcliffe and the ALR, the FBI, London police, and Michael Bakwin, who shouldered most of the legal costs.

On a rainy evening in 2008, I met Julian Radcliffe at the ALR office on Hatton Garden, a street that houses London's Diamond Row. At dusk, its shop windows are aglow with iron bars, bulletproof glass, and glittering diamonds. It's a fitting location, and the ALR operates with the same security as the diamond traders. Visitors are announced and buzzed through a locked, windowless door. Inside, under a low ceiling, are a few computer terminals, filing cabinets, and three glass-windowed offices with their shades drawn. In an adjacent room more computer terminals are staffed by young workers, feeding and searching the ever-growing database of stolen art. Radcliffe's assistant led me into a large room, bare save for a table with a few chairs and a steel safe that loomed in the corner.

When Radcliffe entered a few minutes later, he took the chair closest to the safe; during the interview he seemed to be guarding its contents. He looked like a character out of a John le Carré novel: tall, lean, a wisdom-lined face, a gray pinstripe suit, crisp white shirt, and red tie.

Radcliffe said that his rogue entrepreneurial streak had led him on a crooked career line through the worlds of

intelligence, insurance, and finally to this delicate junction of criminals, the business of fine art, and the world's richest collectors. The ALR's record stands for itself: over $200 million in art theft recoveries, including the Cézanne stolen in 1978 and recovered in 1999, an Edouard Manet still life stolen in 1977 and recovered in 1997, and Pablo Picasso's *Woman in White Reading a Book*, stolen in 1940 and recovered in 2005.

The Picasso was a Holocaust loot case that came up in 2002, when a French collector about to purchase the painting asked the ALR to run a search on its provenance. Sarah Jackson, an ALR staffer at that time, examined two lists: the ALR's and the *Répertoire des biens spoliés en France durant la guerre 1939–1945*, comprising art looted from France during World War II. Nothing came up on the ALR search, but the *Répertoire* held a grainy photograph of *Woman in White* and said that the painting had been stolen from the home of Justin Thannhauser, a prominent Paris art dealer. The same Picasso was now being slated for sale by David Tunkl Fine Art in Los Angeles, consigned by a family that had owned it for twenty-six years. Over four years, Jackson traced the history of *Woman in White*, and this is what she found.

*Woman in White* had been painted by Picasso in 1922 and bought from the artist's Paris dealer by Alfred Flechtheim, who later sold it to Carlota Landsberg, a German Jew. Landsberg fled Germany during the war but left her Picasso in the care of a friend, the art dealer Thannhauser. A letter from Landsberg to Thannhauser proved the transaction. The ALR obtained a photograph of the Picasso in Thannhauser's estate files. On the back of that photograph were the words "Stolen by Germans" and "Landsberg." Jackson then found a letter Thannhauser wrote to Landsberg in 1958, where he confessed to her that in 1938 or 1939 his family had fled the country, leaving her

Picasso hanging on their living-room wall. In 1940, during the Nazi occupation of Paris, the Thannhauser home was looted; the painting vanished.

The Picasso next turned up at a gallery in Paris, in 1975, and was sold to an art dealer in New York, who sold it to the family that currently owned it, the Alsdorfs. Jackson also found out what happened to Carlota Landsberg. She moved to New York and had since died, but the landlady at her last residence remembered the name of her grandson, Thomas Bennigson, who had visited her. Bennigson lived in California. He eventually received a portion of the money from the sale of the painting, as did the ALR.

"Famous paintings are just a small percentage of what is being stolen," Radcliffe told me. He echoed Paul, almost to the word. Radcliffe told me that most of the art on the ALR list consists of minor paintings and antiques, and fewer than 1 percent of those are ever recovered. He could patrol the big and midsized houses to a certain extent, and he could monitor the major art fairs, but there were still plenty of other ways to launder stolen art.

Art dealers, for example, often played the innocent. "If they bought a painting for a cheap price, it was just luck thrown their way," Radcliffe said. "When the Register first started up, there were a lot of cases where art dealers searched a title, found that it was stolen, and did nothing about it. They didn't want to get involved. Those dealers might not buy that painting, but they might turn around and suggest someone who would be interested in buying it."

Radcliffe also knows that art thieves like to search his database. He gets phone calls from people who want access to a search but won't give their names. It makes sense. If thieves search the database for a painting they've stolen and it doesn't come up, they know they can sell it through

an auction house. It wasn't rare for busted art thieves to be caught with catalogs from the Art Loss Register, he told me.

In the over one thousand recoveries Radcliffe has enjoyed, in only three cases was the thief not after a paycheck for the stolen art, and most of the art that wasn't immediately passed on to a dealer or auction house was stored in a vault, a closet, an attic, or a basement.

"Transactions in the art world are often carried out anonymously, i.e., 'sale of the property of a gentleman,' and this cult of secrecy can be taken advantage of by criminals," said Radcliffe. "The art trade is the least regulated and least transparent activity in the commercial world, and the portability of the times and their international market make them very attractive for moving value, unobserved."

Radcliffe said that the average value of stolen art is under $10,000 and that thieves will pass these items off to fences, who will then move them into the outlands of the art market: to small auction houses or galleries, or across oceans. "That doesn't mean that a painting won't eventually wind up at one of the superstar auctions; it just may take years, even decades, to get there." About half of all stolen art recovered by the ALR was found in a different country from where it was originally stolen.

"Any art and antique dealer who purchases stolen art is helping these criminals," Radcliffe said. "We have heard some extraordinary excuses by dealers, collectors, and museums justifying their purchase and retention of stolen art in the most blatant cases, including that they will provide the best home for the item, that they have researched it, that the original victim was insured, or that the law is simply unfair." Radcliffe pointed out that it was always those same dealers who changed their tune when they became the victims of art theft.

I asked Radcliffe about the art establishment's attitude toward the Art Loss Register. "I'm used to being one of the most controversial and reviled figures in the art world," he said with a smile. Then he parodied an average art dealer's take on him: "Julian Radcliffe is the most eccentric man I have ever met and he hates the way I do business."

Radcliffe's international roster of clients was slowly expanding. In 2000, he approached officials at the Maastricht art fair, one of the largest and most prestigious in the world. "That's where we made our mark," he told me. Radcliffe and a team of six of his staff dug in and searched almost half of the items being sold that year at the fair—6,500 searches on 15,000 items. They worked around the clock. Initially, Radcliffe wasn't paid by the fair, but because he found a few stolen items, he is now. (He wouldn't tell me what he'd found.)

"Christie's and Sotheby's now account for 35 to 50 percent of the art market," he said. And because of that, "20 percent of all the art sold at Maastricht has already been through Christie's and Sotheby's. It's all interconnected." After his success at Maastricht, Radcliffe approached the Grosvenor House Art and Antiques Fair in London. "Why don't you come and work out of the servants' quarters?" he remembered being told. He did, and the ALR ran searches on one hundred items from the catalog. Two turned up as stolen. "One of them was being sold from the stand of the chairman of the fair," Radcliffe said. Other major art fairs followed: Art Basel and Art Basel Miami.

"The pattern is clear. Once we arrive somewhere, the number of stolen items reduces, because everybody is more careful," he said. He cites Christie's and Sotheby's: "When we started, one of three thousand showed up as stolen. Now, one out of every seven thousand items is identified as stolen."

Dealers were different. "These old dealers have survived for fifty years without me; they don't like my computers, my regulations, or the control." He mimicked them: "Radcliffe, tell us, if one of our best suppliers gives us a stolen item and gets busted, why would they ever come to us again?"

By the time we sat down for our conversation, it was about ten years after *The Thomas Crown Affair* had been remade. In addition to battling the war against old thinking and against the myth of the rogue art thief, Radcliffe was also battling globalization. He could spend years tracking a painting and cover the planet doing so. But he was tenacious. He opened a data-entry office in India just to keep up with the constant stream of information flowing into the ALR. The center in India was important, he said, because the list was growing. When Radcliffe had bought the initial list from IFAR in the late eighties, it had stored twenty thousand items. By the time we met, the Art Loss Register held more than ten times that number.

"Art theft is like a disease you catch from your friends," he said, and smiled.

"In 1985 I was twenty-one years old and so was Mike Tyson," Paul said. "And that's just how I felt. Undefeated."

1985 was the sweet spot: pre-ALR, and pre–Ellis's Art and Antiques Squad. He was weaving around the country at breakneck speed, fearless. The game was changing, expanding, and if he kept up he could make a fortune. Knockers and thieves had spread out far beyond Brighton, and for good reasons: the Sussex Police were actively investigating burglaries, and the residents of Brighton had become more savvy about whom they let into their houses. The reasonable solution for thieves and criminals like Paul

was to use Brighton as home base but to fan out across England in search of the prize.

That was the year Paul reached the height of his powers. He had a steady source of product coming in from thieves and knockers who knew him by reputation, so he no longer had to go out and get it himself, though sometimes he went knocking anyway, just for the fun of it.

Paul had a larger pool of dealers and auction houses to choose from now. He'd off-load different products in different places. He could use the dealers in the Lanes for anything that was replicated. For paintings, he could travel to London, to the auction houses. If he needed to get rid of something quickly, he could always use Bermondsey Market as a dumping ground.

"Everyone was a target—no mercy," he said.

Paul had transformed himself. He'd bought a suit and expensive shoes. He wore a Rolex, and he had a few. He had developed expensive tastes and opinions. "Guys who wear a solid gold Rolex during the day are announcing themselves as nouveau riche. What you want for the day is steel and gold. It wears better. In the evening you can wear your Rolex Prince." He smoked a pack a day, and he didn't have a business card or a schedule. He was working sixteen-hour days, always looking for new targets, new sources, new dealers, and new networks. He had created an illusion and he wanted to sustain it. "The idea was to make people think I was someone else. My goal was to come off like an English country gentleman. I was moving around the country a lot. I could wind up in any town or city, in a hotel room dealing with thieves, or at the desk of an auction house in London. I was practically on my way to becoming a yuppie," he laughed.

Paul would wake up in Brighton, but his days could lead him anywhere. He would get in his car and drive, following

the flow of knockers and thieves: Manchester, Birmingham, Yorkshire, Liverpool, Newcastle, Wales, Plymouth. London was a ninety-minute drive from Brighton, Scotland a twelve-hour drive. Wherever the criminals went that week, Paul would follow.

"It's called working local: You drive to a place where you don't live. You do a job. You go home before the local police ever know about it." He added, "It was quite a geography lesson for a young man." He bought a Ford Granada and after six weeks noticed that he'd clocked eleven thousand kilometers. "It was the biggest Ford you could buy. I installed a ladder on the roof." Long-term storage was never a problem. He outsourced everything and sold as much as he could as fast as he could. When he arrived in a town or city, he would check into a hotel and open for business. Word got around, so he didn't need to go out as much anymore. "That year I was the prince of thieves," he said. "My hotel room would be like a demented Tupperware party."

As an organizer he had to be better educated than thieves and able to evaluate art in a rough and quick way. "It didn't mean I had to have a degree in art history, but I had to be able to recognize quality." That wasn't as hard as he'd imagined. "Quality sits up and slaps you in the face," he said.

He'd rent a suite, tip the doorman, and execute his most charming smile. Paul talked to the staff as if he were one of them. He was from their world, so they were on his side. When thieves came calling with stolen goods he'd "cash 'em off." "Once I had a whole truckload of stolen antiques in the lobby of a hotel. It wasn't a problem. The trick is to act like what is going on is normal. And if the staff know and like you, that helps a lot." In those days there was no Internet. For every fifty art thefts, maybe one or two would

be reported. Paul had come a long way, but he always went home to Brighton.

"Nineteen eighty-five was my most successful year as an art thief," he said. That year he made close to one million dollars in profit from stealing and handling stolen art. "I was pissed off I never crossed that million-dollar mark," he laughed. "Fuck me, it was a wonderful life. Those were the days."

Paul told me he worked the system until about 1993. That was the year he decided to retire. Success depended on a number of factors: his connections as a middleman, access to thieves, a steady supply of product, a network of dealers who acted as bridges into the legitimate art market, and access to big auction houses. It was essential while Paul was doing business that he stayed under the radar, but evading police wasn't always possible. To stay in the game, Paul says, he was forced to collaborate with police forces more and more often, acting as an informant. This was his insurance policy against serving prison time.

In fact, his role as informant had started with the Sussex Police, but the more time he spent in London, the more time he spent in the sphere of Scotland Yard.

Paul won't say how he met Richard Ellis, only that it was under "interesting circumstances." Ellis told me that one day he got a call out of the blue from Paul, who wanted to act as an informant. When Ellis looked into it, he found out Paul was already an informant for the Sussex Police, "so there was a conflict there," he told me. "Still, we kept in touch."

He and Ellis formed a tenuous relationship. Sometimes Paul provided the head of the Art and Antiques Squad with information, but that, Paul said, didn't rule out being arrested. "Richard Ellis was chasing me for more than a decade, but he never caught me."

Still, Paul had mixed feelings about working with detectives. "Show me a stand-up guy who's never had to deal with the police and I'll show you someone doing twenty-five to life. When you become successful, you show up on the radar," he said. "In order to sustain that success you have to work with police or you yourself become the target. All top criminals do this."

Thieves were the most expendable people in the system, and if Paul sometimes had to give somebody else up, he did so. Over the course of his career Paul was caught twice, but in both instances he received a "slap on the wrist" and never saw a prison. For all the paintings he pushed through auction houses, all the antiques and art he sold to crooked dealers, he managed to evade any serious consequences.

In 1993 he had a son, and his perspective shifted. "I didn't want him to have the same life I'd had," he said. That year, Ellis and Paul had a conversation by phone. The detective had some advice for the thief. "Retire," he said. "Quit while you're ahead, Turbo. It's a good time to leave."

Paul decided the detective was right. He told me that when he made the decision to get out of the business, "I burned as many bridges as I could to the criminal world. I didn't want to leave myself a way back," he said. This probably means that he became a known informant to police, and therefore a person no one trusted.

Looking back on his career, Paul noted, he pushed himself up the ladder, from knocker to organizer and handler, but there was one threshold he never dared cross. "I know of a few men who started out as knockers and petty criminals and who worked their way up to become dealers. A few of them are quite successful," he said. It makes sense, considering that those handlers and organizers had access to a steady stream of art product. Paul saw it a different way. "I never tried to

become a dealer. The other dealers would have seen me as a threat. In fact, I always knew that those dealers in London were vicious and competitive and that if I'd ever tried to move into the legitimate trade they would have crushed me."

Instead, Paul elected to stick to his golden rule of staying under the radar. He admits he's been lucky. He'd escaped the Brighton projects, toured the country, and penetrated London society. Not bad for a high school dropout. "Art and antiques were my way out," Paul said. "They saved my life. If the Brighton Council hadn't outlawed that marketplace when I was born, I might have been a fruit and vegetable seller. Or any number of menial positions that go nowhere in life. Instead, I made a fortune by stealing art."

What happened to Paul in Brighton was, in part, the birth of a model for the trade in stolen art that reached far beyond the shores of England. Paul's way of making a living has been exported around the world. "When you read a story about a theft in America, in England, or in India for that matter, you might as well substitute Brighton's name. It's all the same system. A work of art is stolen and, once that happens, the entire purpose then becomes about moving that work of art back up the ranks to the legitimate art market to an end user."

Paul said that during his heyday he laundered such a massive amount of stolen art that it would have been impossible to keep track of it all. "Over those years, if you lined up all the antiques and artwork that passed through my hands, you could fill a container ship. Some weeks I'd be buying two or three vans full," he said.

Once I asked him if he ever had a crisis of conscience about all the people he'd stolen from, all the lives he fed off to make his living. "Do I feel guilty? Good question. Let me tell you something. When you're wearing a Rolex and a diamond pinky ring and you're driving a Ferrari and you've

got a tasty bird on one arm and another one sucking your cock, and you're shoveling cocaine up your nose, you don't feel guilty," he told me. "Think about it. Where I came from I was meant to be shoveling roads and eating cabbage soup. This was my way of fighting back," Paul said.

"I can tell you exactly what my frame of mind was during those years: The world is one big pussy and I'm going to fuck everyone. I didn't want to mess around with a few hundred dollars. I wanted thousands and thousands, and I didn't give a fuck what I had to do to get it. And the thing that made all of this possible for so long was that there was high-value stakes with very little risk, and it all happened under the radar."

In 1993, Paul slipped away, under the radar.

"It was a good time to go," he said. He even contemplated going back to school.

Paul told me there were a few incentives for his departure from the life of crime: Richard Ellis and the Scotland Yard Art and Antiques Squad; Julian Radcliffe and the establishment of the Art Loss Register; and the clampdown at Bermondsey Market that same year, in 1993. "Ya right, do you remember that? Those fucking morons who bought those paintings? What a bullshit story that was," Paul said. "I just don't believe that story. Do you?"

# 10.

## CAVEAT EMPTOR

*"Now we owned the paintings. Again."*

**DANNY O'SULLIVAN**

I'd heard the story about Bermondsey Market long before I met Richard Ellis or Julian Radcliffe or Paul—around the same time I met the thief in Toronto and was researching the *Walrus* article about art theft in Canada. A colleague came into my office one day and said, "There's a guy I think you should meet. His name is O'Sullivan, and he has a bizarre story about buying stolen art. I told him I knew someone who was researching the subject. He said you should give him a call."

"What's the story about?"

"It has to do with some ancient law in England and a famous antiques market or something. Just talk to the guy. Really, it's a weird story." And he gave me a phone number.

So I called Danny O'Sullivan. He agreed to meet, and when we did, he pulled up in a Cadillac. O'Sullivan has a wrestler's build. He was carrying a folder filled with court

documents and newspaper clippings. We sat down, and he smiled. "I think it's a hell of a story," he said. "Ready?"

On February 26, 1993, around noon, Danny O'Sullivan and Jim Groves strolled into Bermondsey Market. It was Friday, when the market transforms into a thriving antiques trade. Hundreds of dealers from across Europe and the United Kingdom set up shop, hawking mountains of peeling furniture, rusting knick-knacks, and your great-grandmother's candlesticks. It was the same place Ellis had come to retrieve his family heirlooms so many years ago, the same place Paul loved to off-load anything he needed to get rid of in a hurry.

That afternoon O'Sullivan was just tagging along, on vacation from his salesman's desk in Toronto at Quebecor, the Canadian printing behemoth. For O'Sullivan the noisy market was old hat. He'd grown up in London, working-class poor, the son of a truck driver who worked nights. He'd spent quality time with his father only on Sunday mornings. Sometimes they'd ride the bus an hour and a half to Petticoat Lane Market. In the crowd, little O'Sullivan would stay close to his father. He remembers his dad buying him a pair of shoes there for a pound. "After market we'd go to the pub. He'd have a pint, me, lemonade."

Jim Groves, O'Sullivan's brother-in-law, was equally at home in the throng of shoppers. Groves was a native Londoner who worked for Westminster City Council. As far as O'Sullivan was concerned, Groves was a good guy, even if he had recently separated from O'Sullivan's wife's sister.

The two men meandered the labyrinth of stalls filled with precisely the sort of stuff O'Sullivan disliked—junk. But it was junk that Groves prized: secondhand cake trays, egg cups, lighters, old furniture.

Groves paused at a stall where an old portrait caught his eye. The face in the picture was solemn and dignified, properly English. O'Sullivan was ambivalent; he had no love of art, had never bought a painting in his life and probably never would. Still, back in Toronto he'd sometimes watch *Antiques Roadshow*. The television program had taught him a valuable lesson: there was money to be made from other people's junk.

The stall's dealer eyed Groves and sensed an easy sell, according to O'Sullivan. The dealer told Groves he had another painting in his car, stashed there to protect it from the rain. He retrieved it and unrolled it for them to see. It was another vintage portrait, larger than the first, more intensely pompous. Its subject wore a poofy gray-white wig. The face was older, double-chinned, punctuated by a left eyebrow cocked arrogantly. A well-fed body disappeared beneath officious orange robes. To O'Sullivan it was Monty Python fodder, but Groves was keen on both paintings and doled out £60 for the first and £85 for the second. The dealer wrapped them in brown paper and bade them farewell.

Groves left Bermondsey feeling good about his purchase—he figured the paintings were a real steal. O'Sullivan had kept his money in his wallet, happy with nothing.

Back at his flat, Groves showed the portraits to a couple of friends, who were distinctly unimpressed. One of them, though, pointed to a small set of initials in the corner and suggested Groves get a professional opinion.

Groves invited O'Sullivan along on the field trip, to Sotheby's. Just that week a Picasso had fetched $2 million on the auction floor. In Sotheby's basement, hidden among the crates and boxes of fine art jetted in daily from across the globe, an art appraisal service was offered, free of charge. A

woman working the appraisal desk unfurled Groves's two paintings and froze. She recognized one of them.

Then she told Groves, "I think these are stolen." She summoned security guards and rang the police. O'Sullivan's reaction was instantaneous. "I'm outta here." Not that he wanted to abandon his brother-in-law, but this wasn't what he'd signed up for. Groves stayed put. These were his paintings—he'd paid good money for them, and he wasn't running.

Scotland Yard arrested Groves on the spot, drove him to the station, and showed him into a cell. Officers were dispatched to search his flat. To make things even more confusing, the police kept asking him about a third painting, one he knew nothing about.

Lincoln's Inn is one of four legal societies that every barrister practising law in London must join. On a Sunday evening in 1990, the only person at the Inn had been the warden. Just before five o'clock, he was knocked out by a series of blows. When he regained consciousness an hour later, his nose was broken, his hands were tied with wire, and his keys had been stolen. One man, maybe two, had unlocked the door to the Inn's Great Hall, a lavish banquet room for judges and barristers, the walls of which are populated with historical portraits staring down at the long wooden tables and leather chairs. Three portraits were delicately removed from their ornate, heavy frames and whisked off into the night.

The next morning the *Times* reported that the stolen trio of portraits was worth £6 million. Police speculated it was a made-to-order job for an unscrupulous private collector. They had no strong leads ("Did anyone see a red car leaving the scene?" they asked).

The police didn't know what to make of Groves. Could it really be dumb luck? The unlikely collision of high art and

flea-market penny-pinching? It had happened before. Groves was informed that the smaller portrait he'd first spied at Bermondsey lying face up in the rain was painted by Sir Joshua Reynolds. Reynolds founded the Royal Academy of Arts, and the portrait was of Francis Hargrave, the first treasurer of Lincoln's Inn. It had been hanging in the Great Hall since Hargrave had sat for Reynolds in 1865.

The second portrait, the one that had been rolled up in the dealer's car, turned out to be the work of master portrait artist Thomas Gainsborough. Poodle-head was Sir John Skynner, a judge, whose painting was commissioned in 1786. The National Portrait Gallery, the Tate, the Metropolitan Museum of Art, and the San Francisco Museum all hold portraits by Reynolds and Gainsborough in their permanent collections.

The third painting police kept questioning Groves about was a portrait of William Pitt the Younger, a prime minister of England, by Gainsborough's nephew, Gainsborough Dupont, who had studied under his uncle. When the police found nothing but socks and underwear at Groves's flat, he was released, charges dropped. The next day Groves accompanied police to Bermondsey, but the dealer who had sold him the portraits had vanished.

Groves's bargain-hunting instincts had proven truly stellar. His thanks? Being arrested, interrogated, and locked up in a cell while his flat was tossed. He was £145 poorer, and the paintings, rumored to be worth millions of dollars, had been confiscated. No reward had been posted or offered to Groves.

Danny O'Sullivan headed back to Toronto with a first-rate story to spin at the office. Still, for a salesman who loved the idea of a healthy return on investment, it was no Hollywood ending. Then Jim Groves received a phone call.

As O'Sullivan later recounted, "a staffer at a major London newspaper realized there was a medieval law that applied to Jim's case."

The law's origins were murky. It was called "market overt," and it predated the thirteenth-century reign of King John. In simple language, market overt stated that for any goods bought "between sunrise and sunset" and "in good faith" at certain open markets in London, legal title of ownership was allowed to pass to the buyer, even if the goods in question were stolen. Groves perked up. Bermondsey Market, it turned out, was one of only a few areas in London still protected by the ancient law.

"The newspaper," O'Sullivan remembered, "said they would back Jim if he decided to test the law." Market overt was an old loophole yawning into the twentieth century, and Groves could exploit it. Skeptical, Groves rang Stephens Innocent, a prominent London law firm, to get an expert opinion. Did he have a case? Innocent told him that, indeed, he had a case if he wanted to press it. Groves said yes.

Stephens Innocent moved quickly and aggressively. The law firm filed a lien against Scotland Yard for confiscating what the firm pointed out was Groves's property. The paintings slipped back into Groves's hands.

Then another interested party entered the fray: the insurance company that had paid hundreds of thousands of pounds to Lincoln's Inn. The insurers had been quietly keeping tabs on the events, tapping their calculators, and consulting more lawyers. And they found a loophole in the loophole. Their argument: Groves could keep the Joshua Reynolds, but market overt didn't apply to the Gainsborough. Why? Because the Gainsborough had been fetched from the car, and the car had been parked outside the limits of Bermondsey Market. Clever.

The insurers also dangled a finder's fee in front of Groves—£10,000. All Groves had to do was return the Gainsborough; the lawyers and lawyers' fees would vanish. Groves wasn't interested. Why take a £10,000 finder's fee when the painting might sell at auction for more than one million? The case seemed to be heading to court. A fresh round of headlines appeared in the tabloids. Then yet another player weighed in: Mark Dalrymple.

Around the same time that Groves was making headlines, a woman purchased a watercolor at Bermondsey Market for £15 and hung it in her living room. A couple of days later a friend came to tea and looked at it with astonishment. It was a Paul Klee, probably worth over £30,000. The woman could have used the market overt defense, like Groves. Instead she settled for a finder's fee of £3,500. "I didn't want to have stolen art hanging in my flat," she told a reporter.

Mark Dalrymple handled her claim. For a decade Dalrymple had made it his mission to obliterate market overt. With all the publicity the Groves case was garnering, Dalrymple also found something he could exploit—public outrage. The media coverage fueled Dalrymple's crusade. The *Observer* ranted, "Antiques markets just a 'charter for thieves.'" The *Daily Telegraph:* "The Ass That the Law Leads to Market."

One newspaper detailed the sad adventure of a burglary victim who headed to Bermondsey Market the Friday after the break-in only to find several of her bronzes and seventy-one pieces of her Chinese ceramic collection. The next day she went to Portobello Market, and then to Camden Passage. She returned to Bermondsey, where she recovered her harp. In total, she tracked down over two hundred items of her stolen collection at London flea markets.

It was a national disgrace. Scotland Yard jumped on the cause and released a statistic claiming that one-fifth of all goods sold at London markets was loot from burglaries. Of market overt, Richard Ellis stated: "We would like to see it abolished."

On January 3, 1995, Britain's House of Lords struck down the law of market overt, almost a thousand years after it had been created. Dalrymple was pleased, but in an article for *Lloyd's List* he noted, "The change in law, unfortunately, [is] too late to benefit the insurers of two portraits, by Gainsborough and Reynolds, which were stolen from Lincoln's Inn." The law did not apply retroactively. Still, it was a serious blow to art thieves in England.

O'Sullivan's lawyer had a bright idea: find out how much the insurance company had paid out to Lincoln's Inn and buy the Gainsborough from them. The suggestion played on the basic assumption that the insurance company, like O'Sullivan, was interested not in art but in money. O'Sullivan was shown a list of prices paid for Gainsboroughs at recent auctions. The numbers all had one thing in common: six figures, sometimes seven. The insurance company conceded it had paid £75,000 for the Gainsborough. Groves had already paid thousands on lawyers' fees; he couldn't afford that deal.

But O'Sullivan decided he would risk it. He mortgaged his house and for the first time in his life bought a painting—an amazingly expensive one. "The insurers gladly let the Gainsborough go for the fee," O'Sullivan told me. "Now we owned the paintings." Then he added, "Again."

O'Sullivan flew back to London and joined Groves when the portraits went up for auction. He remembered, "There were forty or fifty people in the room, well-dressed Englishmen. White collars. Blue shirts. And everything

happened very quickly. I was totally surprised. Paintings I thought were beautiful sold for peanuts. Paintings I thought were total garbage sold for thousands. An art auction is a strange place to go, I tell you. It really opens your eyes." O'Sullivan was beginning to understand that the world of fine art seemed to operate on its own code, its own secret rules, of which he was grossly ignorant.

The Reynolds sold as planned. The gavel came down. Bang. "Sold, for £22,000. Next item!" O'Sullivan knew who bought it—Lincoln's Inn. They'd offered to buy it directly from Groves and O'Sullivan for £20,000. He felt better right away, knowing it was gone from their lives. Then the Gainsborough came up, with a base price of £45,000. A gentleman bid £35,000. Silence. The gavel cracked. "Next item!"

"I'd thought they'd sold the Gainsborough. Because of the way he banged the hammer down," O'Sullivan said. "I thought, £35,000. Bang. Gone. I said to Jim, 'That's not too bad. We've sold it. At least we got some cash.' And then Jim said to me, 'No no no. We didn't sell it. It didn't meet the minimum.'"

"Holy mackerel," said O'Sullivan.

Groves approached the highest bidder after the auction, to ask if he was still interested. "The person said, 'Maximum I go is thirty thousand,'" remembers O'Sullivan. "We said, no way we're going to go for thirty thousand." The Toronto tourist was out of pocket £75,000. "Now I have a mortgage. I realized, if something went wrong at work, I could lose my house."

The Gainsborough went home with Groves. O'Sullivan flew back to Canada with a sinking feeling. Two weeks later he received a check in the mail, the proceeds from the Reynolds. When he thinks back on it now, O'Sullivan

admits they should have bypassed the auction house and just sold the Reynolds to Lincoln's Inn for £20,000. "Not because it would have been the right thing to do, but because they would have made it twenty thousand clean. The auction house charges a holding fee, insurance. They hit you with everything under the sun. We finished up with 17,500."

Two years passed. O'Sullivan says Groves hung the Gainsborough portrait of Judge Skynner at his flat. Groves's divorce had come through, and as far as O'Sullivan could tell from his desk in Toronto, he made no effort to sell the painting, and certainly made no further payments toward O'Sullivan's debt. O'Sullivan reached boiling point. "I told Jim, listen, give me the money you owe, or give me the painting." Groves didn't have any money.

Unbeknownst to Danny O'Sullivan, they'd jumped right into another hot debate, this one raging around laws meant to keep masterpieces at home in England. The debate culminated when Canadian media mogul Kenneth Thomson outbid London's National Gallery on a Rubens. Groves had applied for an export licence, and it was denied. The now former brothers-in-law, who weren't exactly friends anymore, decided to skip the red tape. They became smugglers. O'Sullivan smiles coolly and shrugs his shoulders. "Jim took a flight over to Toronto. He carried the painting under his arm rolled up in a case."

Judge Skynner had never intended for his image to leave English soil, but almost two hundred years after his death, his portrait touched down at Toronto's Pearson Airport. O'Sullivan was hoping that he'd have an easier time selling the Gainsborough in North America. He'd opened a tax-sheltered bank account in the Cayman Islands in anticipation of the huge sum of money he was expecting to collect. Nothing happened. His lawyer couldn't seem to find

a buyer. So O'Sullivan consulted another Toronto lawyer, Aaron Milrad, who specialized in art.

Milrad advised O'Sullivan to have the painting restored and appraised. O'Sullivan, not thrilled about the idea of pouring more money into the Judge, decided to go along with it. He handed the portrait over to Laszlo Cser, a discreet and well-regarded Toronto-based restorer.

I visited Cser at his studio in 2004. He is tall, with long black hair, and was dressed in a black shirt and black pants. The first thing he said to me was this: "Your success in life is directly proportional to the amount of risk you're prepared to take." Cser also said he was "one of the old dinosaurs. Self-taught." But he qualified that statement: "I'm also the beneficiary of many lifetimes of work. I do not subscribe to luck. I believe in preparation and opportunity."

Cser said it took him thirty seconds to diagnose the Gainsborough. "It was a wonderful work by a great artist with a technical seamlessness in it. There was no strain or difficulty. I meet it directly, face to face, and develop a relationship with the painting on an intuitive level. You have to actually see what is in front of you. And to respect what the artist did when they created the work. That's the low bow you have to take in this profession."

The Gainsborough had been rolled up quite a few times, and several cracks needed mending. The painting itself needed to be relined, due to its removal from the frame during the robbery, Cser surmises. A layer of surface dirt had also accumulated. Cser worked forty to fifty hours on the Gainsborough, which cost O'Sullivan close to $6,000. Cser justified that cost by stating, "When you have a heart operation, how long do you want the surgeon in there? I bring twenty-nine years of experience to everything I approach. Preparation and knowledge are essential. Danny went home happy."

Next on Aaron Milrad's list was having the painting appraised. O'Sullivan was referred to Richard Alasko, the president of the American Society of Appraisers, who flew up from Chicago. His expert opinion cost O'Sullivan $4,500. Next O'Sullivan sent the painting to a gallery in New York. He did not fly it south in a garbage bag. Instead, he paid shipping costs and insurance premiums and filled out Customs forms. That meant more lawyers' fees. The process cost him a few more thousand dollars. "The painting was hemorrhaging cash," he said.

For three months the Gainsborough sat in a New York gallery. When I called the gallery, the owner was not interested in talking about the Gainsborough. On the phone he said, "Do you know what this painting is?" Then he hung up.

Maybe the stolen-art stigma had followed the painting across the ocean. Or maybe Americans have no love for portraits of British judges. After idling in New York, the painting returned to Toronto, where O'Sullivan's patience was flagging. "It's really tough having all that money tied up in a painting," he said.

Then followed a couple of teases, just to keep O'Sullivan guessing. The recently launched cruise ship the *Queen Elizabeth 2* expressed interest but would not commit to a deal. And a mysterious buyer approached O'Sullivan's lawyers with specific instructions: Drop the painting off at one of the large banks downtown (O'Sullivan won't say which one) and leave it in the care of a third party. The client would then come and examine the painting. If the client was impressed, a lawyer would be in touch. O'Sullivan went along with it. The mystery caller never made an offer. The bank returned the portrait.

Then Charles Lippman called, the first of what had by now evolved into O'Sullivan's fleet of lawyers. Lippman

sounded optimistic. He'd found a promising buyer, rumored to be, of all things, an English judge. It was to be another secretive transaction; at this point nothing surprised O'Sullivan where the secrecy of the art market was concerned.

The contact turned out to be a Lincoln's Inn lawyer. That lawyer held funds in escrow while the portrait was once again shipped across the Atlantic, back home to England, to be inspected. Then it was over. The funds were released to O'Sullivan's account—sold for $100,000. O'Sullivan had lost $25,000 on the deal.

It had been nearly a decade since O'Sullivan and Groves had stumbled onto the paintings in Bermondsey Market. The two portraits had been owned by lawyers, stolen from lawyers, and haggled over by dozens of lawyers. They'd been instrumental in overturning the market overt law. For Danny O'Sullivan, it had been a series of financial pitfalls.

The proceeds from the Reynolds and then from the Gainsborough hadn't even covered the cost of O'Sullivan's initial mortgage, which meant there wasn't a dime left over for the £17,000 Groves had spent on his legal fees.

When I asked O'Sullivan if he had any advice for anyone entering the art market, he required no time to search for an answer: "Buyer beware."

# 11. _ _ _ _ _

## LAPD CONFIDENTIAL

"I can get all the alarms I want, but that won't do the job."

**BOB COMBS**

Detective Donald Hrycyk drove out to inspect the crime scene.

His destination was a mansion in Encino owned by a real-estate tycoon and his wife, who had built a paradise in the hills, above the sprawl, like so many of the rich in Los Angeles. They had also spent half of the last century building a multi-million-dollar collection of paintings.

Hrycyk noted that both victims were in their eighties. One was bedridden, the other had dementia, and they employed a large staff to help them: gardeners, a butler, and twenty-four-hour caregivers. On the afternoon of August 23, 2008, the side door of their house had been left unlocked and the staff had been out—even the maid. At least one person, perhaps as many as two or three, had slipped in and stolen more than a dozen paintings, including Marc

Chagall's *Les Paysans*, Diego Rivera's *Mexican Peasant*, and Arshile Gorky's *Cubist Still Life*. The couple was in their bedroom and did not see anyone, or their paintings, leave. Some of the paintings were worth hundreds of thousands of dollars. The Chagall, Rivera, and Gorky were worth millions. "It was one of the largest art thefts in the history of the city," Hrycyk told me. By this point in his career, the detective had developed a methodology for residential burglaries—a postcrime checklist.

The mansion was a one-hour road trip from his desk at police headquarters. When he arrived, Hrycyk asked the owner if he had photographs of the stolen paintings. He did; he had detailed records of his art collection. This was rare, and it gave Hrycyk an advantage.

Most L.A. detectives dealing in stolen property would feed their information into the giant electronic memory of California's Automated Property System (APS), a database maintained by the Department of Justice, where all the missing things that all the people in California have had stolen live on for a time. But "the APS wasn't built for unique items like artwork," said Hrycyk. "It was designed for manufactured goods from the Industrial Revolution, engraved with serial numbers, like cameras, TVs, and computers."

Instead, once the detective had gathered those photographs and was back at his desk, he emailed them to the Art Loss Register, the FBI National Stolen Art File in Washington, and Interpol. The faster Hrycyk fed them those images, the easier it was for an auction house anywhere in the world to identify the works as stolen. Check.

The Art Loss Register, Hrycyk told me, provided him with a more specialized institutional memory than his own government database. He was in contact with Christopher

Marinello, a lawyer with the ALR, who said that 491 art-works were registered as stolen in California. Almost half of those, 236, had been taken from private homes, and Marinello speculated that the paintings either would be found within a few months to a year or would head underground for a generation. It was an ominous prediction, and one Hrycyk agreed with.

Next, Hrycyk tackled the media. Many art dealers and auction houses don't look at lists of stolen art before they buy art, but they can't ignore the news. The stolen paintings were by brand-name artists, and expensive, so there was some gritty glam to the story. "That really helps," said the detective. There was also a carrot to dangle: a $200,000 reward. Hrycyk usually discussed the possibility of rewards with victims of art theft if there was an insurance company responsible for the claim. So far, he had been profiled in *Los Angeles* magazine, *Art & Antiques*, *LA Weekly*, and *Artillery*, and his cases had been reported in the *Los Angeles Times*, the *Boston Globe*, and the *Times* in London. He wrote up a press release and beamed it out to his media contacts. Check.

News of the Encino theft and photographs of a few of the stolen paintings appeared in papers all over the world, including the *Los Angeles Times*, the *New York Times*, the *Independent*, and the *Daily Telegraph*, and on the BBC. At my kitchen table in Toronto, I opened the *Globe and Mail* and read the story over a cup of coffee. Hrycyk's press release was reported as far away as Taiwan, and the detective told me he did an interview with a radio station in Colombia.

The *Los Angeles Times* article quoted Richard Rice, manager of Galerie Michael in Beverly Hills. Rice, a senior consultant and dealer to Hollywood celebrities, noted that

L.A. art collectors were a particularly secretive bunch; they didn't show off their collections. The good news was that this group of paintings was rare and would be difficult to sell on the open market, because only a small group of galleries in New York, London, Vienna, Paris, Zurich, and Geneva specialized in these artists. It's a small world, Rice was saying. Not small enough, Hrycyk was thinking.

While Hrycyk was fielding media inquiries and analyzing evidence from the mansion, he was also posting images of the paintings on the LAPD Art Theft Detail website. The website had evolved into another valuable tool and was a quantum leap forward for his two-detective unit. The Art Loss Register charges per search and the FBI website is searchable only to other branches of law enforcement, but the LAPD Art Theft Detail website that Donald Hrycyk and Stephanie Lazarus built is free to anyone who wants to look at it, and information or pictures posted on it come up in Google searches. So when an auction house did a quick Internet search on any one of the stolen paintings, their names and images would pop up in the usual 1.23 seconds. The Art Theft Detail website had already yielded some impressive recoveries: Hrycyk estimated it alone had been responsible for finding over a half-million dollars' worth of art.

One example on the website: In 2003, an investment counsellor was moving offices—furniture, boxes, and an Andy Warhol print. An assistant told the moving company to be especially careful with the print because it was valuable. The print never made it to the new office, and the investor didn't realize for a few weeks that it was gone. Hrycyk investigated, and employed his system of recovery—including posting a photograph of the Warhol print and its edition number on his website. Almost a year later, an attorney representing an art collector walked into

Hrycyk's office and handed back the Warhol. The collector had bought it in good faith through an L.A. art dealer, said the attorney, but had recently spotted it on the LAPD Art Theft Detail site. Once the collector saw that it was stolen, he couldn't enjoy its presence in his house any longer. (He was reimbursed by the dealer.)

In addition to the stolen art databases, the media coverage, and the web presence, Hrycyk also sent out what he calls a "Crime Alert"—an email beamed directly to professional contacts, including art galleries, dealers, auction houses, and police forces in California and far beyond. The Crime Alert included all the information registered with the ALR, but it was sent directly to the places where a thief might try to sell the work—to the art community. Hrycyk has spent two decades developing these contacts, and every time he meets with a new auction house or art dealer, the information is absorbed into his Crime Alert list. Check.

One week later Hrycyk received an anonymous tip from a man who identified a private residence in San Diego as the possible safe house for the stolen art. An LAPD officer was dispatched to knock on the door. "We explore all leads," said Hrycyk. The woman who answered was a professor, and she agreed to a search of her house. There was nothing suspect, certainly no stolen paintings.

Later that week San Diego police got a tip suggesting that a cache of weapons was being stored in the same house. San Diego PD couldn't take any chances, and this time more force was used. The police turned the residence upside down. Nothing. The hunt was based on a bad piece of information. It turned out the professor had rented a room in her house to an ex-convict and the two had had a disagreement. She had kicked him out. "It was a revenge tip," said Hrycyk, and then continued, "This is a tough

case. No witnesses, little evidence, no informants, no video footage, and nothing to identify a suspect." Hrycyk could only guess at the level of sophistication of the criminals he was dealing with. "If we get lucky we might come into contact with the thieves while they are trying to move the art. If that person hears about the reward, they could earn $200,000. That hasn't happened yet. The thieves might sit on it awhile. If they aren't desperate for money, that would be a good strategy." He paused. "The paintings will turn up. It's just a question of how long." For now the detective would wait. He had learned to be a patient man.

At night Los Angeles is an electrified concrete field with giant patches of darkness that hover like storm clouds above its glow—the surrounding hills. As usual, Donald Hrycyk got up at 3:30 AM and cruised the freeway system into the asphalt heart of the glittering city. When he arrived at his desk the sky was still dark; sunrise this June morning hit at 5:40. A few hours later, after checking for updates on his cases, he left his desk and came to meet me.

I visited Los Angeles during a heat wave in the summer of 2008, just a few months before the burglary in Encino. By midmorning, the city had wilted under the open sun, the nicotine-colored haze shimmered under a rusty blue sky. Hrycyk picked me up outside the Metro Plaza Hotel, a stone's throw from Olvera Street, where the first house in Los Angeles was built. The street is now home to a cheerful alley of stalls selling Mexican American tourist trinkets and food, and is itself within view of Union Station, the gateway to the city before the airport was built.

The detective shook hands with me. We'd spent hours on the phone, but this was the first time we'd met in person. Hrycyk's uniform, I learned, was always the same:

plain workmanlike slacks or jeans, a comfortably worn loose checkered shirt, black New Balance running shoes, the big digital watch—and an easygoing manner. His eyes are a pale shade of meridian turquoise, the same color as the muscle car he drove in university, and cast a quiet, assured gaze. Hrycyk's face holds the mark of a life lived under the powerful California sun, pale skin colonized by patches of pink. I pointed out the sun factor, and he told me about a machine at Venice Beach that can take a picture of a person's face and reveal the years of sun damage under the surface. "It's like the way you can put a painting under ultraviolet light and see all the years of damage to the canvas. To the eye it's invisible, but the damage is there," he said. "History."

Hrycyk studies people, isn't quick to speak, and doesn't project a hint of antagonism or machismo. He watches and learns. During our phone interviews before and after my visit, the detective never once interrupted a question I was asking, and he always took a moment to think before giving an opinion. He patiently corrected me a few times, when I said "robbed" instead of "burglarized."

"*Robbery* means to take by force or fear. *Burglary* is to enter a premises with the intent to steal. I work in Burglary Special," he said. Of the art detectives I interviewed, he was the most transparent about his casework and the details of his investigations. He had the feel of an old-fashioned detective who loved his work and seemed to live for it. If I ever had something stolen, I would want Hrycyk to investigate. As we cruised through Los Angeles, he seemed as if he were a part of the city and not just a person working for the municipality.

One of the first stories Hrycyk told me on that visit wasn't about art theft or any of the cases he had handled: it was about the character of Los Angeles itself. Earlier that

week, a young girl selling lemonade in front of her house was startled when a man ran up to her homemade stand and ran off with her change jar. The twelve-year-old didn't hesitate. She called 911 on her cell phone and ran after him. The girl followed the man for more than ten blocks in the white heat while keeping police updated on his location. The LAPD cornered the lemonade-stand thief in patrol cars while the girl watched. She got back her money. "That's Los Angeles," said Hrycyk. "People here are fighters."

On the drive to his office, Hrycyk took me through the downtown limbo that locals call Skid Row, where lines of men camp out on the curb, barely dressed and washed. "This is the corner where hospitals sometimes just leave unwanted patients with no health coverage. They drop them here with nothing but their hospital gowns," he said. "There's a fire station near here and the trucks actually have decals stencilled on the side that read 'Skid Row.'"

Our destination was the Parker Center, at that time the police administrative compound, an eight-story building at 150 North Los Angeles Street. It was squeezed into a neighborhood between Little Korea and Chinatown, not far from the Civic Center. From the roof of the parking garage off San Pedro Street, Hrycyk pointed to a set of old row houses in the near distance. "Raymond Chandler used to live in one of those." Right around the corner there is a major collection of art—the Geffen Contemporary at MOCA (the Museum of Contemporary Art).

Out of the bright sun, inside the blue and white hallways of Parker Center, officers and detectives clipped past us. Hrycyk pointed out that parts of the police compound had been transformed into an art gallery of sorts; we looked at a series of crime-scene photographs from the fifties, sixties, and seventies on display in the halls. The photos had

been found in a storage closet decades after they were taken by crime photographers. There's Charles Manson, taken after he was arrested for the murder of Sharon Tate; an old getaway car riddled with bullet holes; a stark field where the body of the Black Dahlia, murder victim Elizabeth Short, was found—the case James Ellroy turned into his most famous crime novel, *The Black Dahlia* (adapted into the film starring Josh Hartnett). There were portraits of the Hat Squad of the 1940s and 1950s, detectives wearing cream suits and cream fedoras staring out from sepia-toned prints— think *L.A. Confidential.* History.

One case Hrycyk had investigated stretched back to Hollywood's golden age, the 1940s, he told me. "Lana Turner had commissioned Peter Fairchild to paint a full-length portrait of her." Fairchild worked on Turner's portrait for weeks, and was close to finishing when one day it simply vanished. In 1994, it surfaced in the collection of a person who had purchased it twenty-five years earlier from an auction house. "That case was so old that there was no original crime report or paper trail to fall back on," Hrycyk said. "At the time the portrait was found, Lana Turner was in hospital. She was dying." Turner's daughter decided to let the matter go, and the painting remained with its owner. Hrycyk noted that Turner's portrait had never left Los Angeles—it had been hanging, hidden from the public, on a collector's wall.

Burglary Special is just down the hall from Homicide Special; each division's door has taped to it a piece of 8½-by-11 paper run off a photocopier, with bold black letters announcing its title. Hrycyk opened the door to Burglary Special. The room is bare-bones, cubicles pushed together in sections of four or six, a few shelves stuffed with papers and books, filing cabinets, and a row of windows to let in natural light, which softens the glare of the fluorescents

strung along the ceiling. Behind Hrycyk's desk there's a crack in the wall that runs floor to ceiling—a souvenir from an earthquake.

This is where Hrycyk spent his days, across from his partner, Stephanie Lazarus. "Steph isn't in the office today," he told me. "But maybe you'll meet her later in the week. In the old days Burglary Special was primarily made up of teams of two detectives working on one problem," Hrycyk explained. "The tradition of detective work has always been to work in teams of two, with one higher-ranking detective taking the lead and mentoring a lower-ranked detective. It's one of the ways we learn." Los Angeles PD has been working this way for over 150 years, since it was first formed in 1853.

The history of Burglary Special stretched back almost that far, and its name means exactly what it advertises. The detectives here hold citywide knowledge of their areas of crime—they view burglary through a wide-angle lens. When there is a complex pattern of burglaries that stretches across more than one division, that case is passed to this room. Art theft fell into this category.

Hrycyk provided a quick tour. There was the "hotel theft detail": self-explanatory. The Interstate Theft Task Force, which dealt with, for example, Colombian gangs that conducted professionally choreographed baggage thefts at LAX. He explained, "The jewelry salesman leaving the airport will stop at a red light. One thief slips out and ice-picks the back tire. The salesman pulls over to the side of the road. The thieves get out. One helps the salesman with the flat tire. The other helps by taking the briefcase with the jewels. The salesman won't even know what hit him until they're out of sight. Half a million in stones, gone, just like that."

Like all the desks in Burglary Special, Hrycyk's is equipped with a worn brown phone. I pointed out that his phone looked like an antique. He laughed. "Yeah, these are very old phones," he said. "They are made from parts that aren't actually manufactured anymore, so when one breaks down we have to cannibalize others to keep it working."

His desk is piled with art theft case files and is separated from Lazarus's by a wall of thick blue binders, each one labeled by year: 2007, 2006, 2005. Across the room is a rickety set of simple brown bookshelves packed with dozens more blue binders that go back to the 1980s; these are the binders that Bill Martin began.

Detective Martin retired in 1992, and for a time another detective picked up his art theft cases. In 1994, though, Don Hrycyk was recruited to return to the Art Theft Detail—to lead it. When Hrycyk took over, he was surprised to learn that all those blue binders had been moved to a storage warehouse, with a destruction date. One of the first things he did was retrieve the binders he was now holding in front of me. "If I hadn't, they wouldn't exist." The detective flipped through a couple of pages. The notes were handwritten, sometimes with photographs of artwork paper-clipped to a report.

"A formal case always begins with a piece of paper," he explained. "A report is written down from notes taken from the crime scene, as well as witness statements. Once the report is filed, there is a record that can be accessed in the future." Hrycyk's blue binders represent hundreds of unsolved cases. Without those reports, there would be no record in the department that those crimes ever took place—it would be as if they had never happened. When Hrycyk took over the unit, his challenge lay in finding the time to transfer the information from the binders into

a computer database where he could actually sort and use the data.

"When I started at the LAPD there were no computers," he said. "Everything was handwritten. My handwriting was so bad that I was looking for a way out." Hrycyk brought the first computer into Burglary Special. "Now we've turned into the computer nerds for the squad room. We're always investing our own money buying stuff so that we can try to keep relevant." When Lazarus joined the Art Theft Detail in 2006, the two detectives dedicated volumes of time to data transfer. "I'm not sure how many hours Steph and I spent transferring names of suspects, contacts, and names of stolen artworks into the computer system. Hundreds of hours." It was administrative grunt work, but with a payoff.

Hrycyk's careful preservation of information resulted in a comprehensive list of art thieves from all over the world. As a test, I asked him to look up the name of the art thief I had met in Toronto, and I gave him only the first name. The detective punched a few details into the keyboard, waited a second, then scrolled down the list for about a minute, and stopped.

He turned and said, "Is his name ——— ?"

Hrycyk was correct. I thought of Paul saying, "He who controls the information controls the world."

When I asked Hrycyk to speak generally on the subject of art theft he did so cautiously, and always with a caveat: "Almost every case we work is unique. We learn from each of our cases," he said, looking at his computer. Most of the cases Hrycyk investigated fell into the category of home burglaries and usually didn't make the news; they slipped under the media radar because the art wasn't famous enough or the victims didn't want to go public. Hrycyk, though, with his bird's-eye view of the problem,

saw art disappearing from all over the city, and he noted that thieves were evolving, becoming more aggressive, even though the art community had not adjusted accordingly. It was as it had always been—secretive.

During our first meeting at Parker Center, Hrycyk gave me a list of names and phone numbers to help me with my investigation. It was as if he'd recognized that, because of the secretive and sensitive nature of the art community, I'd have a difficult time getting anyone else to talk to me while I was in Los Angeles. I examined the list. It included a couple of high-end auction houses. I phoned them and left messages, but they did not return those calls. Also on that list were the names of a well-known art dealer, Leslie Sacks; the head of security at the Getty Center, Bob Combs; and one of the most famous artists in Los Angeles, June Wayne.

Wayne lives in a beautiful low-slung house on Tamarind Avenue, across the street from the Hollywood Forever Cemetery, where lie the bodies of, among other stars, John Huston, Peter Lorre, and Rudolph Valentino. "Valentino is my neighbor," Wayne told me. "Once a year I used to see one or two women dressed in black come to visit him, but now several hundred ladies in black show up. The cemetery partly supports itself by holding rock concerts. It also shows free movies projected on the wall of the mausoleum for the poor people of Hollywood, who show up with lawn chairs and beer. When that happens, a lot of my neighbors have a coronary. But this is Hollywood," she laughed. "The fact of the matter is, the U.S. thinks it's a movie. Otherwise, you cannot explain the dramas that go on in this country now." This afternoon Wayne is sitting on a white couch in her spacious living room, her recently printed catalogue raisonné lying open on a nearby table.

Wayne was ninety years old when I visited her live-in studio, although she had the curious eyes and spark of a twenty-five-year-old. Her ninetieth birthday party, which Hrycyk and Lazarus attended, was featured in a "Talk of the Town" piece in the *New Yorker*. She told me that when she canceled a recent lecture at UCLA, a few members in the closely knit arts community simply assumed she had died. "That's what happens when you reach my age," she said, and smiled.

Wayne, one of the preeminent figures of the Los Angeles visual arts community, arrived in Hollywood around the same time that Lana Turner was crowned the first scream queen for her role in *Dr. Jekyll and Mr. Hyde* and Humphrey Bogart and Ingrid Bergman were starring in *Casablanca*. "When I got here in the 1940s, Edward G. Robinson and Vincent Price were in charge of culture. Hollywood's rich and powerful supported the museums in New York, and even when this city built its own museums, the boards were controlled by people from other parts of the country. I remember there was actually an initiative to get board members who were from Los Angeles," she told me.

"The community of artists here was very much affected by geography—this vastness of Los Angeles—and the fact that it's an automobile culture. So there were these clumps of artists, like clumps of bacteria on a petri dish. Bacteria, if they are close enough to each other, stimulate each other. If they are too far apart, they will die. So when we got together, it would be very intense. Los Angeles was large enough for many kinds of creative people to coexist without annoying each other: writers, filmmakers, musicians, and artists. And there was a tremendous influx of talent because of the refugees that Hollywood brought over, to save from Hitler—I'd visit Toscha Seidel and listen to him play

chamber music. Have you ever gone to a Passover seder with Aldous Huxley reading the Song of Solomon?"

Wayne proved instrumental in helping the artistic bacteria in Los Angeles to thrive. In the 1940s and '50s, she focused on the art of lithography. At a party in 1959, she met W. McNeil Lowry, director of the Ford Foundation. He was so impressed by Wayne's passion for lithography, he asked her to send a pitch to the foundation detailing what would be required to reinvigorate that art. Wayne told me she worked on that proposal for six months, sent it in, and the Ford Foundation said yes; she received $2 million in start-up funds. In 1961, four years before the Los Angeles County Museum of Art opened to the public, she opened the Tamarind Lithography Workshop, a haven in Hollywood where artists from across the United States and beyond could visit to work on printmaking. Tamarind became renowned as a global center for lithography, and Wayne attracted some of the most exciting talent of the day.

"Back then print was the poor man's art," she told me, "and part of my job at Tamarind was to bring the price of prints up . . . That was quite a test in market impact, and I was thoroughly excoriated by art dealers and curators here, who enjoyed being able to buy prints for five or ten dollars."

The price of prints climbed, though, and Wayne's own work skyrocketed in value over the decades, while Los Angeles became the second-largest art market in North America. And along with the growth of the legitimate market came the criminals. Wayne told me she has had art stolen at different points in her career—at least eight major works, and many lesser-known, smaller pieces. In the early 1970s, she was creating large tapestries, one of which was purchased by the University of California at Los Angeles

to decorate the lobby of the molecular biology department. Wayne supervised the installation herself. "It was built to last," she said.

In 1975, the tapestry disappeared. "The thieves who did it must have worked hard. It was really high up, and bolted right to the wall," she told me. "They used a ladder for sure. And because it was sewn on to a metal grid, they could not have rolled it up when they stole it. They would have been forced to walk it off campus. I have no idea where that one is," she said. "My personal feeling was that it was an inside job, and I'm convinced it went directly from the wall to the airport onto an airplane to somewhere far away, like the Middle East."

Wayne told me a stream of smaller prints had also been smuggled straight out of her studio. In fact, Wayne said, her dealer had spotted a few of those prints within the last few years at a well-known Los Angeles art gallery. Wayne wasn't sure what to do. "Years have passed since they disappeared," she said. "This is not uncommon, though, in the art world."

For decades, she has kept handwritten lists of all the artwork produced at Tamarind. "I lead an anti-art-theft life," she said. That afternoon, she picked one of her notebooks off a shelf and opened it up on her lap. They reminded me of Hrycyk's blue binders. Her finger scrolled down a neat list with names of prints, dates, and status. "See," she said, as her finger paused now and then on the page in front of us. Quite a few of the entries had the word "Missing" next to them.

Wayne met Hrycyk and Lazarus because she had shipped eleven pieces from her studio for a show at Rutgers University. The eleven tapestries went into eleven crates, but only ten crates came back to her. She called the police and was directed to the Art Theft Detail. "Within hours of those detectives getting involved, the image of my missing tapestry was all over the Internet." One week later, Hrycyk

and Lazarus walked through her door. "Those darlings came here with the tapestry in their arms. The tapestry was dusty and dirty but not damaged," she said. The huge tapestry, part of a series she called Lemmings, hung on the wall above us, over the open staircase that leads to the second floor of her studio, dominating the space.

On that afternoon, we discussed the growth of the arts community and the impact of the rising prices paid for art on instances of theft. "The slippery part of art theft is the roiling art market," she said. "The commoditization of fine art is the new way to make fast money. Art has turned into an international product. Things have changed."

June Wayne died on August 23, 2011; her obituary appeared in the Sunday *New York Times*.

During my visit to Los Angeles, Donald Hrycyk dedicated many hours to giving me a tour of his empire of cases— his work was the most detailed example I found of a North American city interacting with the global black market.

The stories the detective told me had a ring of familiarity to them. Hrycyk didn't know the term "knocker," but there were certainly knockers in Los Angeles. Paul's business model was practised here; prizes were being stolen from houses and slipped into auction houses or galleries and then onto a collector's wall. Because Hrycyk often found himself face to face with some of the city's most prominent citizens, he was careful not to mention names unless it was necessary or there had been media coverage. Some of the cases he discussed were also posted on the Art Theft Detail website as examples of situations to avoid or be mindful of—cautionary tales for art dealers and collectors.

He told me about the Hollywood film producer who'd been raided of $400,000 worth of art, including a Tiffany

lamp and a 1937 drawing by Pablo Picasso called *Faune*. When Hrycyk showed up at the mansion, it looked like a straightforward break-in. The window of the back door had been smashed, and shards of laminated glass were still stuck to its frame. Laminated glass, though, stays stuck in the formation in which it is broken. Hrycyk noted that the shards on the door were bent outward, toward the garden. "The window was broken from the inside. So the thief had already had access to the house. He then beat the glass while standing in the dining room. This was an inside job," he concluded.

The film producer, like the couple in Encino, employed a large staff: twenty-nine people, including nannies, maids, cooks, gardeners, and assistants. Hrycyk interviewed each of them, but no one knew or saw anything. He went through his checklist and waited. A few months later Christie's in Beverly Hills called. A man had walked into the auction house with a Picasso, valued at around $100,000. He said he was a football player who had some money to throw around and had bought the print on a whim. "It's ugly, though," he said. When Hrycyk had beamed out his initial Crime Alert, Christie's had printed up the photos and kept them in a binder. The employee checked the binder, saw the match, and called Hrycyk. Keep the man there, Hrycyk said.

Beverly Hills police surrounded the auction house in unmarked vehicles and seized the Picasso, wrapped in a dirty T-shirt, from the trunk of a BMW. Hrycyk examined the Picasso, and the man. "We'd met before," he told me.

Sammie Archer III had almost become a pro football player but was, in fact, the movie producer's chauffeur. In Archer's pocket Hrycyk found a list of art and antique stores. One of the antique dealers had bought most of the movie producer's stolen art from Archer, no questions asked, for cash—except for the Picasso. By the time

Hrycyk showed up at the antique store, the dealer had sold the Tiffany lamp to a dealer in New York. Hrycyk followed the chain of sales. He learned that in just a few months the lamp passed through five buyers, almost quadrupled in value, and crossed an international boundary. "It had been appraised for $75,000, but it had been sold to a Canadian collector for $275,000," Hrycyk told me. "And every time it moved, it got more expensive, and cleaner. If I hadn't found this guy [the chauffeur] at that particular moment, we probably would never have recovered it."

Auction houses were a frequent destination for artwork stolen in home invasions, just like in the United Kingdom. Hrycyk told me about a married couple who answered an ad in a newspaper placed by an art dealer interested in appraising and buying art collections. The dealer arrived, but the husband was late getting home from work, so only the wife was home. She was polite, invited the dealer into their house, and showed him a work by American artist William Aiken Walker, famous for his depictions of eighteenth-century cotton-field workers in Virginia. "The painting was a beautiful example of Walker's signature work," noted Hrycyk. A few minutes later she felt a chill of fear when she realized the "dealer" didn't seem to know anything about art. She went into the kitchen to turn off the oven. When she came back, the "art dealer" was leaving, with the Walker. He walked out the front door, got into his car, and drove away.

A few months later Hrycyk was looking at a photograph of the same Walker, gracing the cover of an L.A. auction house catalog. Hrycyk called, attended the auction, waited for the thief to show up, and arrested him. "If he'd held on to it, or taken it out of the area, we might not have caught him," he told me. Like Sammie Archer III, the thief had been caught because of his impatience, greed, and lack of imagination.

I got the sense from Hrycyk that dealing with auction-house cases could be tricky and required equal measures of diplomacy and grit—that L.A. fighter spirit. He told me about a brawl he got into with a prestigious house. That case had started when a New York art collector returned to his apartment to find a window pried open and works by Picasso, Miró, and Chagall stolen. The NYPD didn't turn up any suspects, but the collector was enterprising. He printed up a flyer with pictures of his stolen art and sent it to auction houses and art dealers across the country. One of his flyers landed on the desk of a major auction house in Los Angeles; Hrycyk wouldn't say which one. Close to a year later the auction house received an unframed Picasso aquatint from the Vollard Suite entitled *Minotaur aveugle guidé par une fillette dans la nuit*, valued at $50,000.

A staff member still had a copy of the flyer, and it looked like the same print. She'd dealt with Hrycyk before and rang to let him know. When Hrycyk called back he was directed to the auction house's attorney. "It didn't go well," he told me. "It was clear the lawyer was more concerned about protecting clients than the prospect that his business might be used to launder stolen artwork."

Hrycyk tried to schedule a meeting to inspect the Picasso, but the meeting kept being moved or canceled. He realized the delays were a play for time—the attorney had contacted the New York consignor of the print and informed him that the police were investigating. "So this attorney decided to make himself the arbiter, to determine if the print was stolen and whether the consignor was criminally culpable. That's my job," said the detective. "By alerting the suspect, the attorney had allowed him precious time to conceal any other pieces he might have been in possession of—the Chagall and the Miró stolen in the same burglary. He now also had time

to rehearse a story that might sound plausible, knowing he would soon be interviewed by the police." Instead, the seller stuck to a ludicrous explanation: that he had bought the Picasso from a man on the street.

Hrycyk was finally granted permission to examine the Picasso. He pored over it. Bad luck. It was one of an unnumbered series consisting of 250 prints, all made in 1934; there were 249 others exactly like it. Hrycyk contacted the print's owner, who sent him an old photograph of it. The detective put it under high magnification and peered at Picasso's signature. When he enhanced the image, he saw something in the lower right-hand corner, cut off by the frame. "It appeared to be the number 92." Hrycyk spent hours researching Picasso's series and hunted down sixteen of the remaining prints from the same 1934 edition. None of them had a number in the corner.

Hrycyk went back and studied the auction house's Picasso. There was no number on it, but that didn't mean the number had never been there. Hrycyk noticed that the right-hand corner had "a disturbance" exactly where the number was on the photograph. The detective needed a pair of better eyes, so he photographed the mysterious corner of the auction-house Picasso and sent the images to an El Segundo aerospace corporation that conducts detailed photo-imaging analysis for the U.S. Air Force.

The analyst found what Hrycyk couldn't: a visible erasure had been made to a pencil notation in the corner. The super-magnified view clearly showed that someone had erased a number from the Picasso, and the erasure exactly matched the visible portion of the number on the photograph of the stolen print. What is amazing is that even after someone had erased the number, the aerospace analyst could see it clearly: what Hrycyk identified as a 92 was

actually a 97. The lower part of the French numeral 7 had been cut off in the photo.

The analyst went further. He magnified the image of Picasso's signature on the photograph and corrected distortions caused by the angle at which the photograph had been taken and by the size of the image. He measured the exact position of various points in the signature in relation to the edges of the Minotaur image above it, which he then compared to the same reference points on the sixteen similar prints that Hrycyk had tracked down. When superimposed over the photograph, only one print matched the location and measurements of Picasso's signature—the print at the auction house.

Hrycyk doesn't sound self-satisfied when he tells this story. He's deadpan. The Picasso was returned to its rightful owner, but only because Hrycyk was stubborn, and because of aerospace technology. Hrycyk also found evidence that suggested enterprising criminals from various fields were becoming more interested in fine art. When the LAPD raided the home of a well-known drug dealer named Darrin Wright, it found a cache of fine art along with drugs. Hrycyk was called in to make sense of it.

"Wright was fascinating," he said. "He bought and sold drugs but stacked his home with art. We found over two hundred works stashed there when he was arrested, and there was evidence of selectivity. Apparently he'd put the word out, 'If you bring me art and antiques, I will buy them from you.' He seemed to enjoy collecting other people's treasures." Wright may also have been accepting art as payment for money owed to him, and it is possible that he was positioning himself into the middleman slot as handler, like Paul. "He was hoarding it, maybe trying to figure out what it was worth, and perhaps studying the various paths

it could take while being laundered into the art market," suggested Hrycyk.

Up the food chain, art galleries and dealers were also being burglarized. Before Hrycyk had first started out, in 1986, he'd rarely set foot in a gallery, but now he knew most of the dealers, and some were facing aggressive thieves. Hrycyk told me there were gangs who smashed their way in through front windows with blunt objects and drove away with the artwork: this really was the Wild West. That became clear to me when I rode along with him and Lazarus to the antique-store burglary on La Cienega Boulevard. But that was a sophisticated theft compared to some of the crime scenes the detectives were called to. "Sometimes these guys are just brutal," said Hrycyk.

Leslie Sacks Fine Art is tucked into a strip mall in the upscale L.A. area of Brentwood. Its owner agreed to meet me one hot afternoon. The entrance to Sacks's gallery faces a parking lot, where a mounted flag advertises to the passing traffic: MIRÓ, CHAGALL, PICASSO. Sacks had been burglarized twice in two years. In both cases, the thieves smashed his windows—triggering the alarm—and quickly raided the room. After the first burglary, in which a David Hockney was stolen, Sacks paid for Plexiglas windows and doors, but his security measure wasn't enough. The thieves returned, and brought a giant steel pipe to smash the Plexiglas repeatedly until they knocked it out of its frame. That took a little longer and required more force, but even though the alarm was triggered in the process, they still had enough time to steal another Hockney. They walked right past a Picasso.

When Hrycyk investigated, he noted that fact. "It was possible they were filling an order for a Hockney, or that

they were smart enough to know that a Hockney would be easier to sell on the open market than a Picasso . . . less recognizable. Either way, the gang responsible was savvy." They have not been caught, and the Hockneys have not been recovered.

On the afternoon I visited, Sacks Fine Art was displaying works by David Hockney, Frank Stella, and Jasper Johns, ranging in price from $20,000 to $60,000. "The entire business of dealing art is based on trust," Sacks told me. "And there will always be dealers who violate that trust and who take advantage of people's greed and vulnerability. Good dealers with good sources are the ones to use because this reduces the risk for the buyer." For Sacks, good business is all about building personal connections and knowing the people with whom he is doing business. "When a painting is stolen, it has to be laundered," he said. "There are two ways to do this. One is to send it to Japan or to another country very far away. The other way is simply to hide it somewhere for a very long time, until anybody who would recognize the stolen painting is dead or has long forgotten it." The art market is self-policed, Sacks admitted. "That system works most of the time, because a dishonest dealer will be ostracized from the community." He remembered one man he once did business with who turned out to be a con man. The man built up a sense of trust with Sacks over a period of many years. "I later found out he lied about every aspect of his work. He generated false invoices and false artworks. I offered him a chance to give me back what was stolen from me." In this case, it was money. "I said give me half of what you owe me. He laughed at me." Sacks informed his colleagues about the man.

As Sacks pointed out, art isn't the only industry to rely on trust. "Diamond dealers function in the same way," he said.

And it was because of that trust factor that he thought buying at auction houses was a risk. "Would you buy a diamond at an auction? Would you buy brain surgery at an auction?" Sacks called the entire trade around auction houses "the Las Vegas complex." He felt that there were too many back-room deals and that it was impossible to know what was actually happening inside those businesses. "Every Picasso is different, every invoice is different," he said.

Later, Sacks stood at his gallery's front door between a pair of large bay windows in a blade of six-o'clock sunlight that cut harshly through the glass. He watched a mechanical wall of bars lower over his gallery windows—the new countermeasure. It was something of an iconic image: an independent gallery owner, a self-made man, protecting his business.

He talked to me about what happens to stolen paintings by well-known artists, like the Hockneys taken from his gallery, but he approached the issue from a philosophical point of view. "In America everybody wants everything now, and everybody believes they can have it right now," he said. "This is not the case in many cultures around the world. In the Middle East or China, time is viewed very differently. A person could buy a famous work of art, a Picasso, say, and not worry about having to do anything with it right now. That person may wrap up that stolen painting and hide it away in a cellar or a safe and not plan on touching it during his lifetime. He may view that stolen painting as an inheritance—not even for his own children, but for his grandchildren."

A few minutes later we were gliding down Santa Monica Boulevard. Sacks was at the wheel of his Porsche, its windshield refracting a hazy pink sunset. He turned to me and said, "The art world is way stranger than you could possibly imagine. But maybe you've figured that out already."

Later that week, Hrycyk pointed out that it wasn't just the art inside galleries that vanished—sometimes it was the gallery itself. He told me about one gallery that had accepted work from hundreds of clients over a number of years. Then the gallery disappeared. "Not a single victim phoned the police," said Hrycyk. "It's a great example of how people can lose things and just keep going, as if they're made out of Teflon." Hrycyk heard the story almost by accident. An LAPD officer from another division had brought a photograph of her recently deceased father into the gallery to have it framed. When the officer went to pick it up, the gallery was gone. Her partner said, "I think there's a unit in the LAPD that deals with this kind of stuff." Hrycyk sent out a Crime Alert and was eventually contacted by thirty victims. "Some of those victims went back to 1999," he said. He found evidence that the gallery owner was moving around the country, attending traveling shows, home shows, "lotus blossom shows."

He tracked her movements through Oregon and New Mexico and eventually found her in Dallas. He issued an arrest warrant, and when the thief was caught, Hrycyk went to Dallas himself to interview her. She was sixty-eight years old, and during the interview she admitted that she'd kept most of the art in a storage locker on the outskirts of Dallas. There Hrycyk found hundreds of canvases. He rented a U-Haul, piled all the stolen art into it, and drove it to the evidence warehouse in Los Angeles.

On a stifling afternoon I was honored to get a VIP tour of the evidence warehouse, not far from Parker Center. The warehouse sits on a near-lifeless industrialized corner in downtown Los Angeles. The building is unmarked, with a thirty-foot-high fence crowned by razor wire, and for good reason: it's a giant safe, stocked full of valuable goods. Past

the security gate, inside the open hangar, thousands of boxes line tall metal shelving units stretching deep into a department-store kind of limbo. It was sort of like a Walmart, except all of this stuff had been seized as a result of criminal investigations across the city.

In the area near the garage-door entrance, the cardboard boxes on shelves are organized into loose categories: ammo, watches, baseball bats, cell phones, knives, foreign currency. When I visited, one box held dozens of walking canes. There was a box of fake badges, of course. And there were a couple boxes of books, sorted into two categories: literature and self-help. In literature was a novel by Dennis Lehane, and a Harry Potter book. We veered to the left, down a long aisle of shelves that opened into an area occupied by a neat stack of paintings and sculptures on the floor. Hrycyk lifted an abstract painting. He was careful handling the art, but not delicate. "This was supposed to be a de Kooning," he said. "It's homemade. A man named Dr. Likhite was trying to sell this for $15 million."

Vilas Likhite was a doctor. His father had been a teacher to the family of a maharaja in India but had relocated to the United States. When Hrycyk interviewed Likhite, he told the detective he remembered playing with the maharaja's children. "He wanted the status that he'd been in the presence of all his life," said Hrycyk. "So he started to buy cheap art, and transformed those works into signed art from the modern masters." Likhite found people in Australia who specialized in forging provenance papers, and suddenly he became a source of million-dollar artworks. The elite of his community flocked to him.

"This art represented power and status," said Hrycyk, pointing to a sculpture. It was a fake Brâncuşi. Likhite's price tag: $28 million. He pointed at a statue of a Buddha.

"Likhite was selling that for $48 million," he said. "He claimed it was made out of jade from the eleventh century, from China. Obviously, it was not."

Hrycyk received some complaints, did some investigating into Likhite, and decided to conduct a sting operation. He arranged for a fellow LAPD officer to go undercover, posing as a businessman from mainland Korea who wanted to bolster his art collection. "Likhite had this old-world charm," Hrycyk remembered. "When the undercover officer walked into the room, Likhite stayed on his feet, and asked for permission to sit down." When the deal was done, Likhite was caught in a hotel room in possession of twenty-four fake canvases, including a wannabe Jasper Johns and a fake Mary Cassatt.

Later, when Hrycyk executed a search warrant on Likhite's house, the detective turned up more fake art—all of it now sitting in the pile we were looking at in the warehouse. "The irony of the case was that he didn't need to sell anything," said Hrycyk. "He had a good life." Hrycyk stared down at the canvases for a moment, and then walked across the warehouse to an even larger open area at the very back. He stopped and looked at hundreds of stacked canvases, prints, and framed paintings. They took up a residential garage worth of floor space and appeared to be enough art to stock a midsized commercial gallery. Some of this art was the work he had hauled back from Dallas, from the art gallery that had disappeared.

"Auction houses disappear, too," he said. "We had a case where someone bought an established auction house, and same story. It was doing business with hundreds of clients. Then suddenly it closed, and all the art was gone. You'd be surprised at how easily people, and businesses, can just vanish," he said.

When June Wayne moved to Los Angeles, the city had no major museums, but now it holds over a dozen institutions, including the Getty Center, the Museum of Contemporary Art, the Los Angeles County Museum of Art, and the Natural History Museum of Los Angeles. Hrycyk had toured all of them and had been called to investigate crimes at six museums, he told me.

The first was the Natural History Museum. "They have a lot of stuffed animals," he said in a deadpan, "but they also have this sealed display case that contained Egyptian artifacts." The case held a piece that was straight out of a mummy movie—an inscribed scarab ring from ancient Egypt. "Apparently it had a curse on it," he said. The ring was stolen.

When Hrycyk arrived at the crime scene, the museum was spotless. "They'd completely cleaned it up. The debris had been swept away, and the shattered pieces of the display case had been tossed into a box. The staff didn't want anything to look out of order, nor did they want anyone to know that anything had been stolen. They thought I'd just take a police report and that would be the end of it. When we took fingerprints, they were surprised. It had never crossed their mind that we would work to solve the case."

Hrycyk declined to name another major museum that had had a near theft, which he had heard about by accident. An employee from a different museum had called the detective to ask if he had heard the rumors about a *Thomas Crown Affair*–like heist gone awry. He hadn't. He made a couple of phone calls, got the name of the museum, and called them. The story turned out to be true.

"When I arrived at the museum, my skills were not wanted," he said. The in-house security staff told the detective that they had already identified a suspect—they could handle this, they said. "I decided to do my job anyway."

This is what had apparently happened: A thief hid in a part of the museum that had been closed off due to a staff shortage that day. Barricades had been placed at the entrance to the darkened gallery, and the thief took advantage of the reduced lighting and lack of personnel. He tried to pry large multi-million-dollar paintings off the walls: a $3-million Jasper Johns, a $3.5-million Fernand Léger, and a Picasso. "Had this theft been successful, it would have been one of the biggest in California history," Hrycyk told me. The thief went for the Picasso first and took it off the wall, but the frame made it too big to walk away with. "You could see how he had started to take the frame apart from the back. It appeared that this was taking a long time. He'd exerted a tremendous physical effort. The only thing that defeated this man was that he hadn't brought the proper tools. He thought he could just lift these artworks off the wall, not knowing they were bolted down. I think he ran out of time and fled," Hrycyk said.

"When I got there—and again, I wasn't even supposed to be called—the private head of security had already jumped to conclusions. Based on his perception of the facts, he was positive this was an internal theft, that it could not be anything else." Hrycyk interviewed each member of the security staff and determined that although the security guards had walked through the gallery several times, they had gone through the process mechanically. "They turn on a light, cast a glow in the room, look around, turn the light off. Their eyeballs are open but they are not seeing anything," Hrycyk said. A few days later Hrycyk decided that this was not an inside job: it was a crime of opportunity, and the would-be thief was still out there.

Hrycyk had cultivated relationships with key staff at several museums across the city, including at one of the

world's richest and most secure private institutions, the Getty Center. The Getty had been embroiled in a long legal battle over a number of antiquities which Italy claimed had been looted and then delivered to the United States via a sophisticated network of traffickers. In 2007 the institution returned forty pieces to Rome, including a fifth-century CE marble statue of Aphrodite.

I toured the Getty twice, and it was an incredible experience. Visitors are dropped off or park inside the low-slung garage built into the foot of the hills. To get from the parking garage to the museum is a Disneyland-like ride. A tram arrives every few minutes to pick up passengers and ascend the hill. The ride lasts about four and a half minutes, and the scenery is beautiful: rolling hills, wild grass, and sky. At the top of the hill is a clearing in view of neoclassical stone steps that glide up to the reception hall. Then the visitor walks through the reception atrium and into a large interior courtyard with tables, chairs, a hot-dog vendor, and a few to-die-for views of the hills, the property, and the center's gardens. It is another minute-long walk across the courtyard to the door of the exhibition hall—a long journey from the entrance to the art.

Hrycyk arrived at the Getty one afternoon in 2004, not long after a couple had strolled up to a Lee Miller photograph in one of the exhibition halls. The photo was powerful: a Nazi officer who had recently committed suicide, his blood running down his face, the revolver in his dead hand. Miller had worked in Paris for some of the war, documented London during the Blitz, and visited the concentration camps at Buchenwald and Dachau shortly after they had been liberated. The photograph on the wall was taken at Buchenwald.

The couple stopped to inspect the gruesome image. The man stared at the Miller photograph for a moment, then he

walked up close to the Plexiglas frame and started punching it. He didn't hold back, and his blows were so hard that the protective glass spiderwebbed. The woman, visibly frightened, watched as the man ran out of the gallery. Of course, the problem with vandalizing a work of art at the Getty is that the only way in or out is by the tram. The enraged man recognized this problem, and as security chased after him, he blended in with the crowds by slowing down to a walk and pretending to appreciate the artwork. He made it to the tram without being caught.

When Hrycyk showed up, he dealt with Bob Combs, director of security. They watched footage from an arsenal of cameras. Hrycyk identified the woman, and when he tracked her down at her home, she was embarrassed. Her male friend turned out to be a UCLA graduate student. He was arrested and pleaded guilty. "Sometimes people do strange things," said Hrycyk. "It shows you, people are not predictable."

The Getty Center is equipped with one of the most thoughtfully designed security systems of any museum in the world, and when I met with Combs, he confirmed that the museum had never had a piece of art stolen. Combs was in his early fifties, clean-cut, wearing slacks and a shirt tucked in and carrying a walkie-talkie, which often crackled with reports and questions from staff all over the museum. "My Scout leader was a locksmith, so that's where it all started," he told me.

Combs's career began when he was twenty, working security for the Art Institute of Chicago. He didn't have a lot of control over the environment there. At the Getty, he has almost total control: he presides over an army of security personnel, monitors an array of cameras and alarms, and keeps constant track of the flow of visitors wandering

the galleries and grounds. In fact, he worked for the center before it was built. "I had input on the initial architectural designs. Any thief would be hard pressed to get past the system that has been set up. We've got plenty of opportunities to stop you."

His security parameter includes six buildings, as well as the 750 acres of land that surround the center. "That land acts like a moat around us," he said. Actually, the entire security system at the Getty was designed in concentric rings that overlap, with one purpose: "Protect the asset." That means the art collection, including *Irises* by Vincent van Gogh, one of his most famous works, worth at least $100 million.

Some of Combs's concentric rings are more visible than others. A fence surrounds the property, far from the center itself. A web of security cameras is built into the center's design. Motion sensors are placed in rooms, in doorways, and in halls, and connected to alarms. "Most areas have redundancies." The center has what he calls "saturation coverage." Translation: Anyone walking around looking at art is slathered in layers of security.

When Combs was consulting on the initial security design of the center, he created a set of plans that were color-coded: red, green, blue. Any area shaded in red held artwork; green was a public space, like the courtyard with the hot-dog vendor. Blue was for transition areas between art and public space—the hallway to get from the gallery to the hot-dog vendor. His idea: Don't have a lot of places where visitors travel from red to green. Instead, a patron should have to walk through a blue area before getting out to a public space.

"Security has two components: operations and technology," Combs said. Technology, no matter how

sophisticated, does not sufficiently protect the collection. "I can get all the alarms I want, but that won't do the job." For Combs, the factor that makes the center secure is the human presence—his security staff and the center's other employees. When Combs was tasked with assembling his team, he searched the world for different models of training and settled on one.

"I studied El Al, the Israeli airline," he told me. "They train their staff to understand the psychology of a situation, because they can't just rely on the technology." El Al security trainees work a shift on every job at the airline. "That security guard works baggage, concessions, ticketing, parking." El Al also does scenario training. Security officers have to sit down and pretend they are going to hijack a plane or blow it up. How would they do that, knowing everything they know about how the airline worked? When Combs trains a new security member, he gives that person a mission: "Your job is to steal that Rembrandt in Gallery 3. Think it through. What would you have to do? You're dealing with fire alarms, exits, security systems. What are all the steps?" By doing this, Combs also gets an idea of how thieves think and adjusts security accordingly.

Combs also borrowed another cue from El Al: his staff conducts psychological profiling. If a visitor at the Getty asks one of the gallery staff a leading question, that staff member notifies security. A security officer materializes in the gallery with a description of the patron and engages him in polite conversation—a few questions about the visit and whether he requires any additional information. "The guard is getting to know that particular guest. If the conversation arouses suspicion, that person will be monitored in an almost invisible fashion." Staff will keep a watchful eye on the guest, and from the control room, a picture of

the guest will be taken. "That profile is not based on looks. It is based on behavior," Combs said.

I told Combs that I'd visited the Getty a few days before our interview and spent time wandering through the galleries, the promenades, and the gardens. At lunch I'd bought a hot dog from the outdoor vendor. In front of me in line was a man with an earpiece, wearing a dark jacket. I asked him if he worked as security for the Getty. He looked at me for a moment and nodded. I said that I was writing a book about international art theft and that I was interested in meeting Bob Combs. The security official chatted with me for a few minutes and told me how much he liked working at the center. He said it was very well secured in ways I couldn't even imagine. The conversation lasted for about five minutes. When I told Combs about the interaction, he frowned. "That should have been reported," he said. "A visitor saying they're working on a book about international art theft. . . that's a case where the system didn't work."

The Getty's ability to pay well and the beauty of the environment itself provide a bonus security benefit: "Low attrition rate," he said. The security personnel who work at the institution tend to stay. "We're fortunate. It's rare for a member of our staff to leave to work at another museum."

I asked Combs if he had information about how other museums around the globe are affected by art theft. He is one of the rock stars of the museum security field, and each year he attends the international museum security conference held in Amsterdam. For his presentation in 2007, he had put together a list of thefts from museums around the world. It was fourteen pages long, in a minuscule font. At his desk, he flipped through the list for me.

In Los Angeles, an eighteenth-century manuscript that had once belonged to a powerful Italian family was stolen

from the UCLA Library. In Arizona, eight bronze stat-
ues that weighed thousands of pounds were stolen from
the ranch of artist John Waddell. In Paris, two Picassos
were stolen from the home of the artist's daughter. Also in
Paris, eighty works of art vanished from the Arab World
Institute. In Vienna, thieves broke into the Palais Harrach
and stole thirty Fabergé eggs, twenty porcelain vases,
and a painting—a haul worth over one million dollars. In
Florida, a life-size statue of a bronze horse was stolen from
outside the Museum of Florida Art.

In Takayama, Japan, three armed men had knocked down
a security guard and stolen two million dollars' worth of
gold bullion, displayed on the second floor of a museum. The
three men had to drag the gold down a flight of stairs. They
had another man in a getaway station wagon waiting outside.

In Australia, a painting by Frans van Mieris was stolen
from the Art Gallery of New South Wales on a day when
up to six thousand people had visited. The painting was
worth about one million dollars and was small enough to
fit inside someone's coat. In Ireland, fifty sculptures were
stolen from the National Wax Museum, including Fred
Flintstone, Hannibal Lecter, a Teenage Mutant Ninja
Turtle, and four Teletubbies. In Tehran, Iran, three manu-
scripts were stolen from the Reza Abbasi Museum; two of
them were over two hundred years old.

Combs also included acts of vandalism. A Milwaukee
man was looking at Poussin's *The Triumph of David*
when he suddenly tore the painting from the wall and
started kicking it, aiming for Goliath's head. When he'd
succeeded in kicking a hole in the painting, he stopped,
removed his shirt, lay down on the floor, and said simply,
"I'm done." In Paris, a few drunken men broke into the
Musée d'Orsay around midnight. One of the men punched

Claude Monet's *Le Pont d'Argenteuil*, tearing a gash four inches long in the canvas.

At the Getty, as a preemptive measure, staff had access to photographs of known "persons of interest." Combs told me one of those photographs was of Banksy.

"Really, you have a picture of Banksy?" I asked. The idea of seeing a mug shot of the mysterious, globe-trotting graffiti artist, whose identity is a closely guarded secret, was thrilling.

Combs picked up his phone, dialed a number, and requested that the photograph be delivered to his office. Ten minutes later there was a knock on the door and a staff member entered. "We don't have a picture of Banksy," he said to Combs.

"I thought we had a picture of Banksy," said Combs.

"I don't think anyone has a picture of Banksy," answered the staff member.

"Okay, thanks," Combs said.

I was disappointed, but I was sure Banksy wouldn't be.

At the end of our interview Combs got up from his desk and walked into the larger administration offices of the Getty—all cubicles and desks. Framed photographs decorated a wall, and Combs stopped at one. "This is a portrait from 1909, taken at the Boston Museum of Fine Arts in Copley Square." It showed the haggard figure of a man with a handlebar moustache in a faded uniform—a tough-looking man. "He was a security guard at the Boston museum." Combs added, "Imagine what his life was like back then. No iPod on the way to work. These guys worked their whole careers to pass the art they were guarding onto the next generation, and to our generation. We have to take care of the art, and pass it on."

Later that week I was due to spend another day with Hrycyk at Parker Center, discussing his casework. Instead I received a phone call from the detective.

"Something's come up," he said. "An antique store in Hollywood has been burglarized, and Steph and I have to conduct a crime-scene investigation." He paused. "Do you want to come along for that? It would give you a chance to see us work."

The detectives picked me up in the unmarked Impala, and we headed toward La Cienega Boulevard. I shook hands with detective Stephanie Lazarus, whom I met for the first time in the car that day. It occurred to me, watching Hrycyk and Lazarus working at the antique store, that these two didn't seem to be seduced by the allure of headache art. They tackled each of their cases with the same focus, rigor, and determination—whether it was a stolen Picasso or a chandelier.

My visit with Hrycyk revealed a detective at the height of his powers. He had investigated hundreds of cases and developed contacts all over the Greater Los Angeles community and far beyond. He'd built a formidable database of information and a website that allowed him to interface efficiently with the public he served. He also had a partner he was training to replace him when he retired. All of this was his legacy.

And his legacy was instructive about cities beyond Los Angeles. When I met Bonnie Czegledi, she pointed out that because Toronto did not have a detective charged with patrolling the art market, it was impossible to know what was happening underneath that market's serene exterior. She suspected that theft and fraud were rampant and that Canada was a perfect place to steal and to sell stolen works. At that time, I wondered if her theories were plausible.

Spending the week with Hrycyk confirmed for me much of what Czegledi suspected was unfolding in Toronto. And what was happening in New York? That was also a blank. "It's hard to know why New York doesn't have a dedicated unit," Hrycyk told me. "I don't really understand how that is possible, considering how big that market is."

Hrycyk's superiors, though, didn't always see the value of his work. He told me that after taking over the unit, he went long stretches of time without a partner, managing too many cases, and suffered from low morale. He remembered a stakeout he did alone, for hours, in a suspect's backyard. "Those were depressing days," he told me. As recently as the early 2000s, management was talking about shutting down the Art Theft Detail.

Closing the Art Theft Detail would have been the wrong decision, considering that Hrycyk was the only detective in the United States on a municipal force in a large art market who had amassed the experience and knowledge—the power—to understand how art theft worked. Way back in 1986, at the same time that Hrycyk and Martin were prying into the art scene on the West Coast, another agent was coming up the ranks in the eastern United States, also learning about art theft. He wasn't on a municipal force, though—he was with a federal agency, patrolling a much larger theater.

# 12.

## 9/11

*"These works are permanent.
We are fleeting."*
**ROBERT WITTMAN**

The black, unmarked Chevrolet Grand Prix was idling outside the Philadelphia Holiday Inn Express at 9:00 AM, as agreed. The interior of the car was spotless—no empty cans or coffee cups, just the grapefruit-sized police siren, dark and red, lying on the floor on the passenger's side.

In the driver's seat was Special Agent Robert K. Wittman. His business card read FBI, Senior Art Investigator, Rapid Deployment Art Crime Team. Wittman is the first FBI agent in the history of the bureau to investigate art theft full-time, and he is a hard man to pin down. At first he said he did not want to be interviewed for this book, and an FBI public relations agent sent me an email saying just that. I replied with a longer email, stating that Wittman was one of the only people on the planet with experience in hunting and finding extremely valuable artworks—headache art was his specialty. I gave some context for my investigation and

asked again for an interview. A few weeks later I was walk-
ing down the street in Toronto when my cell phone rang.

I picked up, and a smoky voice said, "This is Bob.
Wittman. From the FBI."

Toward the end of his career, Wittman was considered
to be one of the most accomplished art detectives in the
world. When we met in person, in May 2008, he had been
working as an agent for twenty years and was six months
away from retirement. We had had several conversations by
phone, but whenever I scheduled a trip to meet him, he can-
celed. Finally we agreed on the May date, but with this ca-
veat: "You can come down here to Philly, but if I get called
into a case, I could be gone. So I'm hoping I'll be here, but
you never know."

Many of Wittman's years with the bureau were spent
immersed in high-pressure undercover sting operations.
There had been no published photographs of Wittman in
any magazine or newspaper when we met, even though
many articles had been written about the agent's work,
including profiles in *GQ* magazine and the *Wall Street
Journal*. When the *WSJ* ran its feature, the accompany-
ing photo depicted the back of a man's head, shielded by a
white fedora. His guarded identity meant he could be the
phantom buyer to any criminal selling a stolen masterpiece.
Thieves knew him by reputation, and being friendly was
one of his special talents. As he would say, it was one tool
in his box. In person the special agent has a warm, open
face that radiates comfort, and there's a soft-burn charm to
his eyes. His thin, graying hair is cropped short. His skin
is slightly tanned, and the tan didn't match the slate-gray
Philadelphia sky. Wittman traveled.

This morning the special agent was wearing a white
button-down shirt under a blue blazer with gray slacks, a

black leather belt, and black polished shoes. The shirt was unbuttoned at the collar for maximum mellow. His gun was tucked into a holster underneath the jacket. His dress code was chameleon cool. Wittman could walk into any room—a Denny's or a political fund-raiser—and fit in.

"Welcome to Philadelphia," Wittman said as he pulled the car into traffic and began cutting through the downtown grid of clean streets. In the distance, at the Philadelphia Museum of Art, a giant poster of a Frida Kahlo self-portrait stared down at the former U.S. capital city. A few minutes later Wittman turned the car into the underground parking garage of 600 Arch Street, a standard-looking office building with trimmed hedges and mirrored windows and a nothing-going-on-around-here exterior. This is the Eastern Division Field Office of the FBI. In the garage Wittman closed the door to the black cruiser and strode toward the elevator. There's a bounce to his walk, a flow of energy moving forward. Think Al Pacino in *Heat*. On the way he passed another agent, and the two never broke stride as they smiled briefly in the dim fluorescence.

"Hey, Bob, you winding down?" asked the agent, alluding to Wittman's imminent retirement.

"Sort of. Feels like I'm waking up," answered Wittman.

Upstairs at 600 Arch, Wittman had two desks. The first was in a bull pen of cubicles staffed with other, mostly younger, agents—the next generation. Like every FBI employee I met, this group was fit, cheerful, and courteous. Wittman's presence in the room felt paternal. "Hey, Bob," they smiled.

Wittman's other desk sat in a large office he occupied alone. On the wall hung a few photographs of him shaking hands with dignitaries, and posters with motivational phrases. One read, "When You Think You Can't, You Must." The

office was substantial, with a couch, chairs, coffee table, bookshelves, and a wide-angled window in front of the desk with a stunning view of the Liberty Bell, Constitution Hall, and Independence Hall, inscribed with "We the People." The Benjamin Franklin Bridge floated in the distance.

He sat down at his desk, near the window. Wittman looked out this window every day, but often, the agent suggested, he was looking beyond, to the world. He had a prime view of art theft in the United States and as a global phenomenon. The global business of fine art is worth an estimated $200 billion annually. "That's everything—antique markets, art fairs, auction-house revenue, gallery sales. It's a ballpark number, like most in the art world," he said. "That market is totally unregulated."

Figures for the black market were murkier, but in the billions annually, he estimated. Over sixteen thousand works of art, antiques, and collectables were listed that year on the Art Loss Register as stolen in the United States. Over half of them had been stolen from private homes. The rest had been siphoned from art galleries and dealers, with 18 percent from museums and other public institutions, such as libraries (rare books and maps are a constant target). Wittman said museum thefts were usually inside jobs, because it was the employees who held the "keys to the kingdom." There was a lesson to be learned from the way the pyramids were looted thousands of years ago; experience had taught Wittman that usually it was the people who helped care for or build an institution who knew best how to steal from it.

"Art theft is an international industry," he said. "It knows no boundaries." Over the previous decade and a half, in his quest to understand how that black market worked, Wittman had been making friends all over the

global village. "Fifteen years ago, when I started doing this, there was no Internet or speedy communication. You had to make personal contacts."

Destinations Wittman had visited on business included Brazil, Peru, Denmark, Switzerland, France, Germany, Poland, Spain, France, Hungary, England, the Netherlands, Nigeria, and Kenya. Many of those countries were not centers of the art market but were instead source countries, or end points for stolen work that had been sold, or a great place to hide the art for a few years until everyone simply forgot about it. His passport was more CIA than FBI.

Still, for such an international citizen he had the most American of names—Bob. Many people, of course, got to know the agent by a completely different name, or names. They usually figured out the "Special Agent" part too late. These were the criminals he hunted—the growing group of thieves and middlemen who had discovered that art taken off the wall had value beyond its aesthetic beauty and historical importance. The pattern was spreading and could quickly move out of range, too difficult for almost any other U.S. authority to follow. But Wittman had the budget, the reputation, and the skills to go hunting far beyond the borders of the United States, and he didn't often come back empty-handed.

Wittman's résumé of recoveries is supersized: about $215 million of stolen artwork, give or take a few million. These include an original copy of the Bill of Rights, three Norman Rockwell paintings, two Francisco Goyas, and one Rembrandt self-portrait.

The Rembrandt alone was worth over $36 million and became the largest notch on Wittman's big belt of missions accomplished. Some other interesting catches: three paintings by German painter Heinrich Bürkel, stolen near the

end of World War II and found for sale in 2005 at an auction house in Philadelphia; and rare books that had never been officially checked out from the library at Transylvania University in Lexington, Kentucky—one of them a first edition of Charles Darwin's *On the Origin of Species*.

Accolades and rewards have followed. In 2000 Wittman received the Peruvian Order of Merit for Distinguished Service, which was presented to him personally by the president of Peru. A year later U.S. Attorney General John Ashcroft handed him the Executive Office for United States Attorneys' Outstanding Contributions in Law Enforcement Award. In 2003, the Spanish police force thanked him with the White Cross of Law Enforcement Merit Medal. The Smithsonian Institution applauded his efforts in 2004 with the Robert Burke Memorial Award for Excellence in Cultural Property Protection, an honor he shares with Detective Donald Hrycyk.

"I've investigated many types of federal violations, but the investigations that give me the most satisfaction are the ones that lead to the recovery of stolen artwork and cultural property," he once said in an online chat with *USA Today*. "Whether they are owned by an individual, or a museum, they represent the world's cultural heritage. That's worth saving."

Strewn across his desk this day were piles of papers, files, and dozens of audio tapes. He slipped a tape into a recorder and pressed play. We both hunched over the little machine and listened to the tape hiss. First came the sounds of muffled voices talking, then a loud crash, followed by men shouting urgently. Finally, chaos. He pressed stop. "That's from a sting operation I worked in Spain," he said. "When I work in other countries, I'm a civilian. I have no official authority." The police in the background were

Spanish, not FBI. Wittman had been posing as the crooked collector again.

"Going undercover is a technique that is used by law enforcement to gather information. It's another tool in the box, like a hammer," he said. "There are certain parameters. In these cases, hopefully you know something about art."

When I asked him about having to lie while working, he shrugged. "I lie when I'm told to do so in the service of my government. It's that simple," he answered. "Undercover work is all about being yourself," he continued. What the agent meant was that using a fabricated identity didn't mean veering too far from his own manner. His personality mostly remains intact. "If you pretend to be someone else while you're undercover, you'll slip up. It's harder to remember a lie." He added, "A sense of humor helps. It's all about making people feel comfortable." He paused. "Also, a little bit of nervousness goes a long way."

Wittman's preferred fabricated identity was a crooked art dealer or collector who offers to pay large sums of money in cash for stolen art. He would show the money, and the artwork would appear. Sometimes that could happen right after a work of art had been stolen, but often a stolen piece showed up on the radar years later, usually in a different city, state, or country. The agent was gifted at luring criminals who wanted to sell that art into a trap. He would work his way into the community, earn people's trust, and wait for the painting to materialize. Wittman could spend months infiltrating an organization, befriending its members, and waiting for the right moment to strike. He was a natural at diving into the underworld—smart, charming, handsome, relaxed—and he treated these new relationships like a chess game. "You need to master your subject and stay one or two moves ahead of your opponent . . . Forget

what you've seen on television." His objective: "Winning a person's trust and then taking advantage of it."

He did this with grace. One of his prey, a corrupt Santa Fe, New Mexico, dealer in Native American artifacts, sent Wittman a note after being arrested, which the agent quoted in the book he wrote once he retired:

Dear Bob: I don't know what to say. Well done? Nice work? You sure had me fooled? We're devastated, and I guess that's the idea. But even though we're devastated, we enjoyed the times we spent with you. Thanks for being a gentleman, and for letting us have a pleasant Christmas and New Year's. If you hadn't done what you did, they would have brought in someone else to do it, and I don't think we would have found him as personable as we found you. So there's no blame involved.

Wittman knew better than anyone that art theft cases were some of the most difficult to crack, because of the distance that art could travel quickly and almost invisibly. Paintings were easy to transport and easy to hide, so investigations could be long-term affairs.

One month after our meeting, one of Wittman's sting operations came to an end. The mission involved million-dollar artworks by Claude Monet, Alfred Sisley, and Jan Brueghel the Elder that had been stolen at gunpoint from Nice's Musée des Beaux-Arts in August 2007. Wittman had passed himself off as an art collector with money to spend and spread the word that he was looking for deals.

Bernard Ternus was pulled to Wittman by the undercover agent's offer of $4.6 million in cash. Still, Ternus wanted to spend some time with the buyer before he delivered the goods. Wittman invited him onto a yacht, where

they sipped champagne, just a couple of gangsters on the sea. That went so well that in January 2008 Wittman flew to Barcelona to hook up with Ternus again. They shared a lifestyle, Ternus thought.

A few months later, Wittman introduced Ternus to a trusted friend from France, also a lover of art. Wittman's friend was an undercover lawman with the Gendarmerie Nationale. The FBI agent let the two get comfortable with each other before making his exit—Wittman built the relationship, the French agent closed the deal. That French agent promised Ternus that he would pay up in Marseille, near where the paintings were being held. Wittman stayed at home for the bust. The paintings arrived in a van, and the French police moved in. The FBI agent confided to a *WSJ* journalist that he celebrated the recovery with a mug of coffee on his back porch, alone. The museum in Nice opened with the paintings hanging in place as if they had never been gone.

Robert Wittman's training began long before he joined the FBI. He grew up in Baltimore, where antiques were the family business. "My father would take me to flea markets. I would see how he bought and sold. When he opened up his Oriental Galleries, he had two different stores. One was in Baltimore, where I helped him out. So I knew how he dealt," Wittman told me. That became an advantage later in life.

"Let's say you want to infiltrate an art convention. You have to know the terms, the language, and the ways of doing business, to be a part of the whole aura. It's knowing how to do a con. Puffery. How to con a mark. How to identify a mooch," he said. "Puffery is the exorbitant description of the times. There's a way of doing it where it's totally legal. And that raises the prices. Mooch is someone who has a lot of money and believes everything you tell them. Don't be a mooch."

The young Wittman was restless and wanted to see the country. He first contacted the FBI at the age of twenty-three. "I always knew I wanted to be an FBI agent," he said. The bureau rejected him: not enough work experience. Almost ten years later Wittman spotted an ad in the newspaper. The FBI was hiring. By that point Wittman was a Certified Public Accountant, had earned a degree in political science, and had published magazines and books for the agricultural sector. "I was always an entrepreneur," he said. He applied again, and this time the bureau said yes. He was thirty-two. "I think they hired 350 agents that year." Six months later, after a security and background check, Wittman arrived at Quantico, Virginia, for training: legal defensive tactics, physical training, and shooting. "It was a sixteen-week program," he said. Art investigations were not taught at the academy when Wittman went through.

After Quantico he was posted to Philadelphia, a city he'd never lived in. "The location had to do with the needs of the bureau," he said. "When you join up, they tell you that you have no say where you're going."

Wittman started working in the Philadelphia field office's property-crimes squad, which dealt with a host of issues ranging from stolen goods to mail and wire fraud—violations of the Interstate Commerce Act, and therefore under federal jurisdiction. One of the specialties of the Philadelphia property-crimes squad was art theft, because of one agent, Bob Bazin.

Bazin was to Wittman what Bill Martin was to Don Hrycyk. He was an older, more experienced agent who took Wittman under his wing and had an interest in stolen art cases. It was 1988 when Wittman walked into the Philadelphia office, and Bazin was dealing with two high-profile art theft cases. A large crystal ball had been stolen from the

Asian wing of the University of Pennsylvania Museum of Archaeology and Anthropology, the second largest crystal ball in the world. At the Rodin Museum in Philadelphia, an 1860 sculpture, *The Mask of the Man with a Broken Nose*, had been stolen in an armed robbery, and Wittman told me it was the only one he could think of in which a Raven stainless-steel pistol was used to steal art. "That's the gun that looks like a lighter," he laughed.

Bazin and Wittman worked those cases together. "By the time I got to Philadelphia, Bob was nineteen years in and was more traditional in his investigations. Back in those days you didn't travel. He kept it local," Wittman said. The Rodin theft had occurred about a month before Wittman landed in Philadelphia. The thief had ordered the guards to the floor, tied them up with wire, and fired a bullet into the wall. Then he tore the sculpture off its pedestal. The Rodin Museum has one of the largest collections of the French artist's work outside of France. "*The Gates of Hell* is there," said Wittman.

A reward was posted for the sculpture, and someone called in a tip. "We had a person who came in as a cooperator," Wittman remembered. The cooperator gave the FBI the name of a man. The bureau did some surveillance, took photos of the suspect, and secured a search warrant. Bazin and Wittman found the Rodin sculpture, undamaged, wrapped in brown paper, hidden in the basement of a brownstone house on Pine Street.

"The thief had been counting on easy money," Wittman said. "He had a friend who worked at an auction house and was hoping to turn it over quickly. He didn't think it through. The Rodin theft had made world news. He thought it would be easier to move, but it ended up under the furnace."

The thief was Stephen Shih, a twenty-four-year-old unemployed truck driver. Before the Rodin Museum robbery, he'd hit liquor stores for cash. He moved on to French art when he figured out how much money some of the Rodin sculptures were worth. "He thought it would be less risk, with higher reward," said Wittman. The Rodin was the first art theft case Wittman helped solve. Wittman and Bazin got the giant crystal ball back as well.

Two years later, in Boston, the Gardner Museum catapulted art theft into the U.S. media in a way it had never been before. Isabella Stewart Gardner was an eccentric Boston socialite who amassed her art after her son died. The paintings, in a way, were her children, according to those who knew her. When Gardner died she left an inflexible will: not a single object could be moved, or the entire museum would immediately be given to Harvard. The board of the museum was powerless to add to or subtract from the collection after the theft of thirteen works. They couldn't even move a vase. So they came up with a clever solution: they hung an empty frame in place of Vermeer's *The Concert*. When the empty frame went up on the wall, its image became almost as famous as the Vermeer itself—never allowing the public to forget the crime. The Gardner theft was never solved. Instead it has come to symbolize the perversity of art thefts everywhere. Scotland Yard, the FBI, and a private detective named Harold Smith, along with Richard Ellis and Paul, have all gone searching for the Vermeer, a quest chronicled in *The Gardner Heist* by Ulrich Boser. None has found it.

The depth of the crime, the financial loss, the beauty of the paintings, and the heavy media attention culminated in Ted Kennedy's introducing the Theft of Major Artwork (Theft from Museum) statute in the U.S. Senate in 1996. It

passed. The new law made it a federal crime to steal from a museum or to steal a work of art worth over $5,000 or older than one hundred years. And if a piece of art was worth over $100,000, it didn't matter how old it was, the FBI could step into the case. "Under federal law you can't own stolen goods, but before that statute you could say, I'm a good-faith buyer. Not anymore. Now I can go seize it," said Wittman. "You don't have to give it to me, but if you don't, I can arrest you, put you in jail, and take the painting anyway. If you don't turn it over, then every moment you have it makes you liable. The law doesn't help with anyone's home or gallery, just museums," he added. "The definition of *museum*, by the way, includes universities and libraries. The new law gave us another weapon in the arsenal to recover stolen artwork and cultural property." It also gave Wittman a niche position at the bureau.

After the Gardner theft the FBI decided to invest in his art investigation training, and in 1991, Wittman enrolled in a class at the Barnes Foundation, for one day a week, over a period of a month. "I decided it would be better to know more about art. I didn't have a good art history background," Wittman said. "I was just another student." But when I visited the Barnes, I mentioned to one of the staff that I was in Philadelphia to meet with Robert Wittman. She rushed away and came back with a picture of Wittman posing with staff at the Barnes. "We love Bob," she said.

"There were about twenty people in the class," Wittman remembered, and, as he pointed out, the Barnes was not an art school. "It's a foundation that teaches the ideas and theories of Dr. [Albert] Barnes. I didn't think the theories were all that pertinent to theft investigations." What was important: "You start to develop an eye for art, to speak knowledgeably," he said, sounding very much like Hrycyk.

"Renoir made over a thousand paintings of women. How do I know for sure that the painting being sold by a criminal is the same one that was stolen? I've seen 150 Renoirs come up, and there are often no photographs of the work." Wittman paused for a moment, then started on Monet. "Do you know how many boat scenes Monet painted, or water lilies, or river scenes? How about Warhol? How many different versions of Marilyn are there? And the difference, in those cases, might be that one work has a dot of yellow and one has a dot of purple."

Later, Wittman based his own training program on the experience he had at the Barnes. "In a few hours I can train an agent to tell the difference between a Monet and a Renoir, which is light years ahead of most cops, as well as most of the public." After spending some time at the Barnes, Wittman could look at a painting with confidence: "Picasso, blue period."

In 1995, Bob Bazin retired. Wittman was now the primary art theft agent for the entire country. The education, the casework, and the experience started to add up. Wittman's reputation was spreading beyond Philadelphia—and beyond the borders of the United States. "In 1997, we got a case going involving a piece of gold in Peru, from the tomb of the Lord of Sipán. It was the largest piece of gold ever found, and it had been missing for ten years." Wittman went undercover as a buyer of pre-Columbian gold and was offered the piece by two smugglers in Miami. That was a spectacular find, but it was followed by a case that eclipsed it.

In December 2000, a guard at Sweden's Nationalmuseum was about to finish his shift when a man approached him with a submachine gun. The guard surrendered. Inside the museum, two other men were already in place. They quickly removed three paintings: two Renoirs

and a Rembrandt. Behind the museum is a small river, where the men had parked a boat. The boat was genius. No one expected it.

There was more. The thieves had spread tire spikes in front of the museum, just in case of a chase. They'd also set up bombs to explode in cars parked throughout the city. So while explosions rocked Stockholm and distracted the Swedish police, the thieves disappeared down river with the multi-million-dollar paintings.

A few days later they demanded a ransom, which the museum refused to pay.

Less than a year later there was a break in the case. Narcotics police stumbled onto Renoir's *Conversation* during a drug operation. "We weren't looking for the painting, so it was a bonus when we found it," said a Swedish police spokesperson to the press. Three people were arrested, but two paintings were still missing. It seemed to be another link between headache art and organized crime.

Then Renoir's *Young Parisian* turned up in an unexpected location: Los Angeles. The Renoir was found during a joint task force investigation by the FBI, U.S. Immigration and Customs Enforcement, the Los Angeles County Sheriff's Department, the Copenhagen police, the Danish National Police, and the Stockholm County Police. An international crime syndicate had been trying to offload the two remaining paintings but was having trouble. They had decided to export the second Renoir from Sweden to the United States. Maybe they would find a buyer in Los Angeles? Instead they found themselves overpowered by several agencies working in tandem. When the Renoir was recovered, there was no press release or party. Everyone kept quiet, and Wittman was called in. He set his eyes on the last stolen painting—the Rembrandt—and

prepared to go undercover again. The information they'd received was that the Rembrandt was still in Sweden, and for sale.

In September 2005 Wittman flew to Sweden and met with a couple of Iraqi brothers, Baha and Dieya Kadhum, who had been caught in the initial police sweep after the museum armed robbery but released due to lack of evidence. The trio got along, of course, and agreed to meet again, in Denmark.

Wittman flew to Copenhagen, where the FBI agent promised them $250,000 in cash; they agreed to regroup at a hotel. Danish police moved in ahead of time and renovated the hotel room into a closed-circuit television studio. When Wittman showed up with the money, the brothers spent a long time counting it. They went through every bill. It was all there.

One of the brothers went out the door and came back with a bag. Inside was a package wrapped in blue cloth. And inside the blue cloth was the Rembrandt self-portrait. Wittman marveled at the painting, then picked it up and walked into the washroom. He'd brought along a black light. Rembrandt painted the self-portrait on copper. If the painting he was holding was real, there'd be no glare under the black light. There wasn't.

"This is a done deal," Wittman said. His voice was picked up on the microphone system by the dozens of officers waiting for the agent's signal. A Danish SWAT team rushed the room, and also surrounded two accomplices waiting downstairs. "It's like finding a lost child," he told Simon Houpt, who recounts this story in his book, *Museum of the Missing*.

"Famous paintings are just a tiny proportion of what's stolen," the FBI agent told me. He said that 99 percent

of what is sold back through legitimate channels is not a Monet—meaning it was not a famous or expensive painting. "Most material is stolen from people's homes, and most of it is valued at less than $10,000—but it's still very important to these people. A lot of material is stolen from private galleries, too. Famous paintings are just a pixel in the big picture."

Near the end of our visit in Philadelphia, Wittman and I walked to a Starbucks around the corner from Independence Hall. Over a latte the agent discussed some of the frustrations he knew were felt by the larger arts community toward law enforcement.

"Everybody is afraid of artwork cases," Wittman said, "because they don't understand how to work these cases. There are so many people who are buying, and they have so very little knowledge of what they are buying," he explained. "Very few business models are based on a customer spending so much money on an unknown quantity. For now, it always goes back to the 'buyer beware' clause. Caveat emptor is the law of the land."

Wittman said that the only way to stop the wave of crime is through education: "Educate buyers not to become victims. When you stop that, you stop the criminal, and then the criminal moves on to other areas of crime." Still, the experience of being the most famous federal agent in the country capable of prying back stolen art was sometimes overwhelming. At lectures he was often barraged by pleas from audience members who had had art stolen. "Sometimes I have to tell them, 'I can't help you. I'm only one man.'"

One of the last undercover missions he took part in unfolded in Warsaw. On that trip he was staying at an expensive hotel. Wittman got into a car to go meet with criminal

dealers; a Polish SWAT team followed close behind. He looked out the window at the crumbling Eastern European architecture and thought, "I don't know if I want to do this anymore. It's stressful. I'm getting old." In the coffee shop he looked at me and said, "On that sting operation I just didn't feel the thrill." Then his eyes sharpened. I didn't believe him.

As we walked back to the FBI Eastern Division office in the warm afternoon sun, surrounded by tourists wandering between Independence Hall and Constitution Hall, I asked Wittman why it was so important to continue to hunt these stolen paintings. Why did this matter so much to him? The special agent didn't hesitate with his answer, "The Rembrandt that I recovered was four hundred years old. Do you know anyone who is four hundred years old?" he asked. "Cultural property is permanent. We are fleeting."

A few months later a small retirement ceremony was held in a Philadelphia banquet hall to celebrate Wittman's career. When I asked Wittman if he had trained a successor, his answer came swiftly, "No."

He did, however, help spawn a new federal initiative: the FBI Art Crime Team, and there were now a dozen agents across the United States learning the basic techniques of art theft investigation. The genesis of that new FBI team occurred on a perfect blue-sky morning, just a few hours away from Wittman's office.

On September 11, 2001, Wittman was at his office in Philadelphia watching television coverage of the two airliners that crashed into the twin towers of the World Trade Center. The next day, Wittman was standing at Ground Zero. The New York FBI office, at Federal Plaza, had been

shut down; it was too close to the smouldering destruction zone. Agents from Philadelphia and New Jersey were called in. Wittman recalls the scene: "It was a sight that you couldn't wrap your mind around. The size of the devastation wasn't possible to convey from the pictures the world was viewing on television screens. There was so much dust you couldn't see the curb. All the air was gray. It was like the moon and smelled like burned rubber," he said.

Wittman was deployed to work "psychology," but for ten days he dug for bodies instead. He told me he stayed at Ground Zero "until the rescue project became a reclamation project." His eyes were still adjusting to the reality that the towers were history, but in one corner of his imagination he was holding an altogether different picture: Boy Scouts waving a U.S. flag.

When 9/11 exploded, Wittman was in midhunt for a few pieces of precious American heritage—three paintings by Norman Rockwell, whose apple-pie depictions of small-town utopia had graced hundreds of *Saturday Evening Post* covers and informed a generation of postwar American families how life could be. In the year Rockwell died, 1978, thieves stole seven of his paintings from the Elayne Galleries in St. Louis Park, Minnesota. It was the largest single theft of Norman Rockwells in history, and there were no clues, no trail to follow.

One of the stolen Rockwells was titled *The Spirit of '76*. In that picture, Rockwell had painted a group of Boy Scouts standing on the shores of New Jersey. In the background, very small, were the Twin Towers. At the time that they were stolen, the paintings were on loan from a company called Brown & Bigelow, a manufacturer of posters and calendars that often featured Rockwell's work. The Rockwells vanished until 1994, when the Norman Rockwell Museum

received an unexpected offer from José Maria Carneiro, an art dealer in Rio de Janeiro.

Carneiro admitted to having the paintings and said he was willing to sell them to the museum. The museum politely declined and informed the Elayne Galleries. Then silence. A few years later Carneiro called the Elayne Galleries, hoping the gallery would be interested. It was— it bought back two of the paintings, *Before the Date* and *Cowboy before the Date*. The FBI was also informed. Wittman looked into it.

Carneiro had the rest of the paintings, but the FBI was powerless to act—the art was on foreign soil. At Wittman's behest, the Attorney General's office of Pennsylvania filed a mutual legal assistance treaty request with Brazil. The MLAT call was essentially a plea for help from the Brazilian authorities, and it was the first ever request of that nature made by the United States to Brazil. The request was approved by Brazil's National Congress in February 2001.

In September of that year, Brazilian police executed a search warrant on Carneiro's house, but the paintings were not on the premises. In October, Carneiro was subpoenaed by the Brazilian government and forced to admit that he was in possession of the remaining paintings. But he would not tell anyone where the paintings were. In December, Wittman flew to Brazil to meet with Carneiro. Wittman changed the dealer's mind. Carneiro led Wittmanto a location sixty miles north of Rio. The Rockwells were there.

When Wittman described finding those paintings, his voice was guardedly emotional. "You can actually see the World Trade Center in that painting," he said. "This is American heritage—a Norman Rockwell painting with Boy Scouts and the World Trade Center in the background.

Recovering those Rockwells was the U.S. equivalent of protecting Europe's seventeenth-century paintings."

What he couldn't do was make an arrest. No one could trace the paintings back to the original thief, and there was an information vacuum about where the paintings had been for the time gap. "Carneiro wasn't completely clean," said Wittman. He knew the paintings had been stolen but told the agent he'd received them from a person who owed him money. If that was true, it was another example of paintings being used as credit-card payments.

Wittman brought the Rockwells with him on the plane back to the United States, in a folder he kept near him. The Twin Towers were gone, but recovering those distinctive images gave the FBI agent the feeling of at least having saved a small piece of an American ideal that seemed to have been lost. In the hours and days following 9/11, while Wittman was sifting through the wreckage and finding only bodies, under the structural remains of the towers also lay, buried and burned, over $100 million worth of fine art. That fact wasn't widely reported in the immediate aftermath of the terrorist attacks—just a couple of articles, one of them in *USA Today*—because the human loss was far more important.

. The World Trade Center was operated by the New York Port Authority, and, as *USA Today* reported, the Port Authority had set aside 1 percent of the cost of building it for public art projects. These included a bright red, twenty-five-foot Alexander Calder sculpture that looked a bit like the wings of a giant bird—*WTC Stabile*, in front of 7 World Trade Center. A painted wood relief by Louise Nevelson called *Sky Gate–New York* hung in 1 World Trade Center. A painting by pop artist Roy Lichtenstein from his Entablature Series was in the lobby of 7 World

Trade Center. A 1974 Joan Miró tapestry, *World Trade Center Tapestry*, hung inside the lobby of 2 World Trade Center.

Lichtenstein's thirty-foot sculpture *Modern Head* did receive some airtime in the days that followed the collapse because it had survived, with a new skin of dust. It looked as if the Nevelson could be salvaged as well. A Dubuffet was also spotted in the ruins.

In addition to the Port Authority art budget, some of the richest companies in America had occupied the Twin Towers, and many of them had adorned their walls and boardrooms with pieces of art that will never be seen again. Cantor Fitzgerald alone possessed a collection of three hundred Rodin sculptures that were demolished that day. I left messages with a few of the companies that once had offices in the World Trade Center and were known to house impressive collections of art. No one returned my calls. My hunch is that none of the companies felt comfortable discussing any losses from that morning, except for the horrible human toll.

Perhaps the most striking symbol of art that survived the collapse and the ensuing inferno was a J. Seward Johnson Jr. bronze sculpture, commissioned by Merrill Lynch, of a man sitting on a bench. The man held an open briefcase on his lap, and the briefcase held a stapler, calculator, tape recorder, and some pencils. According to *USA Today*, mourners at Ground Zero left flowers in the sculpture's hand and filled his briefcase with them. A note on one of the bouquets read, "In memory of those who gave their lives to try and save so many."

Matthew Bogdanos lived one block from the World Trade Center, and on September 11, 2001, he was at his office

in Lower Manhattan when he heard the first plane hit. Bogdanos held a degree in classics and was a sometime boxer and a dedicated marine. The U.S. military had paid his way through law school, and just a few days after leaving his marine unit in 1988 he'd signed up with the New York district attorney's office. He worked as an assistant U.S. district attorney, but he was also a marine reservist, and on the morning of September 11, he ran from his office back through the chaos and dust to his apartment, where he found his family, safe. That night Bogdanos phoned his military superior and left a message: "I want in. Big time."

Eight months earlier, the Islamic fundamentalist Taliban government of Afghanistan had destroyed hundreds of ancient statues, including two giant Buddhas carved into the face of a mountain in the sixth century CE. Men stood in the desert with rocket launchers and tanks and aimed missiles at their serene faces. Afghanistan's information minister confirmed that the fighters were acting on direct orders from Taliban leader Mullah Mohammed Omar, who defended the cultural warfare by saying, "All we are destroying are stones. I don't care about anything else but Islam." The statues had been Afghanistan's most popular tourist attraction.

In October 2001, the United States invaded Afghanistan, and the mullah and the Taliban fled into the mountains. Matthew Bogdanos was there with the U.S. forces, working counterterrorism. When the United States invaded Iraq in 2003, Bogdanos followed the war on terror, initially to work counterterrorism, as he had done in Afghanistan. But he inadvertently took charge of the largest museum theft so far in the twenty-first century.

In April 2003, Bogdanos was camped in the southern city of Basra when news broke that the National Museum of Iraq in Baghdad was being trashed. Bogdanos was

enraged. He made a phone call to his superior with a special request: assemble an elite unit, secure the Baghdad museum. There was some resistance, according to Bogdanos, but he is persuasive and charming.

When he arrived at the gates of the National Museum, the institution was in shambles. Amid the clashes in Baghdad, the museum's staff had fled and the collection was left unguarded for two days. Gangs of thieves had access to the building's galleries and underground chambers for just over forty-eight hours, between April 10 and 12. The criminal interlopers ranged, according to Bogdanos, from sophisticated mercenaries with assigned shopping lists of ancient items to frustrated citizens who saw a chance to steal a piece of their heritage that they could sell or save. Under Saddam Hussein the penalty for illegally exporting cultural property was death; now it was a free-for-all, because no one was in charge.

Together, the museum crashers stole thousands of ancient Assyrian and Babylonian sculptures, jewels, and artifacts. These were treasures from the cradle of human civilization, some of them preserved for more than five thousand years. Bogdanos was in a race against time, and his theory was that much of the stolen treasure was rapidly being smuggled through Jordan, Lebanon, and Israel en route to London, Paris, and New York City.

The media attention was intense: "It's as if the entire Mall—the National Archives and the Smithsonian—had been looted, along with the Library of Congress," lamented the *Washington Post*. Article after article detailed the travesty. The United States was the main culprit, many speculated. It had invaded but had not planned to protect the museum. Art theft, on a massive scale, was suddenly intertwined with the war. According to Bogdanos, just a

handful of the museum's stolen loot could easily form the curriculum of "a year's course in art history. But now they were history—vanished."

Over the next few months Bogdanos led what proved to be one of the most complex art theft investigations in history. His team tracked thousands of stolen items moving quickly across a fierce war zone. Prized missing pieces included the Gold of Nimrud, a thousand-piece collection of gold jewelry and precious stones dating to the eighth and ninth centuries BCE; the Sacred Vase of Warka, humanity's oldest carved-stone ritual vessel (circa 3100 BCE); and the Mask of Warka, the first naturalistic sculpture of a face (also circa 3100 BCE).

After assembling his elite special-forces team of thirteen, Bogdanos actually moved into the abandoned Iraqi museum; he slept, ate, and worked there—got to know it as no other Westerner ever had. Half of its staff returned to work, and a few cried when they saw the state of the museum. That was just the beginning. Over the course of what became his six-month residency, Bogdanos had to contend with an international media prone to sensationalism, reporting that 170,000 pieces had been stolen. His team calculated 14,000. Bogdanos tried in vain to find international support for his mission, but everyone was busy or outright scornful—one UN official who came to appraise his efforts told Bogdanos outright, "I'm here to watch you fail."

It was an impossible assignment. Bogdanos had to secure a crime scene smack in the middle of urban combat and conduct interviews in a foreign language, with dwindling political support, an insurgency about to explode, and no accurate catalog of the museum's inventory. He eventually came to feel overwhelmed about the investigation. "I thought it would be linear. I thought it would be sequential," he told

me. "I can do a crime scene investigation in my sleep; I've done thousands. I thought the mission would take three to five days. Obviously I was exactly wrong."

His team recovered more than five thousand missing pieces, but for Bogdanos, the ratio of recovered to missing antiquities wasn't good enough. "I consider the mission a failure. And I don't use the word *failure* lightly. Name someone who could be wrong more often than I am," he said to me, alluding to a list of assumptions he made during his recovery mission at the Iraqi museum. "I thought the investigation would be relatively easy and the recovery would take years. In fact, the recovery was immediate and the investigation will take years. I thought the international community, who were the loudest in condemning the losses, would be the first to line up to do something. Oops. UN? UNESCO?"

Bogdanos thought countries that had preached a love and appreciation for the preservation of art would be the first to help out. "France? Zero recoveries or personnel sent to Iraq to help. Switzerland? Zero recoveries or personnel sent to Iraq to help. Germany? Zero recoveries or personnel sent to Iraq to help. Turkey? Ditto. Iran? Ditto. I thought antiquities transcended politics. Big oops."

In fact it was difficult for Bogdanos to muster support from anyone within his own government either, he said. The U.S. troops on the ground were skeptical of his assignment and had little interest in helping his small team. Bogdanos had requested aid from the FBI. The bureau sent one agent to the museum, for one day. By sunset, the agent said there was nothing the FBI could add to his investigation. Bogdanos and his team were on their own.

Despite the frustrations, Bognados's efforts managed to drag a much-needed spotlight onto the problem of art theft.

When he left Iraq, he wrote a book about his experience there, *Thieves of Baghdad*. He dedicated his royalties to the rebuilding of the museum and toured aggressively.

One afternoon in March 2004, I went to New York to hear Bogdanos speak at the Plaza Hotel about his experience in Iraq. He was addressing the Art & Cultural Heritage Law Committee of the American Bar Association, and his audience was mostly lawyers of two breeds: those who believe that the market for art should be regulated and those who think it works as it is. The session he was taking part in was titled "One Year After the Looting of the Iraq Museum" and had been organized by Bonnie Czegledi and Patty Gerstenblith, cochairs of the committee. It was Czegledi who'd encouraged me to travel to New York for the conference.

Bogdanos was part of an impressive list of guests, including Zainab Bahrani, professor of archaeology at Columbia University. Bahrani was the first speaker, and she noted about Iraq, "Antiquities are sold on the black market. Looting is now an export business. In 3400 BCE the first system of writing was invented. Beer was another wonderful invention of the Mesopotamians. Music, writing, visual arts," she continued. "These moments are comparable to the Enlightenment or the Renaissance." Bahrani provided the context for what had been stolen. She did not mask her utter disappointment and frustration at the situation.

When Bogdanos stood up, he took command of the room and conjured up the image of Iraq, post–American invasion, and the broken-down museum. The colonel is five nine squared with a near buzz cut, rank and stars pinned to shoulders and breast. His mission on the ground was to recover more than fourteen thousand looted pieces of antiquities.

He described his methodology: "We decided it was more important to recover items than prosecute offenders."

His etiquette was simple: "It is considered rude not to accept tea when it is offered. I drank more tea than I thought was humanly possible. I decided not to wear my helmet or body armor. I wanted to earn trust."

His strategy: "We established an amnesty program." This meant that Iraqis could simply return the precious cultural heritage of their country to the museum, no questions asked. Bogdanos then went on to chastise the *New York Times* for erroneously reporting that a sacred vase that had been returned in the trunk of a car had been broken into sixteen pieces during the looting. "It was recovered in sixteen pieces," he noted, "because it was always in sixteen pieces." The vase had survived from 3200 BCE.

The museum itself had been damaged, but not as badly as the media reported, he said: "Of 451 display cases, only twenty-eight were damaged. Many Iraqis viewed this as Saddam's private museum. It had the finest collection in the world of 100,000 Greek and Arabic coins."

He added, "It is inconceivable that this wasn't partly an inside job. So we're looking at professional thieves and random looters." This followed Wittman's logic on museum theft. Bogdanos knew that some of the stolen items had been in a basement vault, and whoever found them would have done so in the dark.

His final message, probably delivered with the blessing of his U.S. military commanders: the looting could have been a lot worse. Despite Bogdanos's recovery successes, he knew that most of the stolen treasures would follow the established pattern of art thefts—the items that had slipped away would spread across the globe from thief to middleman to dealer to collector. It was almost impossible to track them as they moved to hot spots in the art market, where dealers would sell to collectors willing to pay small

fortunes to own a piece of ancient Babylonian or Assyrian history.

When I asked Bogdanos about the state of global law enforcement and its capability for dealing with the international black market in stolen art, he answered, "To say that there is an international law-enforcement community organized around stolen art is not only misleading, it's an oxymoron. There is no such thing. It is fair to say we have an international law-enforcement community in regard to fugitives. But we don't with regard to art. It is really everyone in their own discrete worlds, in some cases doing a very good thing, but limited in their scope."

In 2008, I visited Bogdanos at the Manhattan district attorney's office. He was his usual high-energy self, trim, with those boxer's shoulders. He was, in fact, carrying athletic gear for a softball game between the DA's team and the police. His office was adorned with awards and photographs. He said that he'd heard no recent news of any Iraqi antiquities. "It's gone quiet," he said. "Not a whisper."

I asked him again about the lack of information and how that affected the ability of any government or law enforcement agency to continue hunting down the missing antiquities from the museum, or any other stolen art. From across his desk, Bogdanos cocked his head.

"Do you understand the difference between information and intelligence?" he asked. "Information is just what comes from out there." He opened up his arms and gestured out the window to New York City. "Information is facts, little pieces, whatever is floating around. Intelligence is what happens to information when it passes through a human source, someone who knows something about the subject, who can make sense of that information, make it

useful. There's very little information, and even less intelligence," he said.

In Washington, D.C., there was, in fact, one person who was responsible for gathering and analyzing information related to international art theft.

# 13.

## INTELLIGENCE

"Nobody wants to be regulated. Anyone
who is faced with regulation will resist it."
**BONNIE MAGNESS-GARDINER**

The White House hovers in the mist. Just a few blocks
away, at 935 Pennsylvania Avenue, sits the hulking
brownstone block of the J. Edgar Hoover Building, the
national headquarters of the Federal Bureau of Investigation.
This morning the Hoover Building is flanked by lines of
police cruisers coated in a light rain; men in dark rain gear
cradle machine guns in front of the entrance to the garage.

The lobby is bland and bureaucratic. Everything is
corporate clean. Agents in suits and security tags hustle
through the turnstiles. The only pictures on display are a
series of portrait photographs: the Top Ten Most Wanted
Men. Most of the pictures are grainy shots with block text
under the mugs offering a $100,000 reward for informa-
tion leading to their capture. The top left-hand picture
when I visit is of Osama bin Laden. For him the govern-
ment is offering $25 million, plus a $2-million bonus from

the American Pilots' Association and the Air Transport Association.

Bonnie Magness-Gardiner meets me at visitor check-in. She's a slender woman, in her early fifties, wearing a blazer, blouse, and slacks, with glasses and chin-length graying hair. She looks distinctly like an elementary-school principal. If you saw her on the street you would never guess she leads the bureau's battle to fight international art crime.

The FBI unveiled its Art Crime Team in March 2005. Its official rationale for devoting resources, money, and agents to the cause of stolen art was the looting of Iraq's National Museum and the spread of that loot to American shores. The media's mourning of the ancient treasures had put a spotlight on the recovery efforts by Matthew Bogdanos and his team. The FBI and the CIA had taken equal shares of the blame for being unable to prevent the 9/11 attacks, and it's possible that the FBI was searching for some much-needed positive PR. By middecade, the bureau was allocating much of its resources to counterterrorism, so it seemed an awkward moment to introduce a new cultural property squad. But that's exactly what the bureau did. My hunch is that Robert Wittman must have done some politicking, but the agent told me, with a smile, that he was sticking to the official explanation.

To launch the Art Crime Team, the bureau employed the tactics of a media-savvy corporation unveiling a new product. There was a cool new logo—a badge-sized circle with images of famous stolen art: the tormented head of Edvard Munch's *The Scream* in the bottom left, a stolen Iraqi antiquity near the top. At its center sat the serene face of Leonardo da Vinci's *Madonna of the Yarnwinder*, the mother of Christianity holding her baby Christ. Stamped across the circle were the three letters ACT, emblazoned

in a comic-book burnt orange. The outer rim of the circle was trimmed in a more conservative font and read "Federal Bureau of Investigation Art Crime Team."

Over the next year, stories in the *New York Times*, the *Washington Post*, and dozens of other newspapers around the world carried the intended message: eight agents had been handpicked from hundreds of applicants for the new team and were supported by special prosecutors to handle the complexities of these cases—a fact undoubtedly noted by art thieves and by crooked dealers and collectors, who rarely saw the interior of a courtroom, much less a stain on their reputation, a conviction, or a prison sentence.

The FBI also rolled out a new website. Its pages included a stroke of bureaucratic genius—the Top Ten List of Most Wanted Stolen Art. The "Top Ten" concept had worked wonders for most-wanted fugitives, so why not for paintings? It was sexy, by government standards, but it didn't quite work. Paintings and sculptures, after all, don't have the same allure as those grainy black and white mug shots of tough men out to destroy our pursuit of happiness.

Still, the announcement, the team of agents, the legal support, and the new website did more to focus attention on the problem of international art theft than any other law-enforcement agency in the world ever had. This was the famous FBI, after all, which had busted Al Capone, killed John Dillinger, and, ultimately, infiltrated the American imagination. It was now officially hunting art thieves.

"Art and cultural property crime—which includes theft, fraud, looting, and trafficking across state and international lines—is a looming criminal enterprise with estimated losses running as high as $6 billion annually," stated the FBI's website.

Although the Art Crime Team may have been a political PR maneuver, it gave Wittman a more secure position, a larger budget, a group of agents to work with, and more influence. There were now agents in cities across the United States being trained to investigate art crimes while they tended to their other caseloads. Wittman also got a dedicated manager.

Magness-Gardiner, a trained archaeologist, had served ten years with the U.S. State Department's Bureau of Educational and Cultural Affairs before taking over the FBI's Art Crime Team. After the invasion of Iraq, it was Magness-Gardiner who was tasked with keeping an eye on that country's cultural heritage—including the National Museum and the ten thousand archaeological sites left unguarded during the war. "I talked to a lot of generals. They weren't always particularly interested in what I had to say," she said delicately. She switched departments, was issued her FBI identification, and dug in at the Hoover Building.

Magness-Gardiner is not a field agent. She coordinates the ACT operation, analyses information, and, once a year, gathers her FBI team together to trade information. Agents like Wittman may crawl the globe busting art thieves, but it's Magness-Gardiner who is the guardian of the data they bring home to the bureau. The National Stolen Art File, which the FBI has been building for three decades, sits in a laptop under her desk.

"It was started in 1979, with cards in a drawer, not long after IFAR's list was created. In 1995, those cards were converted into electronic info." The ACT manager told me that she accessed the database on a weekly basis, and added new items on a monthly basis. Compared to the Art Loss Register, which holds over 200,000 stolen works, the FBI's National Stolen Art File is relatively small, with about 6,500 items.

Magness-Gardiner also dispenses and gathers information from across the globe. When we met, she'd recently spent a week in Macedonia, where members from a dozen different Eastern European police forces gathered to learn from her experience—officers and detectives from Romania, Poland, Albania, Serbia, Bosnia, Hungary, Bulgaria, Moldova, and Montenegro. "These are source countries," she said, meaning they were exporters of looted art that usually had to cross a number of international lines to get to the buyers in Paris, London, and New York.

"Often their art is passing through other countries to move on. So these people meet, and they build a network." The year before, she had trained a group of South American law-enforcement personnel in Bolivia. "And it's good for us, too, to make contact with those investigators. A lot of art crime in the U.S. has an international component," she said.

It was Bonnie Czegledi who first mentioned Bonnie Magness-Gardiner to me. The two Bonnies had met at international conferences while Magness-Gardiner was with the State Department. They struck up a professional relationship. When Magness-Gardiner took over the Art Crime Team, I got her contact information from Czegledi. "She knows a lot," Czegledi told me. "She is definitely someone you need to talk to." After I exchanged emails with the FBI PR department, Magness-Gardiner agreed to a series of phone interviews over several months. I then requested an in-person interview. We met in the fall of 2009, in Washington, D.C., just days before the U.S. capital was paralyzed by snowstorms.

That interview was a chance for me to cross-check information from interviews with Paul Hendry, Donald Hrycyk, and Robert Wittman. They were players working ground games, whereas Magness-Gardiner had the intelligence job.

My questions to her focused on the challenges of understanding and policing the enormous black market.

I asked Magness-Gardiner if it was fair to say that no one had a handle on how large the black market in stolen art had become. "Yes, that's fair to say," she answered. "It's an illicit trade, and we don't really have very good statistics. Not all art thefts are reported, but roughly, it's a four- to six-billion-dollar industry globally. Those numbers were produced by British-based insurance companies a decade ago. It would be extremely difficult to come up with any solid number," she explained. "When we say 'black market,' really what we mean are those stolen items that are in the legitimate market and shouldn't be there. The black market isn't separate. So we're talking about items that have no history. The collectors, the museums, and the dealers all partake on some level."

Magness-Gardiner was hinting at the unregulated art market. Czegledi had driven home that point in our early interviews; thieves like Paul and agents like Wittman had agreed. But I wanted to hear the head of the FBI Art Crime Team state it clearly, and she did.

"Art is one of the biggest unregulated markets in the U.S. The business of art tends to be very closed and secretive. It is still business done on a handshake. Financial transactions are quite difficult to track, because you don't have a paper trail. How art is bought, sold, and moved is a challenge in itself to understand. When a piece of art is bought or sold, there is the movement of the physical object from one location to another. There is also the transfer of money from one bank account to another. There is nothing to link those two events." She was confirming Hrycyk's observation that some art dealers act like drug dealers.

"Another problem built into a business-on-a-handshake model is the issue of provenance. The first thing we tell a

new agent to do is to find out whether or not the work of art that has been stolen is, in fact, real. Where does it come from? Where are its records? We don't know until we do a background investigation on the piece of art." She continued, "Looking at the authenticity of a piece is always detective work. Unlike most other material items manufactured today, art does not have serial numbers. Lack of a serial number is one element that really distinguishes art from other types of property theft. The only parallel is jewelry and gems—difficult to trace because they don't have a serial number either, and so they are particularly valuable to thieves," she said.

"The middlemen and the dealers don't want other people to know their sources. This can stem from a legitimate business concern, because if other dealers find out who their sources are, they could use those same sources."

I asked Magness-Gardiner about the myth versus the reality of the international problem. Early on, Paul and I had discussed the motivations of art thieves, and he had stuck to his point that criminals steal art for money, first and foremost. The Dr. No theory had dogged everyone, but did Magness-Gardiner agree with the British thief?

"Thieves usually steal art because they want the money. They are burglars, not art specialists. They need to have a method of turning the objects they steal into money. They'll take it to a pawnshop, a flea market, or walk into an art gallery and try to sell it. They don't have a sophisticated network," she said. "But when you're dealing with high-end art, there's a network. It moves from the thief to a middleman. It's the middleman who knows how to get it to the market without tipping off the market or the police." She described Paul's middleman model perfectly. If that was the case, and thieves were so easily exploiting the holes in the

unregulated market, why did the market itself not bend to regulations? After all, wouldn't that go a long way toward fixing the problem?

"They don't want to be regulated," Magness-Gardiner said. "Nobody wants to be regulated. Anyone who is faced with regulation will resist it. In the U.S. we've made a case for regulating weapons, and there were people who complained. We still do it. In the art world they would say, 'There's no harm in these transactions. This is a free market economy, an open market, and we're exercising our right to sell something.'" It was the same speech the Art Loss Register's Julian Radcliffe had heard, ad nauseam, from dealers and galleries that didn't want to pay his search fees. "But the system has its consequences," Magness-Gardiner pointed out. "You can sell works of art, and they cross state and international boundaries fairly easily. We do demand importation documents, but we do not regulate."

The actual transportation, she says, isn't the issue. "It's the transaction—when you sell it, transfer it, trade it, or give it to someone else. That's why art has become an excellent vehicle for money laundering. For example, you can take a Picasso out of the country and sell it at an auction. The person who sold it might have earned $20 million and put it into a Swiss account that we don't know about. With other objects, like a car or a house, a person has some sort of document that identifies them as being the legitimate owner. That does not exist with art. You wouldn't sell a $5-million plane without a document, would you? With art, there is no document. I'm constantly amazed." She sounded just like Hrycyk.

I steered the questions toward the interaction between dealers and thieves. From my discussions with Paul, it seemed as though the crucial point of contact between the crime and the legitimate market was the first trade. "The

dealer who handles stolen art usually buys it from somebody he knows. He may suspect that this work of art is not quite legal, but he is not required to ask if what he is buying is stolen," Magness-Gardiner said. "As long as that dealer doesn't ask the question, the seller doesn't have to tell him. There is no law that requires a dealer to ask if something he is buying is stolen. So now he's bought a work of art for a bargain-basement price, and there is no evidence that he knowingly bought it as stolen property. How do we prosecute him?"

Then she pointed out, "It's very easy to move lesser-known paintings into the legitimate market. Once it gets to the second person, and they handle it, nobody will notice that painting moving further into the market. It's the thief, and that first contact he sells it to, who knows that the artwork has been stolen. By the second transaction nobody knows anything, and nobody asks questions."

Paul had always said that a British thief received about 10 percent of the value of a work in that sale to a dealer. I wondered if that figure applied in the United States as well. "As far as I understand, the price you're going to get for a stolen work will be 10 percent or less of its auction value. The person who's doing the first transaction knows that the painting is stolen. And it's that knowledge that makes him vulnerable to prosecution. There's a discount price, and he knows it. The handler or the middleman, who sells it to somebody without telling them it's stolen, is going to try to sell it for full value."

The underground economy for stolen art, according to Magness-Gardiner's statement, seemed to adhere to certain basic rules that applied across North America and the United Kingdom. Dealers were receiving great discounts on price, and so could earn large profits, by selling directly either to a collector or to another dealer up the chain of supply.

If the FBI understood that the pressure point was in that first transaction, moving from middleman to dealer, why were they not more focused on prosecuting dealers?

"Most of those cases fall under the National Stolen Property Act," Magness-Gardiner answered. "What this means is that the person dealing with the stolen object must have knowingly done so. It's about the element of knowledge. The FBI has to prove that the person knew that the object was stolen. That is a significant hurdle. How do you prove that someone knew something was stolen when it's hard to prove who owns the work of art in the first place?"

Magness-Gardiner had heard all the excuses from dealers and gallery owners caught in possession of stolen pieces. "I found it in my grandmother's attic, I bought it at a flea market, somebody came in off the street and offered this to me, I bought it at a small auction house."

Auction houses were the other easy way to deliver stolen art straight into the legitimate market. Radcliffe had recognized this problem and hoped to close that loophole, but there were hundreds of midsized and small houses that did not consult with the ALR. And thieves could always take a chance with the big houses. In the FBI's view, I asked, what kind of a role did the houses play in feeding the black market? "They are a vital part of moving stolen art back into the legitimate market. Sometimes the FBI will get a tip about a valuable painting that has turned up at a small auction. For example, there's a [Henri Fantin-]Latour out in Virginia, being sold with some old furniture. We'll go and have a look. There's always a chance it's legitimate, but usually you would want to bring a painting that's worth a lot of money to a big auction house," she said.

"In other cases, private sales continue until a piece of art gets through so many hands that it can move to Sotheby's

or Christie's. At that point it's almost impossible to trace it back to a crime. The person who stole it will probably never be caught."

I asked her how many times a year the FBI found stolen art at auction houses in the United States. "Ballpark figure: fifteen or twenty times a year. It could be a victim or an agent, or I could see a notice in the art newspaper," she answered.

"Art tends to go into collections for long periods of time. A painting that is stolen could be out of circulation for a generation until it turns up again. Many of these objects go into a collection and remain there until that collector dies."

I circled back to the idea of the rogue collector—the Thomas Crown myth that had captured the world's imagination—but Magness-Gardiner remained firm that this was not the scenario that the FBI's cases had revealed. It was the opposite problem—Paul's golden rule of staying under the radar—that the bureau was most concerned with, and the effect of that model on the entire system, from dealer to collector to museum. "There is no Dr. No," she said. "Or if there is a Dr. No, I haven't come across him. A collector has a responsibility to know where his next purchase has come from. The collector, ultimately, is responsible. If a collector buys something that is stolen, it's stolen. Good title cannot be passed to stolen property in the United States. So it's the collector's responsibility to provide the next buyer with information on the ownership, to the best of his ability. Collectors can be really helpful in demanding that dealers provide them with the information that they need—with provenance. There are no laws to be enforced, so it's simply an ethical way of dealing. It's not a requirement," she said. "Collectors are the consumer, though in some cases,

museums become the ultimate consumer, because they are often the recipients of art donations when a collector dies or when he wants to downsize his art collection."

Czegledi had discussed this issue with me. Museums and larger art institutions were regularly the beneficiary of donations for which they sometimes gave large tax credits. So, at its worst, the black market funneled stolen art into the hands of collectors, and then those collectors passed those stolen works into our most esteemed institutions and were rewarded by the government for it. If that was the case, I asked Magness-Gardiner, wouldn't the Internal Revenue Service be interested in the connection?

"I've talked to the IRS about this. The IRS doesn't care about good title on those pieces that are donated. The IRS cares about value," she said.

I told Magness-Gardiner that I was interviewing Donald Hrycyk and wanted to know what kinds of interactions the FBI had with detectives on other local police forces. "The FBI relies on them for information," she said. "The first thing they have to do is file a police report, and then get in touch with us. In some cases, the local police force knows that there is a National Stolen Art File, and they will send me the information directly." Of course, there were hurdles in terms of communication and the quality of information that was relayed to the FBI. In the same way that Paul had to dumb down his orders for the thieves he hired to go into houses to steal art, most police officers did not possess the specialized knowledge to properly file a report on the pieces that had been stolen. It was a conundrum she faced on a regular basis, from her national perch. "Sometimes a local police officer looking for help or guidance will call me, and say something like, 'We have this painting that's been stolen. It has some trees, a hill in the background. What is it?'

More than 75 percent of the time there are no photographs of a painting that has been stolen," she said. When owners have not photographed their collections, police are left grasping for the right vocabulary. "If you're an agent investigating a specific work of art that's been stolen, you might only have a piece of paper that says, 'Oil Painting, $10,000.' Okay, great, so it's an oil painting." Magness-Gardiner laughed.

"I will take the info and put it in the National Stolen Art File. I don't take any proactive steps to circulate the information, though. That's not the purpose of the National Stolen Art File," she said. "Months later I might get a phone call from a different local police force. This could be in another state. They will send me photographs and information on the art that they've found. I check the National Stolen Art File. In that one-in-a-hundred case, I'll say, 'Hey, that was actually stolen from a couple in California.'"

Rarely, though, did the FBI manage to track down the criminal responsible for the crime. "You don't usually find it in the possession of the thief. It would go from the thief to a fence, a pawnbroker, an antique shop, a gallery owner, a furniture store, a bar, a restaurant, a private person. I'm naming all the ones I'm familiar with. Then immediately, or after twenty-five years, someone will bring it to auction. We often find stolen art when it comes up for auction because there's publicity. It might change hands two or three times before it becomes public," she said.

"Once stolen work gets into an institution it just stays there. Then someone who knew the painting was stolen will see it and inform us. It could be ten years later, or twenty. At that point, you can recover the work of art, but you can't identify the thief."

Magness-Gardiner paused as she thought about the ways in which the FBI is alerted to stolen art cases. "One

of the most frequent ways we find stolen art is when some-body knows a person has a piece of stolen art. That some-body might be an irate neighbor or wife or boyfriend, or someone going through a divorce. It's often a relative. 'My sister has X. My husband, whom I'm fighting for custody of the children right now, I know he took it.'" She smiled. "Hell hath no fury."

Sometimes artwork was smuggled out of the United States, and the FBI handled those cases as well. These were Witt-man's specialty, but he wasn't the only agent to work those types of cases. "There was a case in St. Louis. A couple of col-lectors put their art in storage, and the company went out of business. The collectors just kept paying the storage bills, but their two hundred pieces were gone—works on paper, sculp-ture. One Mark Rothko was sold to a Japanese collection—it made it through a dealer to a legitimate buyer in Japan. I think it took two years to get it back. The FBI did get most of those works back. It was quite an undertaking," she said.

"The same agent in St. Louis who'd worked that storage company case also worked on the case of a stolen Norman Rockwell painting. It turned up in Steven Spielberg's art collection. The agent had received some information that suggested he could track the Rockwell down, decades after it had been stolen. We did a cold-case investigation and pre-pared a press release, which went up on our website," she explained. "When Spielberg's dealer was preparing to loan the piece, he Googled it. Our FBI art theft page turned up. I'm sure it was a shock to them—that the painting was sto-len from a private collection in 1978." The FBI informed Spielberg that one of the paintings in his Beverly Hills mansion, Rockwell's *Russian School Room*, had been sto-len. "The director took it off his wall immediately. We were the element that allowed that painting to be found."

According to Magness-Gardiner's intelligence data, the black market had systematically infected the legitimate art market, and local police forces were not trained to patrol the billion-dollar unregulated market. Information was rare, and stats were almost nonexistent. Wasn't it vital, then, for knowledge, as scarce as it was, to be passed on from one generation of FBI agent to another? I pointed out that Robert Wittman had recently retired. Was there a system in place to transfer that flow of experience and information on? "I can make recommendations and try to ensure continuity, but continuity is not built into the system." She paused. "Some of the talents required are not those that can be taught. An agent that's good at this work has to possess a profound interest and knowledge in artworks. I can bring agents to seminars and explain art history to them in an intellectual way, but that only goes so far," she said.

"It's the agent that has to have the willingness to spend his or her spare time going to museums, learning about certain artists, the sorts of things that would allow that agent to ask certain questions, the right questions, when they're investigating. Both Bob Wittman and Jim Wynne, our agent in New York, have that quality and those talents. It's not a question of waving a wand and saying, 'Replace those agents with younger agents who have a love and passion for art and can investigate well.' The best I can do is suggest they work closely with someone, to teach them."

On that note, we discussed the evolution of the Art Crime Team. "It's thirteen agents now. Scattered across the country. Each one is in a different city. They deal with specific regions. New York, Chicago, Los Angeles. New York is the busiest of the three, and second is a toss-up between Los Angeles and Chicago," she said. Once a year

Magness-Gardiner assembles the ACT agents for a week to discuss active cases, get advice, and get to know each other. Sometimes she invites guest speakers: gallery owners, art dealers, cultural lawyers. In 2008, she held the meeting in a Customs department facility in Santa Fe, and for the first time included a detective from a municipal force to train with the team—the LAPD's Stephanie Lazarus.

"I hope it was useful for her, to see what we're doing and how we're doing it. It was very useful for us, because we had the opportunity to ask her how a municipal force works, what its limitations are, what it can provide." The LAPD Art Theft Detail and the FBI Art Crime Team had already collaborated a few times. Once, when the FBI raided a television art-auction office, it confiscated thousands of artworks, many of them fakes. There was so much material that the FBI needed help storing it, and Donald Hrycyk gave the federal agency access to the LAPD storage space, in the warehouse I toured there.

Magness-Gardiner spent about two hours relaying information and answering questions that afternoon in Washington. She was polite and direct, and I got very little sense of an ego at play—she came across as a straight arrow. In many ways, she was the opposite of Special Agent Wittman. Wittman was an aggressive, balls-to-the-wall kind of agent, always ready to leave his desk and hop on a flight to infiltrate a criminal organization. Magness-Gardiner was the quiet scholar who stayed at the desk, sorting through information. The picture she drew of the black market was a perfect match for the system that Paul had described in Brighton and London, and the one in Los Angeles that Hrycyk had perceived.

When I'd first sat down with Bonnie Czegledi in Toronto and she'd outlined all of the issues and challenges at play in

the black market, I knew that even if she was right, it would be a challenge to clearly define the shape of the international problem she was describing. Over the course of interviewing Paul and Richard Ellis in the United Kingdom and Hrycyk and Wittman in the United States, I felt as if I was beginning to see that shape and its scope. An image began to form in my imagination—a map of the world, with the continents as dark forms. Little pins of light were scattered across the continents, representing sources of information on art theft. Every time I made contact with someone who had a piece of information, a little light would pop up on my mental map. There were now glowing pins in Philadelphia, Los Angeles, in London, in Brighton. There was one in Toronto—Czegledi. The point in Washington was especially bright, and represented the highest authority on art theft in the United States. I also imagined dotted lines that stretched between those points, representing communication. A line led from Czegledi to Bonnie Magness-Gardiner. Another connected Magness-Gardiner and Hrycyk. There was a line between Paul and Richard Ellis. In a perfect world, all the points of light would be connected to every other point of light, but that wasn't happening. Information flowed, but not at the speed or in all the directions that it should.

There was another pin of light in Canada, and lines connected it to the Art Loss Register, Interpol, and Bonnie Czegledi. In one of the largest countries in the world, it was one of only a few points of light, and sat directly north of the largest art market in the world.

# *14.* _ _ _ _

## MONTREAL

"Biker gangs have specialists for telemarketing,
for fraud, for credit cards, and now they have
specialists for art too."

**ALAIN LACOURSIÈRE**

On September 4, 1972, at 1:30 AM, the white hallways
and galleries of Montreal's Musée des Beaux-Arts
were quiet save for the footsteps of one of three
guards on duty, who had just finished his round on the sec-
ond floor. Now he was ready for his break: a cup of tea, a
moment of peace.

Three hooded men appeared and ordered him to the
ground. The guard couldn't move fast enough for them.
One of the men fired off a round from his sawed-off shot-
gun to punctuate the command. The slugs lodged in the
ceiling high above them. The two other guards on duty
heard the gun and rushed to the room. They were over-
powered, bound, and gagged.

All three guards were forced to lie down on the marble
floor of Arthur Lismer Hall, listening and squirming. It

took an hour for one of the guards to wriggle free and call police. The thieves worked quickly: their nocturnal visit to the museum lasted only thirty minutes.

A skylight under repair had been their drop point into the galleries, where they removed eighteen paintings, including Rembrandt's *Landscape with Cottages*, then worth over one million dollars. Works by Pieter Bruegel the Elder, two Jean-Baptiste-Camille Corots, two Jean-François Millets, a Gustave Courbet, an Honoré Daumier, a Eugène Delacroix, and a Thomas Gainsborough were also missing from the walls. In the museum's 112-year history, there had never been a robbery of this magnitude. The men left no trace of their identities, and police had little to go on.

Then the thieves made contact. One of them called the museum and demanded a ransom of $500,000, which was later lowered to $250,000. The museum director wanted proof that the men had the goods; he asked for one of the paintings, as a gesture of trust. The thieves bit. The director was told to go to Montreal's Central Station and open a specific locker. He did. And there it was: a Bruegel, and in good condition.

Police had tapped the telephone lines, but the calls were never long enough to be traced. Then another point of hope: a meeting was arranged to trade cash for art. The thieves were told that an insurance adjuster would bring money for one more painting. It was a standard police tactic; a Montreal police officer posed as the adjuster. The meeting was aborted when one of the thieves spied a police car near the rendezvous point. They never made contact again. It has been speculated that the paintings are in the hands of organized crime, and may still be in the Montreal area.

A few key criminal dynasties took root and flourished in Montreal after World War II. These included the Mafia,

concentrated in a Montreal suburb, and the Hells Angels biker gang, a group of which had migrated from California, setting up headquarters in the nearby city of Sherbrooke but whose ranks and clubhouses spread across Montreal during the 1970s and 1980s. The Hells Angels' reach extended to both Canadian coasts, but in Quebec, secluded by cultural barriers, they remained firmly discreet—except for the occasional gangland murder that added to the city's criminal mythology and made for grim headlines in the Montreal *Gazette*, *La Presse*, and *Le Devoir*. It was the Hells Angels who came to dominate the black market of drugs, gambling, and prostitution in Quebec. They seemed to be unstoppable—an efficiently organized crime machine ruled by Maurice Boucher, president of the Montreal chapter. By the early 1990s, "Mom" Boucher was one of the most powerful crime lords in Canada, presiding over an army of biker soldiers. In 1994, Boucher decided to annihilate his competition—including rival gang Rock Machine. He sent two Angels affiliates into a motorcycle shop in downtown Montreal, where they murdered two Rock Machine members. A war began. It was bloody, and it attracted the full attention of the Montreal police, the Sûreté du Québec, and the Royal Canadian Mounted Police.

Alain Lacoursière was on the Montreal force when the biker war exploded. He'd grown up in rural Quebec, joined the police academy right out of high school, and risen quickly among his peers. In 1992, he was a thirty-two-year-old lieutenant in charge of twenty-two police officers working fraud cases. Lacoursière was intelligent, driven, skilled at reading con men, and miserable in his work—he matched the art-cop pattern. "I hated the job, and I was starting to hate myself," Lacoursière told me.

The depressed young lieutenant had some vacation time saved up. He took two weeks off and went to Paris, which

he'd visited as a teenager. Once again he got lost in the lush gardens, dim bistros, and sprawling museums and galleries. He loitered in the Musée d'Orsay and the Louvre. The clean, organized art institutions were in so many ways the exact opposite of his regular beat across the ocean, touring the dirtiest corners of the human psyche. Time away from his life as a fraud investigator opened him up enough that he fell in love with art again, just as he had when he'd studied it in high school.

Lacoursière felt rejuvenated when he returned home, but he knew the feeling wouldn't last. He kept working fraud cases—but he promised himself he would find a way of incorporating his love of art with his police work. He told his wife about his decision, and she was supportive. He enrolled in an art history night-school course at a local university.

He also contacted the FBI in New York and Interpol in France with an open-ended request: Did they have any stolen art files that might have a connection in Canada? Lacoursière wasn't sure what to expect, and he hadn't obtained his superior's permission to make those requests. The FBI answered first. The agent who replied was happy to send a few cases north. From the FBI's point of view, it was rare for an officer from another country, much less from a municipal police force, to request information on cold cases about stolen art, or even to offer to lend a hand with any cases at all. The FBI sent the Montreal cop pictures of missing art.

Among the material, Lacoursière found a fuzzy photograph of an antique tapestry estimated to be worth $200,000. By this time his desk was strewn with dozens of catalogs from local auction houses. Just like Paul, he was scouring those catalogs to learn about the art

market—what sort of pieces were selling, for what prices, and who was selling them. One of the catalogs advertised a piece that seemed similar to the stolen tapestry, but the picture the FBI had sent was of poor quality, and the auction was slated for the next evening.

Lacoursière phoned his FBI contact and asked him to courier a high-quality photograph. The detective said he was pretty sure it was the stolen tapestry, but not absolutely. The FBI was skeptical but dispatched a courier north. The picture arrived in Montreal early the next evening. Lacoursière compared it to the one in the catalog. It looked like a match. He tucked the picture into an envelope, got into his car, and broke the speed limit, but he arrived at the auction house too late. The auction had begun.

Lacoursière sat down in the audience. When bidding opened on the tapestry, he looked at it on stage and then eyed the photograph. Same tapestry, stolen out of New York, and now it was about to be sold to a legitimate buyer in Montreal. Lacoursière raised his hand and placed a bid. A few seconds later the gavel came down and the lieutenant was the proud new owner of the tapestry. "I bought it for $195,000."

After the auction Lacoursière approached the proprietor. He took out his police badge, as well as the FBI file and picture. "I didn't want to ruin your auction," the detective told the owner, who was grateful, if disappointed at the lost sale. Lacoursière phoned his FBI contact the next morning, and they arranged for the tapestry to be returned to the FBI's New York office. The agent told Lacoursière that nothing like this had ever happened before, and asked him if there was anything the agent or the FBI could do in return.

"Yes," the Montreal lieutenant answered. "You can write a letter to my boss telling him this type of work is

valuable." It was straight out of the Richard Ellis play-book—get a letter circulating among management stressing the value of the work. The FBI did exactly that, and sent a letter of appreciation to Lacoursière's superior officer and to the Montreal mayor's office. Meanwhile, Lacoursière requested permission to investigate a few other leads in the art world. His boss said no; stolen art just wasn't worth the time. But then Lacoursière's superior received a phone call from the mayor, congratulating the department. The superior's decision was overturned, and Lacoursière was granted permission to spend 25 percent of his time on stolen art investigations, as long as he could keep up with his other casework.

Lacoursière started exploring the arts community and found the same patterns as every other art detective I interviewed. He was quickly overcome—there were too many cases to keep up with. Art thefts and art frauds were, it turned out, rampant in Montreal. Lacoursière found himself going through the international learning curve. In 1995, for example, a burglar stole a huge abstract painting by Quebec artist Jean-Paul Riopelle from a house in Montreal's wealthy Westmount neighborhood. Before he stole it, the thief showed a picture of the painting to a prestigious French auction house, which expressed interest. By the time the family arrived home from a weekend at their cottage, the Riopelle and the thief were already on a plane for Paris. The painting was quickly auctioned off for $200,000 just as Montreal police were getting around to filing a report. Same pattern, different detective.

From the outset, Lacoursière's mode of investigation was aggressive: deep submersion in the art community. The detective needed to meet the local art players. He also searched the international community for like-minded law

enforcers who tracked stolen art across continents. Sound familiar?

It turned out that artwork in Canada, and in particular in Montreal, was prone to theft at all levels, but in this case there was an interesting variation to the pattern—the Hells Angels.

One destination for stolen paintings was the house of Joseph Ghaleb, a known associate of the Hells Angels with connections to the Mafia and to Colombian criminal organizations. In 2000, Montreal police raided his business. Lacoursière was called in to inspect a cache of art. The paintings were being stored in a stockroom with a suspended ceiling. At one point, the detective lifted one of the squares on the ceiling, just to see if anything was being hidden up there. He felt something weighing it down and, luckily, stopped himself.

Another officer lifted a ceiling square a few feet away and looked around. Lacoursière was holding up fifteen blocks of C4 explosive. Lacoursière had to maintain the same position for hours while the bomb squad did its work. Later, Lacoursière identified sixty-three paintings at Ghaleb's house worth more than $1.5 million. "We know from his lawyer that this was about paying off a drug debt," he said. In December 2000, Ghaleb pleaded guilty to a charge of concealment of artworks, for which he received a sentence of six months in prison. Ghaleb was murdered in November 2004, but his art collection indicated that stolen art was now a big business, being used by organized crime. It was a currency, as already proved by Richard Ellis in the Russborough case, when he found the stolen Vermeer in the possession of a diamond dealer in Antwerp.

On a spring morning in 2001, Canada's Royal Canadian Mounted Police, the Sûreté du Québec, and the Montreal police conducted a sweeping raid on the Angels. Later

that day, Lacoursière was called on to tour an array of biker residences and clubhouses. The forces were sorting through drugs, guns, and cash, but they'd also found caches of art, which the task force didn't know what to do with. Lacoursière "recuperated a lot of stolen art," and often found two receipts for each painting. "One was a bill to declare to the government, the other had the real value of the artwork. There are a lot of fake papers for artwork."

At one biker mansion where the police were confiscating items of interest or value, Lacoursière noticed a particularly opulent doorstop. He emailed a picture of it to a few art experts and got a response almost immediately. He then instructed one of the officers to remove the doorstop. The police officer looked at him and asked, "Why? It's just a doorstop."

Lacoursière replied, "It's a bronze statue by Riopelle."

The Riopelle turned out to be worth $75,000, and was one of the most valuable items seized that day. The 2001 raid was the culmination of months of surveillance. The bust resulted in dozens of arrests and convictions. Lacoursière's cases on the Montreal force had attracted the attention of the Sûreté; he'd proved the link between organized crime and stolen art. In 2003, Quebec's provincial police force recruited him to lead an art theft unit. They gave him additional resources, and allowed him to pick a partner. He chose a young detective named Jean-François Talbot. Talbot would be trained as a successor to the new Quebec stolen art unit.

The same year, in 2003, another raid on a biker's house yielded a Cézanne painting locked up in a safe. Lacoursière emailed a picture of the Cézanne to a renowned Swiss-based expert on the artist. The next day, the expert emailed back. He recognized the work; he'd seen it years before and

thought it was in Miami. According to him, the painting was one of the most famous forgeries of a Cézanne ever created.

"You need to know the people who know the culture, and most of the time they're not local," Lacoursière said. "Even though it was a fake, an auction house in New York—and I won't say which one, but it was one of the big ones—had already agreed to put it up for sale. We knew about the Cézanne from wiretaps. The plan was for them to sell it at the New York auction house for $16 million."

"The way this works is that criminals sell it through the auction house to another criminal buyer in the audience at the auction," he explained. "It makes sense, because the auction house gets a percentage—say, a million dollars. But the criminal organization has just laundered $15 million. Not bad." The detective added, "The painting weighs one pound and is sixteen inches wide. That's a lot easier than traveling with cash."

Another case he worked involved two seventeen-year-olds who were breaking into galleries along Sherbrooke Street. "They broke in eighteen times in a year and a half. They would steal a painting, and they would also steal the price off the wall. I think they were using the art to pay off their drug debt."

The evidence linking art theft and organized crime piled up. In 2006, in Quebec City, two drug dealers were arrested for being in possession of fifty pounds of cocaine. But the more surprising find was a stash of over 2,500 paintings in their warehouses. "Every month these guys were placing hundreds of paintings in auction houses across Quebec. They were using the system to launder their blood money. Place a man in the audience who inflates the price and buys the painting. Auction house gets its percentage, money is cleaned," Lacoursière noted.

I had first met the detective on an overcast afternoon in Cairo in early March 2007, on the trip I took with Bonnie Czegledi. Lacoursière, then forty-seven years old, and his partner, Jean-François Talbot, thirty-five, were about to take the podium in a conference room at the Marriott Hotel and speak to the specialized audience gathered under the umbrella of the International Council of Museums. Also at that session were two senior investigators with the Netherlands government, Jordan's deputy minister of antiquities, and a handful of others, including Czegledi and New Hampshire county attorney Rick St. Hilaire. We had just come back from touring the Egyptian Museum, and the three of us were sitting together. Czegledi had often mentioned Lacoursière, the only dedicated art detective in Canada. "We have this giant place, and there's one guy," she pointed out.

Just moments before the Montreal detectives addressed the group, they stood on a terrace overlooking the Marriott's softly curved swimming pool below, from which wealthy tourists climbed out before a gathering summer storm. Lacoursière had a messy wave of curly dark hair and dark, fierce eyes. Talbot had an athletic build, shaved head, and a quiet, penetrating gaze—he looked like Lacoursière's bodyguard. In suits they looked like characters out of *Miami Vice*, a rare stormy Egyptian sky and sprawling Cairo as their backdrop.

At the podium, Lacoursière took the lead and outlined the unit's victories and frustrations. He said that smuggling art from one country to another was far easier than smuggling bank notes or drafts. Customs officials weren't properly trained to identify stolen art, and paintings were a breeze to move across the world. That was good news for organized crime groups, he said, because paintings were

being used more frequently as currency for the purchase of drugs and as payment on loans.

The detective made it clear that paintings were being used to launder money through auction houses; one person traded paintings for drugs, and the recipient could simply auction off the painting for the cash value. Lacoursière also noted that money from drugs was being used to buy paintings. Art, it turned out, was an efficient way to funnel blood and drug money through a legitimate source, so it worked both ways.

The detective said that, in general, all types of crime where art was involved were on the rise, and yet, from his experience interviewing art dealers, most dealers still saw almost no benefit in talking to the police, because it was "one-way information." What the detective meant was that art dealers found that if they reported a crime or suspect behavior or a stolen painting, the police often took that information but gave none in return. The dealers also complained that the police showed a lack of understanding when it came to the art world—the delicate relationships that dealers formed with clients, the value of being discreet, and a basic respect for the artwork itself.

In some cases, Lacoursière said, paintings suspected of being stolen were seized from a dealer or gallery by police but the police provided no way for the merchant to recoup the loss. There was also often little or no follow-up from police. On the subject of provenance, dealers and art galleries stated that they did not have the resources to conduct proper searches on work in their galleries. In the end this was about money and reputation, and police didn't understand that.

Lacoursière's summary of the relationship between stolen art and larger institutions, such as museums, was similar.

Even with all the global media coverage of art thefts, museums were still reticent to report when a piece from their collection was stolen. There were many good reasons for that, he said, and they were similar to those of art galleries and dealers: attracting attention to the crime eroded the trust of donors or artists who gave their work to the museum to safeguard. This cult of secrecy, Lacoursière noted, was encouraged by some insurance companies, which struck quiet deals with museums, advising that going public after a theft damaged the museum's claim and harmed the institution's reputation. Some insurers even suggested that to reveal the criminal act encouraged art thieves. More importantly, it frightened away future donors.

This secretive behavior was the exact opposite of how Lacoursière believed dealers and institutions should react to a theft. Silence, he said, was an advantage to thieves. "It has taken a long time for us to get gallery owners who have had art stolen to talk to us," he said. "At first they didn't want to. But for the past three years, they've started to. That's why Jean-François and I have opened three hundred new cases in Quebec since 2004."

Lacoursière had been investigating art thefts and related crimes for long enough that he was confident in his own knowledge and investigative skills. "We have a very good picture of what's happening in the criminal world in terms of art," he said, nodding. "Criminals use art in many different ways, for many different purposes. And we know who the criminals are. We know the Mafia and biker gangs have specialists for telemarketing, for fraud, for credit cards, and now they have specialists for art too."

"You have to remember that for the most part police don't have time for this kind of work, and they don't know anything about this world. So the Mafia and biker gangs

have been free to operate through galleries and auction houses for many years," he said. "There are twenty-five full-time art thieves working in this country that I know of," he added. "I arrested a guy who has been in prison in seven different countries, and he told me, 'I like Canada. If I get caught here, you have the nicest prisons.'"

I next met Lacoursière on his home turf, on a damp June afternoon in 2007, inside a Montreal courthouse, the Palais de Justice. He was testifying against a con man who had stolen $100,000 worth of art from an artist. The man on trial was the boyfriend of a two-time Olympic gold medal winner, Myriam Bédard. Later that day, he was found guilty. The detective and I sat in the waiting area during a court break, and he looked around at the people leaving the court. "Criminals come here to learn," he said. "To ask, 'how did this person get caught?' I saw a well-known art criminal here, at this trial, yesterday."

When I asked what his most valuable asset is, Lacoursière reached into his suit jacket and extracted his phone. The detective's compact computer held thousands of email addresses, including those of many of the world's cultural experts, art lawyers, and agents with the FBI, Scotland Yard, and Interpol. It also held the email addresses, phone numbers, and in some cases photographs of dozens of criminals he'd arrested or made contact with over the previous fifteen years. "Every time I arrest a guy, I ask, 'What's your email address?'" His database included hundreds of pictures of stolen and forged artwork—all the information at his fingertips when he needed it. Lacoursière had mirrored Hrycyk's Crime Alert system, independently. Both detectives had spent hours exploring the community and building their databases—gathering information. Lacoursière's name for it even sounded like Hrycyk's.

"This is all part of what I call 'Art Alert,' an early-warning system," he said. The idea was, of course, to share as much information as possible with as many people in the art community as possible, fast, in order to keep up with the organized criminal element that was trading in stolen art. One case Lacoursière was tracking at that time involved four men with links to organized crime who had used stolen credit cards to go on a shopping spree, visiting over thirty art galleries across Montreal and buying dozens of paintings with a total value of over $2 million. According to a source, Lacoursière said, some of those paintings had already been smuggled to Israel and Australia. "I can't fly there myself at a given moment. That's what Art Alert is for. It's faster for me to send an email to a contact there. But first I have to have made a contact."

Lacoursière knew who was running the international operation: a criminal mastermind he'd been hunting for years, someone who moves in global circles. "We can't touch him, though. He's out of reach. Higher up. A collector. We know him well, and he knows us. He calls us by our first names. This man is a distinguished citizen of Montreal, and we've received information about him before, but we can't move on it. It's information that comes from a criminal source, and what's the word of a criminal worth against a distinguished collector?"

Lacoursière and Talbot had tracked their suspect's movements all the way to Costa Rica, but when they contacted the police there they received resistance. "The police in Costa Rica told me, this family you're looking at, they are well known and well respected." In fact, the hunt for seemingly respectable citizens was a recurring theme for the detective.

Lacoursière remembers serving an arrest warrant once at an opening at the Musée des Beaux-Arts. "I ran into the

director of the museum at the party, and he said to me, 'Hi Alain, what are you doing here?'"

"I came to serve an arrest warrant," Lacoursière answered.

The director looked surprised and asked to whom. The detective pointed to a man across the room.

"No, no, there must be some mistake," said the director. "I know him well."

Just like Hrycyk, Lacoursière invented his Art Alert system as a way to pry open the often-closed world he was trying to clean up. When a painting is stolen he sends an email to everyone in the world he thinks should be aware of the theft, including his roster of international criminals. "So that they know that I know," he said, and raised an eyebrow.

"You see, we reversed the system. We take it straight to the criminals. We get a tip by email and we get it out there, to all the criminals in my database, as well as the gallery owners and dealers."

Art Alert emails are accompanied by a message from the detective, in both French and English, that drives home his emphasis on community policing:

Welcome to the new interactive tool implemented by the Sûreté du Québec to support the exchange of information between the art market community and art investigation services. You will receive emails on a regular basis providing up-to-date information on art theft, fraud and forgers, safety precautions for protecting your property, or any other relevant information relating to your functions. In return, we expect full cooperation on the part of all members of the artistic community receiving these messages, enabling us to collect any relevant information relating to our functions. Only by truly cooperating

will we manage to reduce art theft, fraud and trafficking, thereby also reducing the impact of these crimes on your activities.

The detective admits that in the murky black market of art, "we are always a few steps behind the criminals. But five years ago we were ten steps behind. Now we're three steps behind," he said. "We have our own tools now. We go to gallery openings, because that's where you find the crooks."

Lacoursière continued, "Criminals now have a lot of tools. They use auction houses and art galleries, and they are fast. A painting can be stolen here and sold across the world in a day. In those cases, it doesn't work if I file a report to Interpol and wait for them to send out that information. That can take months. With Art Alert, I can email the auction houses directly. When I want to know something, I email Christie's or Sotheby's in New York and in London. They know me now, and they get back to me immediately."

The criminal system, though, has evolved too. "Some art galleries are owned by the Mafia, and other organized crime groups," the detective explained. "It's a great business for them because there are very few people who understand the value of a painting. With art, you can just put an extra zero on the end and you've laundered money. Or you can pretend at income-tax time that you made all this money, or lost money, depending. You can pretend that you bought a painting for $1,000, but in reality it was a Riopelle and you sold it for $100,000. It's impossible for anyone to find out."

In Quebec, art theft and crimes related to the black market are worth about $20 million annually, according to Lacoursière's data, but no statistics are available for any other province in Canada, because there is no other officer like him. That is why Lacoursière's work is so valuable. Just like

Hrycyk, he's generating information where there was none. He echoes Robert Wittman's sentiments about recovery, which he says is more important than making an arrest. "My priority is always to get the stolen painting back. My bosses know that, though they don't always share my opinion," said Lacoursière. The FBI's Art Crime Team reports its recovery rate at less than 9 percent, but most international experts put the number far lower, below 5 percent. Lacoursière said that thanks to staying in close communication with the arts community in Quebec, his recovery rate was now 15 percent.

I also visited Lacoursière at his office at the Sûreté du Québec—a monolith of a structure surrounded by high barbed-wire fences in east-end Montreal. He was just a few months away from retirement and in the process of handing over the reins to Detective Talbot—his legacy. The two men came down to meet me at the security-check line, where I emptied my pockets and passed through the metal detectors. Lacoursière wore a loose-fitting black jacket, black shirt, black belt, black handkerchief, and his eyes were framed by black glasses; he looked like an artist.

He took me for a quick tour upstairs, to the second floor, where he and Talbot shared a space with the fraud squad—a bull pen. Lacoursière pointed to a painting by John Little that had been stolen in 1989 and recovered in 2007. It was worth about $25,000. Beside his desk was another painting that looked very much like a Riopelle—a beautiful fake he had confiscated.

Next we went down to the cafeteria, where Lacoursière and Talbot settled on a table near the back, facing a large window with sunlight streaming in. I asked the detectives to compare their departments with other police forces around the globe that have art investigators. Lacoursière listed the FBI Art Crime Team, Scotland Yard's Art and

Antiques Squad, Italy's Carabinieri, and Interpol. He did not mention Hrycyk and the LAPD Art Theft Detail. He did note with surprise that Toronto did not have its own art theft squad, which was strange, because it was a larger market than Montreal—totally unpatrolled.

Lacoursière: "When I fly to Toronto for a case, I'm referred to the Fraud Squad. In the U.S., they say there are fifteen FBI agents working on this problem, but it's just not true. Most of those agents aren't specialized in art. They work other cases. In Montreal, we only have two full-time investigators, and we get into the scene. We visit each gallery and institution at least twice a year: 250 galleries, 100 museums, across Quebec. If we're looking for someone, we always bring photographs. Or we beam them out on email: 'Do you know this guy?'"

Talbot: "Of course, the galleries and dealers want to protect their market. They want to protect their clients. But when we help them, they change their attitude."

Lacoursière interjected, "We rarely need to expose a source. I will always burn myself before exposing a witness."

The detectives told me the trend that year was break-ins: galleries, auction houses, and private homes. Those constituted 50 percent of their cases, especially in high-end neighborhoods like Westmount and Outremont.

Lacoursière: "They go there for the art."

A recent gallery break-in during daytime hours involved three men. One came in first, just to look around. Then two more, wearing ski masks, entered, one of them carrying a gun. They settled on three paintings, which they shoved into a garbage bag. When they left the gallery, the three walked for half a mile through downtown Montreal then disappeared into the Métro.

Lacoursière sent out pictures captured on the gallery's security camera, using Art Alert. The men were identified by a secret source. One had a history of armed robbery, another was known for violent crimes, and the third had a history with the fraud squad. Criminals in Canada, Lacoursière was saying, were migrating from other areas of specialty to art theft. And because gallery security was soft, paintings were excellent targets.

Then the specter of Lacoursière's imminent retirement came up. He had spent fifteen years building his unit.

Lacoursière: "I'm retiring at the end of this year. That's it. I give up."

Talbot: "He's retiring, or at least he says he is. Who knows when he'll do it. Maybe at the end of this year, maybe at the beginning of the next." Talbot will take the lead of the art investigative unit. "I'm supposed to get a new partner, and a civilian who can manage the database," said Talbot.

Lacoursière: "When I needed a partner, I had a choice. I hope it's the same for Jean-François." Talbot has a minor in psychology, which he said was very important for "understanding Alain." He smiled.

Lacoursière: "I still don't understand myself."

Talbot: "We've worked together for five years and put together all the systems we need. They are all in place. And Alain will be available."

Lacoursière: "Sure I will, for approximately $250 an hour."

Lacoursière retired at the end of 2008. A year and a half later I attended a museum security conference at the Ontario College of Art & Design in Toronto. Two detectives from the Quebec squad were guest speakers. Jean-François Talbot was their boss, but he was not there

that afternoon—the unit had expanded under his guid-
ance and now employed three full-time art investigators.
The two detectives had prepared a PowerPoint presenta-
tion for their lecture, and they covered a few of the cases
that Lacoursière and Talbot had worked as well as a few
new ones, including a stolen painting from Alberta that had
traveled across the country, sold from dealer to dealer, and
been recovered after five years.

Even though almost everyone in the room spoke only
English, the host of the conference had agreed that the pre-
sentation could be made in French, and it was unclear how
much information the audience actually picked up from the
half-hour talk. My French is weak, but I followed along.
The picture these detectives painted of the stolen art market
in Canada was the same one depicted by Donald Hrycyk
in Los Angeles, Richard Ellis in London, and Bonnie
Czegledi in Toronto.

Their lecture opened with an error, though. The Quebec
detectives said proudly that, except for the FBI, their squad
was the only art investigation unit in North America. It
was a sad statement, and it drove straight to the heart of
how disorganized art recovery is. Had they really never
heard of Hrycyk?

After the talk I caught the two detectives with their lug-
gage in tow, in the hallway. I asked them if they had ever
heard of the LAPD Art Theft Detail. Neither had, but they
were intrigued. I told them to look up the website. A few
weeks later, I received a Crime Alert and an Art Alert on
the same day, with the same picture of a Montreal suspect.
The two groups had made contact; it had taken only twenty
years.

The Montreal team should be a global example of how
an art theft unit can work, but it's isolated by language and

by geography. Lacoursière developed an entire strategy around the black market, and it was effective. He should be touring the country—in fact, the globe—giving seminars on the information he mined and the cases he worked. Instead, he wrote a book, published only in French; when I went to my neighborhood bookstore in Toronto, they did not have it in stock and would not order it, because they don't deal in French titles.

Jean-François Talbot is a perfect example of how a legacy should work. He was brought in early, trained for five years with Lacoursière, had the support of the department, and was given resources and additional staff when Lacoursière retired. The Montreal unit is a law-enforcement gem, hidden away in the second-largest art market in Canada. In 2010 and 2011, I received almost fifty Art Alerts from Talbot. He was keeping busy, but he had still not built a website for his unit. On so many levels, this was a missed opportunity—as Hrycyk had demonstrated. In Los Angeles, the Art Theft Detail website had been directly responsible for millions in art recoveries. And, as any kid these days knows, if you want the world to see you and pay attention, you need to build a website and start blogging: the stronger your opinions, the better.

# 15.

## ART HOSTAGE

"All those beautiful Hollywood films
are out of date."
**TON CREMERS**

In September 2006 an anonymous blogger called Art
Hostage slipped onto the Internet, armed with contro-
versial opinions about the state of international art theft.
His web page wasn't attractive: no flashy advertisements,
no electronic bling, just a business card–sized rectangle
with the words *Art Held Hostage* in a crooked font. The *g*
in *hostage* was a drawing of a pair of handcuffs. At the top
of his home page, Art Hostage had put a banner: "The only
blog to do what it says on the tin, reveal the truth about art
crime investigation."

Art Hostage seemed to be on a mission to expose the
hypocrisy of the art world—a business that he said was se-
cretive, corrupt, and full of criminals who craved respect-
ability. "From top to bottom there is a dishonest chalk-line
running through the Art and Antiques trade, therefore
one could come to the valid conclusion, the whole Art and

Antiques trade is rotten to the core," he wrote. On another occasion, "The grubby, rancid Art and Antiques trade is one of the last bastions of cash dealings. Whilst other trades have had to comply with money laundering laws the Art and Antiques trade not only still enjoys the dark practice of cash transactions, but also provides a haven for money launderers to wash their ill-gotten gains without scrutiny." This was insider information, he proclaimed, from someone who had intimate knowledge about how the criminal world connected with the legitimate business.

Who was this guy? He seemed like a blowtorch in the basement of the art world, spewing flames and crying foul at the establishment. He was a troublemaker, but he was fun, and his commentary had a no-bullshit-I'm-telling-it-like-it-is style.

His tone was condescending and irreverent, and like any respectable art critic, he wasn't out to make friends. His scorn applied equally and intensely to both thieves and detectives, but there was one group for which he reserved an especially profound loathing: art dealers. His de facto slogan was "The term 'honest art and antique dealer' is an oxymoron."

The Art Hostage site provided a valuable service. For anyone reading one or two newspapers, articles about art theft came in a local trickle. From Art Hostage, who now kept track on a global level, it was a heavy stream. And he couldn't have launched his site at a more opportune time. In 2006 the prices art collectors paid for famous paintings had become outrageous. That year, U.S. music mogul David Geffen sold Jackson Pollock's *No. 5, 1948* for $140 million. Ronald Lauder picked up a Gustav Klimt for $135 million. More private jets were rented for Art Basel Miami than for the Super Bowl. Sotheby's and Christie's seemed to be on

steroids; the combined sales of the two auction house giants that year were over $7.5 billion.

According to Artprice.com's 2006 annual report, in that year alone the price of paintings shot up by 27 percent in the United States. The fortunes that the world's elite was willing to pay for a painting climbed faster in the five years between 2001 and 2006 than in the previous twenty-five. A handful of investment firms were now selling fine art as a portfolio. Art had exploded into a trillion-dollar global business. The market hadn't seen days like this since its winning streak in the 1980s. William Ruprecht, president and chief executive officer of Sotheby's, said, "The reason people say this is different from the last boom is that in the 1980s, the market was driven by Japanese real-estate wealth. When that fell apart, the art market fell apart. Now we have Russian wealth, Chinese wealth, Japanese wealth, hedge fund wealth, entrepreneurial wealth, real-estate wealth. There is a huge concentration of wealth at the top of the economic pyramid, a bigger concentration than anyone has experienced before." As usual, the auction houses were at the center of the money and the trade.

Most of this information can be found in a *Financial Times* article posted on the Art Hostage site; Art Hostage was obviously interested in the latest seven-digit sales of brand-name masters. But his raison d'être seemed to be the dark undercurrent running just below the glittering waterline of the record-breaking auction-house sales. With his simple format, Art Hostage managed to do a better job of demonstrating exactly how crazy art theft had become than had any media outlet or any one law-enforcement agency, including Interpol and the FBI. All he did was post articles on his blog for everyone to read, and, of course, he commented on some of the stories. He was contributing a

new chapter to the short and strange history chronicling art theft on the Internet, which had begun in earnest when a U.S. grad student had a similar idea eight years earlier.

In 1998, Jonathan Sazonoff assembled a list of stolen art from around the world and put it online. He called his website The World's Most Wanted Art. It was primitive, but it did the job—showing a stark, clear list of items that had been stolen in decades gone by. Sazonoff also updated the site to show when works had been recovered. In a section called Major Art Thefts he listed, among others, the Vermeer stolen from the Gardner Museum in 1990 and the lost masterpieces from Montreal's Musée des Beaux-Arts in 1972. By most accounts, this was the first example of a notable public list of stolen art to appear on the World Wide Web, accessible by anyone with an Internet connection.

It all started, Sazonoff told me, when he was a graduate student at New York University looking to make some money. "In the eighties, we were watching the infancy of Ted Turner's empire. One day there would be a dish the size of your hand that would pick up hundreds of television stations, and it was projected that America's greatest export would be entertainment. I thought, that's the field to get into—cable television, the five-hundred-channel universe. I came up with a portfolio of potential projects, and one of them was about stolen art."

The idea had come to him in a university class. "We had a guest speaker one day, a professor named William Fash. He went on to become the chair of anthropology at Harvard and the director of the Peabody Museum. He talked about a theft from the Museum of Anthropology in Mexico City on Christmas Eve in 1985. The thieves cleared out everything, including the Funeral Mask of King Pakal,

a beautiful, unrivalled piece. If you saw the expression of pain on Fash's face, talking about the treasures of the world being stolen . . . It left a mark on me. So I decided to look into pitching a show, and called the FBI. They said, that would be a good idea," Sazonoff remembered. "So I pursued it. The ups and downs of television production is a story for another day, but I found myself in a unique position, as someone between the worlds of art, security, and the media."

Sazonoff's site was picking up viewers while Interpol and the FBI were still trying to figure out how to use the Internet. In Los Angeles, Donald Hrycyk was a few years away from setting up his own site. In fact, there was so little information about stolen art on the web in the nineties that Sazonoff's efforts were noted around the world. One morning he was woken by a phone call. It was Interpol. Calls kept coming: from Christie's, Pulitzer Prize–winning writers, the Archaeological Institute of America. He was invited to the Smithsonian's Christmas party, and was congratulated for his website list by the head of the institution's security, David Liston. When the FBI set up its Art Crime Team website, it borrowed freely from Sazonoff's pilot project, and called to thank him. That was the power of hosting a few choice pieces of information about a mysterious subspecies of crime.

"I started out building an electronic billboard to sell a TV show and ended up becoming an expert on stolen art," Sazonoff said. A few years later, he joined another online effort, the Museum Security Network (MSN), which made use of the Net to gather together anyone working in museum security struggling with problems related to art theft. MSN, run out of an office in Amsterdam, was another project that developed a niche audience spanning

several continents. Sazonoff eventually became its North American editor.

The genesis of MSN didn't have to do with making money; it had to do with one museum security official coping with the aftermath of an armed robbery at Amsterdam's Rijksmuseum. In 1996, Ton Cremers was head of security when a group of seventeenth-century paintings were stolen. Cremers felt isolated and vulnerable. To soothe his lonesome paranoia, he decided to start his own website, as a way to tell his story as well as a place to post articles from the world media chronicling the rising number of museum thefts. The articles were comforting to him, because they indicated that he wasn't the only museum security director dealing with violent criminals. Cremers's web experiment hit a nerve with other museum security personnel, who began contributing their own stories to his site.

"If you only look at your own museum, there won't be too many incidents. But when you can see the big picture, the pattern is undeniable. Security staff started using the information from the site mainly to convince museum directors that this issue was important," Cremers told me. "We owe this new world to Bill Gates, who gave me a communications platform that evolved into a news service about incidents of stolen art from museums. It cost nothing but a few hours per day," Cremers said.

In 2000, Cremers held his first MSN conference, which attracted museum professionals from across the world, including the Getty's Bob Combs. In Toronto, Bonnie Czegledi signed up for the Museum Security Network and watched its progress, as did many of her colleagues in cultural heritage law. The information Cremers gathered indicated that thefts from museums were increasing globally. "In the 1970s and 1980s, there were some spectacular art

thefts that were stealth operations, carried out quietly at night," Cremers said. Those crimes were elegant in a way; they involved careful planning and strategy. But they were polite compared to what followed.

Cremers's data showed a change in trend, from elegance to brute force. "At museums around the world there has been one armed robbery a year since 1975," Cremers said. "But since 2000, there has been a lot more. Ironically, I think this is caused by the increase of security at museums. Thieves are now aware that there are advanced camera systems, and they know they will be detected by computer alarm. So as museums become better secured, the only way to steal art is with an armed robbery—a hit-and-run crime. The only thing thieves need to do is beat the alarm response time. They aren't interested in the silent burglary anymore," he said. "All those beautiful Hollywood films are out of date."

Around 1995, the *New York Times*, the BBC, and the *Guardian* all developed web-based platforms to showcase their news stories, so when a work of art was stolen and a news story was published, there was now an electronic record of those reports available through web searches. Then, in the late 1990s, the FBI, the LAPD, and Interpol threw resources into their sites, and the Art Loss Register list grew rapidly. These developments made tracking stolen art a lot easier for anyone interested. It was all about access to information.

Art Hostage took advantage of this new flow of information on the Internet and began laying it out on his site in 2006, with the value-added feature of his own acerbic commentary. Just like Sazonoff and Cremers, he woke up every morning and trolled the Net for stories and information about art theft. He didn't just link to those stories; he

copy-pasted entire articles. Amateurs borrow, professionals steal, as the saying goes.

Art Hostage was Paul.

In January 2008, a month before our first phone appointment, there was a crash at Paul's front door. Eight officers from four different British police forces knocked the door right off its hinges and raided the house. They confiscated his computer and searched the grounds for stolen paintings and antiques; they found none. The computer was returned a few days later.

"That was always the trick. I never kept stolen art in my house. I always sold it to a dealer or auction house as fast as I could." Paul may have handled millions of dollars of stolen art, but he never kept any souvenirs. He was, though, back on the police radar. What were they looking for? Was it his Art Hostage website that had attracted their attention?

After Paul retired, in 1993, he moved to a quiet seaside town on the south coast of England not far from his stomping ground in Brighton, where he had once wreaked havoc. Compared to those days, his schedule was quiet. Instead of driving halfway around the country every week, playing extreme *Antiques Roadshow* with thieves and con men, he woke up around eight o'clock, prepared tea and toast for breakfast, and sometimes looked at the waves from his kitchen window. After breakfast he moved to his computer, went online, and crawled around the Internet, searching for media stories about art theft. He had become addicted to these stories; in a way, they were a continuation of his own coming-of-age story.

Art theft should have been on the decline with the invention of the Internet, the appearance of intelligent,

experienced art detectives like Robert Wittman and Donald Hrycyk, databases such as the Art Loss Register, and other massive advances in communication technologies. But, as the Art Hostage blog made clear, the opposite had happened—art theft had exploded around the world.

Paul and I explored two narratives during our many conversations: his rise from the streets of Brighton as a knocker, and the current state of international art theft. These stories were linked, and the more Paul told me about his rise as a thief, the more I understood the context of the present-day stories I was reading on his blog. The events being reported in the media were part of a larger pattern that had taken decades to evolve. Paul had retired, but the Brighton knockers had not.

Just four years after he'd called it quits, a 1997 headline in the *Independent* read: "If your antiques have been stolen, head to Brighton." The article stated, "London has a rival for the dubious title of clearing house for the country's stolen antiques: Brighton. Dozens of gangs and crooked dynasties in the pleasant seaside town have perfected systems to divide up the country and go on thieving raids, say police. Because the heirlooms in question are of middle- and lower-ranking quality, owned by ordinary people, they never make news." The article also told how detectives had tracked antiques stolen from the Duke and Duchess of Kent to a Brighton dealer.

It was amazing to read articles like that, because they referenced Paul's criminal descendants. Paul was one of the few people on the planet who could dissect the problem, categorize the types of thieves, and assess the effectiveness of law enforcement. Sussex Police had utterly failed to contain the problem, and its art and antiques squad was quietly disbanded in 1998. The knockers were thriving and

had even mutated into new forms of thugs who were striking smaller towns and big cities across the United Kingdom with impunity. There were now crews of knockers calling themselves art dealers.

There was Lee Collins, who grew up in Brighton but worked London, pulling the same scams as Paul had, except with a new twist: he posed as a high-end antique dealer. Collins talked his way into the homes of at least thirteen wealthy seniors, including the 17th Earl of Lauderdale, who was ninety-four years old when Collins showed up at his door. He paid the earl £200 for an eighteenth-century urn estimated to be worth six times as much. Collins also went knocking on the door of Audrey Carr, a wealthy London widow, and tried to persuade her to sell an Edward Seago oil painting worth £15,000. Carr wouldn't go for it, so Collins lifted the painting off the wall while she watched, just like the Los Angeles case as told by Hrycyk. Collins also persuaded the widow of artist Charles McCall to sell him hundreds of thousands of dollars' worth of her late husband's art for a paltry sum. He was caught, convicted, and served time, and then, in 2010, went back at it and was sent to prison again.

Paul posted an article about two criminal "art dealers" who talked their way into a home and forced a ninety-four-year-old man to part with two paintings by L. S. Lowry, *Children on a Promenade* and *Family of Three*. They ignored the protests of the owner, Dr. Percy Thompson Hancock, removing the canvases from the wall and leaving a check for £10,400. Talk about tough negotiators. Later, Dr. Thompson Hancock received a further check for £6,000 in the mail. Eight months after the theft, the doctor's granddaughter was passing a gallery on London's Bond Street and saw the paintings prominently displayed in

the window, selling for £215,000. She found out that just a few months after they'd been stolen, the paintings had been sold at Bonhams auction house in London for £78,000. The two thieves were tracked down, tried in court, and sentenced to four years. The judge told them, "What you men did was despicable." One had a previous conviction; the other had a list of court appearances dating back twenty-eight years, including a charge of stealing £9,000 worth of antiques from the home of a ninety-year-old deaf and bedridden man. "These people are addicted to this," said Paul.

Paul apologized to the husband in the hallway of the house he broke into in 1980, but his successors were not nearly as kind—some knockers resorted to violence. There were the thieves who showed up at the home of Tom and Sarah Williams, threatening to pull out the Williamses' fingernails with pliers if they didn't give up their antiques. The thieves beat Mr. Williams down and kicked him repeatedly in the ribs. The antiques were later traced to an art dealer, Phillip Capewell. Art Hostage posted about a dozen articles on the trial, and Capewell was convicted and sentenced to five years. After the trial, a detective on the Sussex police force pointed out, "Phillip Capewell is a sophisticated, professional handler of stolen goods . . . Without such people, thieves are unable to make a profit for their crimes. The sentence handed down today sets a clear message that men like Phillip Capewell will be treated seriously by the courts." But Art Hostage pointed out that Capewell had already been to court five times for handling stolen art.

Still, these knockers were quaint compared to gangs like the Johnsons, who approached house burglaries like soldiers at war. Paul loved talking about the Johnsons because they were like supervillains—utterly fearless and relentlessly ambitious. They weren't interested in striking

deals with police forces; they weren't polite; and they didn't stay under the radar. Between May 2003 and April 2006, the Johnsons, a family operation of brothers, cousins, and friends, smashed their way into English country homes, reaping art and antiques that some estimates valued at $160 million. They used 4x4 SUVs to ram the gates of estates. They wore balaclavas. They were worthy of a James Bond flick, and in fact they targeted an estate formerly owned by Ian Fleming, Bond's creator, removing steel bars from the windows and disconnecting the alarm system. They studied their targets for weeks at a time and often left no evidence. They hit the manors that Paul had always felt were too risky to steal from. And they used any means necessary to get the prize. Police marveled at the gang.

In February 2006, the Johnsons raided the home of real-estate tycoon Harry Hyams and stole about three hundred museum-quality artworks worth over $142 million—at the time it was said to be one of the most valuable criminal hauls in the history of the United Kingdom. The Johnsons enjoyed targeting celebrities and public figures: they hit Formula One advertising magnate Paddy McNally and Sir Philip Wroughton, Lord Lieutenant of Berkshire.

In the burglary of Stanton Harcourt Manor, a fourteenth-century home in Witney, Oxfordshire, one of the Johnsons leapt from a first-floor window to escape and broke both his legs. He told doctors treating him in hospital that he had fallen off his brother's garage roof.

In the end, though, arrogance was their undoing—they were caught trying to rip a bank machine out of a wall by hooking it up to the back of a 4x4. They crashed. After the trial, the gang members were jailed for a total of over thirty years. Investigators had hoped that the Johnsons would bargain down their sentences in exchange for the location of

some of their treasure trove of stolen art, estimated in the tens of millions, but the Johnsons wouldn't talk. They were playing the long game and had a retirement fund set up.

Art Hostage predicted that the Johnson convictions would have little or no effect on the epidemic of home invasions playing out across Britain. And indeed just one week after their convictions, another string of burglaries unfolded, targeting high-end art and antiques. Paul reveled on his website, "Art Hostage proved right yet again!!!"

Again and again Paul used his alter ego Art Hostage to post articles that linked art dealers to the steady flow of crimes, then lambasted them for their greed and corruption: "Enough already with the hiding behind the cloak of respectability. Historically, criminals, Art and Antiques dealers in particular, crave respectability when they become successful." Paul, just like the FBI and Don Hrycyk, pointed his finger at the nature of the transaction: "As for cash dealings, there is no excuse if the deal is lawful to use cash. Cash is only used in today's world by those seeking to hide the purchase or sale, be it from the police, customs or the taxman."

Rather than knockers, the Johnsons were more like the gangs of well-armed criminals who were storming museums and art institutions around the globe. As Cremers described the scene from his perch at Museum Security Network, all thieves had to do was beat the response time. Paul had always stayed away from museums, but he knew his way around those crimes and understood the options open to criminals once a blockbuster heist had occurred. Headache art had become a splitting migraine.

Here are a few examples he posted.

In Brazil, at São Paolo's Pinacoteca, three armed men held security guards at gunpoint and removed paintings

and prints, including two works by Picasso. The paintings were later tracked to the home of a local twenty-nine-year-old baker, who'd kept them under his bed. It was the second time in a year that Picassos had been stolen in São Paolo; armed men had already entered the Museum of Art and taken Picasso's *Portrait of Suzanne Bloch.*

In Odessa, Ukraine, a painting by the seventeenth-century Italian artist Caravaggio disappeared from the Museum of Western and Eastern Art, ripped out of its frame by thieves who had entered through a window. The alarm system was obsolete.

In Sweden, thieves smashed their way into a museum near Stockholm and stole five works by American pop artists Andy Warhol and Roy Lichtenstein worth between three and four million dollars. The thieves spent less than ten minutes in the building. The Warhols were among many images he made of Mickey Mouse and Superman. Art Hostage pointed out that, depending on how many copies of those works existed, they could be moved into the legitimate market with relative ease. Warhol was a smart steal because he made multiples.

In Germany, a painting by Carl Spitzweg worth over half a million dollars was stolen from the Kunsthalle Mannheim. In Rome, a group of organized thieves had been operating for twenty years; one painting they stole, a Pietro Paolo Bonzi, had moved to France and then on to Florida before it was recovered.

In Australia, a small portrait by a seventeenth-century Dutch artist, Frans van Mieris, was stolen in June 2007. It was just twenty by sixteen centimeters and had an estimated value of $1.3 million. Someone broke into a building at the Australian National University and stole a 1928 oil-on-canvas work by Tom Roberts. It was small enough

to be hidden under a jacket. The thief was clever and also unbolted the title plaque on the wall, so two weeks went by before staff even realized the Roberts was gone.

In Russia, thieves climbed through an open window of the Hermitage overnight and stole priceless art.

In Norway, the Supreme Court increased the sentences of two men convicted in the theft of the Edvard Munch masterpieces *The Scream* and *Madonna*, and a new trial was ordered for a third convicted man. Art Hostage commented, "The main reason why criminals target public museums and buildings is because they are seen as low risk for potential high return."

Art Hostage actively promoted the idea of tougher prison sentences: "Mandatory 10–20 years jail time for high value/Cultural art theft from public buildings or museums is all that is needed to curb the intentions of the criminal underworld. This will lead to dispersal of all art theft into the private art collecting circles, who are better placed to protect their art collections." Basically, Paul was saying, if you want people to stop stealing from museums, you have to be tougher on them. If not, the risk-reward factor is still great for anyone looking to make some quick money or pay a debt. It was that simple. The Art Loss Register's database in 2011 included as missing or stolen: 659 Picassos, 397 Mirós, 347 Chagalls, 313 Salvador Dalís, 216 Warhols, and 199 Rembrandts.

Paul told me his website attracted the attention of criminals who wanted to keep track of anyone writing about their crimes and to learn what other thieves were up to. "If you're a criminal and you've just stolen something, you search the web in the days afterward to see whether anyone has written about it or posted a picture." But Paul's relationship to his shadowy readership went deeper.

Some criminals were emailing Paul directly to ask for his expert advice.

In Vancouver, British Columbia, the Museum of Anthropology was broken into in the middle of the night. The thieves wore gas masks, deactivated the alarm, and sprayed bear repellent across the floor. They smashed, through display cases and left with over one million dollars' worth of art, including precious gold artworks by artist Bill Reid, whose sculptures decorate the Canadian twenty-dollar bill.

Paul told me he received a mysterious email asking whether the stolen Reids could be returned for a reward, and how to do that properly. Could jail time be avoided? Paul decided to post the instructions on his blog. He advised the thieves to contact a lawyer, who could act as an intermediary between the police and the thieves. There was no point in trying to sell the stolen art now, Paul told the criminals, because detailed descriptions of what had been stolen had been circulated all over the world. It was too hot even for the most unscrupulous dealer. Three weeks after Paul's posting, the Vancouver RCMP recovered the stolen work; no one was arrested. I contacted Bonnie Czegledi, who told me she had heard from a number of sources that a ransom had been paid.

Paul had once again positioned himself as middleman, but this time he wasn't dealing in stolen art. He was dealing in information, receiving it from and sending it to both detectives and criminals. From his house by the sea he surveyed the chaos and tried to make sense out of it. He told me that more thieves were now attracted to art as a commodity to steal. "There is a class of thief who ten years ago would have robbed a bank. Then they moved from banks to the transport vehicles carrying the money. Now they will rob a museum or a gallery. Museums generally can't afford a great security system.

Things really haven't changed since I was working, in the sense that the crime is still low risk for high reward."

Paul's golden rule, he said, still applied: stay under the radar. "The media are getting better at reporting thefts, but it's still the case today that for every piece of headache art stolen, there are hundreds, if not thousands, of smaller thefts that don't come up on the radar. It's your thieves' everyday bread and butter."

And art thieves were ahead in every way, Paul said. "They have access to way more information now. They have global networks of art dealers and auction houses. A burglar who is a total idiot can go on eBay and see how much something is worth, and might even sell it there. eBay is perfect for selling multiples—nonrecognizables." Thieves were successful because the field was still wide open. Even with the Art Loss Register, the FBI, and Scotland Yard, law enforcement continued to lag way behind. Criminals were still ten steps ahead of police across the board—they were winning.

"This is a bigger chess game now," Paul said. The playing field was the world. A painting could be stolen in Los Angeles or New York and sold to a Russian collector, who would import the work of art into a country whose police departments were notoriously corrupt. Paul predicted that art thefts in the United States would spike over the next decade. "For hundreds of years Britain was filling up its closets full of art. Then a lot of that art went across the ocean to North America. It followed the market and the money to the United States. All that loot in one place means that North America is now the target. What used to be a destination for stolen art has now become a source."

Paul said that if he had to go back to being a knocker, he'd pick Florida as his base. "All of those old rich people who filled beach mansions with art. C'mon. Perfect!"

And just like Czegledi, Paul had become a reformer when it came to the business of art. "Across the board, art has to become a transparent business. Prices keep rising, and there are still no regulations in the art trade. Art and art theft are now a huge circular game. The objects don't change. They get passed around. In most cases their value increases. They outlive us all."

In September 2008, the U.S. mortgage crisis erupted into a global meltdown. U.S.-based Lehman Brothers announced it was broke, AIG raised its white flag, stock markets around the world tumbled, banks fell into bankruptcy. Even oil prices took a hit. But one corner of the economy seemed bulletproof.

In midmonth, a two-day auction at Sotheby's of one artist's work netted more than $200 million. The auction featured 223 works by British contemporary artist Damien Hirst. A group of international investors gathered in a room in London and bought dead animals preserved in formaldehyde. A zebra in a tank sold for $12 million. Art economist Charles Dupplin remarked in the *New York Times*, "It's another landmark and an astounding day for the art market in a year that has seen many long-standing records demolished, despite the gloomy world economy." A New York dealer commented, "Today people believe more in art than the stock market. At least it's something you can enjoy." Paul told me, "See. This will never stop. It's a great investment."

The more I got to know Paul, the more I wondered when he was going to be recognized as an international super-pundit. It was impossible to keep track of all the people with whom Paul was communicating—possibly hundreds of insiders from around the globe. There were thieves, including infamous Canadian jewel thief Daniel Blanchard,

who had been featured in *Wired* magazine. Blanchard had stolen a diamond from an Austrian museum, and he'd stolen from hundreds of banks. Paul was a fan of his and emailed me a few pictures Blanchard had forwarded to him, of a woman and dog posing with thousands of dollars of plastic-wrapped Canadian cash. Paul even knew the name and reputation of the Toronto thief I had met in 2003.

On Art Hostage, Paul's audience also included the detectives who hunted the thieves. "In the entire world I can count on my hands the detectives who know how to investigate art thefts," Paul said. "They are all truly eccentric characters. You have to be in order to jump into that kind of work." Paul felt sorry for the art detectives, often loners who, like him, had a passion for missing artwork but who had few resources to spend and often watched as missing masterpieces slipped past the geographical lines of their jurisdiction and out into the international black market.

Paul had kept up a relationship with Richard Ellis; they exchanged email on a host of issues and art thefts in Britain. In fact, Paul was connected to a number of police departments in the United Kingdom. He also traded email with FBI agent Robert Wittman, who said he read the Art Hostage blog for "entertainment" value above all else. When Wittman retired, Paul was sad about it. He had followed Wittman's career closely. As Art Hostage, he wrote some nostalgic posts, hoping Wittman would reconsider, and a few weeks after the agent retired, Paul emailed Wittman asking whether he was still in the game.

Wittman's response: "Of course I am still in the game . . . Call or email anytime and let's unleash hell!" That cheered Paul up.

About Interpol, Paul was gloomy: "Interpol is totally useless—they gather information but have no jurisdiction

to conduct investigations. I call them 'Interplod.' There's no flow of information on the law enforcement side of the equation. Believe me, thieves are laughing all the way to the bank, and most of them aren't even that smart."

Besides thieves and detectives, a growing number of writers, researchers, journalists, and documentary filmmakers were contacting Art Hostage. At one point, Paul sent me an edited trailer for a documentary series that featured him as the host. It was slick, and there were some great scenes of "Turbo Paul" strolling down a street waxing poetic about art theft mysteries. Journalists were also sending him notes, looking for quotes for their stories when major thefts occurred. In late 2009, Paul told me that he was in contact with David Samuels about a story Samuels was writing for the *New Yorker* on the Pink Panthers, the superstars of the organized crime world who had orchestrated spectacular thefts from jewelry stores in London, Tokyo, Dubai, and Monaco. The Pink Panthers were a global outfit, and the international hubs of the super-rich had become their criminal playground. At the end of that piece, Samuels meets with one of the master thieves in the Panthers crew. The thief tells Samuels that if he comes back to Montenegro he might show him "a Cézanne"—as Paul pointed out, he was perhaps referring to the Cézanne that had been stolen in the 2008 Swiss armed robbery.

In May 2010, five paintings worth more than $160 million vanished in a grand theft from a Paris museum. Then, in early June, Paul sent me an email with a subject line that read, "New York Times Article." He wrote, "Long time no hear???? thought you might like this article in the NYT Magazine for tomorrow. How you getting on with the book?" I followed the link to the *Times* site, to an article by Virginia Heffernan, Samuels's wife and at that time

a columnist for the *New York Times Magazine*. Her piece was called "Heist School" and featured Art Hostage commenting on the Paris theft and the state of international art theft. Heffernan, it turns out, was a long-time fan of the blog. "Cheers, Turbo Paul, you scare me," Heffernan wrote, and then a few paragraphs down, "The minute I saw the Paris heist in the news, I knew Turbo Paul would be psyched: traffic to Art Hostage would spike, his brain would rev high and he would get to peddle innuendo and what he presents as underworld intelligence. When news of big heists break, 'I am at my toxic best,'" Paul had told her.

I phoned Paul that Sunday. "Hal-loh!" he said, once I said it was me. "Did you read the article in the *New! York! Times!*"

"Has traffic to the Art Hostage site spiked?" I asked.

"The web traffic is up from three hundred hits to three thousand, and America is five hours behind me!" Paul boomed. "It's gone absolutely berserk!" He then imagined what it must have been like for all the people who despised him to read the piece online. "How much coffee is dripping down flat-screen desktops! They read the *New York Times* and spat their coffee against their screens, threw their cups of coffee at their laptops in disgust, green with envy. I'm the person everyone hates! They say, 'Art Hostage, I would never read that filth, that disgusting profanity. I wouldn't even dignify clicking on a link!' But they check my site three times a day!"

Paul also said that he was receiving a parade of emails from people who had previously dismissed or maligned him but who were now congratulating him on the attention. In classic Turbo-style, he said, "Now everyone's like, 'Can I suck your cock? Would you like to fuck my sister?' Suddenly, because of an article in the *New York Times*,

everyone wants to be my friend. At the end of the day, that's people," he told me. "Art theft is a small, incestuous world, and people always come back to the same groups, the same affiliations. And I am always lurking there."

I asked Paul how he felt about all the media attention focused on the Paris theft, and about the quality of the analysis in the articles. "Art theft is like herpes," he responded. "It lays dormant and suddenly it comes back every once in a while, and then everyone notices. But the virus is always there in the spine. As usual, there are those who are saying Dr. Nos don't exist. The art is too famous to sell? Well, c'mon, a hundred million dollars' worth of paintings! It's saleable. The initial thieves always sell them. If you're an armed robber and sell stolen art for $100,000 on a million, it's still a good day for you."

Did the exposure from the *Times* article make him want to refine his blog at all, I wondered, based on the attention and the potential for audience growth? Paul laughed. "I'm the same as before. I've only got one gear, and that's turbo. What you see is what you get. No bells and whistles. The blog is about what's happening, and what I'm thinking. I'm a loose cannon, and no one knows what I'm going to do next," he told me. "It would have been much nicer to get a PhD. Instead, I got a PhD in knocking. I have no regrets in that respect. With hindsight, we'd all have bought Microsoft shares for two dollars instead of three hundred dollars, right?"

During our many phone conversations, I never did find out how Paul earned money. As far as I knew, he had no job. Was he living on his savings from his knocking days? Surely the money would be running out. Paul didn't seem to worry about that. He focused on his blog, on growing his international network, and on protecting his niche position as the "Godfather of information."

A few months after the Paris theft, a van Gogh painting titled *Poppy Flowers* (and worth more than $50 million) was stolen from a museum in Egypt. It was the second time that particular van Gogh had been stolen from the same museum. The first theft took place in 1978, and the painting was recovered two years later, in Kuwait. Now it was gone again. A few months later eleven employees from the Ministry of Culture were sentenced to prison for gross negligence and incompetence for not adequately protecting the van Gogh. The painting, though, remained at large. Paul noted that a reward was offered by Naguib Sawiris, an Egyptian billionaire, but it was puny compared to the actual worth of the artwork.

Paul blogged:

Can you believe the balls of this guy? He is a billionaire and the cheapskate offers $175,000 reward for a $55 million Van Gogh. That's 0.3% of the value. Get the fuck outta here. To be fair he is just following orders from art loss investigators and Egyptian authorities. It is called the psychology of low worth. Meaning if the thieves cannot hook into the stolen art underworld then the hope is they will become desperate and take anything that is on offer. The same thing happened on the Swiss art thefts in 2008 when the Cezanne and Degas were stolen from the EG Buehrle Collection, a private museum in Zurich and are worth $150 million. The reward offered by the EG Buehrle museum remains $90,000. I hasten to add the Cezanne and Degas have not been recovered to date. This guy Sawiris and authorities must have been smoking too much Egyptian hubble-bubble pipe, or been sucking on old Grandpa's cough medicine. Drunk or stoned Sawiris and authorities cannot be serious, and if anyone comes forward they deserve all the jail time they will get. Who

in their right mind is going to come forward with information when the prospect of actually getting this poultry reward is remote, to say the least, and added to that, $175,000 for a $55 million Van Gogh.

It was classic Art Hostage: advice to criminals couched in prose worthy of *The Sopranos*.

On September 1, 2010, almost four years after his first Art Hostage post, Paul added one more article to the site—and then his blog went unnervingly quiet. Several weeks passed with no new posts.

This was very weird. Paul and "quiet" didn't belong in the same sentence. I wondered where he had gone and sent him a few emails. There was no response. This was also weird. Paul was an attentive pen pal; he usually responded within the hour, or at least the same day. The art theft blogosphere started to feel lonely. Where would I go to read about the latest bizarre criminal news?

In late October 2010, I emailed Richard Ellis asking for news of Paul. Ellis and Paul had had a complex relationship, but I knew they stayed in touch. I received a reply the next day from the former head of Scotland Yard's Art and Antiques Unit:

> Paul (aka James Walsh) is at present on holiday staying at one of Her Majesty's prisons on account of having been found guilty of Benefits Fraud. He ran as his defense an explanation for double claiming that he had been authorized to do so whilst acting as a registered informant for the police. As he had not been registered with the police for some years and had never been authorized by them to claim any benefits he was duly convicted and sent to prison for 15 months.

I felt a knot in my stomach. Paul had been caught for theft twice and had told me he was extremely happy, relieved, that he'd never had to serve any time in prison. "I really never wanted to go to prison, and I never did," he gloated once. "Art thieves get a slap on the wrist, that's part of the problem." It was hard for me to imagine Paul in a cell.

By then I had been talking to him for close to three years. At various points I'd asked him if I could come and visit, and he'd said yes. For one reason or another, I kept having to postpone the trip. I emailed him again, but there was no response. The Art Hostage site was still up in cyberspace, but its archived collection of news articles and commentary were now frozen.

Then, a few months later, I received an email from Paul: "Hi Josh, I'm back. Call me."

We scheduled another phone appointment.

"Hal-loh? So, did you hear what happened?"

Paul said he had been released on parole. As usual, he'd worked the system and become a model prisoner. He'd stayed for three and a half months at HMP Ford, where prison riots had broken out just before the New Year. Paul said he had helped put a man on a stretcher to be carried out. When we talked, he said he'd decided to cool off a bit before posting anything on Art Hostage. I asked him if this would be a good time to come and visit.

"Are you kidding? I have a tracer around my ankle, and can only leave the house between 7:00 AM and 7:00 PM. There's never been a better time to come and visit. I have no choice, I am here . . . a captive audience." I booked a ticket to London.

Before I visited Paul, I scheduled a meeting with Richard Ellis.

The former detective met me at the Wallace Collection, a private gallery that could not be more British-elite. Housed in a grand brick manor, it holds one of the finest collections of armor, swords, and shields in the United Kingdom. It also holds a number of masterworks by Rembrandt, Titian, and Velázquez. Ellis was sitting in the enclosed courtyard restaurant, just finishing up a meeting with a graduate student who was writing a paper about art crime in the U.K.

Ellis was his usual self: quiet, observant, level-headed. He greeted me warmly and asked who else I was interviewing while in London. I mentioned Julian Radcliffe, and Paul.

"You're seeing Paul?" he said, surprised. "So he's out of prison, is he?"

"He is, apparently."

Ellis mulled it over. "I didn't realize that," he said. Then he smiled to himself. "Please tell Paul hello for me. Tell him, let bygones be bygones."

We spent about an hour together, during which we had a wide-ranging conversation about art theft. I asked Ellis if he really considered himself retired, and he said yes. Then his mobile rang; it was a detective from a police division outside of London. He said into the phone, "I just wanted to find out how the investigation was going on that burglary we were talking about." He was obviously still engaged at ground level with art theft cases here in Britain, perhaps the world. He told me he kept in touch with Bill Martin, Hrycyk's mentor, who had moved to Oregon and started a company. The two had become good friends and talked often.

Midway through our conversation we left the Wallace and walked a few blocks to a small pub, where Ellis bought me a pint of Tribute, a beer made by the brewery

his family started almost two hundred years ago. We raised our glasses. Ellis said he'd grown up in a solid middle-class family and that his parents had emphasized culture. "That's helped me a lot in the art world. I'm not upper class, but I know my way around that world. I can get into that world when I need to. I am comfortable with that world."

I asked him if he'd ever come up against a situation where the powerful forces of the elite had aligned themselves against his detective work. His answer was yes. Once, he'd been investigating a very large and influential company that was in possession of a valuable collection of stolen antiquities. The Art and Antiques unit spent months building the case, and just when it was set to go to court, word came down from above that there would be no prosecution. Instead, there would be an out-of-court settlement. "It was the first time I realized I was over my head." Ellis smiled. "We had the evidence." He said the out-of-court settlement was large—in the tens of millions. "But had we gone to court, it may have bankrupted the company," he added, sipping his family beer.

"I'm thinking of writing a book myself," he said. "I'm not quite sure where to start, but I feel like I've got a book in me." When we left the pub, Ellis shook my hand. Again, he said, "And you will say hi to Paul for me? Okay?"

On a gray London morning I rode a train from Victoria Station an hour and forty minutes to Eastbourne, a resort town and popular retirement destination on the south coast, twenty miles east of Brighton. Paul was standing at the turnstile. I waved from the platform, and he waved back. I'd seen pictures of him, and we had Skyped a couple of times. He looked different now, in person. He'd lost

weight, was taller than I imagined, about six feet two, and had piercing blue eyes. His face still held the openness of a boy's. He looked friendly and totally unthreatening. Paul stuck his big hand out. "Hal-loh. Ride okay? Come right this way, the car's just there."

He pointed to a black Mercedes in the station parking lot, the most expensive car in sight. The licence plate read, OHO8 ART. The OH stood for Oliver Hendry, his teenage son, who was in the front seat of the car, watching his father entertain what I'm sure was another in a long line of journalists, broadcasters, and other characters who journeyed to Eastbourne for a private audience with the online godfather of stolen art.

Paul nodded at the Mercedes. "I bought it from a former diplomat who had to get rid of it," he told me. He opened the door to the tanned leather interior, and I climbed in. When Paul closed the door, he didn't shut it all the way, so I opened it again and pulled harder. "No! No! These are automatic power doors," he laughed. "See . . ." Then he opened the door and gently pushed it toward the body of the car. The door, as promised, closed on its own, locking into place with a quiet click.

Paul pulled out of the station. "It's about a fifteen-minute ride from here," he said. As we cruised through Eastbourne he commented, "It's a boring place, really. Not much to look at, wouldn't ya say?" It reminded me of his rule—always stay under the radar.

"So, you wound up in a retirement community?"

"Exactly," Paul said. "A sleepy little town. What better place for a retired thief to end up? I like it here. It's very quiet, out of the way. I stay out of London if I can help it."

We turned down a small road with modest houses that ended at the sea. Paul's house, the last on the block, faced

the waves. There was an overcast sky, a pebble beach that reminded me of Brighton, and a pub just next door with a view of the water. Home. Paul parked the Mercedes in front of his house, between his front door and the sea. The outside doors and windows had drawn shades—every one. In the kitchen, beside a row of empty champagne bottles on the counter, he pulled up his pant leg to show an electronic bracelet fastened to his ankle.

"I cannot take this off. I shower with it on. Everything. So they can track me at all times," he said. "It's not so bad. It's better than prison."

Then we walked outside again. We looked for a moment at the water, and then went next door, for lunch. Inside, everyone knew his name. "Hey, Paul." "Good afternoon, Paul." "How are you, Paul?"

"Do they know about your career?" I asked.

"Most of them know," he said. "They've seen me interviewed, with television crews and all that."

Paul ordered steak, shrimp, mashed potatoes, steamed greens, and salad for both of us. Then he got down to business. "So you're finishing your book. That's great news. You know I want to write my own book, and now I have an agent in Los Angeles. And, to be honest with you, I'm worried your book has too much in it about me," he said. "I need to know there will be more to tell. That I can tell it."

I agreed that he was heavily featured in my book, and I had assumed that would be good news for him. "When we first exchanged emails," I said, "you asked me to identify you as an expert on global art theft. Well, by the end of this book, that is exactly what I say you are. I say that you are one of the very few people on the planet who understands how global art theft works, and who can talk about the issues with a sense of confidence and expertise."

Paul cut into his steak. "Look," he said. "To be honest with you, we've known each other too long to bullshit about these things. Am I right? I just want to make sure I can write my own book, my own story." His book, Paul said, was just one in a series of commercial enterprises he was exploring. He told me he'd been engaged in negotiations, through his new agent, with a number of television producers on different ideas for projects. He also told me about a friend of his, a master jewel thief in Canada, who had sold his life rights for tens of thousands of dollars. Now that Paul was out of prison, he wanted to make some business decisions about how to move forward. He was, in a way, transforming himself once again. He'd come a long way from the cocky kid roaming the streets of Brighton. He was now hunting for a post–Art Hostage career.

I asked him if he'd read Robert Wittman's book, *Priceless*.

"I'm expecting an autographed copy in the mail," Paul said. "I hear he sold the movie rights."

We dropped the subject after lunch and walked back to his house. "I'll give you the tour," he smiled. The first thing I noticed was that there was art everywhere—on the walls, stacked up against the walls. It wasn't what I was expecting.

"This is all art that's been bought—honestly—over the years. I mean, the police have been through here a few times. You'll notice some of the paintings have little round stickers on them. Those stickers are to show that they've already been inspected by police and are not stolen. It used to be that some of them had two or three stickers on them," he laughed. "It's like I told you. Don't ever keep anything that's stolen. Always pass it on immediately."

His collection was varied: a lot of older works, portraits, some pre-Impressionist paintings, and, in the stairwell, a

collection of French military portraits. "This is the whole collection of this series," he said. "If you possess one or two, they're not worth very much. . . but the more you have in one series, the higher their value. This is the entire series here," Paul explained, pointing at French soldiers on horses, carrying bayonets. We passed them on the way up the stairs to his bedroom, which was also crowded with art: portraits and landscapes, some of them in beautiful ornate frames. What's that? I asked, pointing at one. "It's from the school of Renoir. You know, all these artists had students, and young painters would mimic their work. From the school of . . ."

Paul showed me his Rolex watches, as promised: one silver, one gold. "I don't really wear them often anymore," he said. "Too flash for me now, to be honest with you."

Then he led me back downstairs. We went into a room populated by a series of large works by Joseph Maxwell, a Scottish artist with whom Paul had become friends years ago. Every painting in the room was a large work, and one, he pointed out, was unfinished. On a desk were framed photos of Paul and Oliver in Maxwell's studio. Paul showed me one of the letters the artist had written to him. I noticed that it was addressed to Paul Walsh. I had come to know Paul as Paul Hendry.

"Yah, that's just another name I go by sometimes. Hendry, Walsh, it's a long story, and has to do with my complicated family upbringing . . . The adoption and all that." Next to the Maxwell room was the living room, with a couch, ashtray, and large-screen television. He turned it on. "I usually have this tuned to Bloomberg during the day, while I'm at work," he said. "But, if I hear a knock at the door . . ." He pressed a button on the TV remote and the screen transformed into four security-camera views

showing various angles of the outside of his house. "That's impressive," I said. "So, you know who's out there at all times."

"It's just an extra precaution," Paul said. "I was in the middle of having the system installed when the police raided my house." He laughed. We both eyed the perfect view of the Mercedes parked outside.

"So let me show you the study, where it all happens," he said. "This is where Art Hostage lives." And he led me into a small room with a desk, a computer, a plush office chair, a broken-down couch, and a built-in bookshelf crammed with books about art theft. Titles included *Art Cop*, *Museum of the Missing*, *The Irish Game*, *Thieves of Baghdad*, *The Gardner Heist*, and *The Rescue Artist*, by Edward Dolnick. There was also a copy of *The Lost Museum*, by Hector Feliciano, and *The Rape of Europa*, by Lynn Nicholas, considered the most authoritative investigation on Holocaust-looted artworks. Lying on the couch was *The Encyclopedia of Popular Antiques*.

On the wall behind the desk were two framed diplomas from the University of Sussex: one for a BA in American Social Studies, the other for an MA in Contemporary History. On the wall directly across from his desk was a large poster of Vermeer's *The Concert*, the painting stolen from the Isabella Stewart Gardner Museum.

Beside the desk, near the door, was a beautiful wooden display case. "Irish secretary bookcase," Paul explained. "And in decent condition." Then he looked at the objects in the room and his eyes landed on his desk. "And, if you're curious, that's a California-model desk ordered from Staples."

He sat down at his computer, which a friend had custom-made for him. "It's a powerful machine, packed with terabytes. It's fast," he said.

Paul opened up his Art Hostage account. He had ways of seeing who visited the site, he said, and kept files on some of his viewers—their email addresses and IP information. "See, I can pinpoint pretty closely who's watching," he said. He showed me some of his more interesting followers. There were hits from the FBI, the Justice Department, the U.S. military. Someone from Jerry Bruckheimer Films had been reading his blog. Eyes from all over the world checked Art Hostage: Canada, Switzerland, Russia, Bosnia, Serbia. "The Montenegro hits are probably from someone in the Pink Panthers," Paul said. "Remember, thieves have egos too. And they like to know what's being written about them."

I asked Paul how it was that he could easily see that the FBI was looking at his site. "They are so funny. They don't turn off their cookies function. So some guy at the FBI is at his laptop, and he's leaving fingerprints all over his Internet searches," said Paul. "I mean, to be honest with you, if I can gather all this info, and I'm just me, some guy in a room in England who doesn't have all that much education in technology, imagine what someone who knows what they're doing could be gathering. Like terrorists, right?"

Paul had not added a single new post on Art Hostage since his parole, but he showed me a chart that tracked the site's users. Art Hostage was still getting three hundred hits a day. He said he wasn't sure when he was going to start posting again. Prison, he said, had taken its toll. He wasn't feeling up to it these days. Still, watching him show me the stats and the site and point out the constant interest from all over the world, I figured it would only be a matter of time until he resumed his alter ego.

Before I left, I asked Paul if he ever went back to Brighton. He said no, he never did. "You know, it's just not

for me to go back there. I have contacts, but, to be honest with you, a lot of the people I know there are still doing the same thing. It's just not the kind of place I need to revisit. You know what I mean?"

Paul asked me who else I'd seen in London, and I said Richard Ellis.

"Did he say anything about me," Paul asked, in a flat tone.

"He says hello," I said. "He says, let bygones be bygones."

Paul thought about it for a moment.

"If you speak to him again, tell him, as far as I'm concerned, we're good."

It was close to five o'clock when we climbed back into the Mercedes. I closed the door gently this time. Paul pulled out from his house, past the restaurant. He turned on his car's speed-radar alert, just in case any police officers were looking to bust him for going too fast. The sky was its usual leaden overcast, and we followed the roads through the peaceful resort.

At the station, we stood in front of the Mercedes and shook hands. He said, "Look, I'm glad you came to see me. I'm sorry if I pressed you on the book stuff, I just want to make sure I can do my own story, right?" I thanked him, and said that I hoped he would write his book, and in his Turbo voice. He told me he had a working title: *Brighton Knock*. That made me laugh—it was perfect.

On the train back to London, the muddy green fields gave way to dirty brick suburbs, then to larger apartment blocks, and finally to the low horizon of thousands of rooftops. I realized that after all the time we'd been talking, the one thing that seemed to concern Paul, the retired art thief, was that I might steal something from him.

Above Paul's desk had been a painting by Australian artist Ainslie Roberts called *Songman and the Two Suns*. "I bought it online," Paul said. The palette was fiery reds, oranges, and yellows. In the forefront a tall, sinewy man stood in a small wooden boat, alone on a sea, with two suns behind him. It made me think of the ferryman on the River Styx, crossing over to the underworld. "Roberts used the concept of dreamtime in his work," Paul told me. "Do you know dreamtime?"

Dreamtime is a complex Aborigine idea, according to which we are eternal energy, both before we are born and after we die. For a short time in between, we are delivered into the physical world. The Dreaming was the Creation; when we die, we live on in Dreamtime. Paul had told me his own creation myth, infused with eternal forces: the dark road, the power of greed, a boy's struggle to focus his energy, the quest to learn and master a world, the great hunt for the prize. And that quest did not seem to have an ending. Even now, in his sunset community by the sea, Paul was still restless. He had created the mythical character Art Hostage as a means to continue knocking on doors all over the world, in cyberspace, still searching for the ultimate prize—he just didn't seem to know what exactly that prize was, or which door it was behind.

One week after our meeting, I was in Toronto when Paul sent me an email. The subject line read, "Return of Art, Hostage that is!!!" In his note he said, in part, "I tried to refrain from my usual self but failed and realized I have only one gear TURBO."

Art Hostage was back. Often, when I read about an art theft in the news, I think back to that first conversation with Paul. "Once you start thinking about this subject, you will never be able to stop thinking about it. Every time

a painting is stolen somewhere in the world and you read about it in the news, you will feel compelled to think about it, and to know where that painting went. It grabs you and never lets you go."

# 16.

## MISSING PIECES

"Sometimes it's hard to tell the good guys from the bad guys."
**DONALD HRYCYK**

Donald Hrycyk led me downstairs from his office at Parker Center to a small storage room attached to the evidence department. A stack of metal shelves held a dozen or so black cases and tubes.

"We had to order these cases special," he said. "They're made for artists, for storing canvases." He paused. "They were very expensive." Hrycyk picked up one of the tubes, put it on the floor, and unzipped it. He pulled out a very large canvas and carried it into the hallway, where he put it down on the floor and unrolled it. It was an Andy Warhol silkscreen of Elvis Presley.

"Is it real?" I asked.

"No," he answered. He rolled it back up, slid it back into its case, and put the case away. He pointed to a framed painting on the shelf. It looked like a Renoir—a beautiful portrait of a woman staring out at the little evidence closet.

"This one is fake too," the detective said. The forged Renoir was sold in 1984 through Sotheby's in New York. "The real one is in Paris," the detective said.

He walked over to the closet and pulled out a small black satchel, holding it up. "This is a burglar's bag," he said. "It was the only evidence left behind by a very smart man."

A master thief had spent a lot of time carefully executing his plan to steal art from a major commercial art gallery in Los Angeles, in the Wilshire area. Apparently the first thing he did was go to the front door, jam a toothpick into the lock, and break its tip so it was hard to open. It bought him time in case the alarm was triggered. The gallery's alarm system was installed in the phone lines, so he cut the outside line. He then created his own entrance. He scaled an outside wall of the building, carrying a small battery-powered saw, and cut a hole in the roof.

"He had to cut through tar, plywood, and planks until he hit the open inside space," said Hrycyk. "Then he used ropes to lower himself into the gallery."

Hrycyk had examined the hole in the roof. "He could have spent all weekend there looting the place. It was just luck that he got away with only one painting." The alarm was triggered when the phone line went dead, but the security person who arrived was stalled by the broken lock. That allowed the thief just enough time to climb back up through his entrance and out to the city. "He wanted all night, but instead he got away with a single painting," said Hrycyk. "It was a Dubuffet worth $100,000. We've never recovered it."

The burglar had left a souvenir—the workbag Hrycyk was holding. "He was good, but he wasn't planning on being in a rush." The bag has a small logo on it, and over the following weeks Hrycyk used it to trace the bag north.

"I found out it came from Alaska. But I couldn't get any further," he said. "This man was incredibly smart," said Hrycyk. The Dubuffet became another unsolved mystery in Hrycyk's list of open cases.

Yet another unsolved mystery for the detective was the absence of data. When we discussed the future of the Art Theft Detail, for example, he said, "We face the same problem as any police unit in any big city. We need data. Everything is driven by statistics, and statistics are very difficult to gather on art theft."

Hrycyk said the FBI's statistics depend entirely on the number of stolen paintings entered into its National Stolen Art File. The Art Loss Register is good at spotting trends, though there are limits and barriers to the information it gathers. "These databases are still not commonly known by law-enforcement agencies. If there was a way for me to capture all the cases that revolve around stolen art . . . but there is not," he said.

I asked him about global statistics, and whether he agreed with the big number that was being thrown around in the law-enforcement community—the often-quoted figure of four to six billion dollars for the annual global trade in international art theft. That figure, in one form or another, was published on the websites of the FBI, Interpol, and UNESCO. "Yeah, I've always been fascinated by that number," he told me. Hrycyk once decided to apply his skills to hunting down the source of the figure. His first call was to the FBI. The bureau told him it wasn't their number and that he should contact Interpol. Hrycyk emailed Interpol, which told him to call the FBI. "It was circular," said Hrycyk. "No agency or organization is willing to take responsibility for it. The truth seems to be that no one knows how large the black market for stolen art is. There simply

isn't enough information on the subject. This is a phantom number," the detective told me.

I'd emailed Interpol near the beginning of my research and requested an interview. They sent back a formal note saying that they rarely granted interviews to press because of the volume of requests from all over the world. I emailed Interpol again as I was finishing the book and said that three different people—Bonnie Czegledi, Richard Ellis, and Bonnie Magness-Gardiner—had suggested I get in touch. One day later I was on the phone with Karl-Heinz Kind, coordinator of Interpol's Works of Art Unit, under its Specialized Crimes Directorate. In Washington, D.C., Magness-Gardiner was the highest word on art theft in the United States; in Lyon, Kind was the highest word on earth.

"Hello . . . just a moment," he said. "I'll shut the door." Kind had been working for Interpol for over thirty years, first in Germany and then from its headquarters in France. We discussed the Myth: I was curious to know whether he'd seen *The Thomas Crown Affair*, and whether people asked him about those sorts of scenarios often.

"Yes, I've seen the film, and I get those questions all the time," he said. "That's a kind of stereotype reaction. It also makes no sense. If somebody is rich, he can afford to buy art. And from a psychological point of view, if someone possesses a high-value item, he's proud of it, and he wants to show it all the time, not hide it from his friends. I have no cases to confirm the existence of that kind of thief, in reality. I think that it's just fiction."

Then we moved on to the reality. At the FBI, Magness-Gardiner had highlighted New York as a destination for the world's stolen art, as Robert Volpe had decades earlier. Another obvious major outlet was London. Did Interpol agree? Kind answered with stellar diplomacy.

"That is a statement I would subscribe to," he said. "The motivation for theft in the vast majority of cases is financial gain. And if you want to achieve that, you have to put it on the market. I do not like to pinpoint one specific place, but the United States and the United Kingdom have the biggest auction markets. There are other opportunities, in Germany, France, and Italy, for example." And when it came to the relationship between the black market and the legitimate market, he was equally diplomatic, though he clearly acknowledged their link.

"The boundaries are sometimes not very clear," he said. "An honest art dealer should refrain from acquiring and selling items without provenance that is proved and documented. The standard answer—'I didn't know. I didn't have the chance to check that it was stolen.' Well, now, it is your duty to check. And you have the tools to do it, and it is free of charge," he told me, referring to Interpol's free database of stolen art. "You can't just turn a blind eye." Of the way that dealers and collectors operated, he said, "We want to change their behavior."

Interpol pulled in reports from all of its 188 member countries and was having some success at gathering information about how large the problem of international art theft had become. I asked Kind if he could define the specifics of that scope for me, in terms of monetary value—and referenced the often-quoted number.

"I may disappoint you," he said. "I don't have a good answer to this question. You can certainly study archives, and reports in the media. Very often you find figures that the illicit trade is six billion annually, but there is no solid ground for that estimation. I would never use that figure."

He agreed with Hrycyk that it was a phantom number.

"Those numbers are just based on previous reports that have been published somewhere. If they are often enough

repeated, they become truth. We never use this number, because we know it is not true. What I know from my experience is that there is a lack of basic information," he said. "Every year we send out requests to member countries, asking for statistical information. Basic questions: number of thefts, and number of stolen items; what kinds of items. Only 30 percent of those countries send an answer, and a lot of those answers are courtesy replies without substantial information. It's clear we're not getting the real picture."

Kind was direct when it came to what he didn't know, and he acknowledged a point that Czegledi had raised in our first meeting, way back in 2003, when she had been pointed to the absence of data.

"A lot of information is unknown," Kind told me. "Some police officers have experience with the specific cases they deal with, but to see a general picture . . . There is a problem. It is a big problem. And it's not just reduced to certain countries. This affects all countries, and all the regions of the world. But if you want to speak of a concise picture, I think it is still a big mystery."

When Detective Bill Martin retired from the LAPD in 1992, his legacy was Hrycyk. The only problem was that Hrycyk didn't have a partner; he was a unit of one with a rapidly expanding caseload working with rotating staff in Burglary Special. He was at the mercy of department politics. His superior officers changed constantly. "That battle never ends. That revolving door affected my ability to retain a partner, which in turn affected my ability to collect data and solve crimes," he told me.

"I remember two different captains, at different points in a decade, coming in and meeting me and expressing

surprise that the Art Theft Detail even existed," he said. Hrycyk was a specialized detective with skills only a few in the world possessed, but in Los Angeles he was on his way to becoming irrelevant. At times he did receive a partner, but it was always short-lived. Someone would be shipped in, spend a year working with him, and then move onward and upward. "I've had a number of very good partners over the years, but they were transient. I'd spend a year training them and then suddenly they'd be sent over to work stolen cars. That's time and energy wasted in this kind of work."

Hrycyk said that for a time the Art Theft Detail even acted as a punitive limbo. "I can think of at least two people who were assigned to me as part of a punishment. They were brought over to this unit and really had no desire to work on art." Going hunting with Hrycyk for missing paintings was, for them, the equivalent of sitting in the corner with the dunce hat on.

Here's one more story Hrycyk told me: Every two years, Interpol holds an art theft conference in Lyon, France, to which the world's top law-enforcement officials, cultural lawyers, and agents are invited to attend what is by far the most important meeting of minds on the subject. Interpol sent an invitation to the LAPD Art Theft Detail in 1999. That invitation was intercepted by an aide to a deputy chief in Hrycyk's chain of command. The aide, with no art functions or responsibilities, nominated herself to go in Hrycyk's place and received approval from her boss. "So we never got the invitation and had no chance to request funding," said Hrycyk. "The aide didn't think we would ever find out. However, she didn't know of our close relationship with our Interpol art liaison, who contacted us later and asked us why someone was going in our place."

Hrycyk objected, but it was too late to get funding and make arrangements to attend the conference.

"I've had eight different commanding officers over the last few years. I'll get a new captain who is very supportive, but sometimes support is not enough." One captain pushed very hard to get Hrycyk a long-term partner he could train. "We had a meeting with the deputy chief, and he said to us, 'Hold off on that for now. It could be that the department decides that an art theft unit is a luxury.'"

He continued, "So here we are talking about a unit that has now been around for close to a quarter of a century, and suddenly somebody has done some sort of review and come up with an opinion that it might not be important." His resources were cut to a bare minimum, and it looked like the end of the Art Theft Detail. Then his superior changed, and so did Hrycyk's fortunes.

"In 2006 I was given the job of selecting somebody to work with. I'd been working art theft for two decades at that point and had acquired a body of knowledge. There was no one else in the department who conducted these kinds of investigations. I'm saying to them that we, as an organization, need to find somebody to train, because it will take years for me to get this new person up to speed," he said. "If we don't find someone, that knowledge will be lost when I retire. It won't exist."

Hrycyk interviewed a dozen detectives and picked a partner he thought would be suitable for the job—Stephanie Lazarus. At forty-six, she was a twenty-five-year LAPD veteran. Lazarus, like Hrycyk, had worked in several divisions, including major crimes and homicide. For six and a half years she served as the night detective, fielding calls and conducting preliminary investigations in the darkest hours while the day-shift detectives slept.

Her duties included driving to the crime scene, assisting with initial interviews, and collecting evidence. Among her special skills was information management, which she taught at the LAPD training academy. That was exactly what Hrycyk required. He had volumes of information and needed to find someone to help him make sense of it. Lazarus did that.

Hrycyk and Lazarus spent hundreds of hours transcribing handwritten information from the blue binders to the database and the website. And they worked the cases. Hrycyk also began to transfer his hard-earned knowledge of art theft investigations to her. While Hrycyk took a vacation one Valentine's Day, a bronze statue was stolen. Lazarus conducted the investigation solo and solved the crime before Hrycyk was back at the office. When we met that summer, in 2008, I got the sense that Lazarus was content to stay in the background. Rarely was she quoted in articles about the unit's successes. She didn't seem to be about the glory, but she was to be Hrycyk's legacy.

For a presentation to his superiors, Hrycyk compared the results of his team of two against the combined results from all the detectives in Los Angeles working property crimes. He included a little diagram: ninety stick figures, representing the ninety detectives in all twenty-one divisions, and the value of their recoveries between 1993 and 2008: $64 million. The art theft unit was represented by only two stick figures, and beside them was the value of their total recoveries over the same period of time: $77 million. Hrycyk and Lazarus had recovered more value than ninety detectives, by more than $12 million.

Back at his desk Hrycyk surveyed the stacks of files and those thick blue binders, filled with hundreds of pictures and reports of vanished artwork.

"The vast majority of these cases are not solved, although that depends on the time period you're looking at. After one year, we might have one recovery. After five years, we might have another. When I teach at the academy I tell the detectives that, despite perceptions, art is one of the best types of property crime to recover. In the press I read all the time that art is something that is never found. That has not been my experience," he said.

This afternoon the detectives' bull pen was mostly empty; everyone was out in the city working cases. The detective turned away from his computer.

"Whenever Stephanie and I make a recovery, everyone in our department becomes an art critic. We bring the art upstairs and they'll peer at it. Sometimes they can't get over how much money these pieces of art are worth. To be fair, to the layman's eyes, it might look like crap. The other detectives are always interested in how something was made, the history of it," he said.

"You have to remember that, off duty, a lot of these people are writers and artists. I know one detective who retired from homicide and opened an antique store. Art can be commercial and incredibly popular. There were lines going out the door for the King Tut exhibit, or when there's a Picasso show. Art isn't just appreciated by the intelligentsia of the nation, it appeals to the average person."

The detective took that thought further. "A large number of average people put aside part of their paycheck to buy something because it is beautiful, because they appreciate art and beauty and want it in their homes and in their lives. From that comes a desire to understand more about it," he said.

"What we have found is that art, to many of the owners, has become a comfortable old friend. A painting is not

just an inanimate object. As a result, this is exactly the kind of stolen property worth tracking down, even if there's no chance of finding or arresting the thief," he said.

"This unit has been in existence for two decades, and we're still trying to figure out how to do this. You have to look at the future," he added. "These artworks will outlive everybody in this building right now."

Over the next year I checked in with Hrycyk every few months. In the spring of 2009, almost a year after my visit, the detective told me about one of the weirdest cases to cross his desk. As usual, it started with a phone call, this time from the son of a very wealthy and respected family who had been integral in establishing the cultural reputation of the metropolis.

"They ran one of the great art galleries of this city, as well as building up a massive collection of contemporary art, including a number of Andy Warhols," the detective said. In the early 1980s the family home was burglarized and five original Warhols were stolen. Shortly after the theft, details of the crime were reported to the LAPD and the FBI National Stolen Art File.

The son had followed his parents into the art business. For a time he owned a gallery in Los Angeles, and even after it closed he remained a prominent figure on the art scene. It was the son who contacted the detective. He said he'd found some of his family's stolen Warhols.

"More than twenty years after the initial theft, he was flipping through a catalog for Christie's when he spied what he was sure were two of the stolen family Warhols," said Hrycyk. The works had appreciated in value, one selling for $130,000 and the other for $150,000.

The detective compared the catalog photos to the theft reports. They appeared to be the same silkscreens. He executed

a search warrant for the Christie's office in Los Angeles. "The staff at Christie's were very cooperative," said Hrycyk. "We seized the artworks." Christie's also supplied the name of the consignor. He was not a regular customer, but he lived in Los Angeles. The detective looked him up.

His suspect was surprised to be talking to the police, and surprised as well to learn who had initiated the investigation. According to the man sitting across from Hrycyk, it was the son who'd sold him the Warhols in the first place, shortly after they'd been reported as stolen. "We couldn't believe it, what the consignor was telling us," said the detective.

Hrycyk couldn't tell which man was lying.

According to a lie-detector test, it was the consignor who was telling the truth. "The man who took the polygraph didn't make any bones about how he got ahold of these things. The Christie's catalog had the provenance listed, and the name of the son was in that provenance."

According to the consignor, the two had been friends; they'd partied together. "When he was seventeen years old, the son stole these Warhols from his family home and apparently traded them for a small amount of cocaine and a small amount of cash. It turned out not to be a wise business decision."

Twenty years later, when the son spotted the Warhols he'd sold for drugs and money, he decided he might be able to make them pay again. "The son had no idea that this guy was still in possession of the paintings. He believed the Warhols had gone through a number of different hands and that he was never in jeopardy of being discovered," said Hrycyk. It was a calculated risk.

"The son finally confessed to what he did," said Hrycyk. "The theft was past the statute of limitations. And even

though the son ripped off his mom, she didn't want to prosecute him, because it would mean sending her own son to jail," said Hrycyk.

Another twist emerged. The son had also bought the other three stolen paintings, from a local art gallery. He'd never told his mother. "Here he is, in possession of his mother's stolen art, knowing that she had made a crime report on these things. The paintings may end up being returned to the mother, and when she dies, the son might inherit them." No charges were laid, but the case was solved.

"It's a strange world out there," Hrycyk added. "Sometimes it's hard to tell the good guys from the bad guys."

Not long after our conversation Hrycyk's world became stranger.

On June 5, 2009, Detective Stephanie Lazarus was sitting at her desk in Burglary Special when she received a call from a fellow LAPD detective. He had a man in the holding cell, a suspect in one of her investigations. Did Lazarus want to question him?

Yes, she did. She headed downstairs.

In the basement holding cell of Parker Center, Lazarus removed her firearm, as is required. She was questioned by homicide detectives and was then arrested for a murder in a cold case over twenty years old.

In 1986, Lazarus was a rookie LAPD officer. That year, her ex-boyfriend's wife was brutally beaten and killed. The only items stolen from the condominium building the night of the murder were the couple's marriage certificate and their car. During the initial murder investigation, Lazarus was dismissed as a suspect, even though she knew the victim and, in fact, had been accused of harassing the couple.

The victim's father wrote long letters to the LAPD, pleading with them to investigate Lazarus. Those letters had been kept on file. No one was ever arrested for that murder.

Hrycyk knew that in 1986 homicide cases were piling up in Los Angeles and that there were not enough detectives to work them. He'd seen the problem firsthand in South Central. By 2008 circumstances had changed. There was time now to open a few cold cases. The detectives at Homicide Special, just down the hall from Burglary Special, were still haunted by the letters from a grief-stricken father. They decided to take another look at the case, and almost immediately Lazarus came up as a suspect. Two detectives were moved out of Parker Center and started investigating their fellow LAPD detective.

At times, it was revealed during pretrial, they trailed Hrycyk and Lazarus. It is possible that during my visit the art detectives were being watched and followed. One day the homicide detectives collected fast-food utensils Lazarus had thrown into a trashcan. DNA samples from those seemed to match the DNA found on the body of the 1986 murder victim.

Hrycyk had spent over three years training Lazarus. She was his personal choice to succeed him. In fact, Hrycyk and I had discussed the issue of a successor on a few occasions. He always said that it was a vital step for the continuation of the unit.

Over the following months the *Los Angeles Times* published pictures of Lazarus standing in a courtroom wearing an orange prisoner uniform, and the *Atlantic Monthly* published a feature about the events leading to her arrest.

Shortly before Lazarus was due to stand trial, I called Hrycyk and asked if he wanted to comment. He declined, saying that the case had no relevance to the art theft

investigations he was working on. I told him that I was interested in the legacy question, and asked him if he thought the LAPD would assign him another long-term partner. He was unsure. "It's not a great time right now, because of the economy. The force is cutting back," he said. California was reeling from debt. One person I knew, in San Francisco, had been receiving IOUs from the state government instead of unemployment insurance checks. The LAPD academy was accepting fewer applicants, and an article in the *New York Times* ran with the headline "California, in Financial Crisis, Opens Prison Doors." It detailed a plan by the government to reform its overcrowded prison system, with the hope of releasing convicts who pose little risk to the community.

Hrycyk did have an update for me: it concerned the old woman with all the television screens, and the Picasso on the couch. She'd come up in the news. Her name was Tatiana Khan, and she was the owner of Chateau Allegré gallery, which we had visited on that June afternoon. Hrycyk had been right to photograph the painting. Khan was a veteran art dealer, and she had sold the Picasso to a collector for $2 million. After buying it, the collector did some research on the painting, and it turned out to be a forgery. The FBI investigated, and in 2009 served Khan with a summons. In 2011, the art dealer pleaded guilty to making false statements to the FBI and witness tampering. Her attorney released this statement: "Mrs. Kahn has a forty-five-year career of selling antiques and fine arts and she's accepting responsibility for making a false statement to an FBI agent in connection with one painting. She hopes to put this investigation behind her and move forward with her career."

One afternoon at the end of my 2008 visit, Hrycyk talked to me about how he would operate were he to cross the line and venture into the criminal trade. After all, he'd spent years learning to think like many different kinds of thieves, in order to successfully hunt them.

"If I were going to plan a new career for myself as an art thief, I'd take lesser-known works by artists. I would find out which artists are popular in the market today, what kind of art people are buying, and stick to a certain dollar amount—$10,000 would be best, but I'd probably go as high as the twenty, thirty, or forty-thousand-dollar range. I could dispose of those works almost invisibly through smaller auction houses that won't put stolen paintings on the cover of their catalogs."

He paused to think.

"I would find an independent art dealer who would not exhibit the works I sold to him—a lot of art dealers work from their homes, and their sales are done behind the scenes, in the back rooms. There are still so many collectors out there who value their privacy and who do not want to draw attention to their art."

The detective said he would not steal from museums or larger art institutions, because that would pose too great a risk. "I wouldn't want to attract attention to myself. I would be quiet," he said. That was the mark of an educated thief: stay under the radar, just as Paul had always advised. Hrycyk, one of the most experienced art detectives in the world, was saying that after all his years of experience, his hundreds of cases, he had learned that Paul's was the best approach.

"If I stuck to those rules I would probably be quite successful as an art thief," the detective said.

Just months after Hrycyk had recovered one set of Warhols, ten more were stolen. These Warhols were

taken in 2009 from the Los Angeles mansion of Richard L. Weisman, a prominent businessman who had personally commissioned the series from Warhol. Weisman had asked the pop artist to create portraits of a series of super-athletes, including Jack Nicklaus, O. J. Simpson, and Muhammad Ali. It was a multi-million-dollar theft from his living room, while he was traveling. The game never ended.

The detective listed the stolen works with the Art Loss Register, the FBI, and Interpol. He followed his system. The Crime Alert arrived in my inbox: another case, another file opened. And after he sent out his press release, articles about the L.A. theft appeared in newspapers around the globe.

Across the ocean, Art Hostage posted one on his site.

# EPILOGUE

t was spring of 2011, and I had just finished an update
session with Donald Hrycyk when Bonnie Czegledi's
name came up on my cell phone.

"Hello . . . Bonnie?"

"I'm in Toronto for a few days," she said.

By then Czegledi's book, *Crimes against Art*, had been
published, with an introduction by John Huerta, general
counsel for the Smithsonian. The book detailed the rise of
art theft and the rise of cultural heritage law; it also served
as a how-to for lawyers interested in the field. After she had
finished her book, she sold her house in Toronto and moved
to France. She owned a farmhouse in the south, where she
could advise on matters of law, and paint—she was, after
all, also an artist.

During one of our first meetings, when Czegledi was try-
ing to explain how big the Problem was, she'd asked me if I'd

ever heard of the mysterious *vent d'Autan*, a wind that came from North Africa and blew all the way through the French countryside, shaking the windows of her house. "That wind actually carries grains of sand to my kitchen from the African continent. It doesn't care about international boundaries, just like the black market," she laughed. "I think that's what the art world needs. A storm so powerful it blows open all the secrets." If not for Czegledi's guidance and education, my story would have started and ended with the Lonsdale Gallery burglary. But she had been generous with her contacts and her enthusiasm during my learning process.

We met at the Coffee Mill, a Hungarian restaurant in Yorkville, not far from a gallery that had been burglarized in a smash and grab a few weeks earlier. It had made headlines in the *Toronto Star*. When Czegledi arrived, she was carrying a press package from Interpol. She placed a photograph on the table. It showed a group of about a dozen people from countries around the world standing in the grand atrium of the international police headquarters in Lyon. There she was on the left-hand side of the photo. Czegledi had been asked to become a member of Interpol's new stolen cultural property think tank.

"So you've made it all the way to the top of the international law-enforcement system," I smiled. "How long did that take?"

"Only a decade," she said. "I think it can help get things done. It's a step toward changing things." I thought back: she'd joined the American Bar Association Cultural Property Committee in 2000 and the International Bar Association Cultural Property Committee in 2001; in 2004, she'd opened her own law offices and become the cochair of the ABA Cultural Property Committee. It was clear when we met that she was determined to move up the

ranks, to learn, and, as corny as it may sound, to change the world. Now she was associated with Interpol, the highest vantage point on the global law-enforcement totem.

I looked at the picture again, of the group standing on the Interpol insignia, which is embedded into the floor like the CIA logo in movies. Then I asked her what they'd discussed at that meeting.

"Here's the thing . . . I can't tell you," she said, and paused. "But if you go to the website, you can see the press release." Then she added, "They are very careful with security." Czegledi mentioned that while she was at Interpol, she'd put in a good word for me. I told her I'd emailed them and they had declined to be interviewed. "I'm not sure if they'll talk to you," she said. "They don't talk to a lot of press. But you could try emailing them again." Her advice was correct, and Karl-Heinz Kind granted me an interview. It was the last interview I conducted for this book.

Czegledi and I had first met just days after the United States had invaded Iraq—me with my empty notebook. A few days after our meeting in Yorkville, Osama bin Laden was killed. I watched the celebrations on TV that night, live from Washington, D.C., and New York. At Bonnie Magness-Gardiner's office, at the Hoover Building, the word "deceased" was added to bin Laden's photo on the wall in the lobby. Interpol removed him from its most-wanted list. It was strange now to think of the domino effect bin Laden had had on the world of art theft, starting with the invasions of Afghanistan and then Iraq, the pillaging of that country's cultural heritage, and the formation of the FBI Art Crime Team—the art detectives of tomorrow.

Before Czegledi had moved to Europe, I'd asked the lawyer the same question I'd asked every member of the

law-enforcement community: Are you training someone to replace you? Czegledi thought about it for a moment.

"No," she said, and gave me a strange look, as if I was missing the point. Our conversation on art theft had been running for more than seven years. Then she asked, "Is your book almost finished, or what?"

After I had been learning from Czegledi for a few years, at the end of one of our meetings she presented me with an antique bronze key. "It's from France. I collect them," she said. "I give them to people I trust." The key was heavy, and it looked as if it had once unlocked a giant door, somewhere far away. When I got home I placed it on a shelf in my kitchen, above the table where I write. It's now a piece of art in my home, and it's worth more to me than its monetary value. From Paul's perspective, it probably wouldn't be the prize—if anyone ever comes knocking.

# ACKNOWLEDGMENTS

Samantha Haywood, an extraordinary agent and friend. Trena White, a skilled and dedicated editor, and the team at Douglas & McIntyre. Meg Storey, my wonderful U.S. editor, and the incredible crew at Tin House Books. My family: Martin Knelman, Bernadette Sulgit, and Sara Knelman. Catherine Osborne, who sent me to investigate a local art gallery burglary; Tom Fennell, who edited the *Walrus* feature; and Christopher Flavelle, who fact-checked that feature. Jess Atwood Gibson, and the Pelee Island sessions. Rachel Harry, who lent me her courage. For guidance and support: Siri Agrell, Shelley Ambrose, Garvia Bailey, David Berlin, Sarah Cooper, Antonio De Luca, Hilary Doyle, John Fraser and Massey College, Graeme Gibson, Jeremy Keehn, Judith Knelman, Deborah Kirshner, Douglas Knight, Anna Luengo, Dave McGinn, Erin Oke,

Sylvia Ostry, Jeff Parker, Martin Patriquin, Eric Pierni, Richard Poplak, Rosalind Porter, Graham Roumieu, Bernard Schiff, Jack Shapiro, Paul Wilson, Fiona Wright. The works of Michael Mann and of David Simon, for structure and inspiration. Terence Byrnes, my teacher. Marci McDonald, an investigative journalist who leads by example. Margaret Atwood, for wisdom, and who told me at the right moment: "The only way out is through." Most of all, thank you to those who were generous with their time and allowed me extensive access to their lives and thoughts, without whom this book would not exist: Bonnie Czegledi, Ricardo St. Hilaire, Richard Ellis, Donald Hrycyk, and Paul Hendry.

HILARY DOYLE

Joshua Knelman is an award-winning journalist and editor. He was a founding editorial member of the *Walrus* magazine, and his writing has appeared in *Toronto Life*, *Saturday Night*, the *National Post*, and the *Globe and Mail*. Knelman's feature article "Artful Crimes" in the *Walrus* won a gold National Magazine Award. Knelman is also the coeditor of *Four Letter Word: New Love Letters*, which has been published in ten countries. He lives in Toronto.